THE SECOND HALI ANNUAL

Editor
Jill Tilden

Associate Editors
Daniel Shaffer, Sheila Scott

Assistant Editors
Nicholas Purdon, Alexandra Trone

Picture Research
Rachel Howells, Sara Elliott

Design
Liz Dixon, Anderida Hatch

Publisher
Sebastian Ghandchi

Project Co-ordinators
Joan A. Speers, Alan Marcuson

Production
Liz Jobling

Promotion & Marketing
Ashley Spinks, Piers Clemett

Advertisement Sales
Christiane Di Re, Conrad Shouldice
Mark Harbour, Richard Jakob

Advertisement Co-ordinator
Angharad Britton

Imagesetting: Disc to Print, London
Colour Origination: Vision Reproductions Limited
Milton Keynes
Printing & Binding: Amilcare Pizzi, Milan

A catalogue record for this book is available
from The British Library

ISBN 1-898113-15-7

Hali Publications Limited are the publishers of **HALI**
The International Magazine of Antique Carpet and Textile Art

HALI is published bi-monthly
For subscription information please contact:
Hali Publications Limited
Kingsgate House
Kingsgate Place
London NW6 4TA
United Kingdom
Tel: (44 171) 328 9341
Fax: (44 171) 372 5924

Hali Publications Limited is a member of the
Centaur Communications Limited Group

Front cover pictures courtesy: Topkapı Saray Museum —
Philip Wilson Publishers; Eskenazi Limited — J.J. Lally
Back cover pictures courtesy: Victoria & Albert Museum;
The Embroiderers Guild Collection; Vakıflar Museum —
Uta Hülsey; Textile & Art Publications — NHK (Japan
Broadcast Publishing Co.); J. Poncar — Serindia Publications

ASIAN ART

Hali Publications Limited, London

AUTHORS

PATRICIA L. BAKER

Patricia L. Baker read Islamic History and Islamic Art and Archaeology at the School of Oriental and African Studies (SOAS), London, where she also acted as External Examiner (BA and MA Art and Archaeology). Until 1987 she was a senior lecturer at West Surrey College of Art. She is now freelance and travels extensively in the Middle and Far East. She wrote her doctoral thesis on the history of Islamic court dress, and her book *Islamic Textiles* will be published by the British Museum Press in autumn 1995.

ALAN CAIGER-SMITH

Alan Caiger-Smith is a potter and writer on ceramics. Some seventy potters were employed and trained at his Aldermaston Pottery from 1955-1993 and his own work is represented in the Victoria & Albert Museum and collections worldwide. He is the author of *Tin Glaze Pottery* (1973) and *Lustre Pottery* (1985, 1991), and co-editor of *Piccolpasso's Three Books of the Potter's Art* (1980).

JOHN CARSWELL

After graduating from the Royal College of Art as a painter, John Carswell worked as a draftsman for Kathleen Kenyon at her excavations at Jericho. Parallel to his one man shows as a hard-edge abstractionist at Hanover Gallery in London and Fischbach in New York, he began his research in Islamic and Chinese art by surveys in the Middle East and India. His excavations in Sri Lanka came to a halt in 1974 with the outbreak of civil war, as did his teaching career in Beirut a year later. Moving to Chicago via SOAS, he became a museum director for a decade. He returned to London in 1988, joining Sotheby's in 1989 as director of the Islamic Department. His multiple interests continue: Princeton University Press is about to publish his new edition of Hourani's *Arab Seafaring*, and the Sadberk Hanim Museum in Istanbul his catalogue of their Chinese collection. This article marries his aesthetic approach as a painter with an analysis of the fundamental principle involved in our fascination with blue-and-white.

ROGER GOEPPER

Professor Roger Goepper was born in 1925 in Pforzheim, Germany. From 1951-55 he studied Sinology, Japanology and Art History at Munich University. He worked at the Staatliches Museum für Völkerkunde in Munich from 1952 until his appointment as the Director of the Museum für Ostasiatische Kunst, Berlin, in 1959. He headed the Museum für Ostasiatische Kunst, Cologne, from 1966 to 1990, and has been teaching at Cologne University since 1966. His research areas include Chinese painting and calligraphy, esoteric Buddhism of Japan and the Himalayas.

ROBERT HILLENBRAND

Educated at the universities of Cambridge and Oxford, Professor Robert Hillenbrand has been teaching at the Department of Fine Art, University of Edinburgh, since 1971 and was awarded a chair of Islamic Art in 1989. He has held visiting professorships at Princeton, UCLA, Camber and Dartmouth. His books include *Imperial Images in Persian Painting*, *Islamic Architecture in North Africa* (co-author) and most recently, *Islamic Architecture. Form, Function and Meaning*. His scholarly interests focus on Islamic art, with particular reference to Iran and to Umayyad Syria. He is a member of the editorial boards of *Art History*, *Persica*, *Bulletin of the Asia Institute* and *Oxford Studies in Islamic Art*, and of the Councils of the British School of Archaeology in Jerusalem and the British Institute of Persian Studies (Vice-President).

COLIN MACKENZIE

Colin Mackenzie holds a BA and PhD in Chinese Art and Archaeology from the School of Oriental and African Studies at the University of London. During 1980 and 1985 he studied in the Department of Archaeology at Beijing University, travelling extensively to visit archaeological sites and museums. From 1989-1991 he was research fellow in the Department of East Asian Studies at the University of Durham and is currently Curator of Asian Art at the Yale University Art Gallery. He is particularly interested in exploring the relationship between materials, techniques and decorative style.

THOMAS MURRAY

HALI contributing editor Thomas Murray is a peripatetic collector/dealer whose interest in Shamanism and Buddhism developed gradually. He lived in a yoga ashram, before studying with the aim of becoming a Jungian psychiatrist. He turned towards textile art on seeing his first *ikat* cloth, a Borneo *pua*: the complexity of the motifs, the virtuosity of the technique and the ritual associations brought together all of his interests simultaneously. He began travelling to Asia in 1978, starting to collect Himalayan masks shortly afterwards. Like *puas*, these masks bring together themes such as *persona* and *archetype*. He now divides his time between California, Asia and Europe. He is a member of the National Association of dealers in Ancient, Oriental and Primitive Art, as well as of the Antique Tribal Art Dealers Association and is also an advisor to the Asian Art Museum of San Francisco.

VALRAE REYNOLDS

Valrae Reynolds is Curator of Asian Collections at the Newark Museum, New Jersey, where she organised the design and installation of eight new galleries of Tibetan art and ethnography in 1989-90. In the past five years, she has been following the extraordinary textiles coming out of Tibet which have entered Western and Far Eastern collections. Her research has centred on the artistic and liturgical uses for these textiles within a Tibetan context.

JOHN T. WERTIME

An internationally known scholar, collector and dealer, HALI contributing editor John T. Wertime has degrees from Haverford and Princeton and is fluent in Farsi. During nine years based in Tehran he did historical research, taught and travelled extensively in Persia and the Near East, collecting and studying nomadic textiles and Persian metalwork. He is the author of numerous articles in serial publications and a contributor to books in the carpet studies field. He is an acknowledged authority in the classification of woven structures and their nomenclature.

RODERICK WHITFIELD

Since 1984 Roderick Whitfield has held the Percival David Chair of Chinese and East Asian Art at the University of London. He first studied Chinese at SOAS and at St John's College, Cambridge, and wrote his doctoral dissertation at Princeton on the Song dynasty handscroll, 'Going Up the River on the Spring Festival'. From 1968 to 1984 he was Assistant Keeper in the Department of Oriental Antiquities at the British Museum. His most recent publication, *Fascination of the Universe*, is about a 14th century handscroll painting of insect and plant subjects, and its significance for the early development of blue and white porcelain. In 1982 he wrote the texts of *The Art of Central Asia*, a catalogue of the Stein Collection, mainly from Dunhuang, in the British Museum. He is at present preparing an explanatory text for *The Art of Dunhuang*, due to be published by Textile & Art Publications, London, in 1995.

RICHARD E. WRIGHT

Richard E. Wright was educated at Dartmouth, Princeton and Harvard and attended numerous symposia in Azerbaijan and Georgia. During the past fifteen years he has written articles for oriental carpet journals in Europe and America, authored a research newsletter, and presented papers to national and international conferences. He has located and published much of the pre-revolutionary Russian carpet literature. His book *Caucasian Carpets and Covers: the Weaving Culture*, co-authored with John T. Wertime, will be published by Hali Publications, London, in summer 1995.

CONTENTS

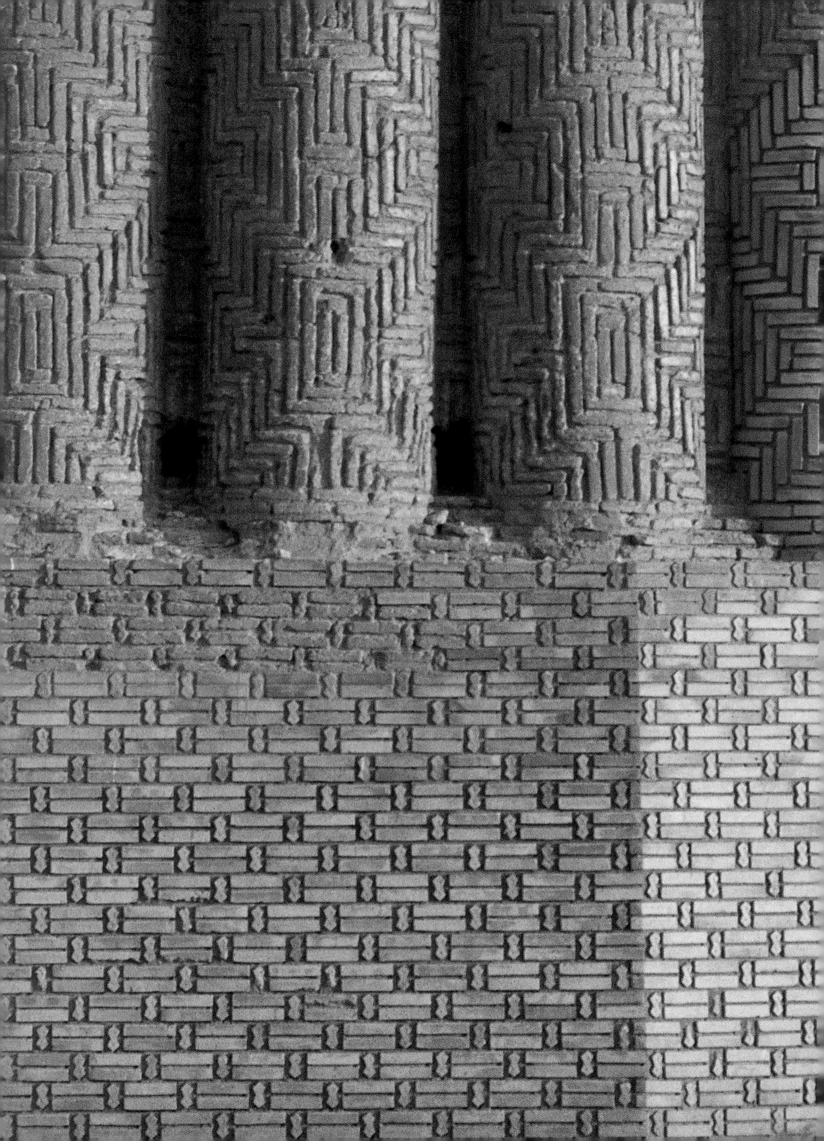

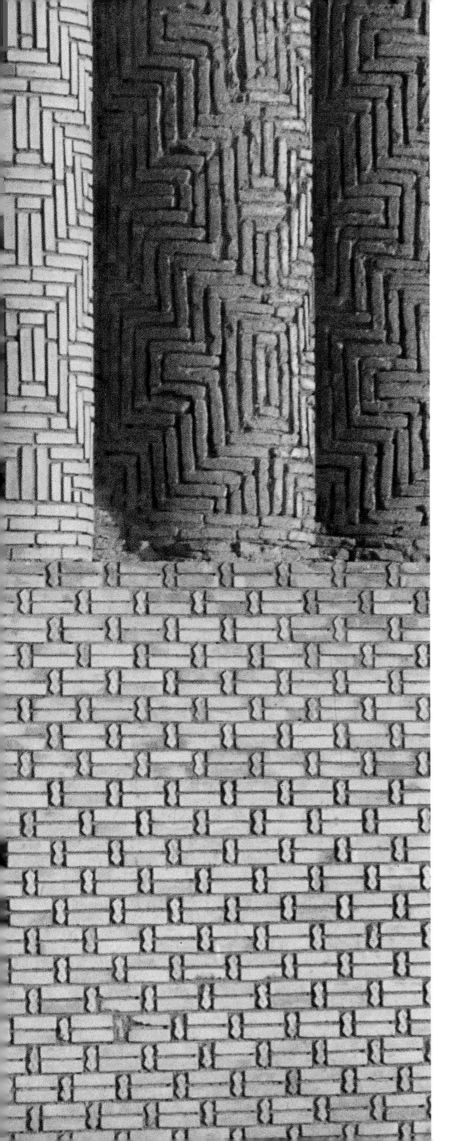

ARCHITECTURE

B. O'KANE

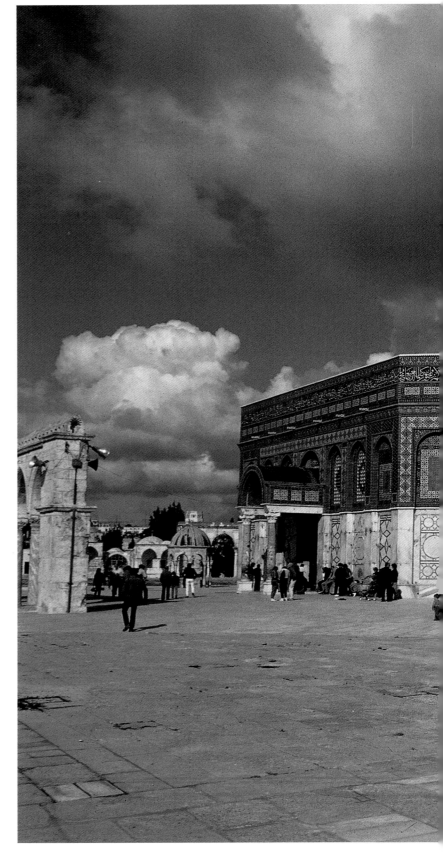

Robert Hillenbrand

From Spain to Afghanistan, the religious and secular architectural traditions of Islam find expression in buildings of endless decorative variety. The author looks here at the essential repertoire of forms and materials, and some of the determining principles behind the rich creativity of ornamentation.

SPLENDOUR &

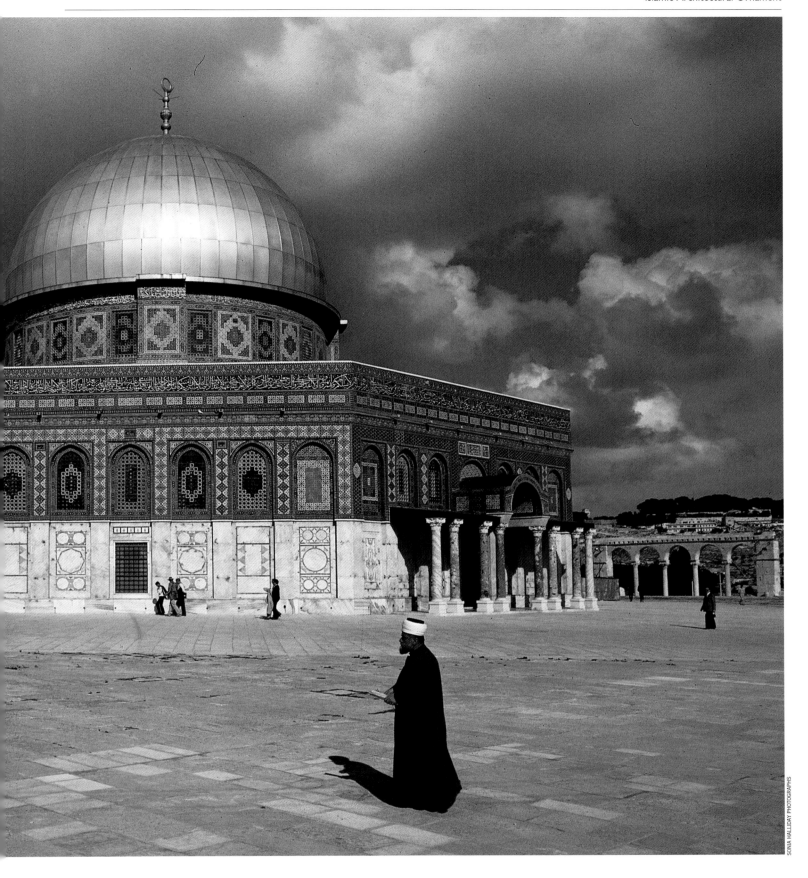

AUSTERITY
Islamic Architectural Ornament

The very idea of discussing Islamic architectural decoration as if it were an undivided entity reveals much about Western attitudes to Islamic art. No one would dream of delivering a paper on Western architectural decoration; any respectable scholarly effort along these lines would have to be directed towards a particular period, region, style or other specialised category. But in our generation at least it is still permissible, and perhaps even useful, to structure a discussion about Islamic architectural ornament in broad, inclusive terms.

Unavoidably any synthesis undertaken in the 1990s must be premature, for it cannot build upon a sufficiently representative foundation of monographic studies of ornament. It is indeed striking that virtually none of the scholars who might be termed the founding fathers of Islamic architectural studies ever explicitly concerned themselves with general questions about Islamic architectural ornament. That did not stop some of them writing penetrating analyses of specific types of ornament – one thinks of the work of Riegl, Herzfeld and Kühnel on the arabesque (**1, 4**) – but a framework for such specific studies had yet to be created.

As it happens, decoration has long been widely recognised as a valuable dating control – a fact which vividly demonstrates that this decoration is by no means fossilised but is a living, changing organism – and its function in beautifying the building on which it is placed is also accepted without question. Sometimes, too, as in the case of Marinid woodwork (**3, 33**), Anatolian brick ornament, Samarra stucco or Persian tilework (**25, 29**), its intrinsic interest has generated detailed studies. And over the years various scholars – such as Richard Ettinghausen, Dalu Jones and Arthur Upham Pope – have tried to construct theories that would apply to ornament in a more general fashion while not purporting to be histories of the genre. But no scholar so far has made a serious, detailed attempt to investigate the mainsprings of Islamic architectural decoration – what makes it tick, as it were. Even Oleg Grabar, in *The Mediation of Ornament* (1992), a study devoted to Islamic ornament as a whole, does not deal with architectural ornament at length. He ranks architecture somewhat uncomfortably alongside geometry, nature and writing as one of the 'intermediaries'

1. *Previous pages, detail left:* **Bukhara, Central Asia, Bayan Quli Khan mausoleum, ca. 1360, detail of arabesque tile decoration on the exterior spandrel.**

2. *Previous pages:* **Jerusalem, the Dome of the Rock, after 692.**

3. *Above:* **Fez, Morocco, Misbahiyya *madrasa*, 1346, detail of woodwork.**

4. *Below left:* **Esfahan, Hakim Mosque, 1656-62, tile decoration on the side *iwan*.**

5. *Below:* **Esfahan, Friday Mosque, north dome chamber, 1088, zone of transition and dome.**

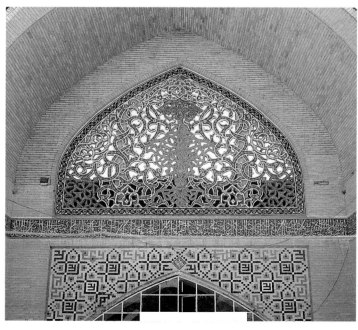

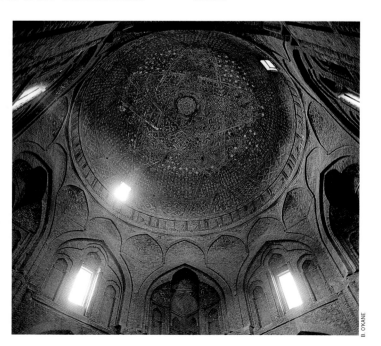

B. O'KANE

6. Edirne, Turkey, Üç Şerefeli Mosque, 1437-47, painted dome of the courtyard arcade.

employed by Islamic art. The discomfort stems from the fact that while geometry, writing and nature are all self-contained categories, architecture is not so easily pigeon-holed; its ornament, for example, partakes of elements taken from all three categories. To that extent architecture is no more a special category than any other medium of Islamic art, whether painting, textiles, pottery or metalwork. Like all of these, it is a canvas to be filled.

Admittedly, architectonic detailing – that is, the articulation of surface by such features as arches, windows, reveals, many of them possessing a strong structural component (**5**) – is specific to architecture, and will be discussed later in this paper; but it does not lend itself to the same type of generalisation as other kinds of ornament. Nor is this the focus of Professor Grabar's chapter, which is devoted principally to the use of architectural themes in applied ornament. This is a side issue in comparison with the major themes of writing, nature and geometry, and it leaves unsolved the problem of distinguishing between architectural themes used on the minor arts and the same themes used on architecture itself.

One minor point is perhaps worth making at the outset: there is no special mystique surrounding Islamic as distinct from any other kind of architectural decoration. Islamic architecture, like any other kind of architecture, is three-dimensional and its decoration, again like that applied to any other type of architecture, has the basic function of beautifying the structure. Such comments may sound banal; but they are perhaps needed as a corrective to the currently fashionable and facile attempts to explain Islamic architecture and its decoration in mystical terms. This is not to deny that a mystical element may on occasion be present; but, if it is, it should be seen as a secondary layer of meaning. In other words, the architecture and decoration of the Islamic world is architecture and decoration first and Islamic only second. "Buildings are meant to be lived in", said Lord Bacon nearly four centuries ago; and it is worth bearing that primary function in mind lest one lose sight of it in the throes of metaphysical speculation about ornament.

None of this, of course, is to deny that Islamic architectural decoration has its own distinctive character, both in its form and in how it is applied; and part of the purpose of this essay is to define aspects of that distinctive character. From among the many features that present themselves for extended discussion, this article will concentrate on the three major formal categories of Islamic architectural ornament – vegetal, geometric and epigraphic – and how they interact (**6, 39**); the importance of colour (**8, 35**); the role of architectonic decoration (**10**); the implications of ensuring adequate visibility for ornament (**2**); and the tendency to concentrate it at key points (**6**). An examination of these topics, which naturally

7. Tinmal, Morocco, Great Mosque, 1153, stucco column and capital.

B. O'KANE

11

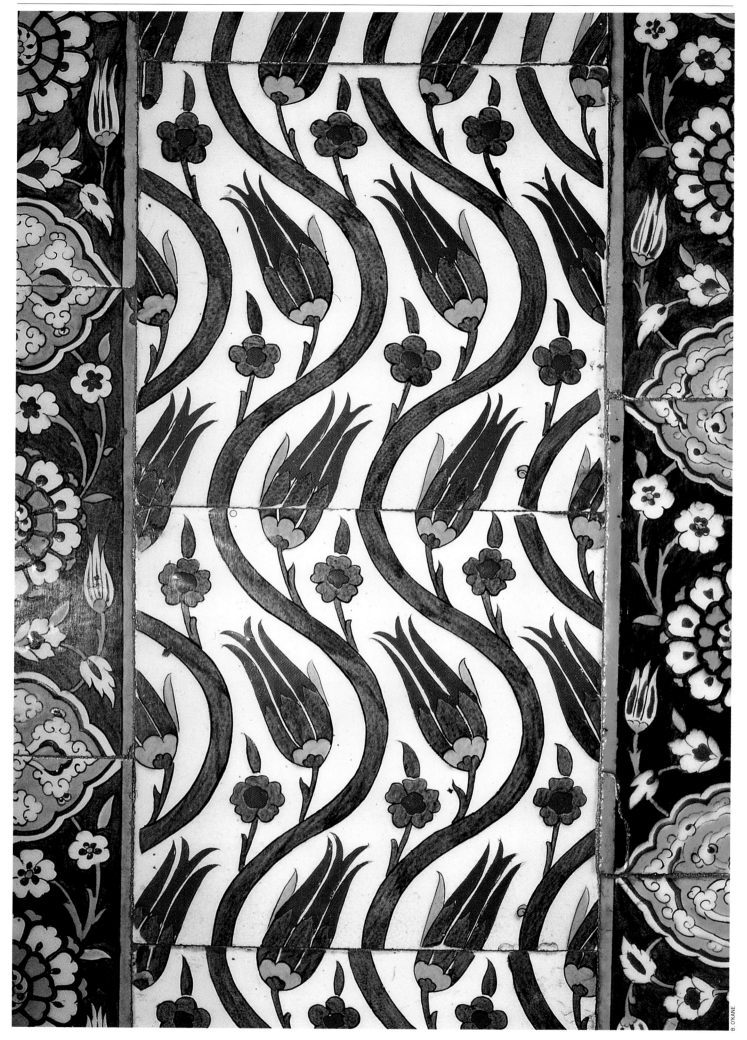

overlap in some respects, should help to tease out some of the immanent characteristics buried below the surface glitter and variety of Islamic architectural ornament.

It must be stressed that these are only some of the many aspects of this complex subject. Other such aspects can be mentioned only in passing. They include the way this ornament is dependent on symmetry, repetition, echo and similar devices; the meanings and purposes which can be read into it; the materials used and their particular characteristics; and the significance of regional distinctions. Moreover, the sources of Islamic architectural ornament reveal not only a high degree of interdependence vis-à-vis other forms of Islamic art, but also the hermetically sealed environment within which the medieval Islamic architect operated. Hence his habitual reluctance seriously to grapple with ideas from either east or west; hence, too, the progressive attrition of the classical element (**7**), even though this was part of the very birthright of Islamic art. The present analysis, as already stated, concentrates on matters other than these, but it is nevertheless salutary to bear this wider picture in mind by way of background.

A separate category comprises motifs which are either original to Islamic architecture – such as the *muqarnas* or honeycomb vault – or which Islamic architects made very much their own, such as the zone of transition which mediates between a square chamber and its crowning dome (**5**), or the interplay of different arch profiles (often with hierarchical intent) or the build-up of complex networks of intersecting arches (**10**, **36**). These last two ways of putting the arch to work in the context of decoration are especially characteristic of Islamic architecture in Spain and the Maghrib.

8. *Facing page:* **Istanbul, Rüstem Pasha Mosque, ca. 1562, detail of Iznik tilework.**

9. *Above:* **Cairo, complex of Qani Bay al-Saifi, 1503, stone dome.**

FORMAL CATEGORIES

The formal categories within which Islamic architectural decoration falls are thoroughly familiar: vegetal, geometric and epigraphic. Yet this is of course not the whole story. Indeed, such categories hide as much as they reveal. In particular, it would be seriously mistaken to regard these categories as fixed, for in other, non-Islamic, cultural traditions those same categories are interpreted in quite a different way which finds scarcely an echo in the Islamic context. This shows how rough and ready such categories are.

In Islamic ornament the vegetal mode, for instance, is only loosely based on nature, and thus the very word used to describe it is not entirely accurate. There is no Islamic equivalent to the leafy capitals of the Chapter House in the medieval Southwell Minster, where some sixteen varieties of plant are clearly recognisable, faithfully yet not pedantically reproduced. Sometimes, it is true, the actual forms of nature are followed – the acanthus, for example, in the classicising ornament of the Umayyad period (660-750) and of the classical revival in 11th-12th century Syria, or the lotus, chrysanthemum and peony in the sinicising mode which flourished in the wake of the Mongol conquest (especially in the 14th century), or, finally, the dianthus, hyacinth, carnation and tulip which adorn so many of the Iznik tiles of the 16th and 17th centuries (**8**). Yet these are all exceptions. Instead, as is well known, the rule for Islamic artists was to reinterpret nature through their own creation of the arabesque – a form that is a plant and yet not a plant (**1**). Imagination, not observation, was the key; nature, it is true, but nature methodised (**9**, **12**).

Similarly, the geometric mode, when examined closely, can be seen to express itself in Islamic architectural ornament in only relatively few basic forms, such as angular repetitive grids, stellar patterns or curvilinear networks (**37**). Even patterns which look quite different at first glance prove on analysis to depend on the same formula. As with vegetal ornament, then, it is the quality of the artist's imagination which transforms the design – a topic to which I shall return later in this paper. The category itself is merely a point of departure. It operates on both the largest and the smallest scale, from the zigzag facade of Mshatta (**23**) and the flowing arabesque networks of domes in Cairo (**9**) and Mahan to the treatment of doors, subdivided into an interlocking mesh within which still smaller compositions unfold, kept in place both literally and visually by their parent panels. It is an effective device aesthetically, but it has its practical side too, since this arrangement allows for the shrinking and expanding of the wood in changing climatic conditions (**18**).

10. *Below:* **Cordoba, Great Mosque, 961-76, dome on intersecting arches.**

Finally, epigraphic decoration on buildings is so very much more than writing – in the sense of words meant to inform – that here too one feels acutely the lack of a sufficiently precise terminology. In many of the finest Islamic monumental inscriptions the meaning of the words comes a poor third to the rhythmic exuberance of the lettering (**35**) and the pattern-making urge to which those letters are subjected (**11**), while in the more illegible inscriptions an element of mystery if not magic may be at work (**4**). And, as in the case of vegetal ornament, there are significant areas which are intensively exploited in certain non-Islamic cultures but which seem to be of little interest to the Islamic craftsman. There is, for example, no satisfactory Islamic equivalent for the combination of superlative elegance and superlative legibility found in the best Roman monumental inscriptions. And while many Greek and Roman inscriptions take the form of a panel – often of very substantial size – the preferred mode for the Islamic epigrapher is the long band (**25, 37**). The Graeco-Roman format offers a slab of text for information; the Islamic format gives the text the subsidiary function of articulating the structure it adorns (**4**).

Much of the potential of these three genres is not seriously explored in Islamic art, and conversely certain aspects of each are brought to a pitch of perfection by Muslim craftsmen. It will be evident from these remarks that the familiar categories of vegetal, geometric and epigraphic are only very rough guides to what is actually going on in Islamic architectural ornament. Nor are the barriers between these categories fixed. Arabic letters sprout palmettes or are cramped into angular geometric forms at the outer limit of legibility (**14, 30**). Arabesques unfold concentrically or spirally, their convergences plotted as regularly as if they had been drawn by compasses (**9**). Geometric networks have the edge taken off their angularity by buds or leaves proliferating at the intersections of the design, frequently muting its original clarity and turning it into something obscurely different (**6, 26**).

Perhaps the distinctively Islamic quality of such decoration lies precisely in the way that the different categories refuse to remain fixed but rather infiltrate each other. They guard a quality of elusiveness, of mystery, seeming to suggest more than they display. Indeed, this ambiguity, this understatement, may be one of the secrets of the special complexity and intensity of so much Islamic ornament – and not only in architecture. Essentially disparate ideas are yoked together, and from their commingling there flowers a host of unexpected felicities.

MATERIALS & COLOUR

Much the same might be said *à propos* the materials in which Islamic architectural decoration is executed. Their range is wide and they offer well-nigh endless possibilities of combination – for the total effect of such combinations depends not only on, say, the juxtaposition of stone, wood and tilework, but also on the relative quantity of each that is used, on whether it is employed once or repeatedly, and the role that colour, as distinct from texture, plays. To take the single case of carved stucco, often used on its own (as in the interior of the Gunbad-i 'Alawiyyan in Hamadan) (**12**), the impact of the material can vary dramatically depending on whether the stucco is painted or plain, lightly incised, moulded or carved in high relief. Similarly, as the facades of the Seljuq Zazadin *han* or the citadel palace at Aleppo show, the type of two-tone masonry known as *ablaq* is enough in itself, when used on a sufficiently grand scale, to prink out an entire facade (**13**). Thus two colours manage, by some mysterious alchemy, to do the work of a dozen; and one must not forget, either – after all, the designers did not – the effect of the variegated play of shadow on the surface of a building, or how the backdrop of a cloudless blue sky would enrich the colour harmonies of a facade.

None of this is to deny that sometimes Islamic architects revelled in using colour on a grand scale – to an extent, indeed, that finds few parallels in world architecture. The back wall of the west *riwaq* in the Great Mosque of Damascus is a reminder that the desire to load

11. Cairo, *madrasa* of Barquq, 1386, detail of inscription on the entrance portal.

12. Hamadan, Iran, Gunbad-i 'Alawiyyan, ca. 1150-1200, interior detail of stucco.

13. Aleppo, Syria, Ayyubid palace in citadel, ca. 1190-1230, entrance with *ablaq* decoration.

every rift with ore, and to extract maximum advantage from contrasts of colour and texture, was already fully developed in the first century of Islam (**16**). At dado level the wall is covered with thin slabs of colourful quartered marble so cut that the grain runs continuously from one slab to the next; late antique accounts of such decoration show that contemporaries detected fully-fledged landscapes in such naturally (and to us randomly) patterned marble, so that beauty of texture and colour was not the only attraction of such ornament. Above this the polychrome grained marble is punctuated by regular openings for windows, each of them filled by a pierced monochrome white marble grille of elaborate geometrical design. Colour is thus used to differentiate two adjoining decorative schemes which use the same material.

In the window grilles too the decoration operates on more than one level; for, quite independent of the interest of the geometrical pattern itself, these windows are each a separate study in the interplay of light and dark, solid and void, in the *ajouré* style of early Byzantine sculpture. Moreover, they were in all probability filled with stained glass – fragments of this material have been found in the roughly contemporary window-grilles of the Dome of the Rock (**2**) – and this would have added a further dimension of soft, mysterious colour to the interior. Above this ran the celebrated *karma*, the gilded vegetal scroll which encompassed the entire periphery of the mosque in a kind of *cordon sanitaire*. The apotropaic powers attributed to this decorative band in medieval times are a reminder of the deeper resonances which may occasionally be detected in apparently 'straight' decoration.

On further reflection, it is of course entirely plausible that a building which appropriated a substantial portion of the state's financial resources for seven years should harbour subtleties of structure and decoration which are not immediately manifest. The impact of the scale and magnificence of that mosque within the packed and squalid urban context of a medieval city is almost impossible to recapture in the 20th-century Western world, where multi-storey buildings are commonplace and slums of medieval type are thankfully for the most part

14. Damghan area, Iran, Mihmandust tomb tower, 1097, detail of brickwork.

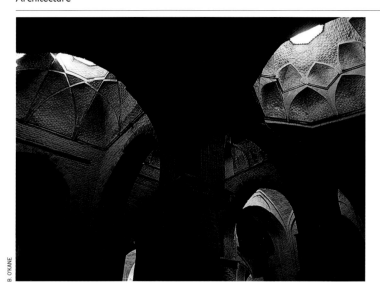

15. *Left:* Esfahan, Friday Mosque, 12th century domes.

16. *Right:* Damascus, Great Mosque, 706, the west riwaq.

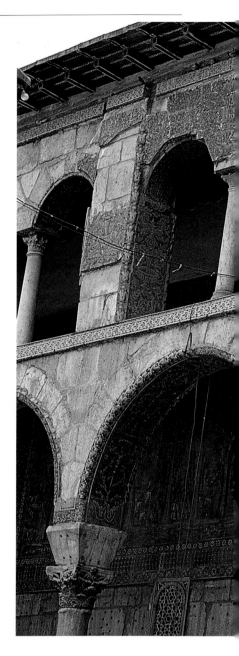

things of the past. Finally, above the *karma* unfolds the great landscape panorama which is the glory of the mosque, a fitting climax to the decorative scheme in scale and vibrancy of colour. Some thirteen shades of green alone have been counted in these mosaics, and indeed it is their subtle colouring which gives this fictive landscape such depth and presence. Yet it is worth noting that all this splendour is achieved by means of only two materials: mosaic and marble. As in the case of stucco noted above, however, marble is used in such radically different ways – quartered, pierced and gilded – that the homogeneity of the material is effectively disguised.

Visually speaking, of course, carved stone, painted stone and plain stone are effectively different materials. The range of options open to the craftsman in tilework was even wider – moulded monochrome or polychrome tiles, star-and-cross panels, tile mosaic, glazed carved terracotta, glazed bricks, vast expanses of a single colour as in exterior domes, and bands with multiple inscriptions in different colours superimposed upon each other in the manner of a palimpsest. Varieties of colour and of glazing technique – lustre, *mina'i*, *lajvardina*, *haft rangi* and so on – further enlarged these options. In areas where brick was the preferred medium of construction, decoration too was often carried out in that medium. Flush, recessed and outset patterning, sometimes reaching heights of quite obsessive intricacy, were all common (**14, 38**).

The use of carved wood and of fresco as architectural ornament has been little studied in comparison with the other materials just discussed, but such cases as Qusair 'Amra (**17**), numerous *hammam*s and later medieval Iranian palaces show that in certain contexts fresco was used on a large scale, while carved (and painted) wood was widely employed for ceilings throughout the medieval Islamic world. In addition it appears regularly as a foil to more gaudy types of decoration in medieval Maghribi *madrasas* (**3**), while mosques of trabeate kind, whether in Anatolia, the Yemen or Central Asia, made lavish use of richly carved wooden columns as supports. Wood is of course the regular medium for doors and *minbars* (**18**), and wooden *mihrabs* are also known.

This necessarily brief survey must suffice to show that the materials and textures available for architectural decoration in the medieval Islamic world were extremely varied, and that within each medium too there was a wide range of accents on which to draw. Unfortunately, little serious work has so far been done on whether hierarchies of medium or of colour operated. Literary texts, for example those which bear on the palaces of Samarra or Cairo, need to be trawled for information on precious materials – such as ivory and ebony – which have not survived in their original architectural contexts but which were clearly of great importance and prestige. Pending such studies, it seems reasonable to assume that the richest decoration was reserved for the most important locations – as witness the case of the now vanished *mihrab* of the Damascus mosque, whose splendour was such that it caused qualms to the God-fearing caliph 'Umar II. Given the degree of pillage to which royal monuments were regularly subjected – the case of Mamluk Cairo is notorious in this respect – and given too the certainty that the richest materials were those least likely to survive the thievish hand of man or time, it must be remembered that the heritage of Islamic architectural ornament bequeathed to this century is seriously deficient, and deficient precisely at the top of the scale. If clothes were regularly burned up so as to extract the metal thread used in them, how much less was the chance of survival of, say, gilded wood?

The most grievous loss is the sense of orchestrated splendour which must have struck any visitor to the great palaces of medieval Islam – a potent compound not merely of architecture

17. Qusair 'Amra, Jordan, second quarter 8th century, detail of fresco painting.

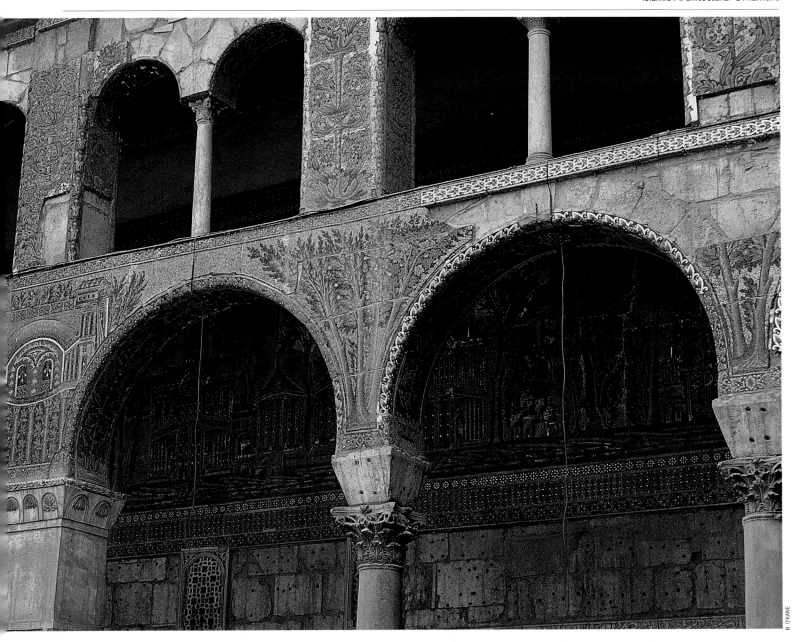

B. O'KANE

and its decoration but also of music, running water (**21**), exotic animals, costly aromas, carpets and textiles galore, automata, precious stones and cunningly contrived manipulations of light and sound. The *tout ensemble* – whether at Madina al-Zahra, Cairo or Baghdad – was, to borrow a phrase from Thomas Herbert, "a compendium of sense-ravishing delights". Of such splendours only the bare setting now remains, and to that extent any assessment of the impact of Islamic architectural ornament in medieval palaces must fall woefully short of the former reality. Religious buildings were by their very nature disqualified from that aura of extravagance and secular display which the medieval accounts of Islamic palaces distil.

ARCHITECTONIC DECORATION

Although most Islamic architectural ornament is applied, passing attention should also be paid to architectonic decoration. It is apt to be overlooked because it is part and parcel of the building and could thus be defined as architecture rather than decoration. Sometimes the borderline between the two can become rather blurred. No one could deny that the intricate mesh of intersecting arches in the upper reaches of the Cordoba mosque (**10**) is essentially decorative, for all that it has a structural purpose; but what of the forest of columns lower down, by which this mesh is supported? Their rationale as a system of roof supports leaps to the eye; but in these rhythmic enfilades there surely lurks a decorative intent as well (**19**).

Similarly, the animated three-dimensional geometry of the roofscapes in some of the major medieval Western Islamic buildings, like the the mosques of Taza and Fez, or the Alhambra, works on more than one level. Structurally, they are no more than a series of pitched roofs; but aesthetically they are an abstract study in intersecting planes enlivened by the dynamic contrast of scintillating light and plunging shadow. Much the same could be said for the sequence of several hundred domes in the Esfahan *jami'*. They impart a powerfully

18. *Below:* **Divrigi, Turkey, Friday Mosque, 1228, detail of woodwork in the *minbar*.**

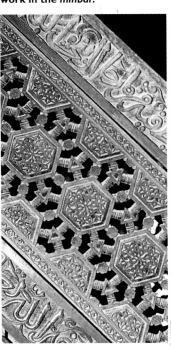

B. O'KANE

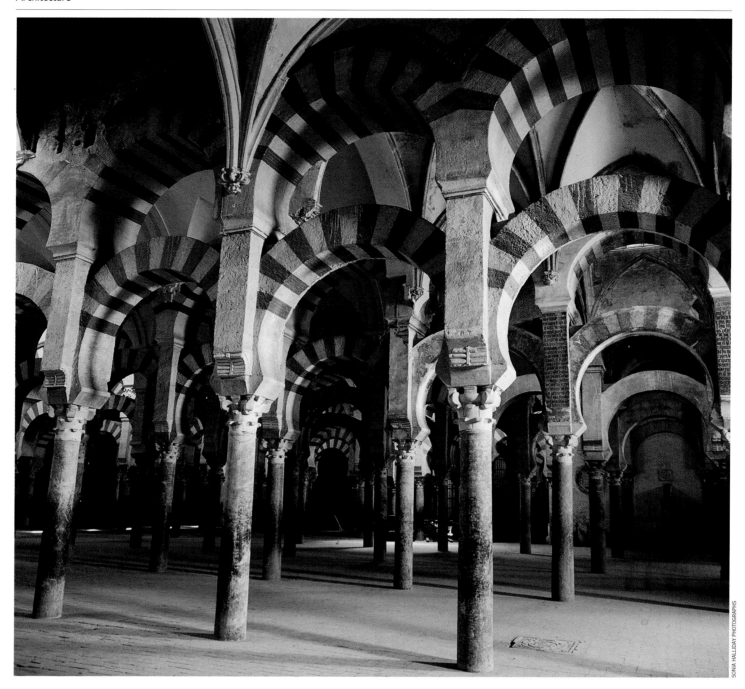

SONIA HALLIDAY PHOTOGRAPHS

sculptural quality to the roofscape, making it a mobile, living space instead of a forgotten corollary to the splendid array of vaulting below (**15**). Or what of the numerous domes, as at Aswan, Qus (**22**) and in the Alhambra, whether over *hammams* or tombs, which are pierced by star-shaped openings? Often these take the place of windows, so that they could be seen as unusual but effective responses to the requirement for a system of lighting. But their decorative and symbolic impact is unmistakable.

More generally, Islamic monuments share with other architectural traditions an automatic dependence on a basic vocabulary of structural elements. These include columns, capitals (**7**), arches, arcades (**19**), domes (**6**), vaults and *iwans* (**25**); and these basic elements are in turn articulated by a battery of devices like mouldings (**23**), fluting (**20**), cornices, string courses, plinths, guard bands (**38**), reveals, panels (**31**), blind arches (**37**), buttresses and bastions. This is the authentic language of architecture; but of course, when used sensitively and imaginatively, it has well-nigh endless potential as decoration. Islamic architects were perpetually on the look-out for such opportunities. Sometimes, when employed on a very small scale, as in the minarets of later medieval Cairo, they are frittered away. But when this language is wielded with boldness, it is a very different story. The raw power of the flanges on the Gunbad-i Qabus or of the rippling muscular bastions on the facade of the Ribat-i Malik is not readily forgotten. Visually speaking, both buildings seem absolutely entrenched solely by virtue of these articulating devices. The splayed and dome-capped corner columns of the celebrated tombs at Bukhara and Multan work in just the same way, anchoring the building immovably in the

B. O'KANE

18

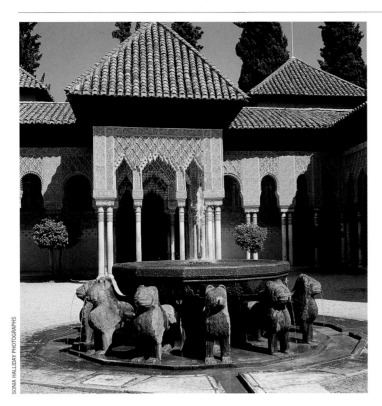

SONIA HALLIDAY PHOTOGRAPHS

B. O'KANE

ground. Yet in each of these cases the articulating elements, for all that they seem to grow naturally out of the building itself, have an undeniably expressive quality which gives them an aesthetic dimension.

These are perhaps relatively straightforward cases. Less clear-cut is, for example, the articulation of a courtyard facade by a sequence of solids and voids, or of an *iwan* by super-posed blank arches in rectangular reveals (**32**), or of a variety of planes, as in the Mshatta facade (**23**). Such articulation does not lend itself so readily to interpretation as do the examples just cited, but here too some decorative intention is plainly not far away. The 'petrified forest' effect of the massed columns at the Cordoba mosque (**19**) or in the Court of the Lions at the Alhambra (**21**) are further examples.

Finally, one should not forget that architectonic decoration is often so intimately linked to applied decoration that it is futile to seek to disentangle the two. Looking at the Mshatta facade, with its bold zigzags (visible half a mile away) on one plane and the filigree work contained within them existing on quite another plane, and visible only from a distance of a couple of feet, we may exclaim with the poet "How can we know the dancer from the dance?" That facade, indeed, may be said to range through the full diapason of Islamic ornament, from the largest to the smallest scale, and is thus an apt point of departure for the considera-tion of some new themes.

VISIBILITY

The discussion so far has focused on the basic categories of Islamic applied ornament, including the contrasts of texture and colour inherent in them, and on the subordinate but still relevant role of architectonic decoration in Islamic architecture. It is now time to look closely at some of the more general principles which govern the way Islamic architectural ornament works: for example, its visibility, its use in concen-trated bursts, its relationship to the surface it covers, and the scope it gives to the artist's imagination.

It does not take more than a brief glance around any partly preserved Islamic city to realise that the stereotype of overall and therefore overdone ornamentation so often associated with medieval Islamic architecture is very wide of the mark. Rather is it the parsimony of such decoration, at least as far as the exterior of buildings is concerned, that is noticeable. Sometimes the guiding principle behind this is a practical one, namely that there is no point in lavishing decoration on areas that will not be seen, or that will be seen by relatively few people. The Giralda minaret in Seville has a largely plain shaft in the lower stories; but then, around the level of the third storey, its walls on all four faces break forth into

19. *Facing page, above:* **Cordoba, Great Mosque, after 786, sanctuary arcades.**

20. *Facing page, below:* **Radkan East, Iran, tomb tower, 1205, detail of flanges.**

21. *Above left:* **Granada, Alhambra palace, Court of the Lions, after 1354.**

22. *Above right:* **Qus, Egypt, mausoleum, 1172, pierced dome.**

23. *Below:* **Mshatta, Jordan, palace facade, second quarter 8th century. Now in the Museum für Islamische Kunst, Berlin.**

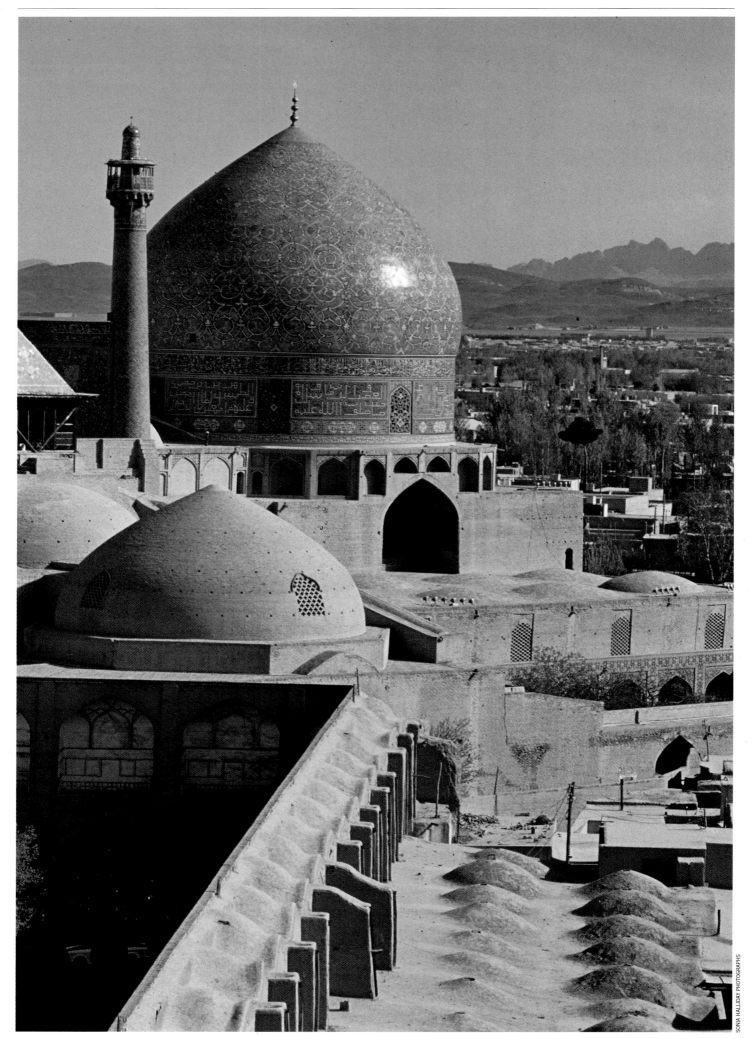

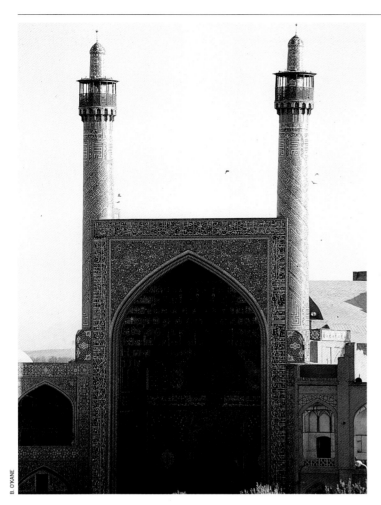

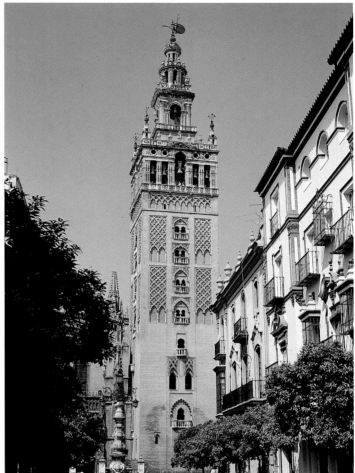

luxuriant interlace patterns (**26**). Clearly the architect reserved his best efforts for that part of the structure that would be visible to everyone, as did his contemporary colleagues building the very different minarets of Seljuq Esfahan.

The domes of the mausolea in the great cemeteries of Cairo are as richly decorated as their lower walls are plain (**9**). The reason is evident as soon as one begins to walk among such buildings: the lower walls are consistently blocked out by whatever buildings are in the foreground, but somehow at roof level the domes rise in untrammelled serenity. Indeed, the cityscape seems able to accommodate dozens of domes without overlap. In Damascus the lower part of the tomb of Nur al-Din is externally a plain, not to say shabby, cube hemmed in by surrounding structures. At roof level, however, the picture changes dramatically, for externally the glory of the complex resides in the conical *muqarnas* domes, whose labile cascading silhouettes provide the obvious visual focus of the whole neighbourhood (**27**).

I n Esfahan the Masjid-i Shah has an elaborate tiled facade fronting the *maidan*, at first sight a textbook case of Islamic over-decoration (**25**). Yet its flanking facades, visible only in snatches from alleys and byways, are as plain as can be. The logical conclusion to draw is that the location on the *maidan*, the centre of the city's life, dictated the use of an elaborate facade for such of the mosque as was visible from it (**24**). The same division between plain and decorated facades can be seen in the Lutfallah mosque, also located on one side of the *maidan*. Thus even if Islamic architecture made less use of diminishing perspectives or echelonning than did European architecture, it was alert to the potential of the directed viewpoint. The way that *mihrabs* are sometimes framed at the far end of corridors of space is a case in point.

In other contexts different rules applied. Thus the Timurid Rigistan in Samarkand, the city's main public square, had a *madrasa* on three of its four sides (**29**) – a reduced version of the later Esfahan *maidan*, which may indeed have been the model in the minds of those who subsequently refashioned the Timurid square in the 17th century. Nevertheless, since the area around the Rigistan was free of buildings, the side and rear facades of these *madrasas* were also clearly visible from a distance – and for that reason they were tiled through-

24. *Facing page:* **Esfahan, the Masjid-i-Shah Mosque, completed 1628-29.**

25. *Above left:* **Esfahan, the Masjid-i Shah Mosque, tiled entrance portal.**

26. *Above right:* **Seville, Spain, Giralda minaret, 1172-98.**

27. *Below:* **Damascus, *madrasa* and mausoleum of Nur al-Din, 1167, *muqarnas* domes.**

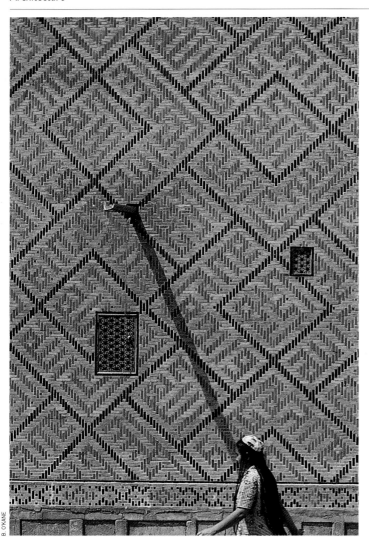

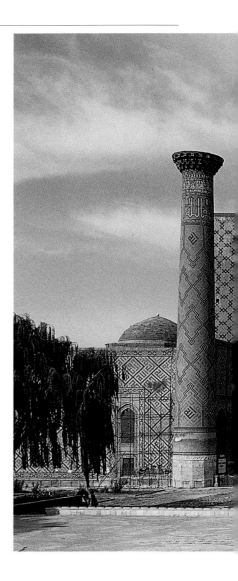

28. *Left:* Samarkand, Central Asia, Ulugh Beg *madrasa*, 1417-21, detail of exterior tilework.

29. *Right:* Samarkand, Central Asia, Rigistan Square, 15th-17th centuries.

out (**28**). Easy visibility of the area in question, not merely its relative importance within its parent building, could thus be a factor in the decision whether or not to decorate it. Such easy visibility also explains the tiling on all four sides of the shrine of Khwaja Ahmad Yasavi, built in Turkestan in the 1390s. The same factor may well have been decisive in the case of the Dome of the Rock, with its matchlessly public site affording excellent views from all sides (**2**); and the external decoration both in mosaic (before 1552) and in tilework (after that date) reflects this.

The principle that visibility was the determining factor in deciding whether or not to apply decoration has wider implications than this. It often governs the type, the placing – even the colour – of inscriptions. A consistent trend dictates that when a building bears both Qur'anic and historical inscriptions, the latter should be more visible (**35**). Sometimes the religious inscriptions are so high that one might think they could be aimed only at God, as in the case of those minarets where the *shahada* is inscribed just below the summit, invisible to the human eye. Familiarity with the sacred text on the part of those who frequented religious buildings could fairly be assumed, and this in turn meant that the recognition of a single word could unlock an entire inscription band.

But historical inscriptions were another matter altogether (**30**). Thus in later medieval Iran the name of the royal patron is often picked out in amber, green or blue letters from the ruck of the surrounding epigraphy and located immediately above the entrance, usually at dead centre (**25**). In Ayyubid Syria an inscription panel in *tabula ansata* form is placed over the doorway at a convenient height to be read, and its text is in legible *naskhi* script (**31**). Sometimes motives of religious propaganda can best explain the overwhelming visibility of certain inscriptions. Thus when Haghia Sophia was transformed into a mosque the four pendentives which supported the dome, and thus 'carried' the entire building, were each filled with an enormous roundel bearing the name

30. *Below:* Sivas, Turkey, Kayka'us hospital, 1218, underglaze-painted tile inscription at entrance to mausoleum.

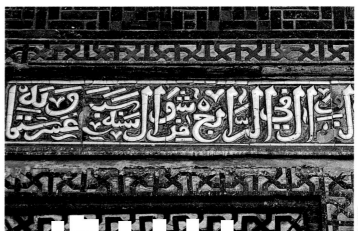

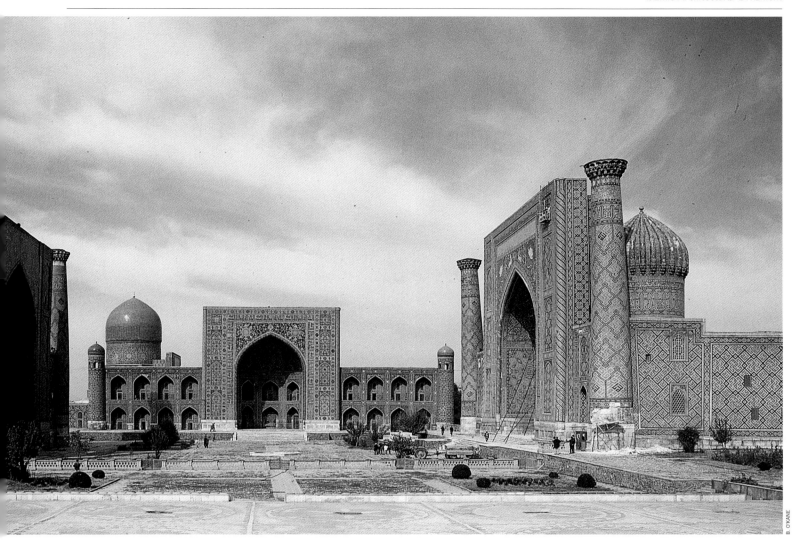

of one of the four Rightly Guided caliphs (**34**). It would have been hard to find a more forceful way to express the idea that a new faith had taken over and that its Sunni orthodoxy was built on unshakable foundations. Whether hierarchical distinctions operated so that the importance of an inscription could be gauged by its height above ground is a matter that must be left to future research.

CONCENTRATION

Closely related to the principle of visibility is that of concentration. There is nothing especially profound about this idea. It makes good sense to concentrate decoration at places where it will have the most effect. In Islamic architecture, the locations that come immediately to mind in this connection are the portal, the *mihrab*, and the royal throne room. Perhaps it is the portal that offers the most varied opportunities. Aside from its obvious potential as sheer architecture, which can find expression in its marked salience, greater height vis-à-vis the surrounding walls, applied ornament, and vaulted or domical construction, it can also work as a two-dimensional facade. In this respect it is essentially a mihrab

31. Damascus, Qilijiyya *madrasa*, **1253, inscription over the entrance.**

writ large (**32**). When the context makes it an entrance into a sacred place, its symbolic resonances are of course very close to those of a *mihrab*. In Shi'ite contexts portals may bear inscriptions which make punning references to 'Ali or Muhammad as the gate (*bab*) to God. Certain Sufi adepts, too, were known to their disciples as *bab* and the inscriptions over the gates to their tombs or shrines might on occasion exploit this title. The *mihrab* too carried associations of a door, in this case leading to paradise, and attempts have been made to interpret its decoration accordingly.

Yet even if such considerations are left aside, the variety of decoration which the Islamic architect accorded the portal is remarkable. In the Marinid *madrasas* of Morocco special emphasis is allotted to wood, notably the cantilevered hood over the main entrance, like a canopy of honour: almost an

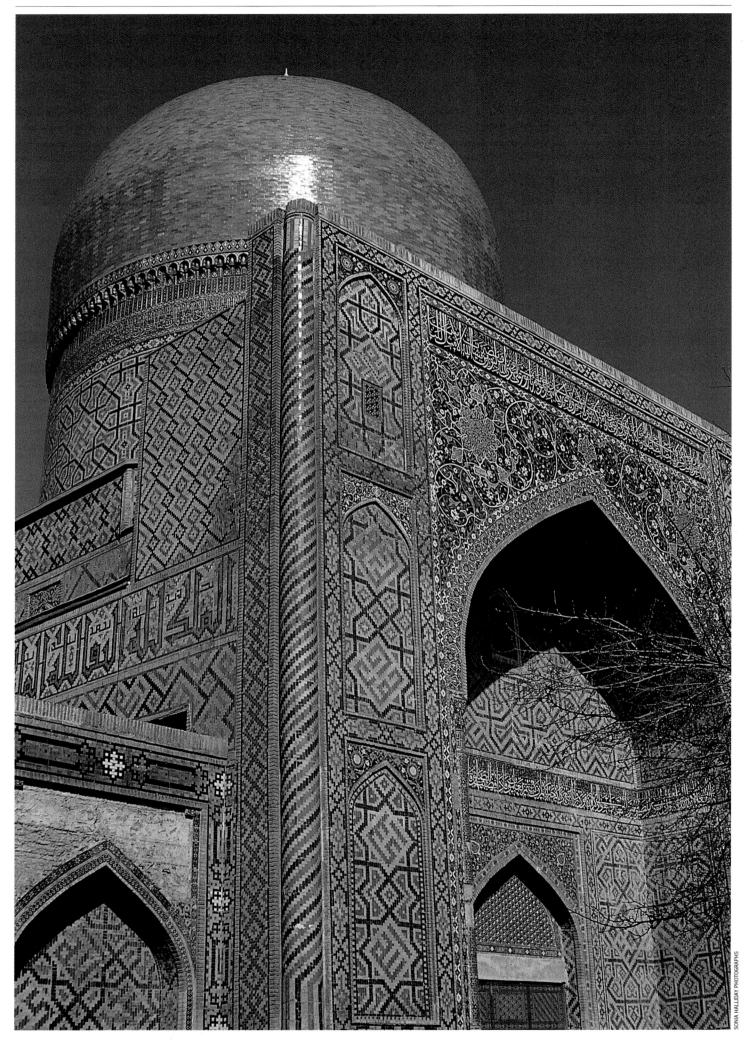

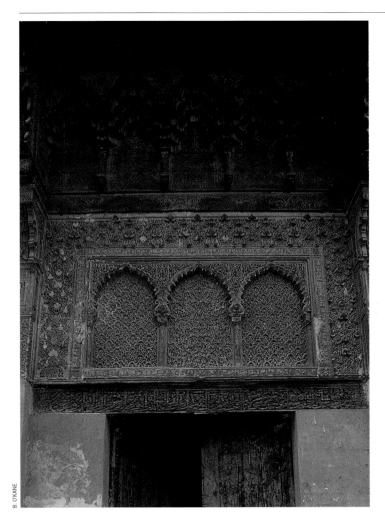

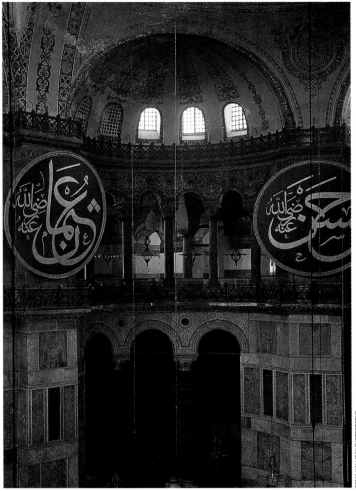

architectural version of the royal *chatr* or parasol (**33**). On either side of this hood the jambs of the portal would be encased in densely carved wood left in its natural colour. Such ornament secures an effect of undifferentiated richness entirely appropriate to a frame – and of course a portal can accurately be described as a frame. Sometimes it is a matter of multiple frames in two-dimensional ornament, as in the Anatolian portals of the 13th century; in other cases, these frames take on a three-dimensional character with a recurrent stepping inwards towards the door itself, as in the Jurjir mosque in Esfahan.

It may fairly be said that, irrespective of the means chosen to single out the portal, it is this area above all which stands out from the rest of the structure. The smooth cliff-like facades of public buildings in Mamluk Cairo – for shortage of space in that city forced architects to think in vertical rather than horizontal terms – are broken by narrow portals whose packed ornament derives added éclat from the blankness of the surrounding walls. So too in Umayyad palaces, where the portal may bear elaborate stucco sculptures of human beings and animals in closely packed superposed layers; or in the 11th-12th century *ribats* of the Iranian world, where it is the greater height of the portal arch, as well as its decorative rectangular frame, that makes the entrance stand out. In certain Persian tomb towers, like the Gunbad-i Surkh at Maragha, it is precisely over the entrance that the otherwise uniform monochrome brick decoration is suddenly enlivened by the infiltration of blue glaze (**37**).

A somewhat neglected chapter in the history of the minaret is the function, as distinct from the type, of the decoration which so many of these towers bear. In a culture which by and large set its face against decorating the exterior facade of the mosque, the minaret – after a period of experiment in the 8th and 9th centuries – took on a special role as a marker for the mosque, and a marker for which the utmost splendour was licit. Thus the mosaic panoramas of the Great Mosque of Damascus (**16**), invisible from the outside, were nevertheless hinted at in one of the minarets which had a coating of glass mosaic. Numerous minarets in the Maghrib bear rich lattices of ornament which, in the context of the bare mosque walls adjoining them, draw the eye irresistibly (**36**). The same is

32. *Facing page:* **Samarkand, Central Asia, Tila Kari** *madrasa,* **entrance to the mosque, ca. 1660.**

33. *Above left:* **Fez, Morocco,** *madrasa* **of Bu 'Inan, 1350-5, portal.**

34. *Above right:* **Istanbul, Haghia Sophia, 532-7, nave, roundels with names of Rightly Guided Caliphs.**

35. *Below:* **Samarqand, Central Asia, Ulugh Beg,** *madrasa,* **1417-21, detail of foundation inscription.**

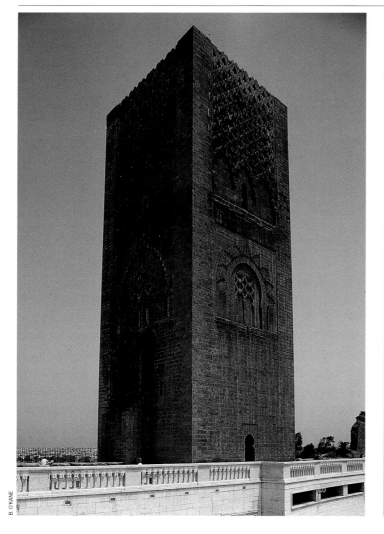

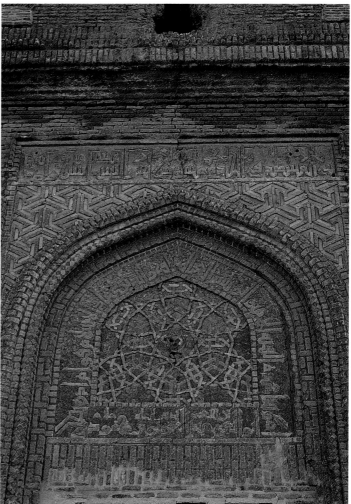

true of dozens of minarets in Iran (**38**). On them, it seems, could be lavished the decoration which tradition or sheer expense denied to the rest of the mosque. Thus the minaret could be seen as in some sense representing the mosque in a nutshell or in a quasi-symbolic manner. Its decoration, then, would be a mark of the reverence accorded to the entire mosque.

And the minaret is, finally, a test case of how architects sought to make the decoration of a building appropriate to its form. In Iranian cylindrical minarets, the brick patterning stresses an infinite continuity, thereby taking up the theme of the circle already announced by the form of such minarets (**38**). The square minarets of the Maghrib, on the other hand, favoured a clear vertical division between one face and the next, and the ornamental panels are accordingly given strong vertical frames (**26, 36**). And the minimalist approach, as followed at the Samarra minaret and in the descendants of that building is to allow the form itself to make a powerful statement – in this case a helicoidal ramp. The austerity, even starkness, of such buildings gives the lie to the popular notion that Islamic architecture is overloaded with ornament. Ornament has its proper place – tiled dadoes of star-and-cross type, inscription bands, entire self-contained panels – and to make its full impact it has to be contrasted with plain surfaces. The Alhambra encapsulates this contrast, its bare outer walls giving no hint of the splendours within. In other buildings, such as the Seljuq caravansarais of Anatolia, or the mosques of Mahdiya and 'Ali Shah in Tabriz (**40**), the overwhelming plainness of the facade throws into sharp relief the decorated portal or *mihrab* that draws the eye like a magnet.

ROLE OF THE ARTIST'S IMAGINATION

What, finally, is the role allotted to the artist's imagination in Islamic architectural ornament? It was his task to clothe the building, or selected parts of it, with ornament. It seems likely that he could give his ideas free rein, both in the type of ornament and in its placing. The derivation of certain key terms in Arabic architectural parlance from vocabulary originally associated with tents is a clue to the importance of textiles in Islamic architecture. Hangings and probably rugs brought life and colour to blank walls, served to subdivide space in an aesthetically pleasing fashion, and created doors or fictive niches or windows, thereby energising empty space.

Tenth century Byzantine ambassadors to the caliphal palaces in Baghdad noted with awe

36. *Above left*: **Rabat, Morocco, the mosque of Hassan, ca. 1199, unfinished minaret.**

37. *Above right*: **Maragha, Iran, Gunbad-i Surkh, 1148, portal.**

38. *Below*: **Firuzabad, Iran, minaret, 12th century.**

26

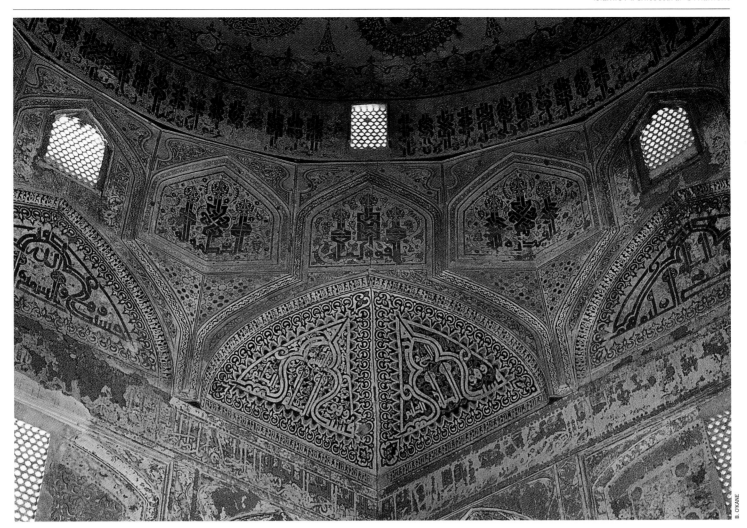

B. O'KANE

that the rooms they passed through were decorated with a total of 38,000 hangings. The accuracy of this figure is less important than the general impression that this was an architecture of textiles. The inevitable disappearance of this technicolour but temporary splendour leaves a significant gap in modern perceptions of what medieval Islamic architecture looked like. We have lost the idea, for example, that parts of a building were like an exhibition space – capable of constant spatial redefinition, in this case by the agency of textiles.

39. Yazd, Iran, mausoleum of Rukn al-Din, 1325, painting on zone of transition.

By the same token, we lose a vital dimension in our picture of how the medieval artist's imagination operated. Happily, there is a glut of surviving decoration in all kinds of durable materials, and its evidence is unmistakable. As we have seen, in vegetal ornament the point of departure was emphatically not the accurate rendering of nature; in geometric ornament the geometric forms themselves are as often concealed as displayed; in epigraphic ornament the letters take on shapes and devices that hinder rather than help reading. True, all three types of ornament are organised; they are mathematical; each is logical according to its own standards. But 'real' it is not. Instead, it is fundamentally abstract, even surreal, and fantasy is the source of its peculiar intensity (**39**). That fantasy, however, is kept under strict control.

40. Tabriz, Iran, mosque of 'Ali Shah, ca. 1310-20, exterior mihrab niche.

Such decoration is difficult to penetrate, perhaps intentionally so; it demands calm of mind, plenty of time, a readiness to contemplate. One senses obscurely that it is not mere decoration, but that it is making a statement; yet the exact nature of that statement remains elusive. There can be little doubt that this extra charge which Islamic ornament transmits has to do with the intellectual and emotional input of the artist. It is that personal, imaginative dimension of his work – expressed physically as an amalgam of line, colour, texture – which brings Islamic architecture vibrantly to life.

Glossary see Appendix

B. O'KANE

CARPETS, TEXTILES & COSTUME

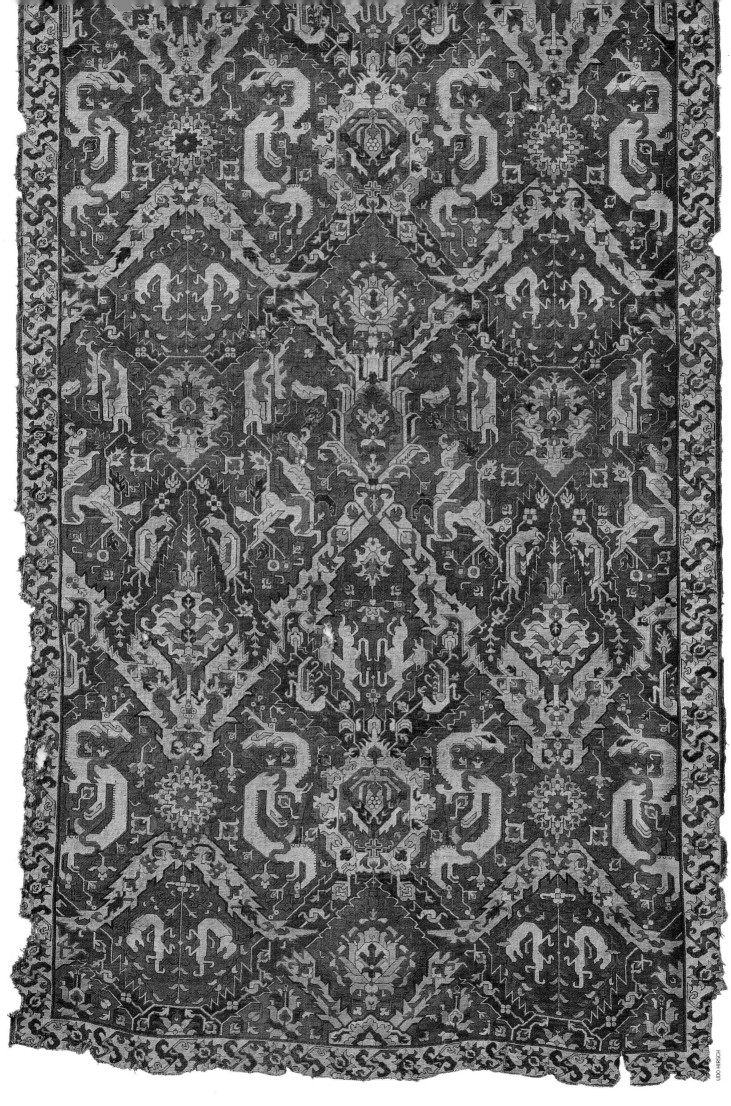

THE TABRIZ HYPOTHESIS

The Dragon & Related Floral Carpets

John T. Wertime & Richard E. Wright

Of all groups of 16th to 18th century 'classical' oriental carpets, the well-known 'dragon' and 'floral' (blossom and palmette) carpets conventionally attributed to the Caucasus are among the most puzzling. Although most authorities accept that they find their design antecedents in the weaving tradition of Safavid Persia, the greatest surviving corpus of these early carpets has been found in the mosques of Anatolia, and none are known to have survived in the Transcaucasian region. Further, while it can be shown that in palette and elements of design 19th century rugs from the Transcaucasus can be linked to the dragon and floral carpets, in other aspects the connections are tenuous. In this essay, the authors, respected researchers in the carpets of Caucasia and Persia, offer a critique of the 'myth of the dragon carpets', and suggest that there is sufficient circumstantial historical evidence to speculate that the carpets may in fact have been made in the Tabriz region of Persian Azarbayjan, and that their true descendants may be found among certain groups of Heriz and Bakhshaish carpets of the 19th century revival period.

31

Above: **Palmette motif from a 19th century Bakhshaish carpet (26).**

1. *Previous pages, left:* **Dragon carpet (detail), collected from the Ulu Cami (Great Mosque) in Divriği, near Sivas, eastern Anatolia. 2.50 x 5.43m (8'2" x 17'10"). Attributed to the Caucasus, ca. 1600, by Belkis Balpinar & Udo Hirsch** (*Vakıflar Museum Istanbul; Carpets/Teppiche*, 1988, pl.74); **dated to the early 16th century by Şerare Yetkin** (*Early Caucasian Carpets in Turkey*, 1978, vol.I, pl.1). **Vakıflar Museum, Istanbul, inv.no. A-5, courtesy Uta Hülsey, Wesel.**

Previous pages, right: **Palmette motif from a 19th century Heriz carpet (22).**

2. *Facing page:* **Dragon carpet (detail). 1.98 x 4.19m (6'6" x 13'9"). See Yetkin** (*Early Caucasian Carpets*, vol.II, fig.143). **Formerly Erich Maria Remarque Collection, courtesy The Textile Gallery, London.**

In 1925 Arthur Upham Pope published 'The Myth of the Armenian Dragon Carpets'.[1] This essay dealt with a controversial group of rugs often containing dragon motifs, and firmly implanted the term 'dragon carpet' in oriental rug literature. At issue was F.R. Martin's 1908 ascription of rugs called 'Kuba' in the marketplace to Armenian weavers in the east Anatolian districts of Van and Sivas as early as the 13th century.[2] Two years before Pope, Heinrich Jacoby had also voiced doubts about Martin's conclusions.[3]

"This structure of suppositions", Charles Grant Ellis wrote in 1975, "should have been utterly demolished by Heinrich Jacoby and Arthur Upham Pope, who underlined their fallacies and pointed out that the construction, design elements, color schemes and even small details, such as borders, can be followed down into semi-antique and recent Karabagh, Kazak and Shirvan rugs."[4] Both Jacoby and Pope had set out to debunk a new 'myth', but in so doing recast an old one: the Transcaucasian origin of the dragon and related floral carpets. This view has held sway ever since.

THE CARPETS

Production of the dragon carpets (**1-6**) is usually thought to have begun in the 16th or 17th centuries. They have vivid colours and a bold angular design that breaks the field into lozenges created by thick, serrated lancet leaves which contain small floral motifs. Various stylised animal figures, including dragons, appear in the lozenges. Large palmettes and blossoms are also a prominent feature. The carpets tend to be long (some exceeding six metres) and relatively narrow, rather coarsely woven and sturdily constructed. They continued to be made in the 18th century and beyond, it is often maintained, while evolving into large floral or blossom designs without the dragon and animal motifs (**7-13**). An alternative view holds that the apparently earliest examples of both types may have been contemporaneous.[5]

Ellis, who has probably examined more dragon and floral carpets than anyone else, treats them as one group structurally and finds considerable consistency in their construction, with only minor variations in the packing wefts and side finishes.[6] 'Packing' wefts are heavy cabled single wefts which interrupt the usual two-shoot sequence of the weaving at irregular intervals. Most, but not all, surviving dragon and floral carpets have these signature wefts. Warps and wefts are normally wool, consisting of two Z-spun yarns plied S (Z2S). The warps are on two levels (partially or fully depressed) and are wrapped with the symmetrical knot. This distinctive combination of structure and handle seems to suggest a common area of manufacture for the majority of the carpets. Ellis speculates that most deviation from the norm in terms of material, number of strands (warps and wefts) and technique came about in the late 18th or early 19th centuries as production spread beyond the original area of manufacture.[7] Many dragon and floral carpets have been preserved in Turkish mosques.

RECENT VERSIONS OF THE MYTH

Ellis tries to link the carpets to factories Shah Abbas I (1588-1629) purportedly established in Karabagh and Shirvan,[8] and assigns them either to Shusha/Karabagh or Shemakha/Shirvan, but generally favours Shusha.[9] Following Pope, he considers them to have been inexpensive commercial products made under a certain degree of professional oversight, which competed in Anatolia with "large contemporary carpets of northwest Persia and of Ushak."[10]

Şerare Yetkin dwells on the evolution of design and ignores the question of specific geographic location. She considers the carpets to be primarily the creation of Turkic peoples in Caucasia. In her schema, those carpets termed 'floral' are 18th century products derived directly from earlier dragon carpets and strongly influenced by 17th century Persian carpets.[11]

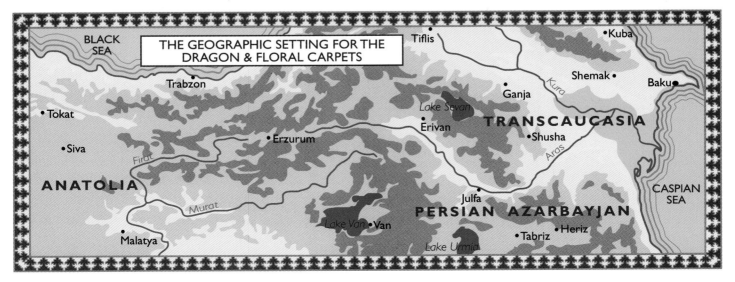

THE GEOGRAPHIC SETTING FOR THE DRAGON & FLORAL CARPETS

BLACK SEA

Tiflis • Kuba

Shemak •

Baku •

Trabzon

Ganja

Kura

Lake Sevan

TRANSCAUCASIA

Erivan

Shusha •

Tokat

Aras

Siva

Erzurum

Firat

CASPIAN SEA

ANATOLIA

Julfa

PERSIAN AZARBAYJAN

Murat

Lake Van • Van

Tabriz • Heriz

Malatya

Lake Urmia

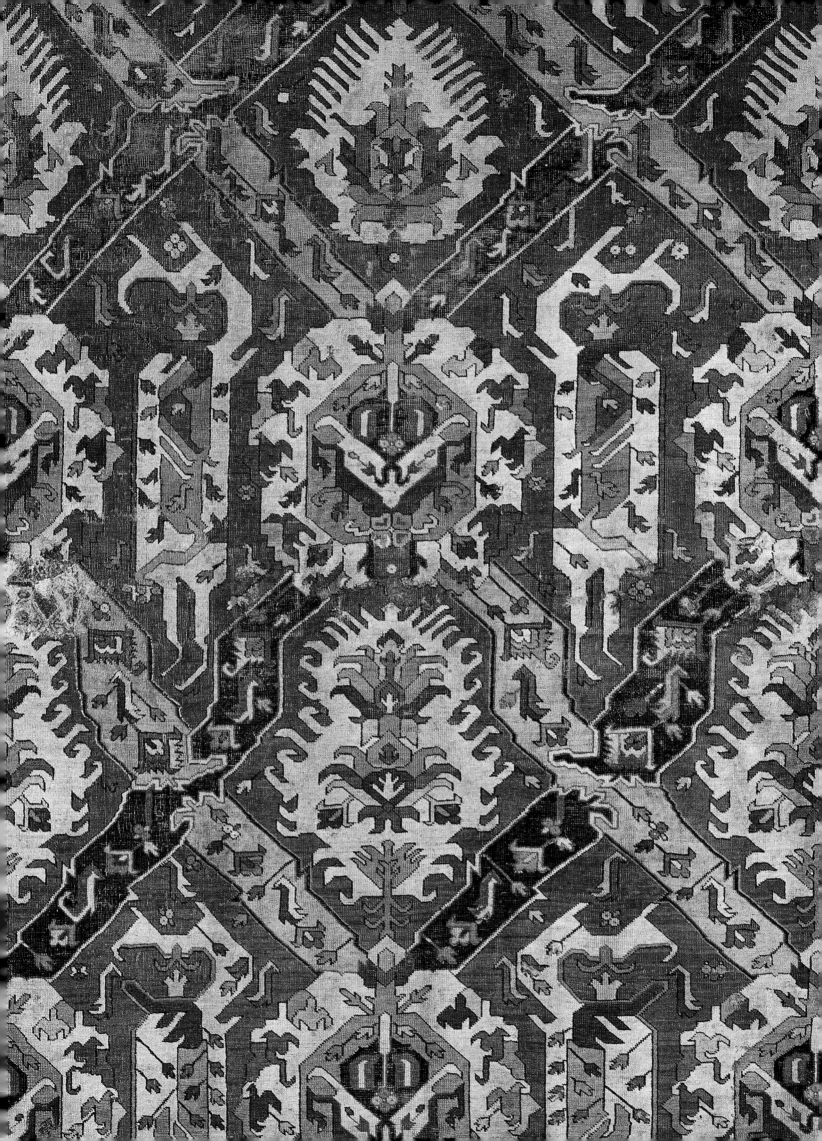

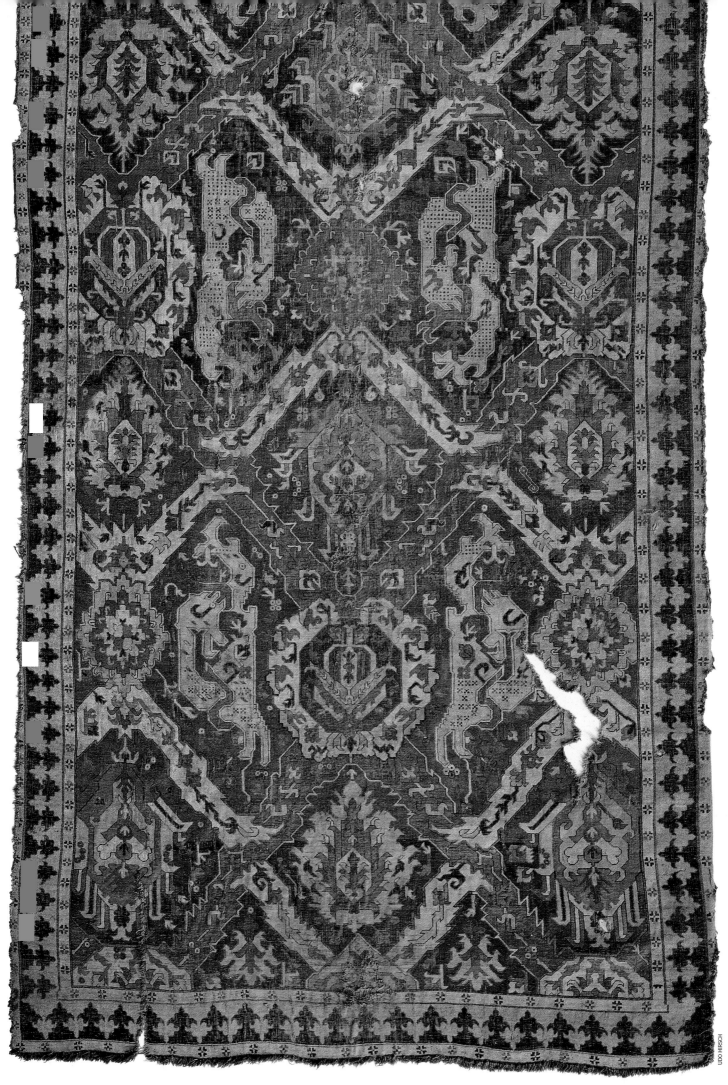

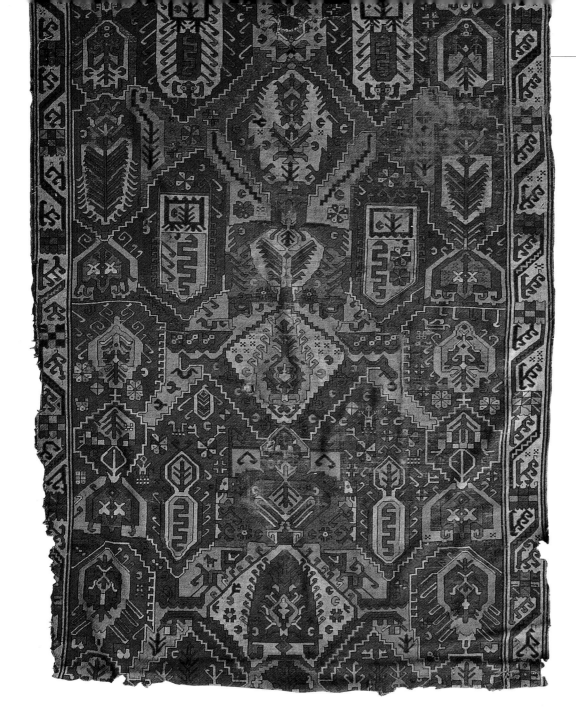

3. *Facing page:* Dragon carpet fragment (detail), from the Vakıflar Depot, Istanbul. 2.25 x 4.60m (7'5" x 15'1"). Attributed to the Caucasus, ca. 1700, by Balpinar & Hirsch *(Carpets,* pl.75); dated to the 17th century by Yetkin *(Early Caucasian Carpets,* vol.I, pl.20). Vakıflar Museum, Istanbul, inv.no. E-104. Courtesy Uta Hülsey, Wesel.

4. *Left:* Dragon carpet fragment (detail), acquired in 1915 from Köse Ömer Aga, Erzurum. 2.00 x 3.86m (6'7" x 12'8"). Dated to the late 18th century by Yetkin *(Early Caucasian Carpets,* vol.I, pl.21). Türk ve Islam Eserleri Museum, Istanbul, inv.no. 97(3076). Courtesy The Textile Gallery, London.

Murray L. Eiland Jr. reasserts the Armenian origin of the dragon and floral carpets, but within Transcaucasia. He contends that similarities of motif between late 19th and early 20th century Karabagh village rugs with Armenian inscriptions (**20**) and the dragon and floral carpets mean that the old carpets should also be considered Armenian work from Karabagh. They were, he thinks, the product of a centre of population containing craftsmen who "specialized as designers and dyers". While suggesting several possible sites during the 17th and 18th centuries – Shusha, Ganja, Shemakha and, "the largest", Baku – Eiland favours Shusha, which he claims has long been an Armenian centre.[12]

Two authors assert a cottage industry production. Jon Thompson does not specify its location, but considers it to have been a flourishing one making adaptations of Persian designs for an export market.[13] Michael Franses seems to place a cottage industry in Karabagh and suggests the carpets were made for "domestic use."[14]

All these speculations have major deficiencies.

SOME TRANSCAUCASIAN REALITIES

Contrary to Ellis's claim that there is a construction as well as a design similarity with semi-antique Transcaucasian rugs, none of these closely resembles the dragon and floral carpets in structure and handle. Typical Karabagh village rugs have relatively coarse yarns but lack the tight, sturdy construction of the earlier carpets. Warps are either on one level or only slightly depressed. Packing wefts are absent. Shirvan rugs are even less similar in their structure and handle. None of these rugs are comparable to the older carpets in size.

The current myth thus rests on the assumption that some motifs found in certain late 19th and early 20th century Karabagh village rugs – the 'sunburst' (**19**), a medallion-like

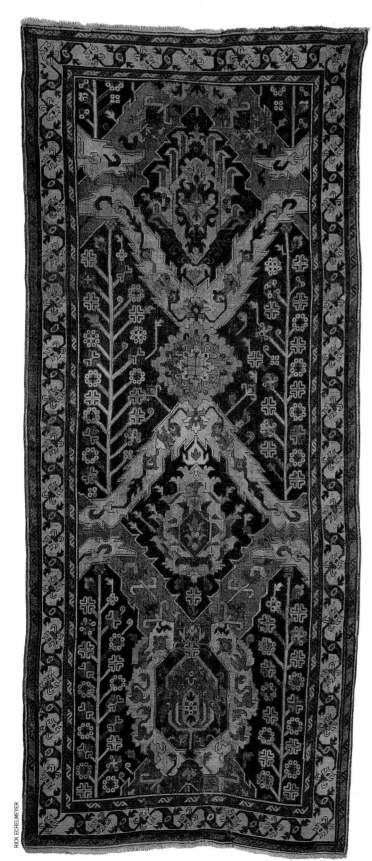

5. 'Dragonless' Dragon carpet. 1.46 x 3.66m (4'9" x 12'0"). Purchased from E. Beghian, London, in 1924. Attributed to Shusha, Karabagh Province (?), 18th century by Charles Grant Ellis (Oriental Carpets in The Philadelphia Museum of Art, 1988, pl.44). Philadelphia Museum of Art, John D. McIlhenny Collection, inv.no. 43-40-62.

RICK ECHELMEYER

U-shaped palmette with outward-turning ends (**18**), and a medallion bracketed by two inward-pointing bars derived from a leaf form, called 'Kasim Ushag' (**20**) – are descended from earlier dragon and floral carpets produced in the same area.[15] These Karabagh village rugs were often made in Shusha District.[16] Some have Armenian inscriptions; most do not. The assumption of direct descent, however, ignores other plausible explanations: (i) that these motifs represent the survival of an old design tradition which was also present in the dragon and floral carpets; (ii) that old carpets from outside the Karabagh area were available for copying, and (iii) that imitable textiles with the same motifs were present there.

These same motifs do, in fact, appear in silk embroideries of undetermined origin known at various times as Persian, Caucasian or Azerbaijani (**16, 17**). Readily portable products of a related women's textile craft, they could be the source of motifs in the village rugs, a point made by several writers.[17] Given the possibility of copying from imported carpets or from embroideries, as well as that of a continuity of village rug design, the assumption that the motifs in late Karabagh rugs came from earlier dragon and floral carpets woven in the same area rests on shaky ground.

There are other difficulties. Throughout the Safavid period (1501-1722) Karabagh Province included, and was ruled from, Ganja, the seat of the Safavid *beglarbegi* or governor-general. Karabagh was subsequently separated from Ganja by Nader Shah (1736-1747).[18] Ellis's contention that Shah Abbas established royal workshops in Karabagh and Shirvan is based on a statement made by a Jesuit missionary, Krusinski, who lived in Persia from 1704 to 1729, almost a century after the reign of Shah Abbas. Moreover, while Krusinski mentioned royal textile and carpet workshops, he did not assign particular types of manufactory to specific locations.[19] The Krusinski hearsay is problematic even with an accurate reading of the source, for by the time of Shah Abbas the trend was to privatise such workshops, not to establish new ones,[20] although at least one royal textile establishment was functioning in Esfahan in the 1640s.[21]

History is troublesome in another regard. Shusha, favoured by both Ellis and Eiland as the source of the dragon and floral rugs, did not exist before 1752.[22] Furthermore, the Karabagh area was predominantly nomadic,[23] and without small urban centres where workshops could have been established.

Large rugs were made in the city of Shusha during the 19th century, but they differ substantially from the dragon and floral carpets in weave, handle, colour and design (**21**). Some which survive bear early 19th century dates, including one of 1224 AH (1809-10 AD).[24] Russian government weaving survey reports of 1887 and 1913 describe these large Shusha rugs and their production setting in detail.[25] In the 1880s the rugs were made to order for local consumption, often designed to fit a particular room, and sometimes requiring a specially constructed loom.[26] Armenians were the principal purchasers; Azeris were the weavers.[27] In 1886 the population of Shusha City was 30,945 – including 18,690 Armenians and 11,940 Azeris.[28]

If the dragon and floral carpets were not made in Shusha, could they have come from either Ganja or Shemakha, seat of the Safavid governor-general of Shirvan? Sometimes Safavid governors established provincial workshops, but nothing to indicate that this was the case in either place has been uncovered by a major study of the Persian textile industry.[29] In the 1680s Ganja was a silk manufacturing centre with handsome bazaars and four times the population

6. Facing page: Dragon carpet (detail). 2.44 x 5.26m (8'0" x 17'3"). Attributed to Shemakha, Shirvan Province (?), 17th/18th century by Ellis (Oriental Carpets, pl.44). Philadelphia Museum of Art, gift in memory of Philip M. Sharples, inv.no. 48-83-1.

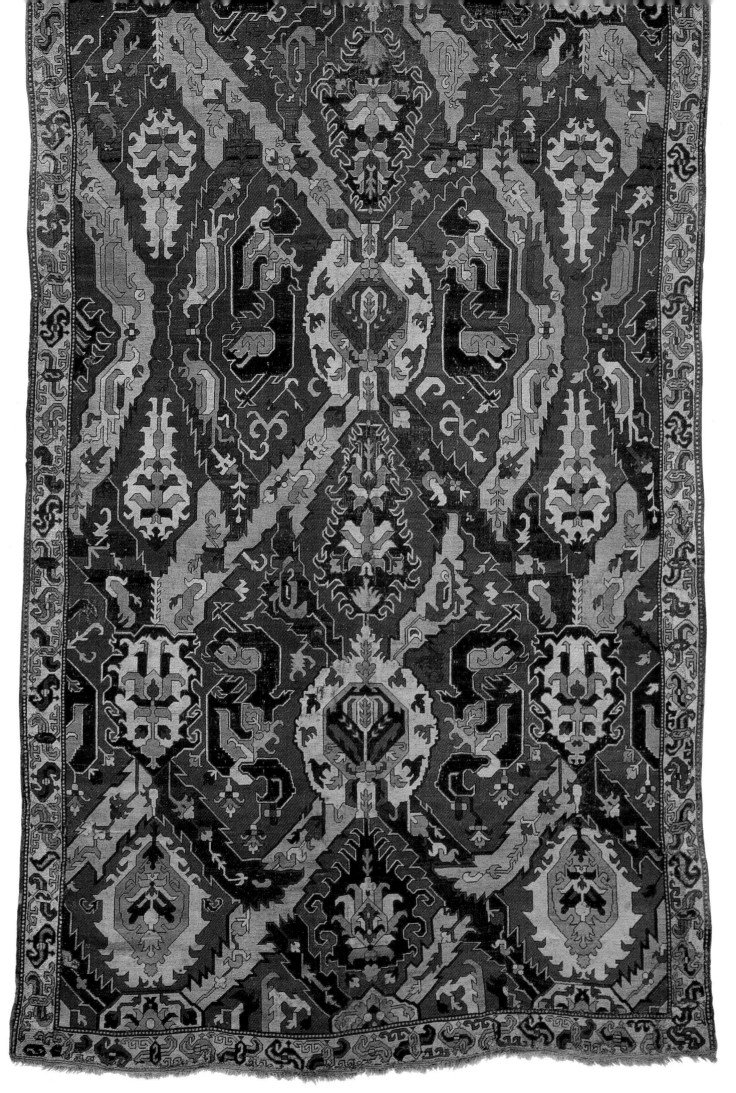

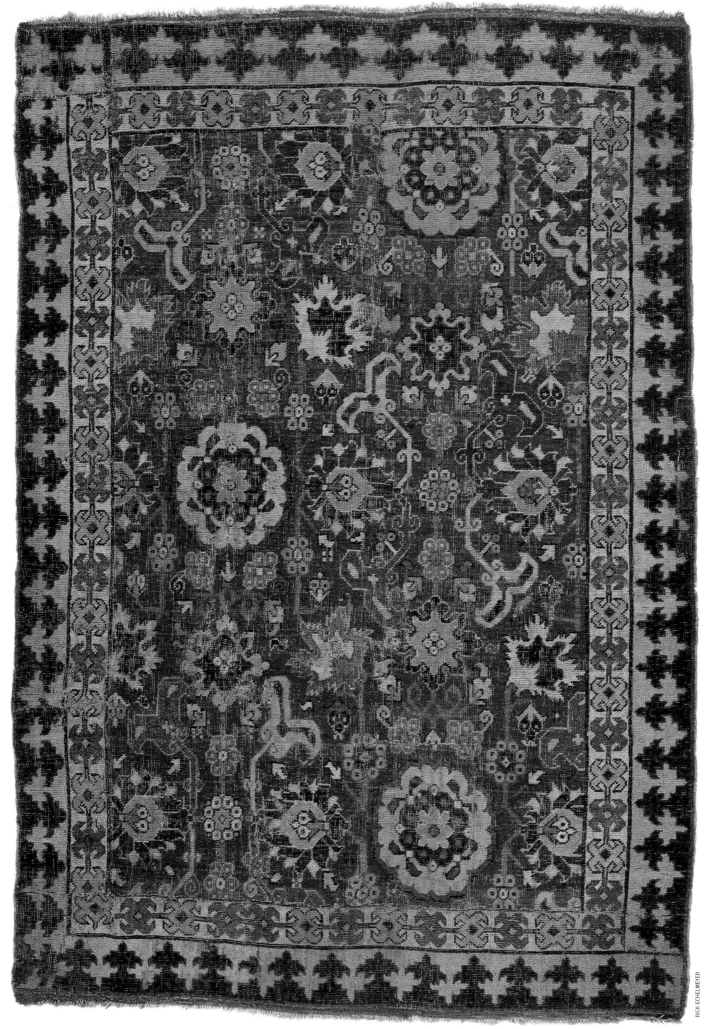

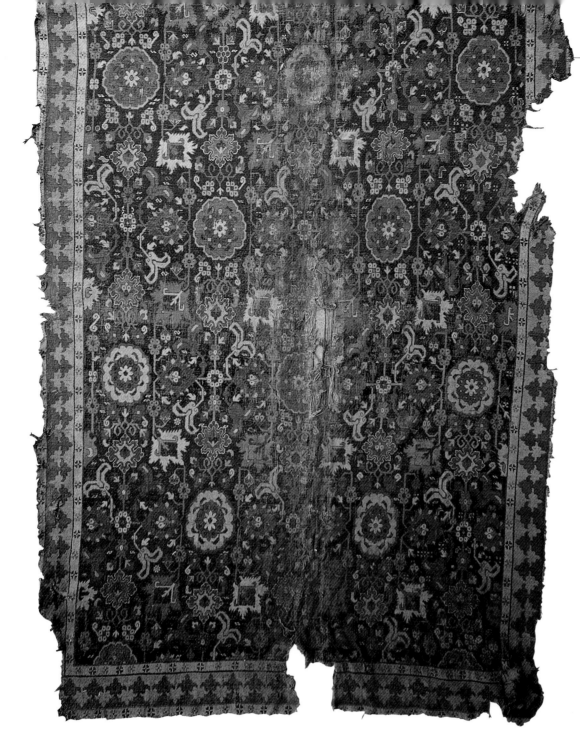

7. *Facing page:* **Afshan design floral carpet corner fragment (with borders attached). 1.25 x 1.88m (4'1" x 6'2"). Attributed to Shusha, Karabagh Province (?), 18th/19th century by Ellis** *(Oriental Carpets,* **pl.46). Philadelphia Museum of Art, John D. McIlhenny Collection, inv.no. 43-40-73.**

8. *Left:* **Afshan design floral carpet (detail). 2.62 x 6.35m (8'7" x 20'10"). Acquired in 1936 from the Ali Pasha Cami in Tokat, eastern Anatolia. Dated to the 19th century by Yetkin** *(Early Caucasian Carpets,* **Vol.I, pl.64). Türk ve Islam Eserleri Museum, Istanbul, inv.no. 941 (694). Courtesy The Textile Gallery, London.**

of Shemakha.[30] Unfortunately, few travel accounts include Ganja, and nothing sheds light on its textile production.

Numerous travellers, however, did stop in Shemakha during Safavid times. While many cited silk and fabric production and some observed silk carpets with gold and silver thread being used by the Sharvanshah and the Safavid *beglarbegi*,[31] none noted carpet making. Travel accounts generally, and those of merchants in particular, identified the products of a region which were significant trade items. Carpets, however, were a minor trade adjunct, and the fact that they were not mentioned with respect to Ganja and Shemakha is not conclusive. The final locus suggested as a production centre, Baku, is untenable, for it was a only small town until the great oil boom at the end of the 19th century.

The bleak prospects for Karabagh, Ganja, and Shirvan as the source of the carpets make one wonder about the old Kuba attribution, now lost among the current versions of the myth. Although the historians of Azerbaijan date Kuba town from the end of the 14th century,[32] it appears to have gained significance as an economic centre only in the 17th century[33] and became the seat of the powerful Khan of Kuba in the 18th century.[34] With a population of five thousand in the early 19th century[35] Kuba town was home to an established weaving enterprise. In about 1820 a Russian traveller, Platon Zubov, remarked on the manufacture there of excellent carpets *(kovry)* and the presence of master weavers.[36]

Despite the presence of depressed warps (and the large formats[37] produced in three Kuba District villages), their thin yarns, fine weave and a very different handle make Kuba rugs unlikely successors to the heavy-bodied dragon and floral carpets.

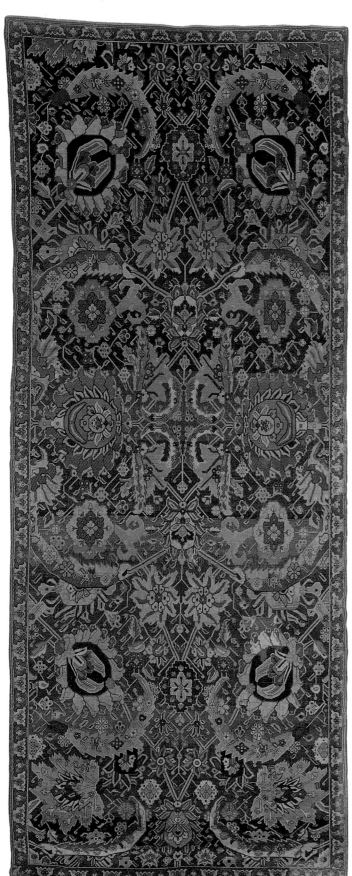

9. Floral carpet. 2.44 x 6.40m (8'0" x 21'0"). Attributed to Karabagh or Shirvan, early 18th century by Charles Grant Ellis (*Early Caucasian Rugs*, 1975, pl.22). Formerly George Hewitt Myers Collection, courtesy Harold & Melissa Keshishian, Washington DC.

An additional complicating factor stems from a detailed survey carried out in 1900, via interviews with weavers in the 27 principal weaving villages of Kuba, in which it is said that the manufacture of pile rugs had begun in the district in 1850.[38] While there is some anecdotal evidence that contradicts this report (two observations of about 1820 place commercial weaving of "carpets" in Kuba),[39] the weight of evidence is that the traditional textile craft of Kuba District consisted of flatwoven sumakh rugs, and that pile weaving, if it existed there prior to 1850, was an exception. Another difficulty for a Kuba attribution is the connection of Armenians with the floral carpets. In the late 19th century, Kuba District had only one Armenian village[40] and earlier travel accounts give no indication of an Armenian presence.[41]

Kuba is an unpromising candidate as the source of the dragon and floral carpets, but one of its products – the so-called sumakh cover, also made in adjacent Kurin District – merits discussion. Covers with designs apparently derived from the dragon carpets date from at least the beginning of the 19th century. Some have highly stylised dragon motifs (**15**). In Azerbaijan such sumakhs are known as *khatai*, a reference to aspects of their design. Other sumakh covers have a design which strongly resembles that of certain floral carpets (**14**).[42] The composition parallels seem to indicate a definite connection between carpets and sumakhs. Since it is unlikely that these sumakhs were *in situ* successors to the early carpets, where could the designs have come from?

One possibility is that the weavers had access to dragon and floral carpets and copied them. Judging from most 'dragon' sumakhs, the possible model was a dragon carpet which conventional wisdom considers to be a late type.[43] In light of the similarity not of a few motifs but of overall design, a direct borrowing seems a good explanation.[44] It is also a plausible one, for what Zubov saw in 1820 was the copying of Gobelin tapestries, weaving commissioned by Yermolov, the Governor-General of Caucasia.[45] Writing in 1930, M.D. Isaev recounted this episode and remarked that some of these copies still survived.[46]

Thus it is evident that there was a weaving establishment in Kuba town quite capable of undertaking commission work. Yermolov was not the only individual capable of ordering such work; the Khans of Kuba had considerable power throughout the 18th century, and were certainly capable of commissioning such undertakings. However, although the financial and technical means for commissioning elaborate copies existed, it does not follow that this actually took place, even though the Yermolov episode does underscore this possibility.

Yet another Transcaucasian reality casts doubt on the conventional thinking. Current versions of the myth appear to assume external financing for the dragon and floral carpets, and suggest two different production arrangements: (i) the workshop, a place housing a permanent loom or looms and supervised hired weavers or (ii) a cottage industry with materials supplied to weavers working without supervision at home. Neither of these arrangements is natural to Transcaucasia, where rug weaving was a self-financed, home-based enterprise throughout the 19th century. Nor is there anything to suggest that this was not the case earlier, a situation that makes workshop production improbable. Indeed, at the end of the 19th century, Russian officials sought, unsuccessfully, to establish workshops.[47] That they had existed during the 17th and 18th centuries and then disappeared is unlikely.

A major doubt concerning a cottage industry stems from its absence in documents which could be expected to have mentioned it. The new Russian masters saw Transcaucasia's economic potential, and assessed the region accordingly. In two books, Zubov, who travelled extensively, discussed this with respect to natural resources and activities such as '

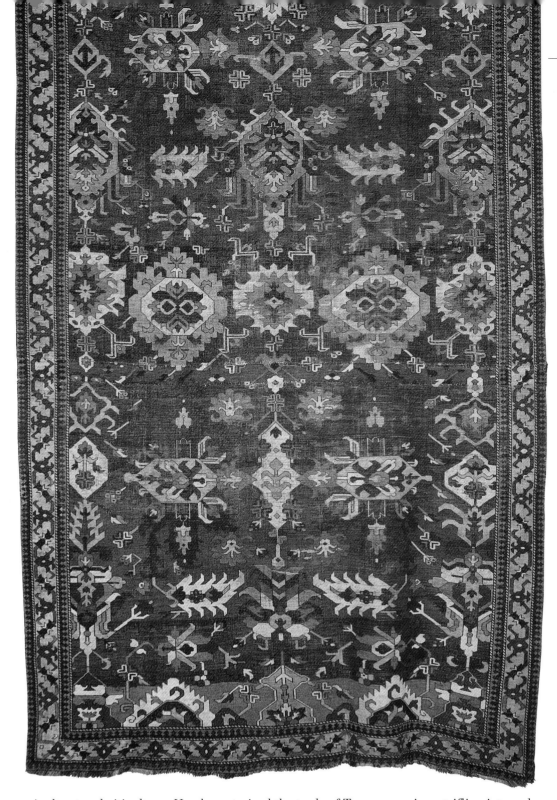

10. Palmette design floral carpet fragment (detail). 2.39 x 3.84 (7'10" x 12'7"). Attributed to Karabagh, Shusha area (?), 18th century by Ellis (*Early Caucasian Rugs*, pl.20). The Textile Museum, Washington DC, inv.no. R36.2.5.

sericulture and viticulture. He characterised the trade of Transcaucasia as trifling internal commerce, something also reported by another early 19th century visitor.[48] A compilation of materials describing the region in the 18th century, and another dealing with the first decade of the 19th, portrayed Transcaucasia as having no trade.[49] It is not easy to think that such descriptions would have overlooked a cottage industry serving an export market.

Later glimpses of the historic record are also negative. The background sections of imperial weaving surveys of the period 1882-1913 do not mention workshops or a cottage industry, and are silent about the dragon and floral carpets. Moreover, none of these carpets have survived in the region. A 1904 government report lamented the fact that all "old rugs" had left Caucasia, but did not define 'old'.[50] While carpets for export might have disappeared, it is not likely that those intended for local consumption would have.

None of this points to a Transcaucasian origin, and in the end there is no credible argument for it. The current myth rests on unsubstantiated assertions which are contradicted by the realities of the region. There is nothing in the setting or the record which suggests the manufacture of such carpets. There are no successors to be found there, for the later village rugs have the wrong structure and handle. The few motif similarities which the late village rugs share with the old carpets are amply explained by other possibilities – silk embroideries, imported carpets, or a once common design repertoire.[51]

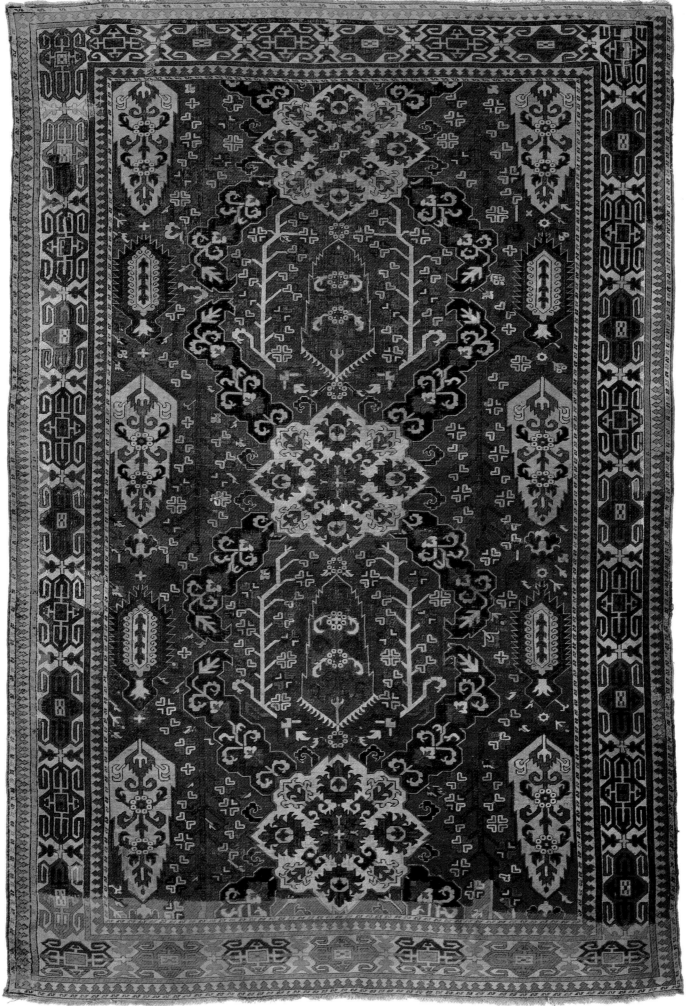

EASTERN ANATOLIA

Martin's interrogation of Istanbul dealers led him to the conclusion that the dragon and related floral carpets came from the districts of Van and Sivas, where they had purportedly been in mosques and churches or in the possession of old families. From Yetkin's work it is evident that Turkish mosques, largely in the eastern half of Anatolia, were repositories for a number of the survivors.[52] That this also could have been the case in churches and in wealthy homes is plausible.

Martin thought that the dragon carpets originated in Anatolia in the 13th century, and that the floral carpets were copied both in Armenia and in southern Transcaucasia from various 18th century Persian carpets. His ethnic and geographic views concerning the dragon carpets have been embraced by Volkmar Gantzhorn, who claims they "originated in the northern settlements of West Armenia, located between the districts of Van and Sivas."[53] Gantzhorn's arguments parallel and go beyond Armenag Sakisian's 1928 attempt to refute Pope.[54] Unlike Martin, however, he dates the carpets from the end of the 16th century, with the majority probably from the 17th, and sees degeneration in composition and motifs in the 18th century. Like Sakisian, he holds that they are integral to a long Armenian artistic tradition.

Gantzhorn's assessment of the floral carpets diverges from Martin's. He considers them to be 17th and 18th century Armenian work, primarily done in Karabagh, and to be separate in design origins from the dragon carpets.

Martin's and Gantzhorn's opinions are based on speculation about design relationships and evolution. Neither offers supporting evidence from historical sources. Although more dragon and floral carpets were found in mosques in Erzurum and Tokat than in any other city, there are few contemporary references to rug weaving in eastern Anatolia during the 16th to 18th centuries. The widely travelled Evliya Çelebi held a government position in Erzurum, but his description of the city's manufactures did not mention carpets.[55] This may be significant, as he did remark on the carpet production of Ushak in western Anatolia.[56]

Erzurum was the centre for merchants trading with northern Persia – Armenians in whose hands the control of most international movement of goods was lodged.[57] From 1700 onwards travel account data on the manufactures of Erzurum and Tokat include fabrics, stuffs and silks, but not carpets.[58] Negative evidence is, again, only suggestive, but so far there is nothing to affirm dragon and floral carpet manufacture in these cities.

Relevant to a possible east Anatolian origin is the matter of successor types. While there was rug weaving during the early 19th century at Kayseri and Konya in central Anatolia,[59] later 19th century rugs from these and more easterly Anatolian locations have neither design nor structural affinities with the dragon and floral carpets.

If, then, there is nothing which indicates the local manufacture of these carpets, is there another explanation for their presence in eastern Anatolia?

Turkish rug scholarship holds that beginning in about 1600, Persian carpets became fashionable among the Ottomans,[60] a fact amply attested by Western travel accounts of the 17th century. Descriptions by visitors who differentiated textiles by type and place of origin regularly noted the presence of 'Persian carpets'.[61] Both Turkish and Persian rugs are mentioned in such accounts, sometimes in the same sentence.

12. *Above:* **Palmette design floral rug. 1.28 x 1.84m (4'2"x 6'0"). Attributed to southwest Caucasus, 17th/18th century, by Michael Franses (Orient Stars: A Carpet Collection, 1993, pl.60). Orient Stars Collection, courtesy H. Kirchheim, Stuttgart.**

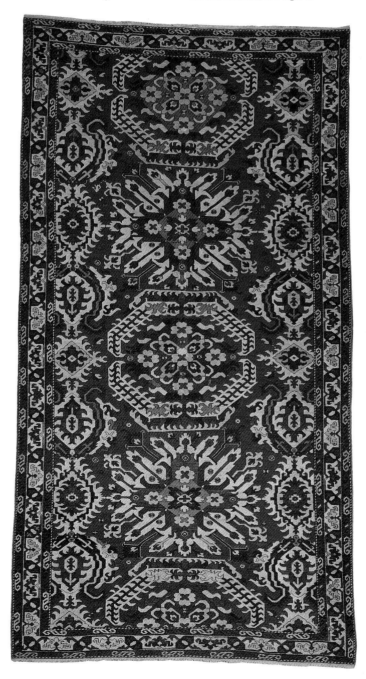

11. *Facing page:* **Cypress design floral carpet fragment. 2.23 x 3.45m (7'4" x 11'4"). Purchased in 1915 from Dikran Kelekian, New York. Attributed to Shusha (?), Karabagh Province, 18th century, by Ellis (Oriental Carpets, pl.45). Philadelphia Museum of Art, John D. McIlhenny Collection, inv.no. 43-40-74.**

13. *Right:* **'Sunburst' palmette design floral carpet, 1.91 x 3.77m (6'3" x 12'4"). May H. Beattie (The Thyssen-Bornemisza Collection of Oriental Rugs, 1972, pl. XII), writes that this carpet "may not have been woven before the second half of the 19th century". Thyssen-Bornemisza Collection, Lugano, inv.no. 648a.**

Those from Persia are variously characterised as 'rich', 'handsome' and 'large'. An account of 1630 elaborated: "...the handsomest are from Persia, which have in them colours so alive, that one can scarcely look at them..."[62]

These travellers did not as a rule go through the Anatolian interior: by and large their observations have to do with Istanbul mosques and the residences of the Ottoman élite. There is, however, no reason to assume that the taste of provincial notables was different. The fashion continued well into the 18th century: "...those [carpets] from Persia are the most esteemed because of fineness and beauty of designs."[63] One Western opinion of Turkish predilections at this time stated: "The Turks admire a brilliant colour and splendid appearance; the Persians are a wiser people and know the value of goods."[64]

Given their popularity, one might expect to find numerous recognisable Persian carpets preserved in Turkey. Surprisingly, however, relatively few appear in Turkish collections.[65] Perhaps they are present, but misidentified.[66] If, however, the dragon and floral carpets are of northwest Persian origin, the problem disappears.

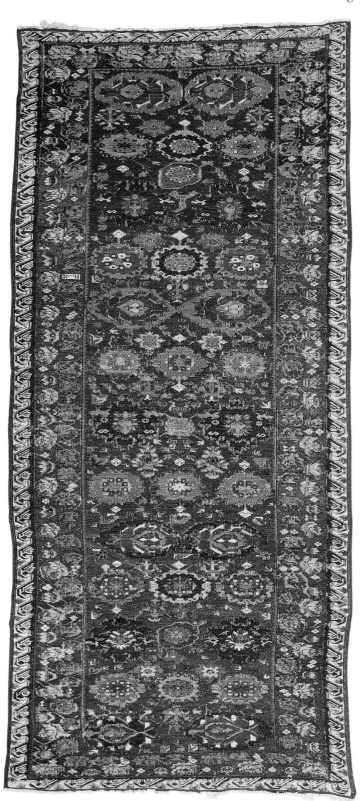

In brief, the east Anatolian attribution for the dragon and related floral carpets is weak. While the presence there of survivors makes such a speculation reasonable, lack of evidence of local production and the absence of successor types undermine the thesis, which is further weakened by the possibility of the carpets' arrival via trade. The revisionist effort to originate the carpets in eastern Anatolia is no more persuasive than the Transcaucasian myth. It is necessary to look elsewhere.

A POSSIBLE SOURCE OF THE DRAGON & RELATED FLORAL CARPETS

Persia's northwestern province of Azarbayjan and the region known as Transcaucasia have been of a piece ethnically and culturally for centuries, and were often part of the same political entity. Tabriz, a major city at least from the Mongol period, held a dominant political, cultural and commercial position. Textiles and trade have always been an integral part of the life of this city. In Akkoyunlu Turkoman and early Safavid times, when Tabriz was the capital city of Persia, its commerce meant the presence of Venetian and Genoan merchants. Joseph Barbaro in about 1470 and an anonymous merchant in 1507 described the carpets used by the last Akkoyunlu ruler, Uzun Hasan, and by the first Safavid shah, Isma'il.[67] These carpets were regarded by Barbaro as superior to those of Cairo and Bursa.[68]

The territory surrounding Tabriz has long been thickly settled and small towns and villages were a part of the greater Tabriz fabric.[69] Many were owned by the city's elite. Barbaro identified Tasuj and Shabestar, small towns northwest of the city, as the source of a variety of textile products including silk.[70] Thus in the early 16th century the city's hinterland was the site of weaving, and the city's royalty used high grade court carpets of unknown origin. The frequent attribution in the rug literature of 'court' carpets to 16th century Tabriz is, however, nowhere substantiated by contemporary accounts. In addition, this ascription necessarily implies that a group of carpets with asymmetrical knots originated in Persian Azarbayjan, where pile is characteristically formed with the symmetrical knot. There is no basis for assigning such a carpet type to Tabriz.

During the 17th century, Tabriz continued as a major economic centre,[71] second in importance and population only to Esfahan, the national capital.[72] The city contained three hundred caravanserais, 15,000 shops, 15,000 houses and had a population greater – perhaps substantially so – than 110,000.[73] Trade routes linked Tabriz to the Ottoman Empire, with which Persia carried on an active caravan trade despite the long struggle between the two powers. A substantial silk export was collected, mainly in Tabriz, and sent by caravan

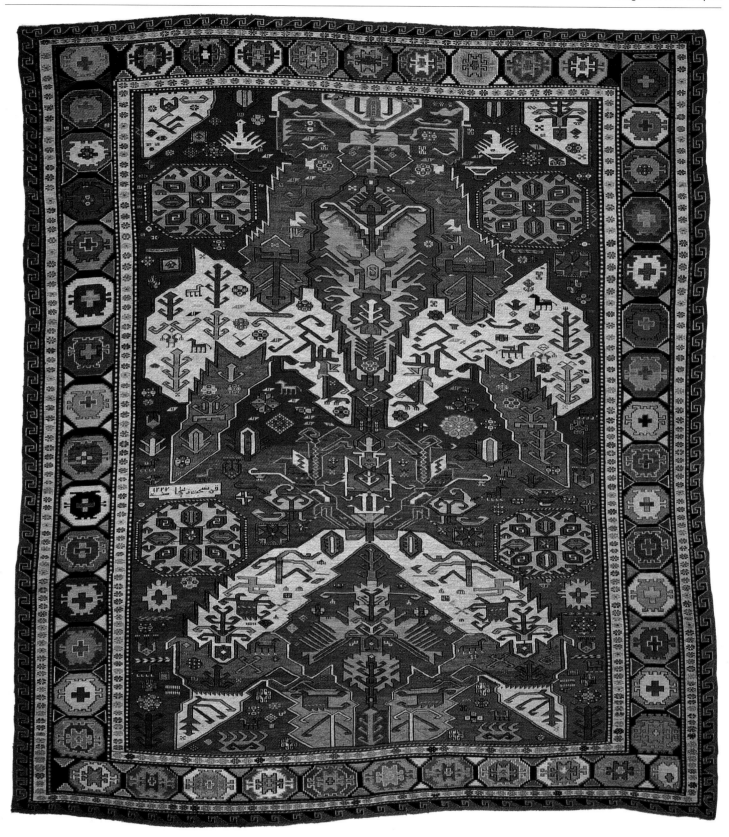

Facing page above: Floral motif from an early Afshan design carpet (7).

14. *Facing page below:* Floral design sumakh carpet, Kuba or Tabasaran, inscribed and dated 1269 AH (1852 AD). 1.22 x 2.90m (4'0" x 9'6"). Courtesy The Carpet Studio, Florence.

15. *Above:* Dragon design sumakh carpet, Kuba or Tabasaran, inscribed and dated 1222 or 1227 AH (1807 or 1812 AD). 2.03 x 2.45m (6'8" x 8'0"). Vok Collection, Italy.

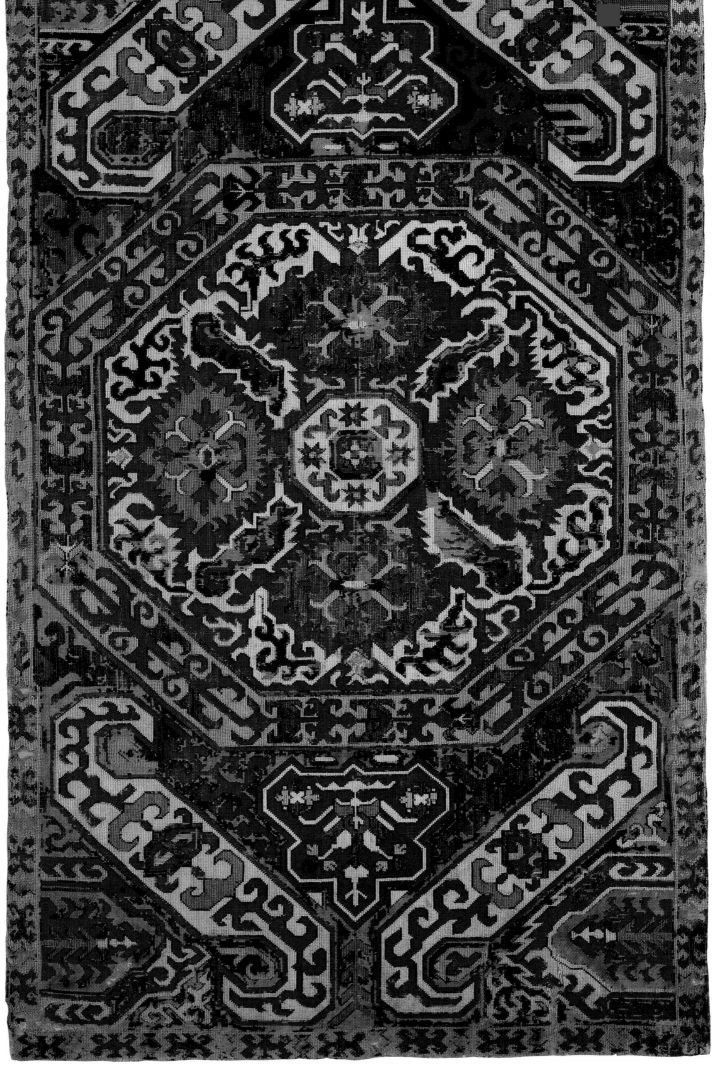

to Erzurum, then on to Erzincan, Tokat, Amasya and Bursa.[74] Dragon and floral carpets have been found in all of these cities.

Tabriz and its environs are cited throughout the Safavid period for a significant textile industry, including silk weaving,[75] an activity also noted in the late 18th[76] and early 19th centuries.[77] Production in 1830, however, was not so robust: "[Tabriz was] the seat of no important manufacture[s]; and even they are the work of domestic looms."[78]

The city was not among the places singled out for excellence in rug production. These, according to Safavid chronicles,[79] and echoed by some 17th century European sources,[80] were the provinces of Kerman, Khorasan and Yazd. Rugs, however, were made in Tabriz late in the Safavid period. In 1702 Franz Casper Schillinger reported that sturdily made rugs *(starck gedruckte Teppiche)*, as well as silk fabrics, were produced in Tabriz and its immediate surroundings *(Umland)*.[81] John Bell mentioned "manufactories of carpets, and silk and cotton stuffs" operating in Tabriz in 1716,[82] and Richard Pococke, a British factor in Aleppo, writing in 1738, referred to a "decayed" business of "silk and woollen carpets in the north part of Persia towards Tauris."[83] The first two were direct observations; the third, hearsay. The fact that Schillinger and Bell noted Tabriz's silk production makes it likely that the rugs they mentioned were woollen.

Since Tabriz rug making at this time apparently encompassed surrounding towns and villages, it may be that a cottage industry was present, as it was a century later (the "domestic looms" of 1830). Thompson's suggestion that the dragon and floral carpets were the products of a cottage industry fits the Tabriz setting excellently. The dragon and floral carpets lack the precise correspondences in design characteristic of workshop manufacture, and show a certain amount of variation in composition, colour, foundation material and construction. These differences are consistent with the output of a cottage industry dispersed over a substantial, heavily populated, geographic area. Tabriz and its large hinterland provide a believable setting for items such as the dragon and floral carpets.

Why would Persians and Europeans not have given more prominence to the carpets of a centre the magnitude of Tabriz? An explanation may perhaps lie in the nature of these carpets. Given then current standards of quality, if the rugs observed by Schillinger and Bell, and alluded to by Pococke, were of the somewhat rough-hewn dragon and floral types, their lack of attention would be understandable.

Two carpets, which Yetkin considers to be 'transitional' between dragon and floral, bear dates close to the period of documented rug weaving in Tabriz and/or its environs. One has the Islamic date 1156 (1743-44), and an illegible inscription in Arabic script.[84] The other is well-known, with an Armenian inscription indicating it was woven by a woman named Gohar, and the Armenian calendar date 1129 (1679-80), or, more likely, 1149 (1699-1700).[85] Ellis believes that this carpet was made in Karabagh in the second half of the 19th century, but offers no cogent reasons for his opinion.[86] Sakisian discussed and illustrated a carpet, then in the Kaiser Friedrich Museum, Berlin, which was 'very similar' to the one made by Gohar and bore what he called a "pseudo-Armenian" inscription.[87]

That carpets from Armenian hands could have come from Tabriz or its vicinity is plausible. An Armenian quarter existed in the city in the late 15th century.[88] The anonymous Italian merchant of the early 1500s noted the presence of Armenian villages north of the city. At the beginning of the following century Shah Abbas relocated Armenians from Tabriz to Esfahan, while others were removed from various locations in both Persian Azarbayjan and Transcaucasia.[89] An English traveller passing through Julfa, north of Tabriz on the Aras River in 1603, the year before the removal of its Armenian population, termed the inhabitants silk merchants and described the non-Turkic settled indigenous people (that is, Armenians) of the area as makers of "fine Chamlets and Carpets."[90] Although seriously depopulated, the Armenian community of Persian Azarbayjan revived during the eighty years following the Peace of 1639.[91] That Armenians would have been in the Tabriz area in about 1700 is to be expected.

16. *Facing page:* **Kasim Ushag design silk embroidery (detail), Azerbaijan, 17th century. 0.65 x 1.16m (2'2" x 3'10"). Orient Stars Collection, courtesy H. Kirchheim, Stuttgart.**

17. *Below:* **Palmette design silk embroidery, Azerbaijan, 18th century. 0.69 x 1.17m (2'3" x 3'10"). The Textile Museum, Washington DC, inv.no. 2.6.**

FRANKO KHOURY

18. U-shaped leaf and palmette design rug, Transcaucasia, 19th century. 1.24 x 2.58m (4'1" x 8'6"). Courtesy Rippon Boswell, Wiesbaden.

19. 'Sunburst' medallion design rug, central Transcaucasia, 19th century. 1.42 x 2.03m (4'8" x 6'8").

There is an additional consideration which makes Tabriz a plausible place of origin for the dragon and floral carpets. Located in a centre of population and wealth which was the hub of major trade routes, entrepreneurs in Tabriz would have been aware of Persia's various carpet styles. A 16th century 'vase-technique' carpet from the Kerman area is thought by some to be the source of the design of the dragon carpets.[92] Sundry floral designs present in classical Persian carpets – for example, the Harshang, the Afshan (**7, 8**) and the sickle-leaf (**9**) – form the basis of various floral carpet types.[93]

The dragon motif itself, having entered Persian art during the Mongol period, suggests a Tabriz origin. From the Mongol through the early Safavid period, Tabriz was a dynastic capital and a major centre of the arts, especially painting, in which the dragon motif figured. The presence of this motif in carpets made in Tabriz is easy to accept, although it is also true that the dragon motif found currency in other parts of Persia and the Near East.

If the dragon and floral carpets were made in Tabriz and its environs, there should be survivors in the area. That there apparently are none can be explained by manufacture for export. In striking contrast to Transcaucasia, however, clear traces of the dragon and floral carpet tradition are present in the 19th and 20th century products originating in the area usually associated with the name Heriz, a town some forty miles to the east of Tabriz.

Weavers in the Heriz area use the symmetrical knot. Warps in their carpets are on two levels, partially or fully depressed. Two weft shoots after each row of knots are normal. While cotton is the usual warp and weft material, what appear to be the oldest Heriz carpets often have a wool foundation.[94] No cabled wefts are found as single shoots, but in some Heriz area carpets a heavy weft alternates with a thinner one. Wool, the usual material of the warps and wefts in the earlier carpets, was replaced partially or entirely by cotton in what appear to be the latest surviving examples of the dragon carpets.[95] Overall, a comparison of the later Heriz carpets (**22-25**) with the dragon and floral carpets shows marked physical correspondence: a similar weave, a coarse, sturdy, heavy-bodied construction and large sizes.

The shared features also include drawing style. As A. Cecil Edwards has pointed out, Heriz weavers have a propensity "to break up curves into straight lines",[96] as did the weavers of the dragon and floral carpets. Cartoons or verbal commands are not utilised by Heriz area weavers. This, too, seems to have been true for the weavers of the earlier carpets. Heriz area rugs have large scale motifs, particularly palmettes which mirror those in the earlier rugs, albeit in a different composition. Such design sharing is also seen in rugs of the Heriz area known as 'Bakhshaish', which also contain large palmettes (**26**). A limited array of colours, clearer and more brilliant in the older carpets but still similar, is found in both.

By the middle of the 19th century a fundamental change in the character of Persian rugs was coming about due to growing Western demand: "...at least as early as 1274/1856 Persian carpet manufacturers had begun to alter the traditional dimensions and designs of their carpets for that market."[97] Instead of long, narrow rugs, dimensions suitable to European and American settings were produced. This change in format seemingly went hand in hand with the adoption of the elegant floral medallion and corner-piece composition fashionable in the West (**27**). Rugs from the Tabriz area were a part of this transformation. Indeed, local entrepreneurs organised an export industry in the city and its surroundings which followed previously existing cottage industry arrangements[98] and entailed urban workshops as well.

Although they both employ the symmetrical knot, partially or fully depressed warps, and two weft shoots, the 19th century woollen carpets known as 'Tabriz' and those known as 'Heriz' differ significantly from each other. Typical 19th century Tabriz carpets are finely woven, thin, lightweight and very precisely executed products in derivative curvilinear designs. How does one account for this substantial divergence in carpet types, particularly if one postulates that Tabriz and its hinterland had previously produced the dragon and floral carpets?

The explanation may lie in the area's silk industry. Pococke's allusion to silk rugs made "towards Tauris" opens up the possibility that the later wool rugs could have been influenced by the local manufacture of silk rugs. Many silk rugs known as 'Tabriz' and 'Heriz' have survived. A number have design features suggestive of cottage industry production; others have the exact correspondences in design associated with workshop products. Both groups

20. *Left:* Karabagh Kasim Ushag design carpet, southwestern Transcaucasia, dated 1909 and with an Armenian inscription. 1.88 x 2.90m (6'2" x 9'6"). Courtesy St John's Armenian Church, Southfield, Detroit, Michigan, gift of Lemyel Amirian.

21. *Facing page:* Shusha city carpet (detail), central Transcaucasia, 19th century. 1.63 x 3.05m (5'4" x 10'0"). Courtesy Rippon Boswell, Wiesbaden.

R.H. HENSLEIGH

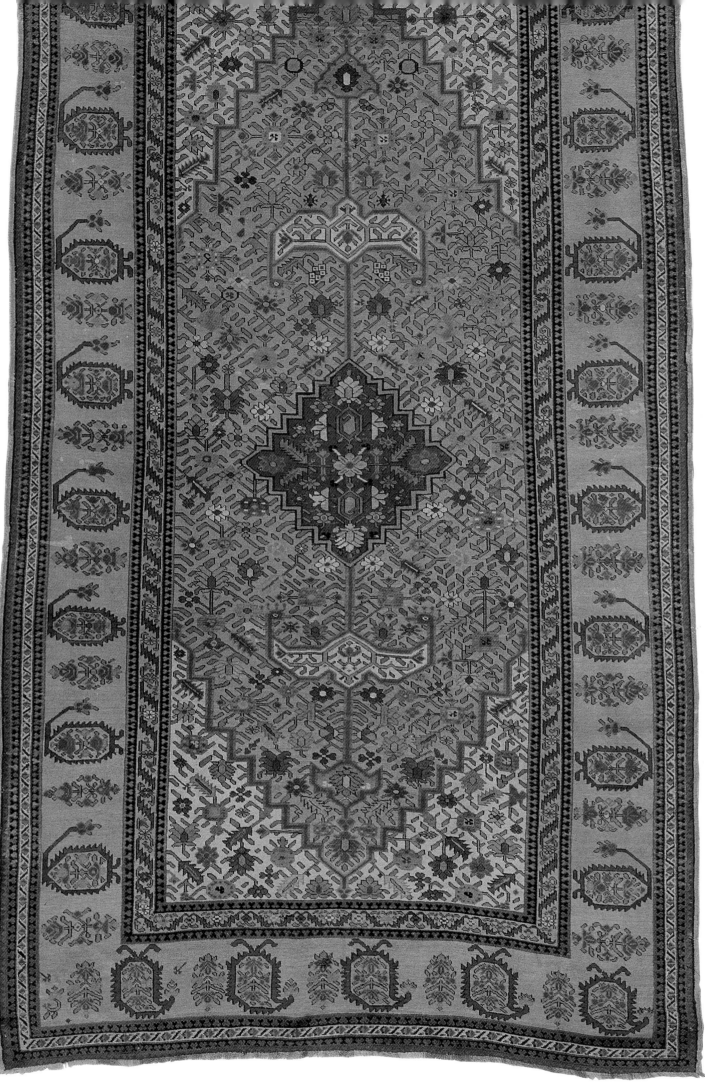

22. Heriz palmette design carpet, northwest Persia, second half 19th century. 2.80 x 3.45m (9'2" x 11'4"). Courtesy Moshe Tabibnia, Milan.

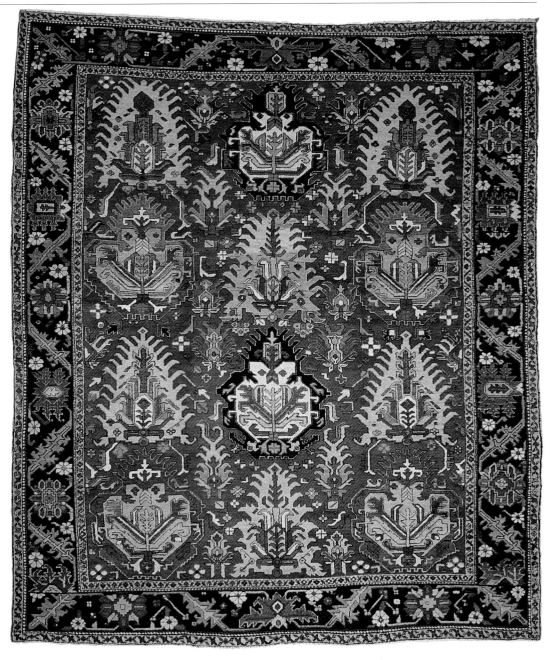

23. Heriz medallion carpet, northwest Persia, second half 19th century. 2.95 x 3.86m (9'8" x 12'8"). Courtesy Sotheby's, New York.

are woven with the symmetrical knot, which places them in Persian Azarbayjan rather than elsewhere in Iran. They have two or sometimes one weft after each row of knots and show varying degrees of warp displacement. A high knot count and supple handle are typical.

Most silk rugs with these characteristics are attributed to the late 19th century, or to its second half. One large silk carpet, however, bears the date "15th of the month of Rajab in the year 1211" (1796-97), the name of the producer, and an inscription in Persian.[99] Another, much smaller, silk rug bears the date 1220 (1805-06) and sundry inscriptions.[100] If the dates are true, they indicate that the Tabriz/Heriz silk rug type stems from at least the end of the 18th century, if not before.

The large silk carpet dated 1211 has a relatively small central medallion and pendants on a densely patterned field framed by corner-pieces. Its border consists of large rosettes placed at regular intervals in a meander of small rosettes and floral sprays. The drawing of the border, guard stripes, and some of the large floral forms in the medallion is curvilinear, whereas the outline of the medallion and the principal filler forms of the field are more rectilinear. In format, composition, drawing and colour this silk carpet is very different from the dragon and floral carpets, but not unlike 19th century Tabriz wool carpets. It also shows the possible beginning of the typical Heriz medallion, pendant and corner-piece composition.

In contrast, the smaller silk rug dated 1220 is pictorial in design and entirely curvilinear in drawing. These carpets may represent types of Tabriz area silk carpets made for consumption in Persia, or for export to Turkey and elsewhere, in the 18th and early 19th centuries.

In the light of these cited examples and their inwoven dates it is possible that with the opening of a large new market in Europe and America, some weavers of woollen carpets – most of those called 'Tabriz' today – emulated local production of silk rugs in fineness of

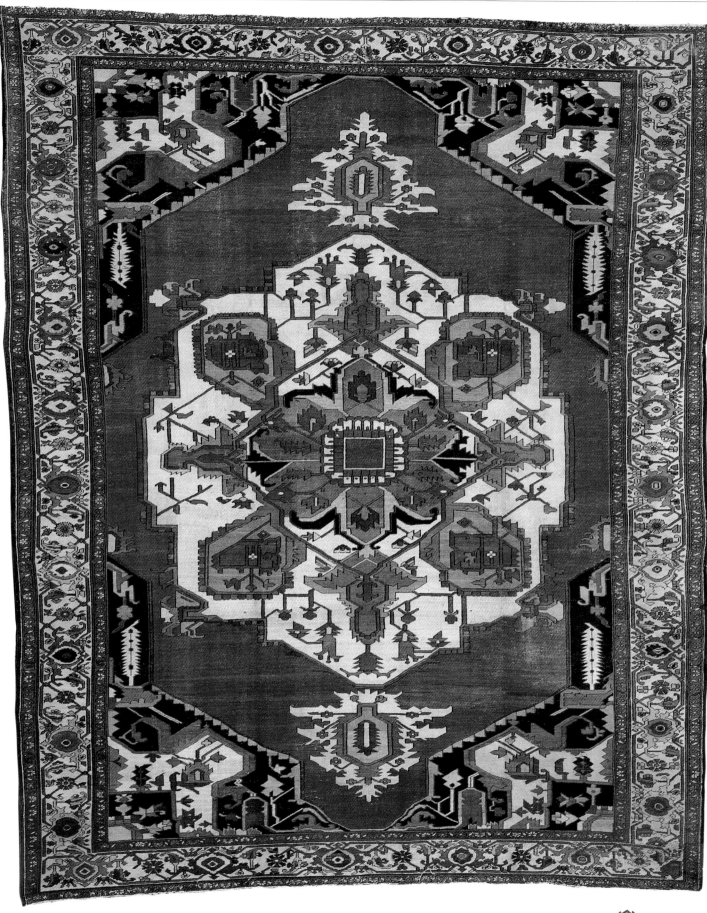

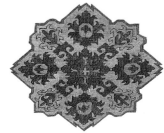

24. *Above:* **Heriz medallion carpet, northwest Persia, second half 19th century. 2.92 x 3.79m (9'7" x 12'5"). Courtesy Sotheby's, New York.**

Right: **Floral medallion from an early 'cypress' design carpet (11).**

weave, curvilinear designs and controlled drawing. It is also possible that others maintained the old practice entailing a heavy-bodied, coarsely woven fabric with angular drawing, to produce the 'Heriz' carpets. By the middle of the 19th century, both types would have adopted new formats and designs and, as woollen rugs, would have flourished in the export market. Admittedly this picture is speculative, but its chronology and assumptions square with the Tabriz setting and the evolution of the Persian carpet industry. The essential point is that greater Tabriz was large enough to contain multiple carpet types.

In brief, the idea of the Tabriz area as a possible home for the dragon and floral carpets is supported both by the presence of possible successors and by the historical record. Carpets were being made there at the right time. The city's large hinterland affords a plausible setting and ample scope for design variations. The late 19th century cottage industry production of large Heriz carpets indicates that the area could have been home to a similar activity at an earlier date. Glimpses of weaving activity in the early 19th and, indeed, in the early 16th century, suggest that the Tabriz area has long produced textiles via a cottage industry.

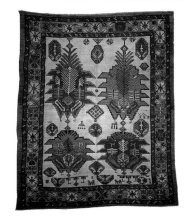

26. *Above:* **Bakhshaish palmette design carpet, Heriz area, northwest Persia, second half 19th century, 2.35 x 3.00m (7'9" x 9'10"). Courtesy Eskenazi, Milan.**

THE TABRIZ HYPOTHESIS

Four types of evidence are required to assess the origin of the dragon and floral carpets: the carpets themselves, where they survived, their likely successors, and the historical record.

Thanks to Ellis's work, there is a good understanding of their physical make-up. A clear picture of designs and colours comes from his publications, from those of Yetkin, and others. The carpets lack the hallmarks of a supervised workshop production and, as suggested by Thompson, appear to be cottage industry products.

Their comparison with late 19th and early 20th century Transcaucasian village rugs fails when viewed in terms of structure, handle and size. The limited design overlap between them could derive from a common repertoire, from carpets obtained from outside the area, or from the small silk embroideries which contain the motifs appearing in the village rugs.

Significant correspondences in structure, handle and dimensions do, however, link the dragon and floral carpets with 19th and 20th century cottage industry carpets of the Heriz region, as does the distinctive angular drawing of designs and, to an extent, their limited palette. There is, then, a possible successor type in the Tabriz area, whereas none is evident in Transcaucasia or eastern Anatolia. Moreover, the Tabriz setting and its weaving history are utterly different from the unpromising one in Karabagh.

27. *Below:* **Bakhshaish medallion design carpet, Heriz area, northwest Persia, late 19th or early 20th century. 3.28 x 5.33m (10'9" x 17'6"). Courtesy Sotheby's, New York.**

Numerous dragon and related floral carpets survived in Anatolian cities situated, in large part, along the important 17th century caravan route from Tabriz to Bursa. Travel accounts indicate that Persian carpets enjoyed considerable popularity in Turkey in the 17th and 18th centuries. Taken together, these facts suggest that the dragon and floral carpets may have arrived in Anatolia from Persia through trade.

The historical record does not reveal any carpet manufacturing in either eastern Anatolia or Transcaucasia, but clearly places the activity in Tabriz and its surrounding area in the first quarter of the 18th century, a period close to that of two dated floral carpets. The record also reveals a cottage industry in greater Tabriz in both the early and the late 19th century. This circumstance dovetails with the carpets themselves: they have affinities with Persian high-style designs, yet have the hallmarks of a cottage industry dispersed over a large area.

Until unequivocal evidence appears, it is reasonable to hypothesise that the dragon and related floral carpets were woven in Tabriz and its environs, under cottage industry arrangements controlled by local entrepreneurs, for export principally to the Ottoman Empire. That the dragon and floral carpets should come from a centre of wealth, population and trade which was open to the artistic currents of other regions of Persia indeed seems logical, for what the Tabrizis possessed, above all, was the ability to manufacture and market a popular product.

Notes see Appendix

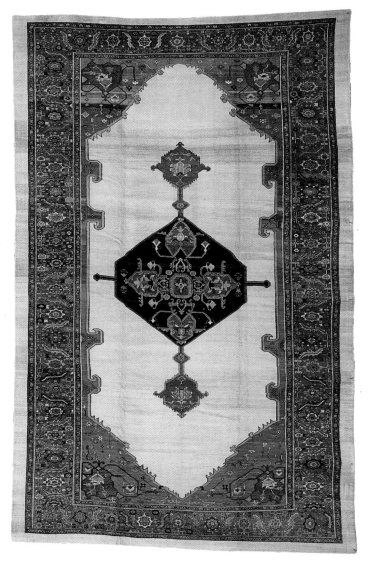

25. *Facing page:* **Heriz palmette design carpet, northwest Persia, late 19th century. 2.72 x 4.37m (8'11" x 14'4"). Courtesy Sotheby's, New York.**

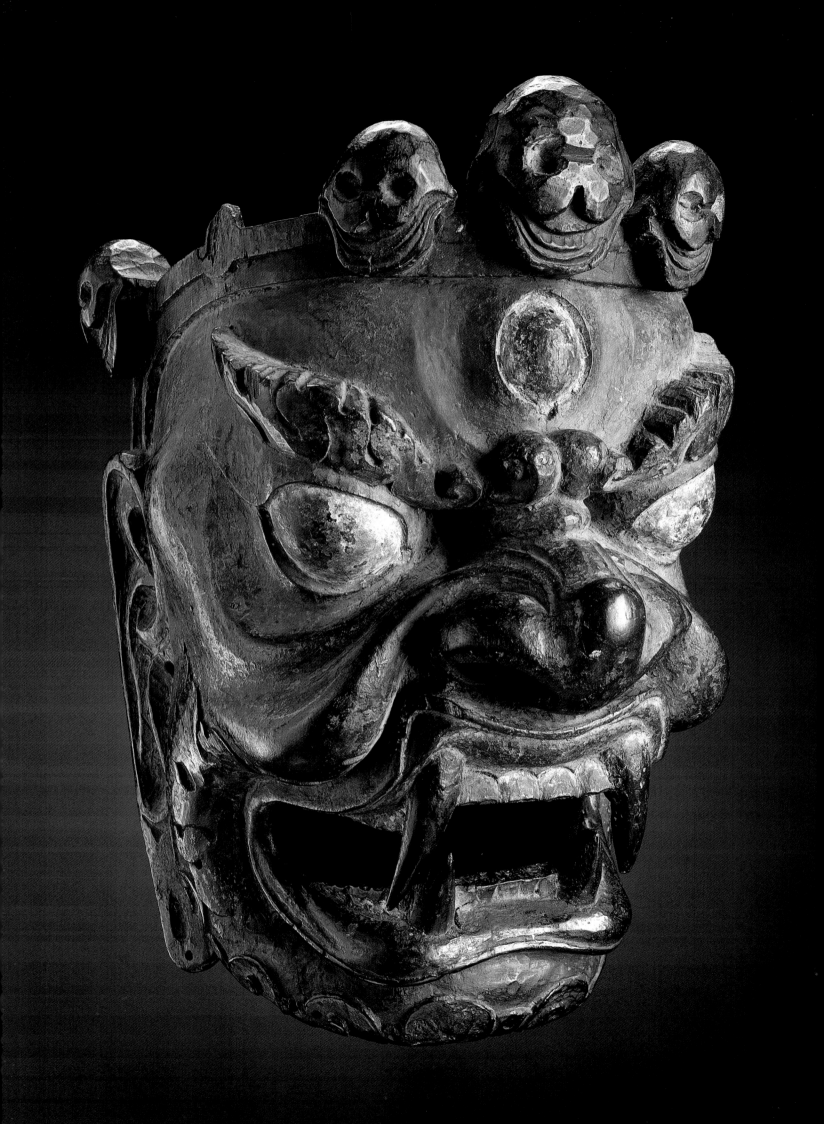

DEMONS & DEITIES
Masks of the Himalayas

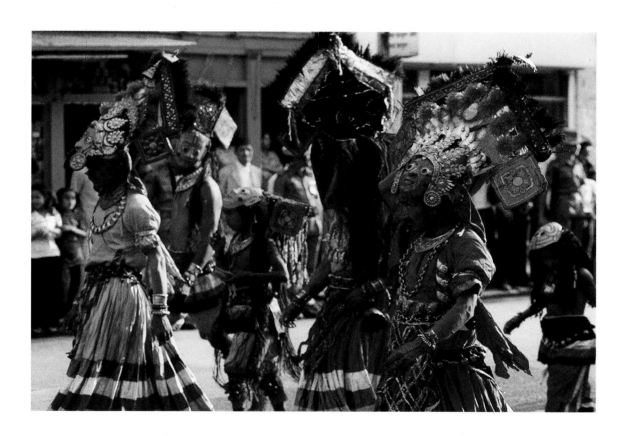

Thomas Murray
Photography by Don Tuttle

The powerful imagery of the Himalayan mask tradition
is drawn from the diverse traditions of shamanism,
village myths and the classical traditions of Buddhism
and Hinduism. In this essay the author probes the 'greater
context' of Himalayan masks, finding in them stylistic
and thematic affinities with cultures as widespread as
those of Eurasia and the Americas, and covering a period
extending from the upper Paleolithic era to the present.

55

Surviving in isolated valleys, and hemmed in by the world's tallest mountains, the peoples of the Himalayas maintain a subsistence economy of pastoralism and horticulture. They identify with the syncretic belief systems known to us as animism, Hinduism and Buddhism, and share a common love of the *masquerade*.[1] The broad dispersal throughout the Himalayan region and beyond of a masking tradition suggests that it has ancient roots.

For the purposes of this article, Himalayan masks will be divided into three main categories. Masks which depict deities, heroes, and comic characters from the 'high culture' of Buddhism and Hinduism have been described as 'classical',[2] and include monastery and temple masks which are worn by Buddhists and Hindus in dance ceremonies. Many Newari masks (**4**) from the Kathmandu Valley in Nepal portray Hindu gods and goddesses or subjects from epic dramas such as the *Ramayana* and the *Mahabharata*.[3] Classical Buddhist masks often depict figures from the great Buddhist pantheon, including ferocious defenders of the faith such as Mahakala (**3**). Some of the Buddhist masks introduced here were used in the mysterious dance known in Tibet as *Cham*, in which protector deities are invoked and negative forces are dispersed.

'Village' masks often incorporate elements from the classical Hindu and Buddhist traditions, but their primary defining characteristics derive from local village myths. Lakhe masks (**5**), popular among the Hindus of the Kathmandu Valley, may be considered to belong

1. *Previous pages left:* Dharmapala (defender of the Buddhist faith), Tibet, 14th–17th century. Wood and pigment, height 38cm (15"). Widely regarded as the greatest classical Himalayan mask to come to light. Private collection.

2. *Previous pages right:* Masked ritual in Nepal with masks depicting Hindu deities, 1973. The children are wearing skull masks. Courtesy James Singer, London.

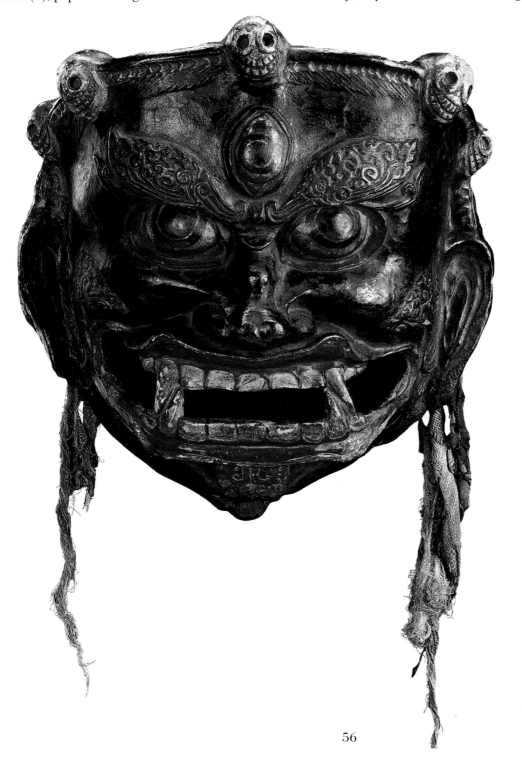

3. *Left:* Mahakala, the great Kala (the god associated with time), Tibet, ca.18th century. Wood with traces of pigment, height 28cm (11"). Mort Golub Collection.

4. *Right:* Indra, Nepal, Newari tribe, 17th century. Wood with traces of pigment, height 28cm (11"). This type of classical representation of the thunder god in wood is extremely rare. Mort Golub Collection.

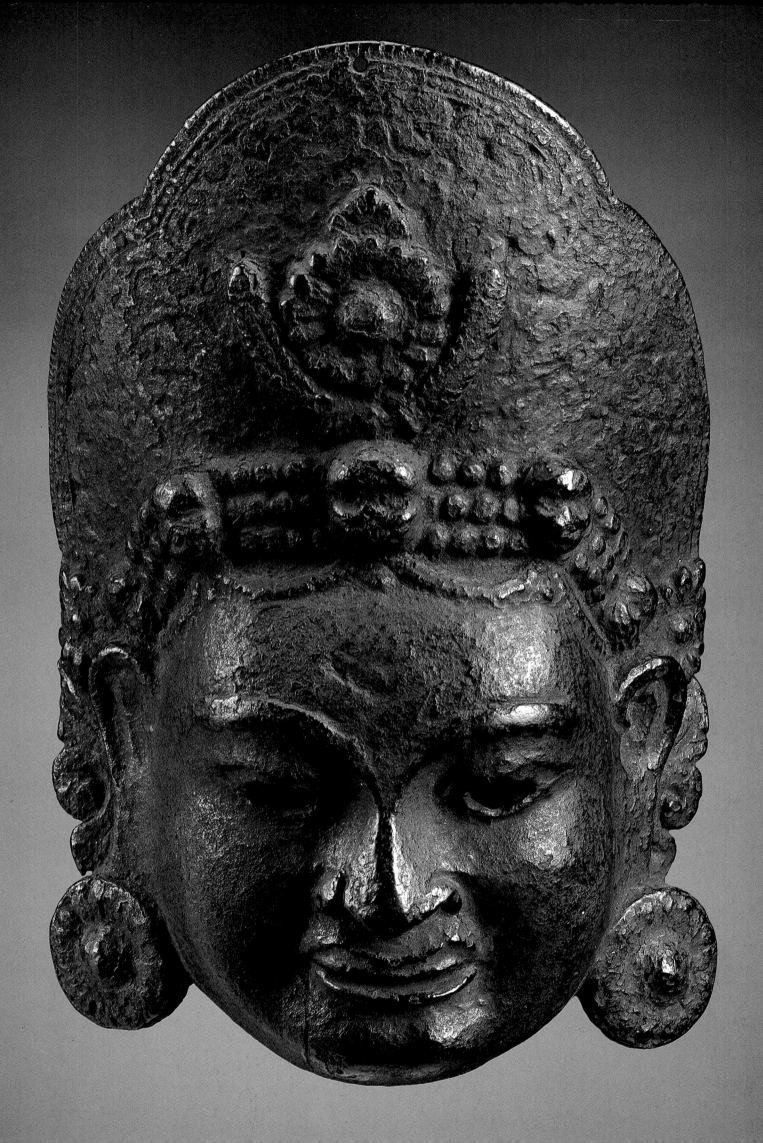

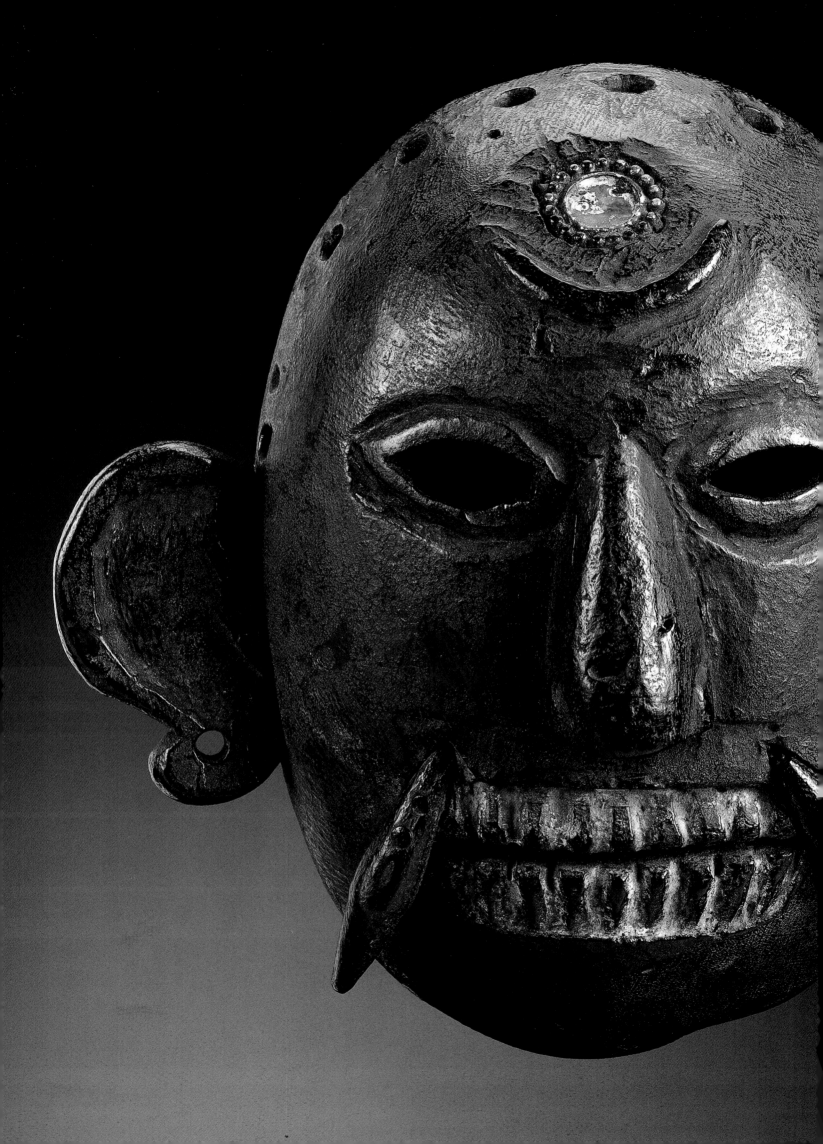

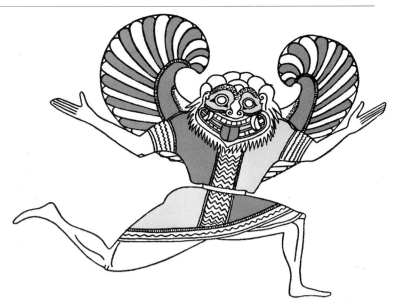

6. *Above:* Gorgon figure taken from an early Corinthian vase, ca. 5th century **BC**. Note the characteristic encircled eyes, large teeth and long fangs all to be found in the Lakhe masks of Nepal. Drawing after Napier, *Masks, Transformation and Paradox*, 1986, pl.46.

5. *Left:* Lakhe mask, Kathmandu Valley, Nepal, ca.1900. Wood, mirror, nails, pigment, attached ears and teeth, height 24cm (9¹/₂"). A strong and rare treatment of Lakhe, a demon who threatens the community during the Indra Jatra festival, and is slain by Shiva, the village protector. This mask bears great resemblance to fanged masks of Borneo, whose stylistic antecedents reach back 2,000 years to the Dong Son bronze age. Mort Golub Collection.

7. *Below:* Gorgon-like face on a more typical Lakhe mask than (5), Nepal, ca. 1900. Wood, foil and pigment, height 31cm (12"). Private collection.

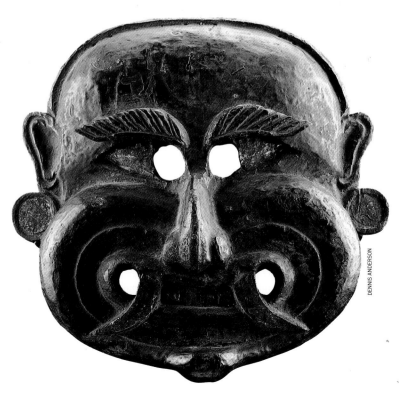

59

to this category. Lakhe is a local demon most commonly depicted with characteristically Gorgon-like features (7) reminiscent of the Gorgon face familiar in Mediterranean sculpture and painting traditions (6). Lakhe's appearance, however, is undeniably linked with Indra Jatra, the annual festival associated with the classical Hindu god, Indra. Readers will note that Indra (4) and Lakhe bear similar markings on their foreheads. Village Buddhist masks, largely created by the rural ethnic Monpa and Sherdukpen peoples of Arunachal Pradesh in northeast India and eastern Bhutan, were often used in morality dramas, such as the *Ache Lhamo*, which will be described in greater detail below.

Primarily from the tribal areas of Nepal, another style of mask, the 'Primitive-shamanic', may have been used by sorcerers for purposes of healing, oracle augury and life crisis initiations (8). Our ignorance is great with respect to these tribal masks. One reason for this lack of knowledge is the very remoteness of their geographic origin. While this has favoured their survival, it has also inhibited our knowledge of the people who created them and the cultural traditions requiring their use. I would suggest that these masks are the expression of an ancient pan-Asian mask culture which was still in evidence at the beginning of the 20th century not only in the Himalayas, but also among Indonesian islanders such as the Batak of Sumatra (9) and the Atoni of Timor, as well as among the tribal people of India, the shamans of Siberia (14) and others.

The making and use of masks, born of shamanism, extended into Himalayan village folk traditions and eventually became absorbed into the higher classical traditions, invigorating them and giving them new meaning. In Asia, masks were probably first used in a shamanic context, and for this reason, my discussion of Himalayan masks begins with the primitive-shamanic.

PRIMITIVE-SHAMANIC MASKS

At best, specific ethnic attributions of primitive-shamanic masks are speculative. The reasons for this uncertainty include similarity of function and iconography and the aforementioned isolation of these peoples from Western observers. However, it is clear that most Himalayan shamanic style masks were created in Nepal. The Magar and Gurung tribes, living at an altitude of 7,000 feet in the middle hills of the Himalayas, have produced hardwood masks which tend toward a glossy, high patina arising from exposure to smoke and butter fat (10). Less well known ethnic groups of the middle hills include the Sherpa, Bhotya, Tamang and Rai, some of whose masks will be mentioned below.

Masks of the lowland Tharu people, living near the Indian border, are often of a softer wood, pigmented with polychrome or white kaolin clay. Hardwood examples also exist.

10. *Facing page:* **Gurung or Magar mask, Middle Hills, Nepal, 17th/18th century (?). Wood, grass, nails, height 26cm (10½").** This character is sometimes thought to be a joker, however we cannot be certain that these masks did not have different identities and ritual functions at the time of their creation, changing with the popular culture over time. **Mort Golub Collection.**

8. *Below left:* **Primitive-shamanic mask, Middle Hills, Nepal, 17th/18th century (?). Wood, lichen, height 24cm (9½").** Note the high cheek bones and strongly North Asiatic eye slits. **Mort Golub Collection.**

9. *Below:* **Karo Batak mask, Sumatra, 19th century. Wood, feathers, pigment, height 32cm (12½").** Used by the Batak in funerary rites, then typically destroyed, few survive today. These rare masks display great affinities to the tribal masks of Nepal. **Private collection.**

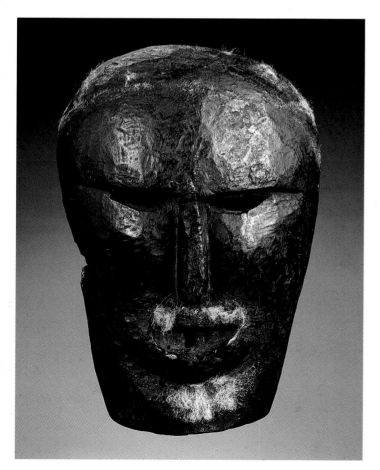

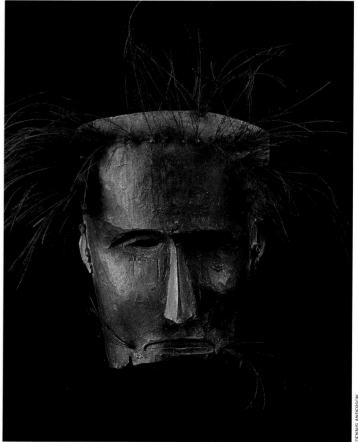

DENNIS ANDERSON

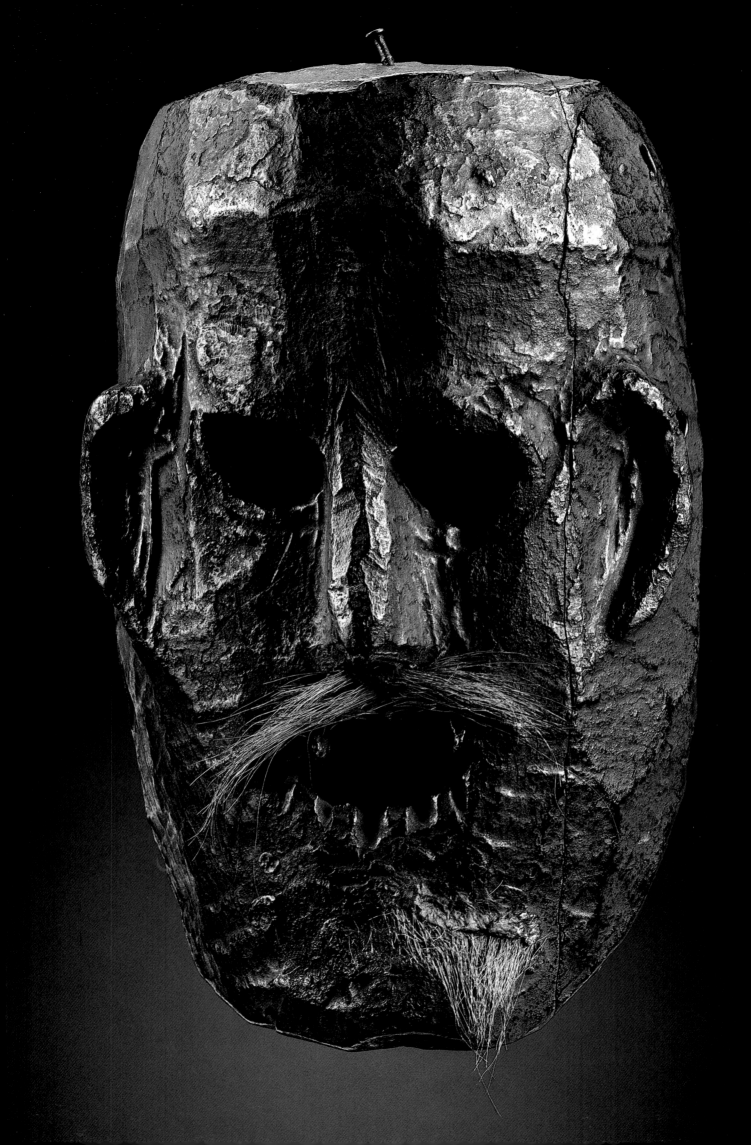

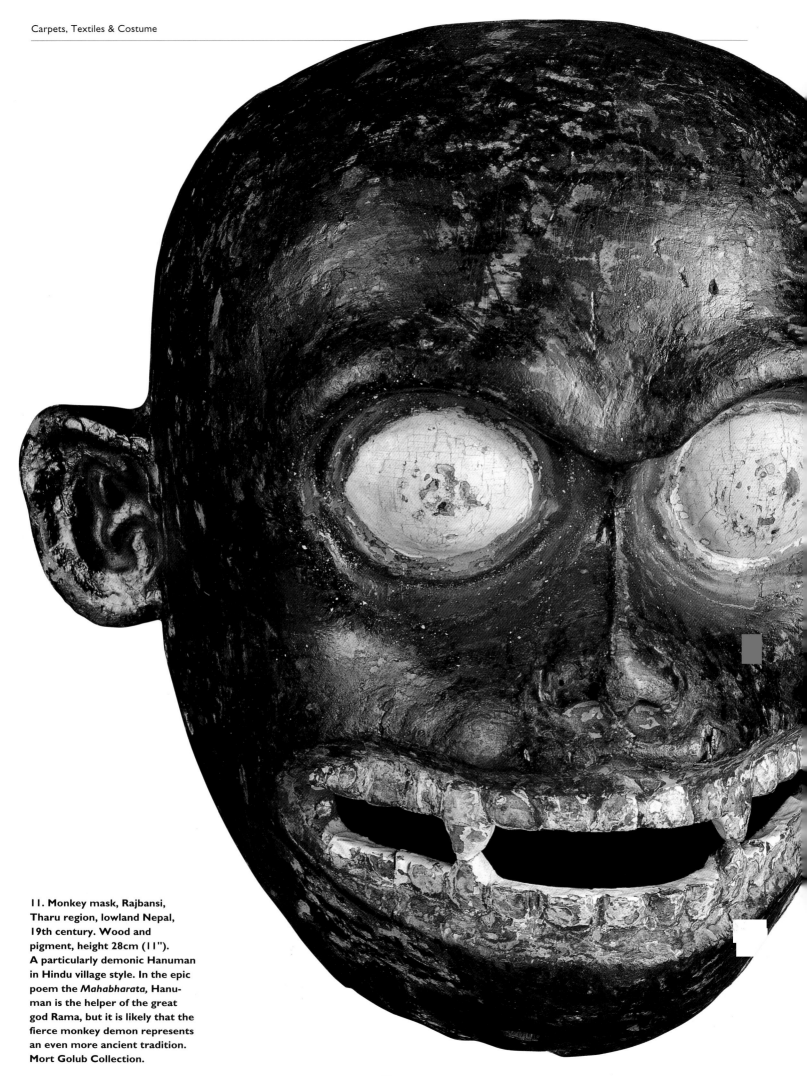

11. Monkey mask, Rajbansi,
Tharu region, lowland Nepal,
19th century. Wood and
pigment, height 28cm (11").
A particularly demonic Hanuman
in Hindu village style. In the epic
poem the *Mahabharata,* Hanu-
man is the helper of the great
god Rama, but it is likely that the
fierce monkey demon represents
an even more ancient tradition.
Mort Golub Collection.

Some masks from the Tharu tribe are among the most primitive examples to have come to light, while those of the Rajbansi (village dwellers in the Tharu) display iconography more directly derived from Hindu models (**11**). The latter are examples of what I have termed village masks, to be discussed in greater detail below. An interesting illustration of the distinctions between primitive and village Tharu masks can be seen in plates **11** and **22**.

On first examination, these masks appear to defy categorisation. Each mask seems to be unique. But after viewing many, we begin to see that they fall into iconographic groups. Masks with fur attachments, creating a bearded, mustachioed character (or characters), whose identity remains undocumented (**9, 10**) are often encountered. Other masks, probably from the Middle Hills, do not now possess bearded attachments, but perhaps once did, and may therefore also belong to this group.

Another character, with a lumpy head and brutish facial features, also appears often; we have dubbed this type 'Potato Head' (**12**). Markings on the forehead sometimes offer a means of classifying masks. One example (**13**) bears a prominent trident mark – an attribute of the Hindu god Shiva – and many masks with this mark have survived. However, in this context the trident does not necessarily imply a knowledge of Shaivite religious dogma, but may simply be an instance of a symbol borrowed in isolation from its original meaning.

Other masks display a solar disc above a crescent moon, but again the meaning of such a motif remains as yet unclear. The mask illustrated in plate **16** has a ring in his nose which is a common feature of the Tamang tribe, though we cannot be certain that this particular type arises from the Tamang ethnic group.

The Rai are known to fashion house-protecting masks from tree fungus (**17**), while another multi-ethnic character mask is created from felt and goat skin.[4] The red pigment around the mouth of plate **18** may well symbolise blood sacrifice, either animal or perhaps (in former times) human.

We may infer great age for these masks. Their black, shiny patina and their surfaces of multi-layered pigment all suggest an unspecified but undeniable antiquity. That they have survived for so long suggests they were greatly valued by the Himalayan societies that created and used them. Passed on as heirlooms from generation to generation, each use added sacred power. It is also clear that old masks were repaired rather than discarded (**16**).

There can be little doubt that many of these masks are hundreds of years old. Precisely how they were used we cannot say, but we may infer much by examining, albeit briefly, the principles of shamanism.

THE ROOTS OF PRIMITIVE-SHAMANIC MASKS

Shamanism is the term commonly used to describe the indigenous belief systems of the ancient cave painters of Europe, the autochthonous Asian minorities, and the North and South American Indians. More of an animist world view than a religion, it is thought to have been brought to the New World from Siberia by reindeer hunters following their prey at the time of the last Ice Age, circa 15,000 BC.

The etymology of the word shaman is interesting. Long believed to be derived from the Siberian Tungus word *saman* (itself thought to be native Altaic), it has recently been suggested that its etymology goes deeper still. It seems that the Siberians borrowed the term from the Chinese *shamen*, meaning 'wandering Buddhist monk', to give title to their own ancient religious practices. This linguistic relationship reflects the respect felt by the Siberians for the awe-inspiring Buddhist practices which they observed. As discussed in greater detail below, Buddhism also assimilated elements of shamanic practices.

Certain themes present themselves wherever shamanism is found. For example, the shaman is not the greatest warrior of the tribe, an office more likely to be held by its chief. Rather, the shaman often begins his or her life as a sickly individual – either physically or mentally impaired. There comes a time when he or she must depart

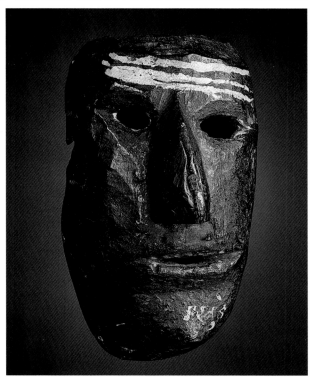

12. 'Potato Head' mask, Middle Hills, Nepal, 17th/18th century (?). Hardwood, pigment, nails, height 28cm (11"). The three stripes on the forehead may relate to Vaisnavite practices. Mort Golub Collection.

13. Mask with trident marking on the forehead, Middle Hills, Nepal, 17th/18th century (?). Wood, height 21cm (8½"). Possibly associated with the classical Hindu god, Shiva. Mort Golub Collection.

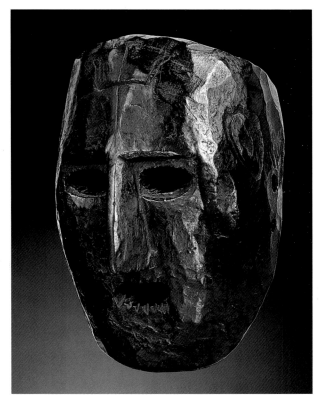

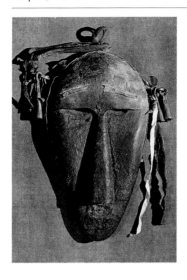

14. *Left:* **Maskoid talisman depicting Old Man Borto, from a shaman's costume, Buriat tribe, Siberia, 19th/early 20th century. Wood, metal, skin, trade cloth. Ethnographic Museum, Leningrad.**

15. *Right:* **Ordos/Western Han amulet, ca. 3rd century BC, with steppe tiger motif. Bronze, length 10cm (4"). Vicki Shiba Collection, Mill Valley.**

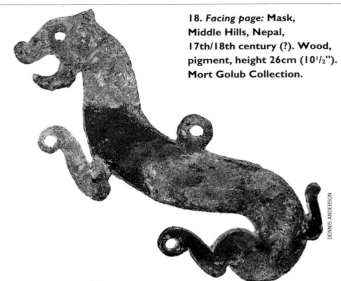

18. *Facing page:* **Mask, Middle Hills, Nepal, 17th/18th century (?). Wood, pigment, height 26cm (10½"). Mort Golub Collection.**

DENNIS ANDERSON

the community and live alone,[5] and it is during this isolation that the shaman calls upon nature spirits, such as animal totems, to be vehicles of self-healing. If unsuccessful, he or she is not heard from again. However, assuming a positive outcome, the individual returns to the community empowered by these spirits in strange and mysterious ways. As a result of this 'conversion experience', such an individual may live within the village, but is always perceived as socially distinct from others in the community.

And what role does a shaman play in his or her community? Ancestor spirits hover nearby, monitoring adherence to local traditions and taboos. They require careful propitiation. Moreover, all of man's ills ultimately derive from the spirit world. Malevolent spirits must be subdued. All of nature is alive with the supernatural. The shaman, through his or her magical interventions, operates on this other plane. Existentially, the individual who is 'the other' within the earthly community more truly inhabits the world of the spirits.

Fertility and 'life crisis' transitions are the basis of many animist concerns and rituals. These include birth, puberty, marriage, attaining a social rank (status) and death. At these moments of transition, an individual is in grave danger as he 'dies' in terms of his former self and has not yet been reborn into his new identity. At these moments of vulnerability,

16. *Below left:* **Mask, Middle Hills, Nepal, 17th/18th century (?). Wood, metal ring, wire, height 23cm (9"). Note the repairs to the jaw, indicating that masks were conserved rather than discarded. The nose ring suggests a possible Tamang origin. Mort Golub Collection.**

17. *Below:* **Mask, Rai tribe, Middle Hills, Nepal, 19th century or earlier. Tree fungus, height 33cm (13"). Associated with protection of the home. Mort Golub Collection.**

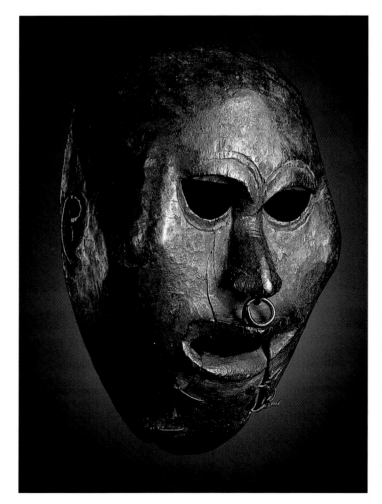

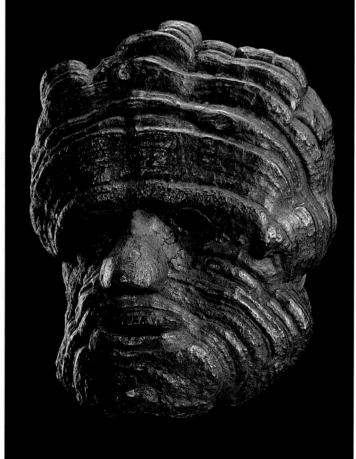

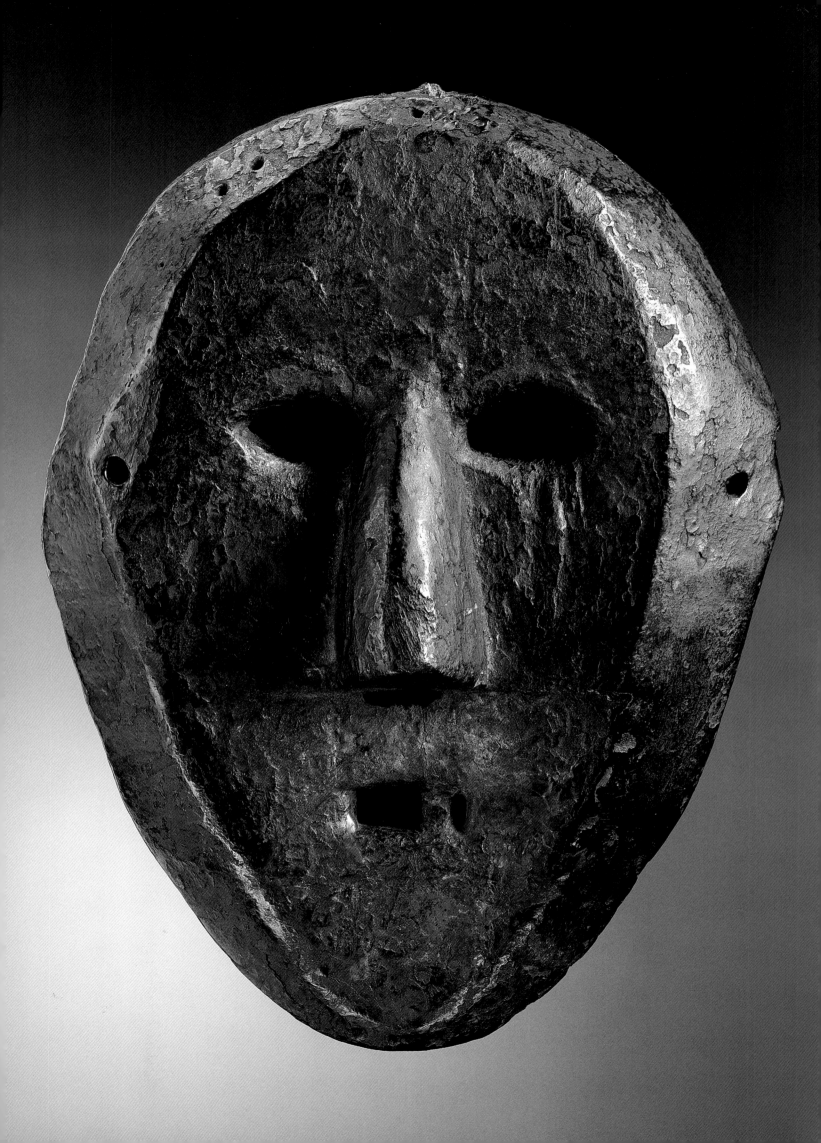

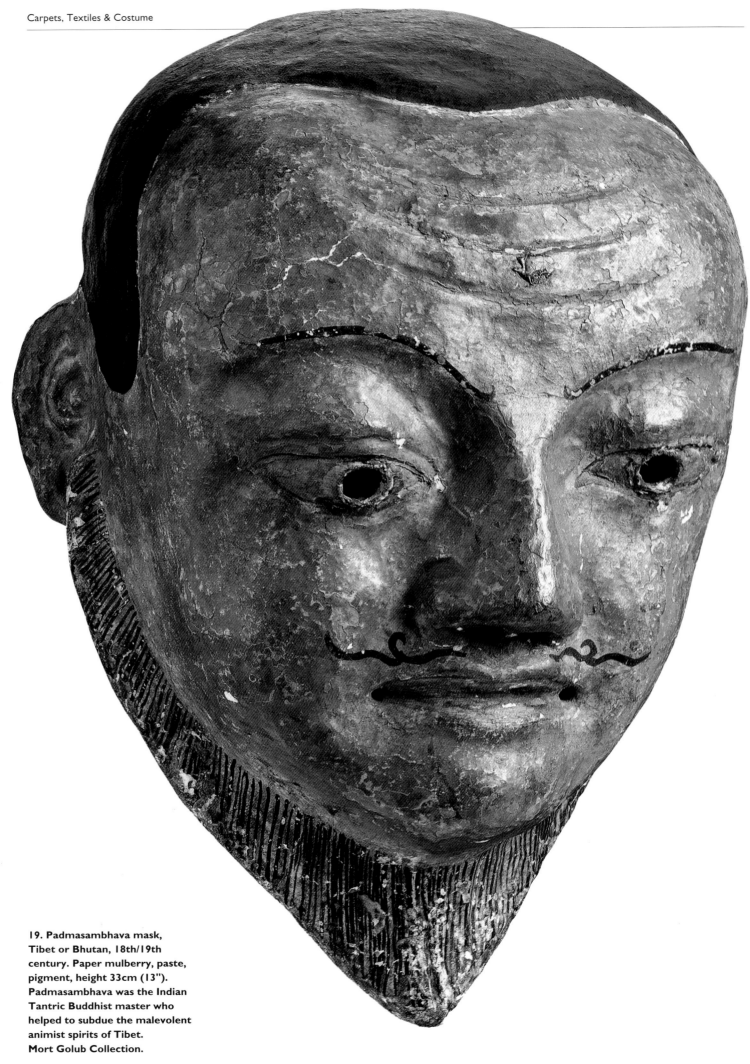

19. Padmasambhava mask,
Tibet or Bhutan, 18th/19th
century. Paper mulberry, paste,
pigment, height 33cm (13").
Padmasambhava was the Indian
Tantric Buddhist master who
helped to subdue the malevolent
animist spirits of Tibet.
Mort Golub Collection.

it is the shaman who ushers the initiate's soul across the uncertain gulf. Therefore, the shaman serves as a bridge between this world and the next, acting as a 'soul guide' to ease these life passages.

In order to operate on this higher plane, the shaman must fully identify with the powers which he hopes to wield. Masks are one of the empowering mediums by which the shaman 'becomes' the spirit which he invites to possess him. Such possession is described as an ecstatic experience. Other tools which help bring about this transformation include ritual costume (**20**), weapons, drums, and perhaps psychotropic substances, including fly-agaric mushroom *(amanita muscaria)* and hemp *(cannabis)*.[6]

The shaman functioned not only as priest of this other world, but as a practising physician whose knowledge of drugs extended to practical cures for physical ills. These organic medicaments might be administered during rituals involving mask use for demonic exorcisms.[7] Folk medicine entailed a great understanding of ethno-botanical pharmacology. This knowledge was preserved from generation to generation, and thus the office of shaman encompassed that of ecological conservator.

SHAMANISM IN THE HIMALAYAS

Central Asian shamanism was diffused on horseback. Early archaeological evidence suggests that shamanism permeated a bronze-using culture stretching from Tibet through Ordos, west China, and southern Siberia. Across this territory, two primary cultures existed, often in opposition – settled farmers and aggressive, nomadic herdsmen. Both held animistic beliefs, each using shamans to intercede in the spirit world for their own particular ends.

Icons of the aggressive herdsmen include animal deities expressed in an art that has come to be known as the 'animal style'. Subjects depicted include the steppe tiger (**15**) leaping on the back of a deer, reflecting the theme of victor and victim. A lineage of shamanic barbarians must include the Scythians (6th to 4th century BC), the Huns (300-100 BC) and later, the Mongols (Genghis Khan, circa 1162-1227, and his descendants). The settled peoples, frequently targeted by the aggressive horsemen, sought refuge in remote valleys where their descendants may still be found today.

Himalayan scholars generally believe that the origins of the Tibetan people lie in the nomadic, non-Chinese Ch'iang tribes who lived off animal husbandry many centuries before the Christian era in eastern Central Asia and in the far northwest border region of China.[8] It is highly likely that they participated in the Central Asian culture of shamanism and the migrations broadly described above. The physical evidence of this prehistoric (pre-7th century AD) shamanic culture can still be found in Tibet today. The Tibetan cultural historian, R.A. Stein draws attention to "the sets of minhirs and tombs arranged in stone circles in the lake region on the southern fringes of the Changthang [the northern portion of the Tibetan plateau]; and the 'animal style' in the decoration of metal objects (knives, stirrups, buckles, etc.) practised at Derge and in Amdo [in eastern Tibet], which is similar

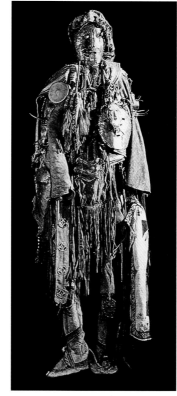

20. Siberian shaman's costume with copper mask, multiple hanging maskoid talismans, skin, bronze mirrors. Ethnographic Museum, St Petersburg.

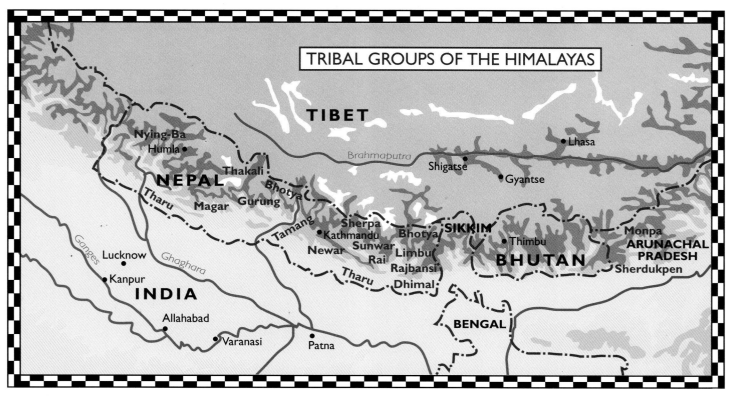

to that of the Ordos bronzes and the 'Scythian' art of the steppes"(**15**).[9]

Some of the cultural minorities of Nepal preserve an archaic Tibetan tongue. They are thought to have migrated from the central Tibetan plateau long ago. Certain scholars suggest that insight may be gained into the culture of pre-Buddhist Tibet by examining today's Magar and Gurung tribes of Nepal.[10] It is my contention that the primitive-shamanic style masks of Nepal (**14**, **21**), so similar to those of Siberia, are a continuation of a common type possibly used in Neolithic Tibet.

Shamanic traditions existed in India as well. These traditions are preserved among the tribal minorities of Central India, for example in Rajasthan. The stylistic conventions of their masks are most akin to those found on the Tarai (**22**), not unreasonably given their relatively close geographic proximity.

THE ROOTS OF CLASSICAL & VILLAGE MASKS

The tribal minorities of India were pushed aside by the advances of the Aryans during the second millennium BC. Little is known about these Aryan tribes except that they entered India through Afghanistan and the Hindu Kush, speaking a proto-Indo-European language. They preserved an oral tradition of the *Vedas* (which were to become the fundamental Hindu scriptures), extolling philosophical principles of *karma* (the laws of cause and effect), caste, and the authority of the priestly class. By its very nature, Hinduism is syncretic, absorbing many indigenous belief systems, including the worship of nature spirits. One finds many elements of animism, and by extension the principles of shamanism, deeply imbedded in this 'high culture' religion.

The other great Indian religious tradition to influence Himalayan masks is Buddhism. Biographical details of the Buddha ('The Awakened One'), historical founder of the faith, are fairly well established. Born a prince of the Shakya clan in Kapilavastu, near the present border of Nepal and India, he was appropriately named Siddhartha (He whose aim is achieved) Gautama, and lived from approximately 560-480 BC. Isolated within the walls of his father's opulent palace, he was spared the knowledge of human suffering. In a series of excursions outside the palace during his twenties, he encountered the existential suffering which all must face: poverty, sickness, old age, and death. These encounters so moved him that he renounced his birthright and became an ascetic, joining yogis in the forest. After seven years of meditation and ascetic deprivation, he achieved Enlightenment under the Bodhi tree in Bodh Gaya.

After some initial hesitation, he decided to share his hard-earned insights and spent his remaining forty-five years teaching. The Buddha's teachings are rooted in a compelling

23. *Facing page:* Dharmapala mask, in a style reminiscent of the Tang dynasty, 18th century (?). Wood and pigment, height 56cm (20"). Mort Golub Collection.

21. *Below left:* Mask, Middle Hills, Nepal, 17th/18th century (?). Wood with pigment. Height 24cm (9¹/₂"). The brow-ridge treatment is similar to the Buriat example in pl.14. Mort Golub Collection.

22. *Below:* Mask, Tharu tribe, Nepal, 19th century. Wood, pigment, height 30cm (11¹/₂"). Strongly reminiscent of eskimo masks, the iconography may relate to masks from tribes of middle India. Private collection.

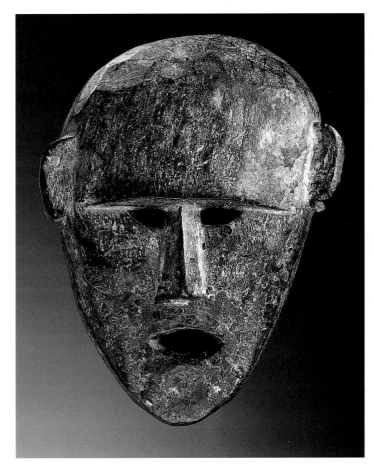

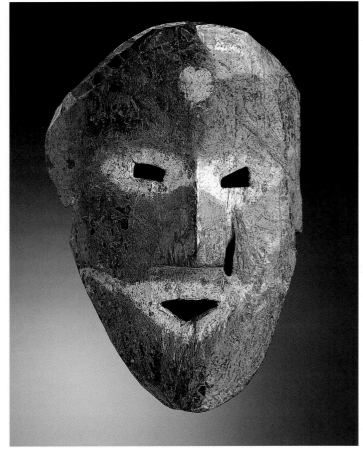

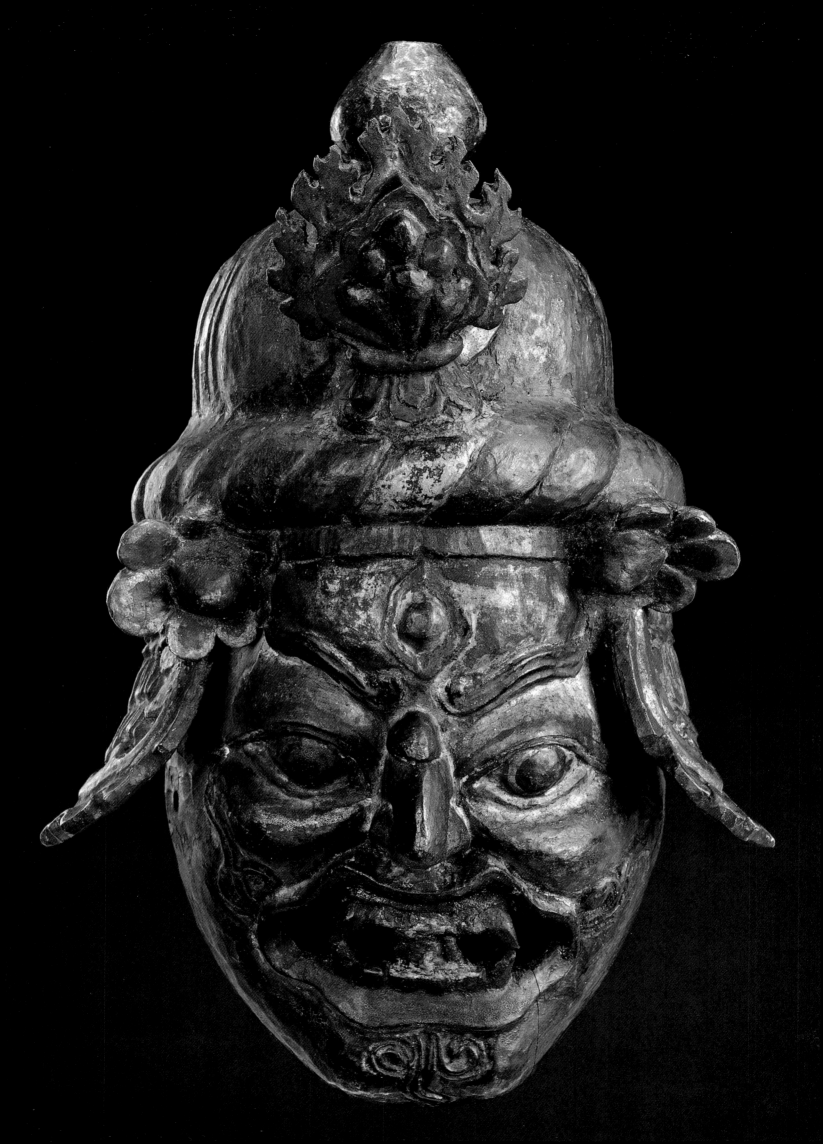

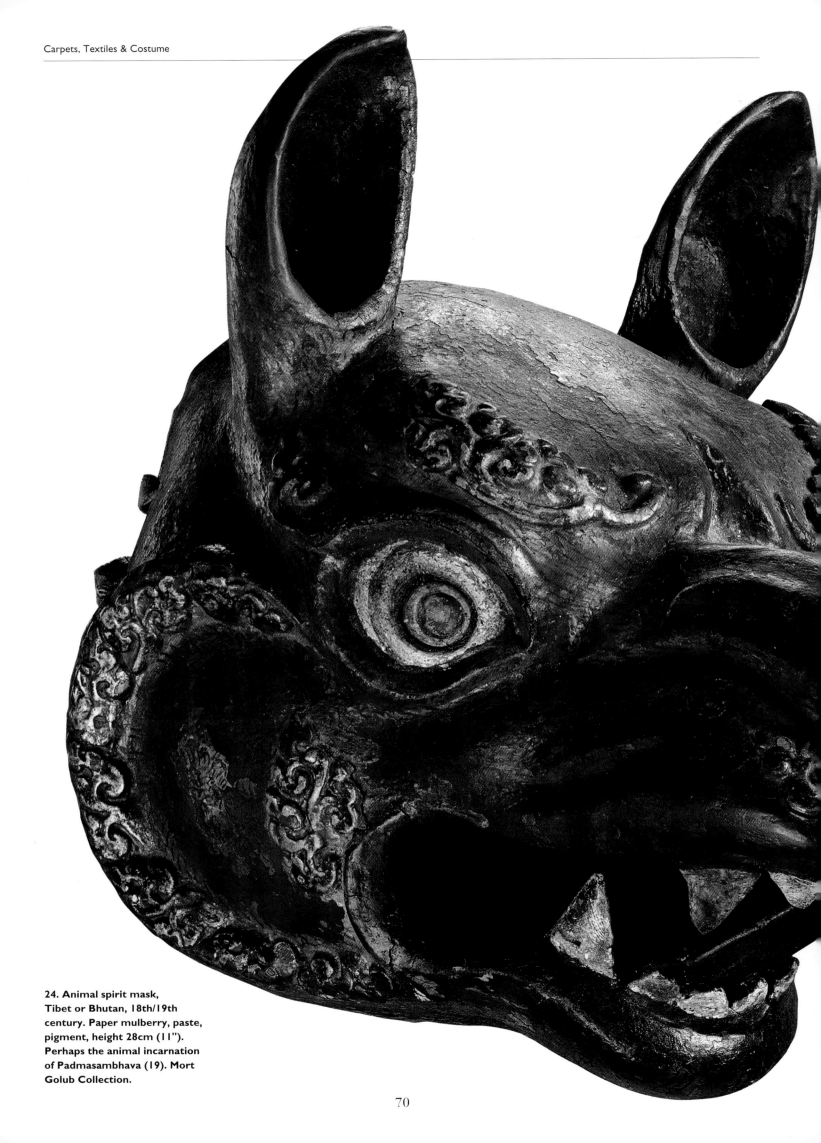

**24. Animal spirit mask,
Tibet or Bhutan, 18th/19th
century. Paper mulberry, paste,
pigment, height 28cm (11").
Perhaps the animal incarnation
of Padmasambhava (19). Mort
Golub Collection.**

25. Chitipati (Lord of the Funeral Pyre), Nepal or Tibet, 18th century. Wood, pigment, height 20cm (8"). Mort Golub Collection.

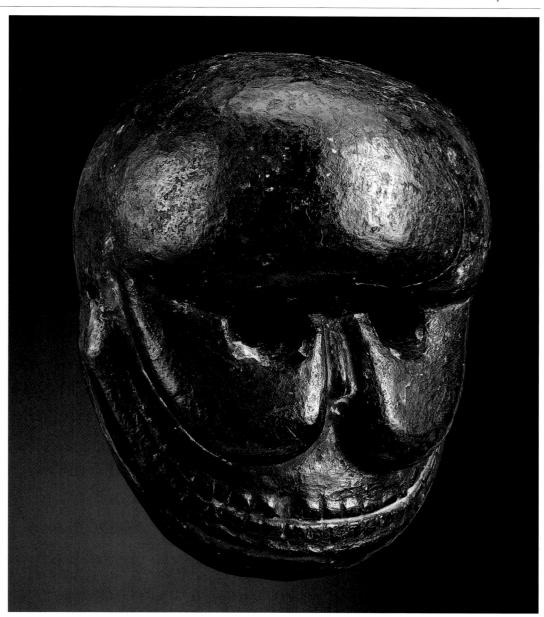

26. Garuda devouring nagas, *tokcha* ('fall from sky') talisman, 10th-12th century. The iconography of this figure closely relates to that of (27). Dated Japanese Garuda masks contemporary with this talisman are known. Height 8cm (3"). Mort Golub Collection.

DENNIS ANDERSON

71

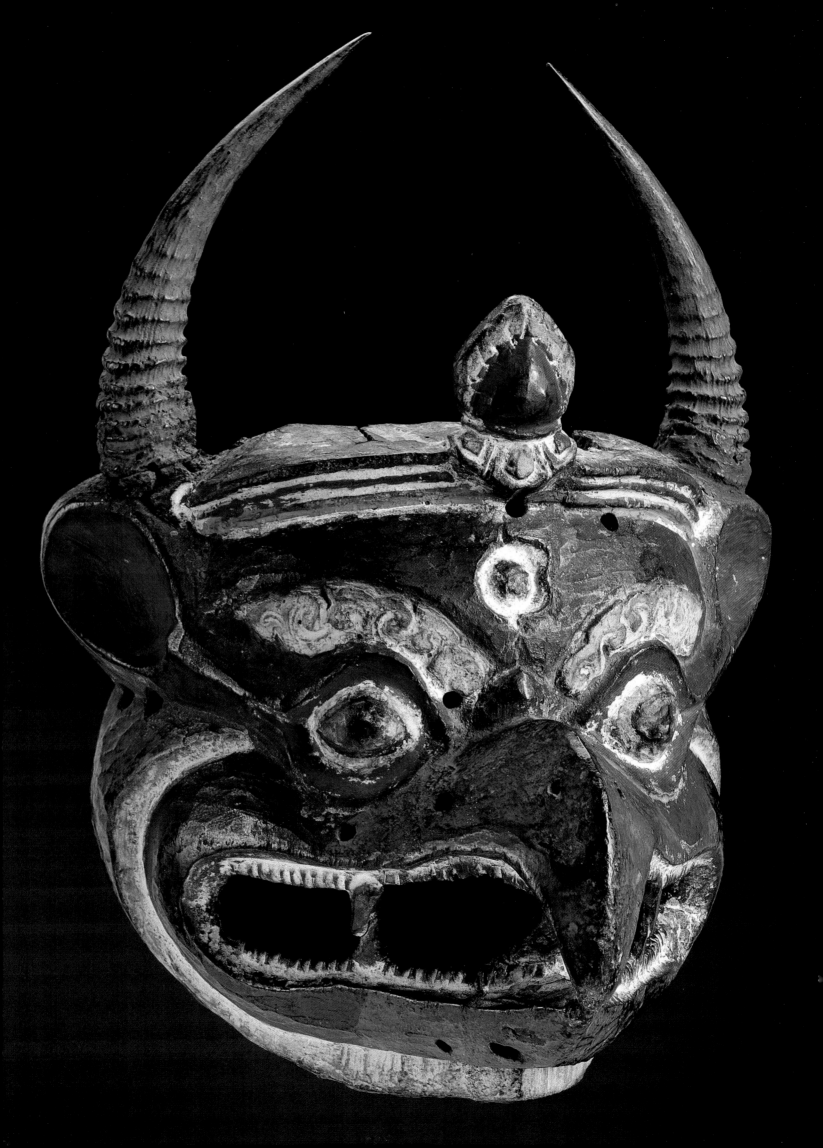

observation: despite all the efforts of human beings to find happiness and avoid pain, their lives continue to be filled with suffering and dissatisfaction. However, the Buddha did not stop there. He recognised that the causes of suffering lie within our very own minds: they are delusion, attachment, aversion, pride, and envy. The Buddha also realised that it is possible to free oneself permanently from suffering through a rigorous and well-structured training in ethics, meditation, and discriminating insight, which leads to a profound understanding of the way things really are, that is, enlightenment – a state of profound freedom and complete fulfilment.

The original Buddhist teachings were atheistic. However, it may be observed that it is human nature to yearn for a personalised saviour. As the tradition was passed from generation to generation, many buddhas and bodhisattvas (compassionate beings who assist sentient beings in their efforts for spiritual salvation) came to form a vast Buddhist pantheon.

THE SPREAD OF BUDDHISM

From its humble beginnings under the Bodhi tree at Bodh Gaya, the teachings of the Buddha spread overland and by sea to nearly all parts of Asia. Buddhism's path to salvation depended largely on the individual's own efforts, and Buddhism's doctrine of self-reliance and non-violence appealed to the merchant class in India and thus it spread along trade routes – north through Central Asia, into China and then into the Far East, Korea and Japan. It also spread south to Sri Lanka and Southeast Asia – Burma, Thailand, Indo-China, and Indonesia. Nepal and Tibet embraced Buddhism at the zenith of its development in India, and it was this tradition which eventually came to permeate Mongolia, Manchuria, Kalmykia and Tuva (the latter two in present day Russia). It is interesting to note that in this final group of countries a form of Tibetan Buddhism returned to the region frequently associated with the origin of Central Asian shamanism.

Buddhism entered Tibet in the 7th century AD. The transformation of Tibet from an essentially animistic culture to a radiantly Buddhist one is a fascinating story. One of the major players in this tale is Padmasambhava. A great Indian Tantric Buddhist adept from the Swat Valley (modern day Pakistan), he was instrumental in founding the first Tibetan Buddhist monastery at Samye (777-779 AD), south central Tibet. It is said that he overpowered the ancient mountain gods of the old religion (Bon) and converted the wrathful deities, convincing them to become defenders of the new faith.

27. *Facing page:* **Garuda mask, Bhutan, 18th/19th century (?). Wood, mountain goat horns, pigment, height 36cm (14"). This subject appears in many masked dramas. Mort Golub Collection.**

28. *Below left:* **Mask fragment, Monpa-Sherdukpen tribes, Bhutan, 12th-15th century (?). Wood and pigment, height 21cm (8¹/₂"). A spirit figure is represented closely resembling ancient Japanese Nō theatre masks. Mort Golub Collection.**

29. *Below:* **Houshang mask, Monpa-Sherdukpen tribe, East Bhutan or adjacent regions of northeast India, 18th/19th century (?). Wood, wool, bamboo, height 21cm (8¹/₂"). Houshang, the Chinese monk who attempted to convert Tibet to a Chinese form of Buddhism in the 8th century, is perceived here as a comic foreigner. Mort Golub Collection.**

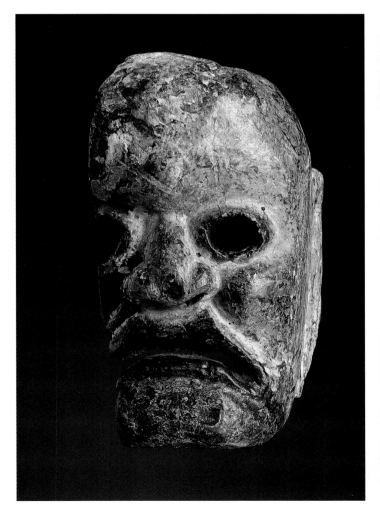

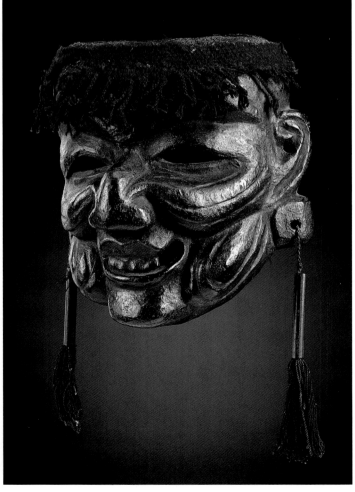

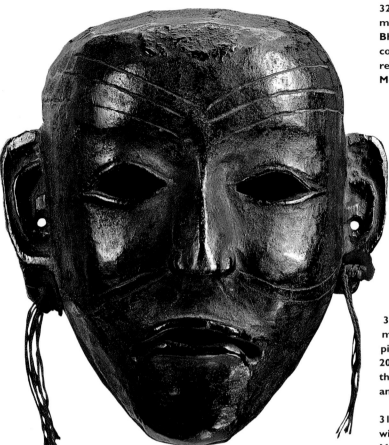

32. *Facing page:* Steppe tiger mask, Monpa-Sherdukpen, Bhutan, 19th century. Wood, cord, height 23cm (9"). Formerly referred to as Sherdukpen style. Mort Golub Collection.

30. *Left:* Monpa-Sherdukpen mask, 19th century. Wood, pigment, trade cloth, height 20cm (8"). This mask belongs to the same stylistic family as (33) and (34). Mort Golub Collection.

31. *Below:* Steppe tiger mask with Tang stylistic references, Monpa-Sherdukpen, Bhutan, 19th century or earlier. Wood, cord, height 23cm (9"). Formerly referred to as Monpa style. Georgia Sales Collection.

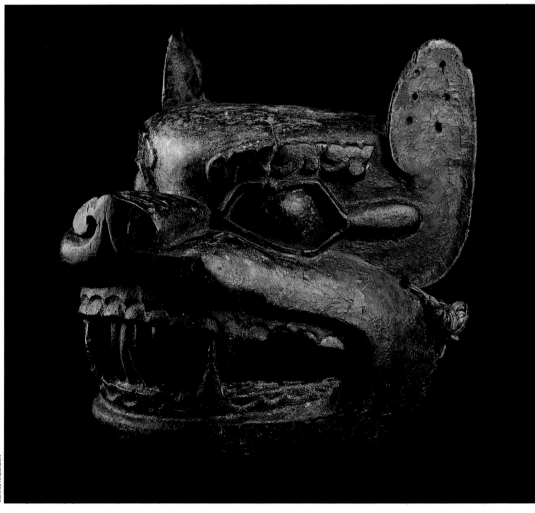

DENNIS ANDERSON

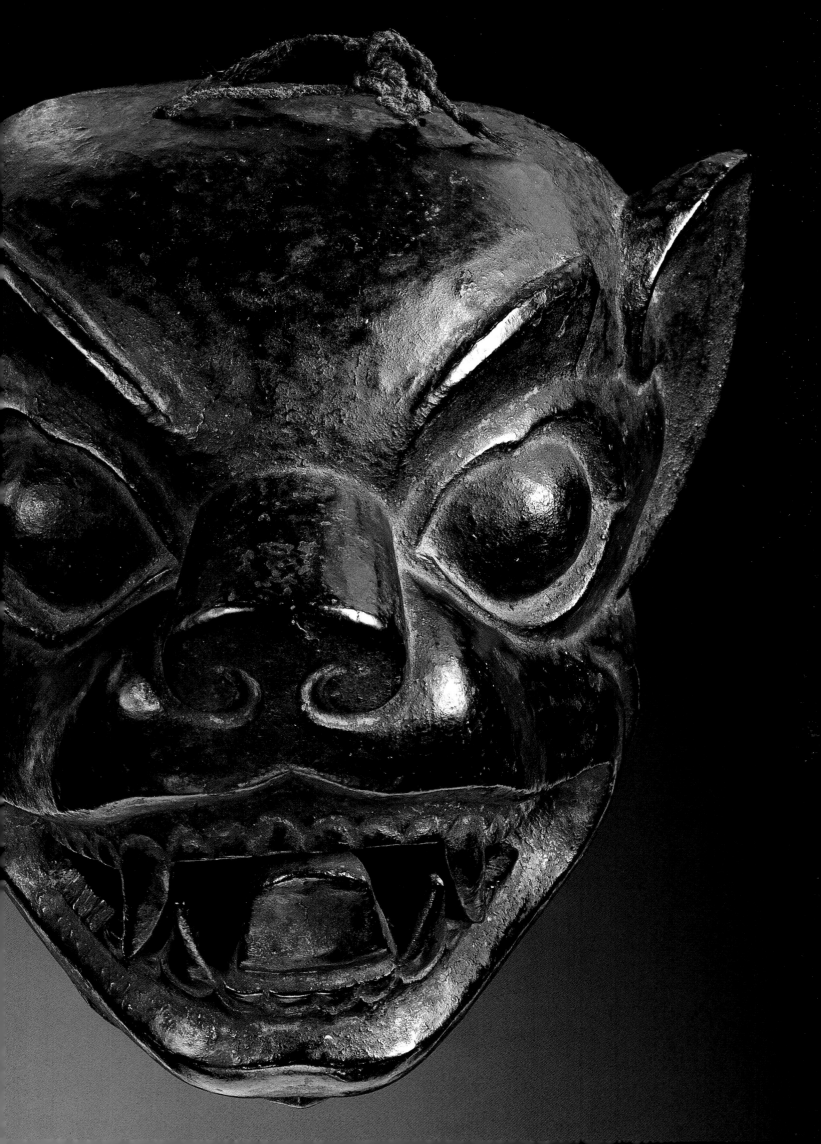

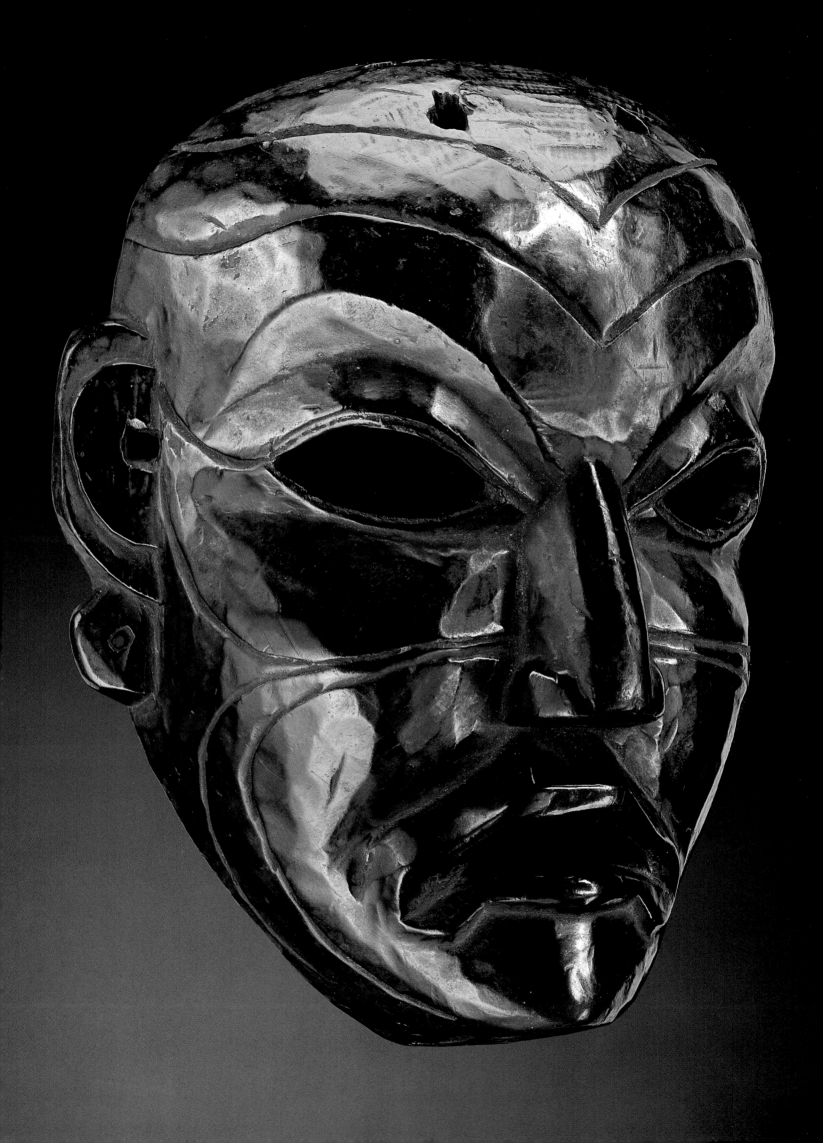

Padmasambhava is also said to have introduced the Vajra Dance (*rdo-rje gar*) at Samye Temple. This practice continues today under the name *Cham* in celebration of Padmasambhava's conquest of the Bon religion. Taking place in a monastery, masked monks in deep meditation perform dramas first imported from India and prescribed by Sanskrit-based Tantric texts. The ritual lasts for three days.[11]

In masks, Padmasambhava appears in his natural and animal manifestations (**19, 24**). Wrathful protectors of the faith or *dharmapalas* (**23**), including Mahakala (**1, 3**), exhibit their fierce *visages* as spectators enter into the transformation process of the masquerade. In this way, Buddhist doctrine is transmitted to literate and non-literate alike through meditation in action. This dance tradition takes a form known as *Mani Rimdu* in Nepal.

Tantric Buddhism often invokes imagery associated with death. Such imagery points both to the demise of ego which is associated with spiritual transformation, and to the all-too-brief duration of our physical existence. Chitipati, the skeletal Lord of the Funeral Pyre, is a particularly powerful example of this iconographic theme, and is easily identified as a grinning skull mask (**25**). Remarkably, but also typical of the wise Buddhists of Tibet, Chitipati is also seen in a humorous light, his joker-like antics offering relief from the profundity of the other lessons observed during the Cham drama.

Remarkable masks are also associated with the Tibetan Folk Opera known as *Ache Lhamo*.[12] A morality play involving participation from laymen and women, this popular drama uses dance and song to illustrate the power of Buddhism to overcome all negative forces. Another folk dance tradition, practised by the Monpo and Sherdukpen people of Bhutan, is the Deer Dance. The story tells that a young man goes into the forest and shoots a deer, having already gathered sufficient food for his family. The deer transforms himself into a god who teaches the hunter that he should not take more than he needs from nature. In this way, the morality play underscores responsible wildlife ecology. A variety of masks (**27-34**) can be associated with these colourful dramas, and are often used interchangeably as their characters appear in more than one drama.

The distinctions made by previous authors between Monpa and Sherdukpen masks were based on the mid-century observations of Verrier Elwin. However, recent investigations into this restricted area by Thomas J. Pritzker could not support this distinction, hence the use in this article of both names when referring to masks that were formerly attributed to one or other of these ethnic groups. This is not to say that one cannot recognise stylistic differences, but that they may be attributed to regional as opposed to ethnic variations (**31, 32**). The extraordinary similarity between Monpa-Sherdukpen (**28, 29**) and Japanese (**36**) masks is no accident. It is clearly a reflection of a shared experience of Buddhist culture .

The subject of Himalayan masks is difficult to narrow. In considering the masking phenomenon of the region, we are drawn into a discussion of an ever-widening geographic and historic scale. Through the microcosm of this topic, we may access a macrocosm as broad-ranging as Eurasia and the Americas, and a time-span stretching from upper Paleolithic to the present. The intention here has been to place the discussion in the wider context, for it is in understanding the depth of their contacts that we recognise the great integrity of Himalayan masks. We perceive objects of relevance and become aware of a new art form.

Himalayan masks represent a truly international style, with stylistic affinities as far flung as Japan (**36**), Alaska (**35**), and Khotan. Underlying this international style is a cultural arrow through time, beginning with the shamanism of the steppes, and moving through subsequent Hindu and Buddhist

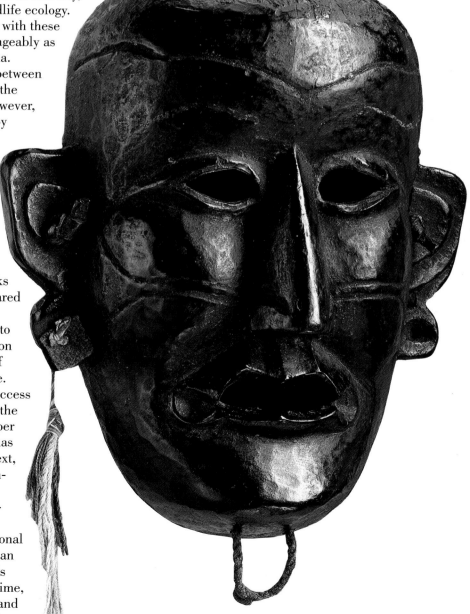

33. *Facing page:* **Monpa-Sherdukpen mask, eastern Bhutan or Arunachal Pradesh, 19th century. Wood, pigment, height 20cm (8"). Mort Golub Collection.**

34. *Below:* **Monpa-Sherdukpen mask, eastern Bhutan or Arunachal Pradesh, 19th century. Wood, pigment, trade cloth, height 20cm (8"). Mort Golub Collection.**

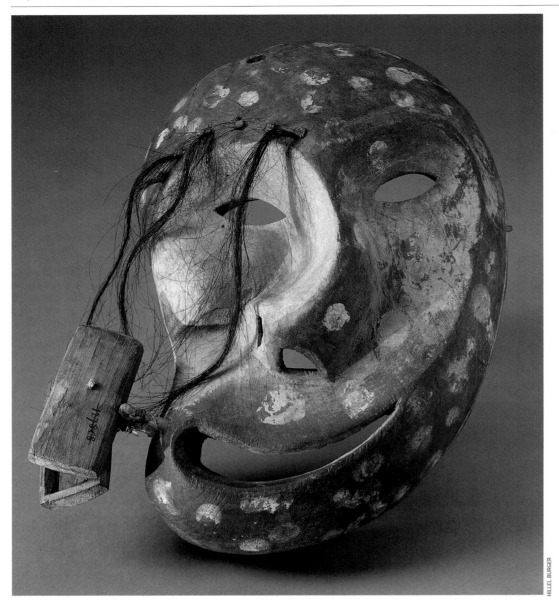

HILLEL BURGER

35. Eskimo mask, Tunghak tribe, Ugashik, southwest Alaska, collected 1887. Wood, hair. Note the rictus, a universal trait in the vocabulary of shamanic masks. Peabody Museum of Archaeology and Ethnology, Harvard University.

masquerade traditions. In addition, a continuous dynamic of cross-pollination occurred between tribal and monastery masking traditions, reinvigorating both. Ultimately, following the insights of C.J. Jung – it can be argued that the psychic 'deep structure' motivations for masking did not change and the old gods were reincarnated with new names.

A comparative analysis of large groups of tribal Asian masks reveals, I believe, a general unity of style and meaning. This unity constitutes strong evidence that the masking phenomenon had a common origin. Thus, in cases where the original meaning of masks and their accompanying rituals is lost, we may attempt to infer insights by using data surviving in other, better preserved, masking cultures.

Thus, although the Scythian 'animal style' may be site and period specific, the idea that animals have power, both awe-inspiring and worthy of harnessing, is something also recognised by the Nepalese shaman, the monk in a Tibetan monastery and the American Indian totem carvers of the Pacific Northwest. So too, the human yearning for wisdom and compassion, embodied by the bodhisattvas, affects us all.

In his book *Himalayan Art*, Madanjeet Singh has this to say of masks: "...these ageless images are undoubtedly the most fantastic and formidable art-link in the entire Himalaya. With these masks, we are presented with a radical departure from cultures and aesthetics more familiar to us. They provoke us emotionally and intellectually. And their examination offers both an occasion to develop intuitions about peoples, far distant and long ago, as well as insights about one's self, here and now."[13]

Notes see Appendix

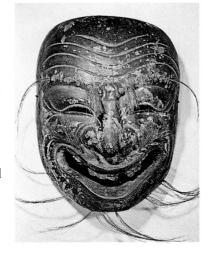

36. Emimen, Bugaku school, Japan, dated 1173. Japanese cypress, kaolin base, *sabi urushi* priming, pigment, hair, height 27cm (11"). This is the oldest surviving example of its type. The 'foolish old man' type can also be seen in (28) and (29). Itsukushima Shrine, Hiroshima Prefecture.

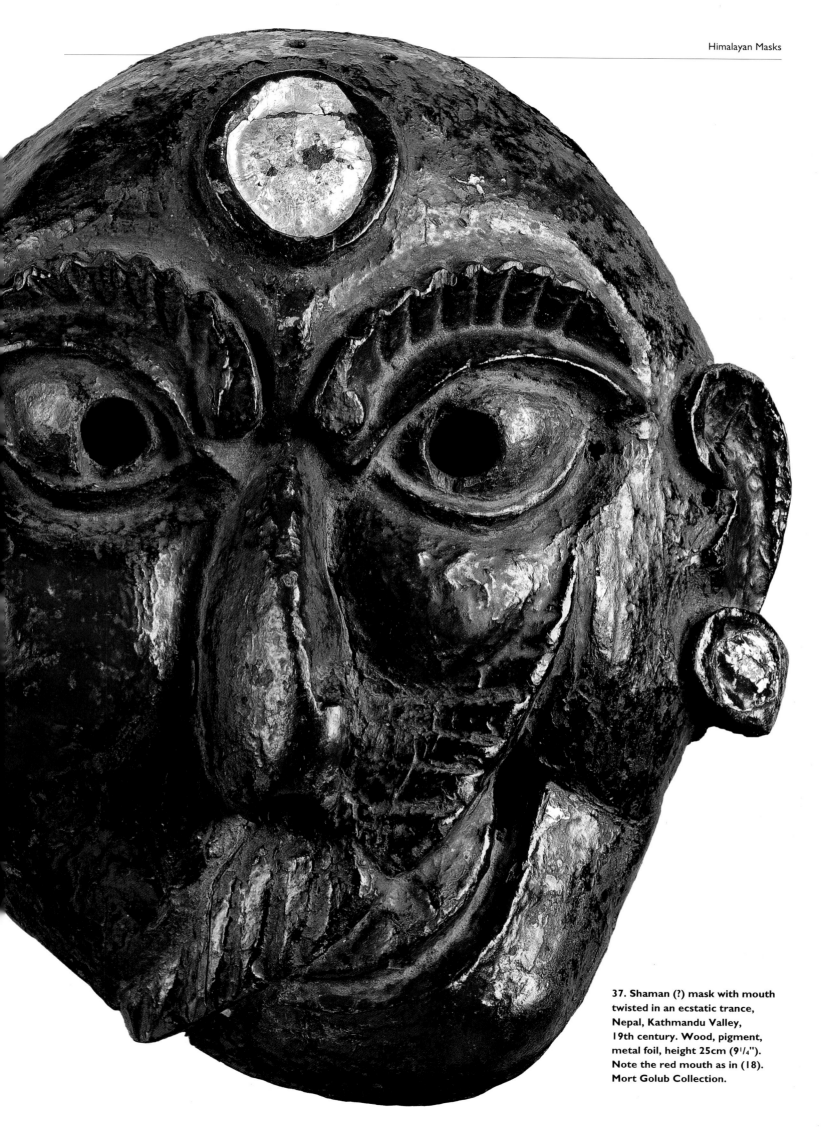

37. Shaman (?) mask with mouth
twisted in an ecstatic trance,
Nepal, Kathmandu Valley,
19th century. Wood, pigment,
metal foil, height 25cm (9¹/₄").
Note the red mouth as in (18).
Mort Golub Collection.

A TIME OF ROSES AND PLEASURE
A Zoroastrian Bridal Costume

Patricia L. Baker

Among the treasures in the Embroiderers' Guild collection, Hampton Court Palace, Surrey, is an antique Zoroastrian bridal costume densely embroidered with a repertoire of bird, animal and plant motifs. The author believes that these motifs express the Zoroastrian view of the world, with ideas of blessing and wholeness strongly present in these essentially celebratory garments. It was through such garments that the Zoroastrian community continued to assert its identity in 19th century Persia, for while the men were subject to a legally enforced dress code, the women were left free to indulge in the brilliant colours and profuse embroidery that give their tradition its unique richness and charm.

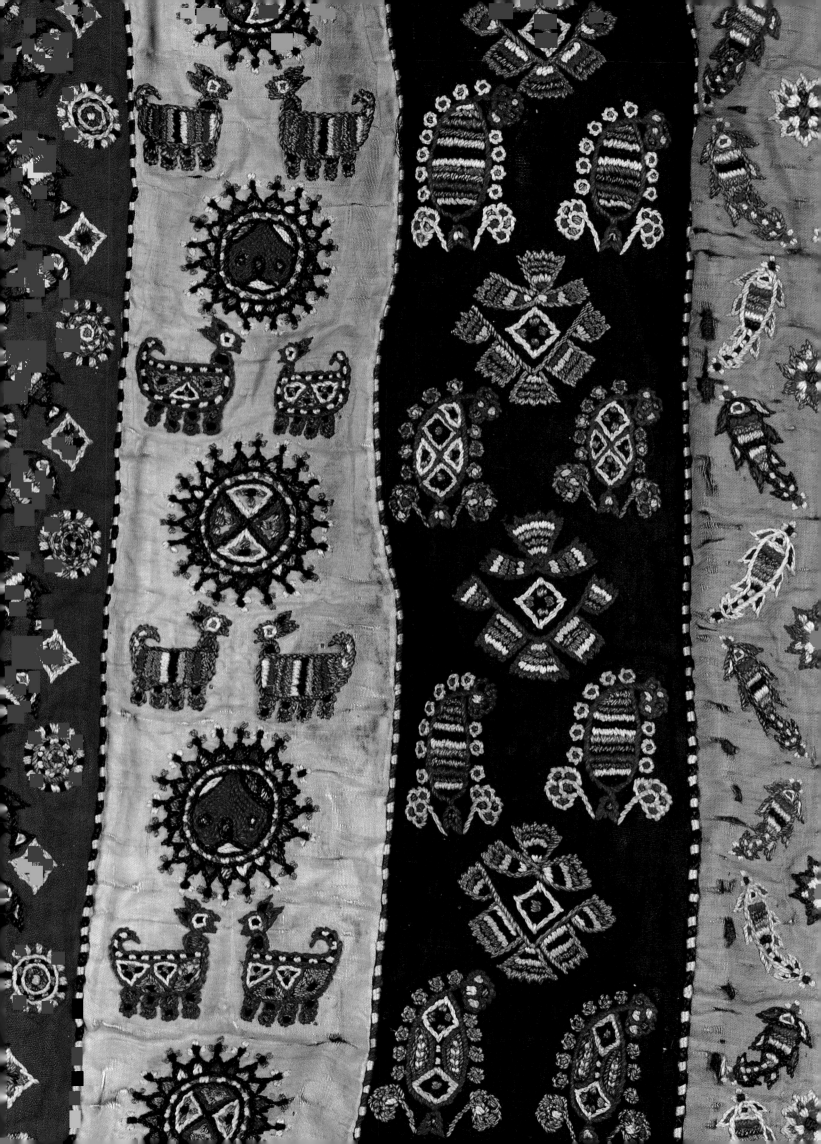

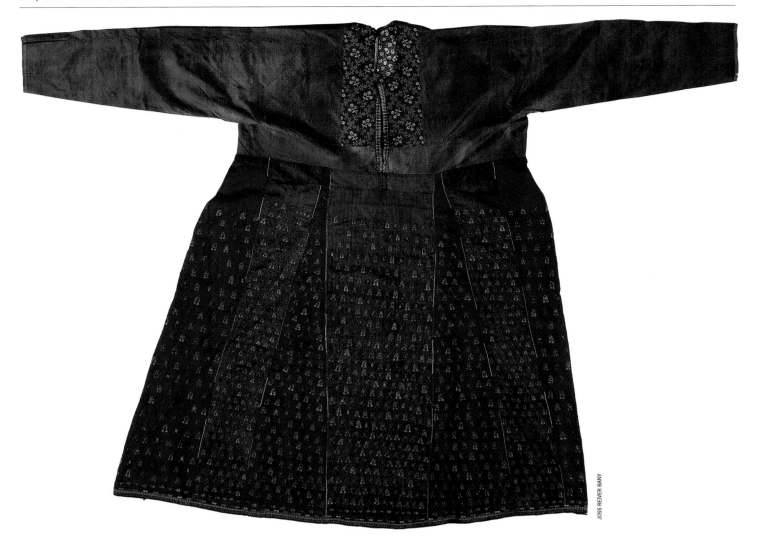

JOSS REIVER BANY

1. Above and detail below:
Silk and cotton tunic (qamis)
from a Zoroastrian bridal cos-
tume, Persia, 19th century.
Length 1.07m (3'6"). Bodice:
printed cotton; sleeves: silk;
waistband: pattern-weave silk;
skirt: twelve panels, alternately
twill and tabby silk, with silk
embroidery. The Embroiderers'
Guild Museum Collection,
Hampton Court, Surrey, Sykes
Gift, inv.no. EG 3459.

Living sometime between 1400 and 1200 BC, Zarathustra (Zoroaster) preached the one uncreated God, Ahura Mazda, wise and just, and the ultimate triumph of good over evil, light over dark. To assist in the confrontation with evil, Ahura Mazda evoked lesser divine beings (*yazatas*) as emanations of himself. Zoroastrian philosophy, contained within the *Avesta*, the sacred scriptures, and the 17 hymns (*Gathas*), expresses the sanctity of God's creations, and the need to preserve the four elements of fire, water, air and earth from all pollution. The teachings of Zoroaster became the state religion of three Iranian empires before the Muslim conquests in the 7th century AD. From the 16th century Iranian Zoroastrians suffered periodic and severe persecution.

The Zoroastrian bridal costume in the Embroiderers' Guild collection at Hampton Court Palace is a gift from Lady Evelyn Sykes, wife of Sir Percy Molesworth Sykes.[1] Presumably the outfit was acquired between 1895-1903, when Sykes was the British consul in Kerman and Baluchistan provinces, central and southern Iran; it is known that both he and his sister, Ella, who first kept house for him there, employed Zoroastrian servants.[2] At the time the cities of Kerman and Yazd were still the traditional centres of Zoroastrianism, although the community had shrunk considerably to around 1,650 families in Yazd (about ten per cent of the town's population) and 345 in Kerman city. The community had never been afforded the same protection and rights under Islamic law as the *Ahl al-Kitab* (People of the Book), that is the Jewish and Christian communities, and in a desperate search for religious tolerance, many had moved to the Qajar capital, Tehran.[3]

As with other non-Muslims, Zoroastrian men were expected to dress in a distinctive way; in Yazd and Kerman they had to wear undyed fabric garments unfashionably styled, described by Ella Sykes as "coats and turbans of a hideous shade of mustard brown. Their Mahommedan oppressors will not permit them to wear the flowing *abba*, or Persian cloak, and restrict them to dingy yellows."[4] They were forbidden the usual voluminous trousers, (white) socks, spectacles and rings; their turban cloths had to be twisted rather than loosely folded as was the fashion.[5] The women of the community were not so affected (**2, 5**). According to Ella Sykes: "...no-one seems to have interfered with the dress of the women, who have long loose jackets of parti-coloured chintzes, and wonderful baggy trousers, a mass of embroidery worked on stripes of different colours, so that with many

checked handkerchiefs wrapping up their heads, they present a very gay appearance."[6]

Such voluminous *shalvar* or trousers are part of the outfit in the Embroiderers' Guild (**3**). The waist-hip section is made of coarse blue cotton gathered in with elastic (this and some machine sewing suggest repairs). On to this are roughly sewn the trouser legs formed from joined strips: for the inside leg, a coarsely woven cotton in yellow and orange, but then a series of plainweave silk strips in the colours of the rainbow (red, green, blue, yellow, black, orange and purple), lined inside with a heavy indigo-dyed cotton. The ample width of each leg is gathered at the ankle by a 6cm deep band mostly formed of dark blue cotton fabric which, like the hip section, would have been concealed in wearing. The yellow and orange striped cotton is overprinted with a stylised pattern, but it is the silk strips which capture the attention. The vivid colouring is profusely decorated with finely worked embroidery, mainly in tiny stem-, straight- and 'magic chain'-stitch[7] in twisted silk of assorted colours. The liveliness of small repeat devices of stylised fish, small animal and bird forms, flowers and *boteh*, roundels and stars, and so on is barely controlled in pyramidic groupings of three, and in criss-cross lattices. A variation of button-hole stitch with some couching emphasises the vertical seaming of the strips themselves and this is also found on the tunic seams.

The silk and cotton *qamis* (tunic), has a similar 'patch-work' appearance with embroidery details (**1**). Perhaps it is the very tunic Sykes had in mind when he spoke at the Society of Arts in 1906: "...a loose shirt reaching to the knees, which is prepared from perpendicular strips of different coloured materials formed together very much in the way that Joseph's coat must have been made. This shirt falls over a pair of very voluminous trousers gathered tight into the ankles, which latter garments are composed of the same material as the shirt, but even smaller pieces of stuff are employed, and they are generally embroidered together like our patch-work quilts."[8]

The bodice yoke, which would have been hidden under a long head-scarf and outer jacket,[9] is of red and green cotton with a small floral print, lined with another printed cotton with a leaf and comma design on a chequered chestnut ground. Full-length sleeves of 'shot' pink and grey silk are set in at right angles; was this the colour known as *sayeh-i kuh* ('the shadow of the mountain')?[10] A high 'waist' band of pattern-weave turquoise green silk leads into the skirt of twelve panels. The back five panels are alternately green twill and madder tabby silk, but this weave selection is reversed for the front seven panels although the colours are the same. All around the hem there are lines of couching emphasising three rows of minute 'Van Dyck' appliqué work in red and yellow silk. The detail is staggering; the maximum height of the Van Dyck pointing is a mere 2.5mm, yet immense care has been taken to turn in the raw fabric edges. Swimming above the points is a line of small fish motifs

2. A Persian woman wearing a Zoroastrian costume of head-dress, shawl, jacket, tunic and baggy trousers. From Ella Sykes, *Persia and its People*, 1910.

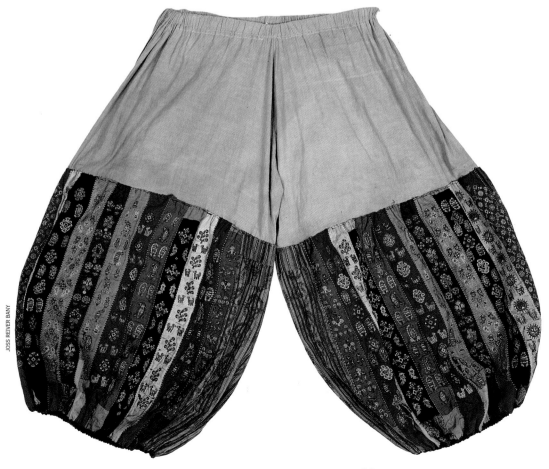

JOSS REVER BANY

3. *Left and detail, previous pages, right:* Cotton and silk bridal trousers *(shalvar)*, Persia, 19th century. Length 95cm (3'1"). The waist-hip section of coarse blue cotton, 0.84m x 0.42m (2'9" x 1'5"). The trouser legs constructed of strips of coarsely woven cotton at the inside leg, otherwise plainweave silk, each strip 15 x 42cm (6" x 1'5") wide, densely embroidered in stem-, straight- and chain-stitch. Embroiderers' Guild Museum Collection, inv.no. EG 3458.

4. **Above and detail on opening page:** Silk bridal shawl or scarf (shown folded), Persia, 19th century. 0.92 x 2.83m (3'0" x 9'3"). Dark green tabby silk, densely embroidered in stem-, straight- and 'magic chain'-stitch. From the ends, offset rows of *boteh* motifs, floral sprays, fish, birds and animals; in the field, peacocks and addorsed parrots, fish, quadrupeds and plant forms; either side of the central medallion, fish, horned animals and plant fans. At the centre a ring of large peacocks and *boteh* shapes, then a band of inscription in Persian. The Embroiderers' Guild Museum Collection, Sykes Gift, inv.no. 3460.

with small *boteh* motifs embroidered on the front panels (before they were joined together).

According to a contemporary of Ella Sykes, M.E. Hume Griffith, the work was done in the home: "As soon almost as a [Zoroastrian] girl can sew she begins to embroider strips of brightly coloured materials in order to have them ready for her wedding trousseau. Over these garments they wear a loose shirt reaching to just below the knees; this is also made of strips of different coloured materials, or in case of a bride is also embroidered."

She goes on to describe the multiple scarves and shawls (**4, 6**) worn on the head by Zoroastrian women, who were required by convention to conceal the hair-line and ears: "Then comes the head-dress; it is far beyond my powers to say of how many pieces this is composed, or as to how they are arranged. The number of coverings on the head is legion! First comes a little tight cap fitting closely over the head and ears. Over this are arranged in a most marvellous way some six or seven different pieces of calico or linen, the top one of all generally being a very bright calico, a mixture of red and yellow being the favourite pattern."[11]

The Sykes gift to the Guild includes one such shawl or scarf (**4**), a length of very dark green tabby silk, again exuberantly embroidered in a host of colours. On the back glue or candle grease protects the motifs worked in stem-, straight- and 'magic chain'- stitch.[12] From the fringes offset rows of *boteh* motifs, sprays of flowers and a zigzag band with fish, birds and animals lead the eye into the main field, which is decorated with peacocks and addorsed parrots, fish, quadrupeds, plant forms and so on. A circle containing eight fish, guarded by horned animals and plant fans is placed left and right of the central medallion, which consists firstly of a ring of large peacocks and *boteh* shapes, then a band of inscription in Persian. This with rows of birds and fishes moving anticlockwise, separated by sequin sprays, encircles the large central roundel filled with concentric chevron lines forming 17 points. The inscription itself consists of a series of couplets,[13] of which the first set, in *hazaj* metre, runs:

Ayyam-i gul ast (u) kamrani	It is the time of roses and pleasure.
Saqi bidih ab-i zindagani	Cupbearer, give the water of life [wine].
Dar sabza khush ast jam-i bada	On the greensward the cup of wine is pleasant,
Ba lala sharab-i arghawani.	With the tulips, purple wine.

This set of couplets was obviously favoured in Persian society as it is found (with some variation in the fourth line) decorating various metal objects from 15th century Persia, and also Mughal India.[14] The next couplet has a different metre *(khafif)* but a similar sentiment:

Sabz u bala-buland (u) khush-raftar	Vigorous and tall and moving gracefully,
Dilbar (u) naznin (u) khush-guftar.	Charming and lovely and sweet-voiced.

However, the final couplet (metre: *mutaqarib*) has a harsh tone, unusual for the context (and for the end rhyme):[15]

Bi-nam-i khuda (u) bi-nam-i khuda	In the name of the Lord,
Ilahi shawad (c)umr-i dushman tabah.	My God, may the enemy's life be ruined.

On the face of it such a sentiment seems unsuitable for bridal wear, but the shawl's colouring and decoration can be related to Zoroastrian marriage ritual. Green was seen at both the betrothal and wedding ceremonies. Representatives of the suitor would call on the girl's family carrying a tray of presents covered with a green cloth; also on the tray were sprigs of thyme and three pomegranates, returned to the visitors as a sign of acceptance. At the wedding ceremony, during the responses and the priest's recitation of the marriage formula, the bride sat wearing a green scarf while a tray was held over the groom's head, on which were sugar balls, an egg, a pomegranate, scissors, green thread "said by some to represent life which the scissors will eventually cut to the appropriate measure" and again also a green scarf.[16] After the ceremony gifts (once more on green-covered trays) were exchanged between the families, and finally the bride left for her new home with a green veil over her face, accompanied by her father, who frequently stopped on the way until rewarded with a coin, a symbolic reimbursement for the expense in bringing up a daughter. Traditionally 33 coins (one for each of the 33 *yazatas* 'divine ones') were so collected.[17]

Each of the *yazatas* was associated with a particular plant, so much so that some Zoroastrian rituals, for instance the *Afringan* (benediction), included the careful placing and exchange by the priests of certain flowers on the liturgical tray.[18] Jasmine was the flower of Ahura Mazda himself, while the lily belonged to Hordad (wholeness), the violet to Mihr (also known as Mithra), a kind of clover to Bahman (Vohu Manah, protector of cattle), while the anemone or marigold symbolised the sacred fire, Atar, and the crocus was associated with the *yazata* Zamyad.[19] The stylisation of the embroidered flowers and plants on these three items means specific identification is impossible, although perhaps we can assume the small spirals represent the many-seeded (i.e. fertile) pomegranates, the fruit, twigs and leaves of which were used in many Zoroastrian ceremonies, both at home and in the temple.[20] Clearly these motifs should be regarded as auspicious symbols, but do the fish, animals and birds have similar connotations?

The four elements – air, water, earth, and fire – were central to Zoroastrian beliefs. As recounted in Zoroastrian sacred literature the creation of the universe began with the sky, then came water in which Kara fish swam, moving quickly to ward off harmful (that is, unclean, polluting) creatures such as frogs and protect the earth which, it was believed, emerged from the cosmic ocean in the form of an island. In the community the fish is thus held as a symbol of good omen and protection, indeed of celebration and feasting. Today, as a century ago, no marriage feast can be complete without fish being served.[21]

Other elements in the shawl's decoration may relate to this theory of creation. The central roundel surrounded by fish could symbolise the cosmic island with its chevron patterning denoting the sacred mountain, and the two flanking circlets symbolising the sun and moon. On the island, we are told, stands the Tree of All Seeds and All Healing, in whose branches the *senmurv* roosts (Persian: *simurg*), scattering seeds of every plant on the land. Perhaps this is the significance of the shrub-like forms incorporating a small bird, which alternate with stylised birds shown in profile.[22] Three other birds have importance in Zoroastrian literature: Karshiptar, whose wings carry Zoroaster's message over the land, Asho Zushta (traditionally understood to be an owl) whose blessed song causes evil spirits to flee, and the cockerel "created to oppose the demons and xsorcerers" by wakening people for the dawn prayer.[23] The stitching of the tree recalls Edward Browne's description of the special writing (*khatt-i sarvi* or *khatt-i shajari*: cypress- or tree-writing) mentioned in connection with Yazd, in which the arrangement of diagonal strokes rising from a central vertical line form letters and words.[24]

5. A Zoroastrian family, probably photographed in Yazd, central Persia, at the turn of the century. From Iraj Afshar, *A Treasury of Early Iranian Photography*, 1992, p.210.

The stylised quadrupeds may allude to the fifth creation, the animal world, in which case the wearer herself would represent the sixth and final creation, that of humans. In Zoroastrian cosmology, the first animal created was the bull and its urine was accordingly utilised in various purification rites, but the little horned motif, featured on both the shawl and *shalvar*, could also symbolise the goat whose milk was used in the *Yasna* (liturgy) ceremony. As for the long-eared, tailed animal, surely this is a dog, whose ability to drive off evil meant its presence was essential at *barashnom* and funeral purification rituals.[25] On the *shalvar*, a strange three-legged animal is carefully worked; clearly a representation of the divine tripedal ass who feeds on spiritual food and so fertilises the earth with ambergris, although its legendary white body, six eyes and nine mouths are not shown here.[26]

With such a host of auspicious symbols on *qamis*, *shalvar* and shawl, the bride may have felt sufficiently protected to voice her true feelings towards the enemies of her community, in just one embroidered line of poetry. Was she the only Iranian Zoroastrian bride to do this? At present this question cannot be answered, but this little personal comment surely accords well with the overall message of ritual protection. *Notes see Appendix*

6. Silk bridal scarf, Persia, 19th century. 92 x 91cm (3'0¹/₂" x 3'0"). Zoroastrian head-dress was normally composed of multiple scarves and shawls; for the marriage ritual a green scarf was traditionally worn. The Embroiderers' Guild Museum Collection, inv.no. EG 3461.

Valrae Reynolds

Fine silks and other luxury textiles have been imported into Tibet from early times, and well-preserved examples of Chinese, Japanese, Byzantine, Central Asian, Persian and European fabrics in a wide variety of techniques have recently been discovered there — some dating back a millennium. From the 8th century, silk cloth was brought into Tibet from China and Central Asia through trade and alliance, and by the 12th century numerous Buddhist pictorial banners were being sent from imperial China to Tibetan religious institutions. Sumptuously depicting the themes of Tibetan Buddhism in vivid colour, these inspired a purely Tibetan production and a tradition that continues to the present day.

SILK IN TIBET

Luxury Textiles in Secular Life and Sacred Art

1. *Previous pages left:* Mandala of Vajrabhairava, the Conqueror of Death (detail), China, Yuan dynasty, ca. 1328. Silk *kesi* (slit-tapestry) hanging, 2.08 x 2.46m (6'10" x 8'1"). Metropolitan Museum of Art, New York, Lila Acheson Wallace Gift, inv.no. 1992.54.

***Previous pages right:* Detail of (5).**

Imported luxury textiles have played a significant – and perhaps too little studied – role in Tibetan culture, from the earliest records of the empire to modern times. In any period one cares to examine, Tibetan art is filled with representations of beautiful, colourful, elaborately patterned textiles. Painted, they appear as the garments in the portrait of a king, as a decorative pattern on the ceiling of a temple; sculpted, as a garment or throne drape on an image of a Bodhisattva. Actual textiles are everywhere in surviving monuments in Tibet: tapestries, appliqués, embroideries, brocades and damasks used as altar coverings, canopies, garments and mountings for paintings. These silk textiles were originally created in Byzantium, Persia, Central Asia, Russia, Japan, France and Italy, as well as in China; some are dated as early as the 10th century.

Factors such as politics, economics, status and tradition influenced the amount, the provenance, the style and the structural type of the textiles entering Tibet at any given time. Textile types associated with royalty, power and wealth combined with religious rituals to influence the use of textiles – actual and painted – for the Buddhist establishment in Tibet.

Textile history is currently being rewritten based on the examples which have recently come out of Tibet, especially those of the 10th to 15th centuries.[1] Tibet is proving to be the single most important repository of early Chinese, Central Asian and even West Asian textiles. Examples were often preserved in large pieces, and are for the most part free from damage by light, moisture and insects.

The special role of textiles in Buddhist art can be seen in the earliest surviving monuments. The decoration of a Buddhist sacred space with depictions of elaborate textile canopies and thrones is evident in all the once Buddhist countries surrounding Tibet. A Northern Ch'i or Sui stone sanctuary of circa 570-600, now in the Metropolitan Museum of Art, New York, shows such a textile – and jewel – decoration carved in relief around the 'canopy' over four Buddhas at the centre of the shrine (**2**). A painted canopy is depicted over the head of a Buddha in an 8th to 9th century wall painting fragment from Kumtura in the Kucha area (**4**). Perhaps the earliest textile pattern to survive in a Buddhist context is carved on the Seat of Enlightenment or Altar of the Mauryan Period (circa 3rd century BC) at Bodh Gaya. Similar types of patterns are found on early Buddhist monuments portraying scenes of worship such as that at Bharhut (circa 100 BC). Other early 'empty' thrones with a roundel pattern are used to signify the 'sitting place' of the Buddha.

THE TIBETAN EMPIRE

The oldest record of the import of textiles into Tibet documents a purely secular and political role for these luxury goods. The Lhasa Zhol *doring* of circa 764 AD, the earliest of the inscribed stone pillars of the Tibetan empire, mentions that after the campaign against the border fortress of Liang Zhou in 758 by the Tibetan commander Takdra Lukhong, the Tang Chinese Emperor Su Zong (756-762) and his ministers were "terrified". To secure peace, they offered fifty thousand "pieces" of silk in yearly tribute. This was paid until Su Zong's death. His son and successor, Dai Zong (762-779), stopped payments and Takdra Lukhong led the Tibetan army against the Chinese in retaliation, capturing the capital Changan in 763.[2]

That silk should be such an important item of tribute is indicative of medieval Asian economic priorities. Throughout the 7th century and until the change to a cash economy in 731, silk cloth was a standard unit of value in China, used to buy "camels or land".[3] That Tibetans should accept silk as tribute in negotiations to stop military advances is consistent with their emerging interest in the material culture worthy of an empire. Silk and the other valuable luxury goods moving along the Silk Route from the 7th to the 9th centuries were perhaps the primary reason for Tibetan army movements and alliances in both eastern and western Central Asia at this time. For instance, in the early 8th century, Tibetan armies moved as far west as the River Oxus to gain access to the western terminus of the trade routes when the eastern terminus had fallen to the Chinese. In 727, the Tibetan army took Gua Zhou, above Dunhuang, capturing vast quantities of silk such that "even ordinary people covered themselves with good Chinese silk".[4]

The pieces of silk mentioned on the Zhol *doring* were probably bolts, a common measure of Chinese

2. Limestone pagoda sanctuary, with textile decoration carved in relief around the 'canopy' over the four Buddhas at the centre of the shrine, China, late Northern Ch'i (550-577) or Sui (581-618) dynasty. Height: 2.41m (7'11"). Metropolitan Museum of Art, New York, inv.no. 1988.303.

silk for tribute and trade. Although the length and width of a bolt of silk are now unknown, the value is on record – in the late 8th century the most desirable type of military horse, from the Uighur state, was worth forty bolts of silk. By the late 9th century, with the Tang empire in 'decrepit' condition, a million bolts of cloth a year were sent to buy a hundred thousand horses of mediocre quality.[5] The realistic portrait of the Tibetan minister Gar TongTsen, attributed to the Chinese painter Yan Liben, is convincing evidence for the type of luxurious garment available to Tibetan nobles in the 7th century (3). Gar, while on his mission to the Tang court in 641 to obtain a Chinese wife for the Tibetan king, is shown wearing a robe with birds in pearl roundels.[6] Foreign envoys bearing tribute to the Tang court received robes of state from the Chinese emperor as part of a 'Patent of Recognition'. Gar's robe, perhaps such a robe of state, is made of the famous and popular 'Sasanian' medallion cloth, produced originally in Persia but so fashionable and desirable that copies were soon being made in China. Similar medallion cloth appears in the 6th to 8th centuries all over Asia, from Egypt to Japan.

3. Scroll painting depicting the Tibetan minister Gar TongTsen, attributed to Yan Liben. National Palace Museum, Beijing.

The Sasanian medallion had reached China as a decorative motif by the end of the 6th century (5, 7). Dated finds at Astana (596-616) in the Turfan region were woven in China. We also see painted medallion textiles in Dunhuang in the same period. The main production site for Sasanian style silk in China was Shu, now called Sichuan. This style was popular throughout China, perhaps because medallions were related to Chinese beliefs in auspicious mirrors and jade *pi* discs of Heaven which, woven into royal garments, would signify harmony with the universe. By the end of the 7th century, Sasanian designs clearly served to indicate royal status in China. The use of this medallion cloth in China subsequently declined, and by the late 8th century 'foreign' style textiles were forbidden by imperial edict.[7]

It is important to recognise, however, that the Tibetan empire was also closely tied to the western sectors of the Central Asian trade route, which in the 7th to 9th centuries were dominated by Sogdians. In western Asia, the new Islamic culture followed many of the established customs of Sasanian Persia, notably the high status of luxury textiles. The original austerity of Islam was soon replaced by conspicuous consumption on the part of the ruling class. The Umayyad caliph Hisham (724-743) required seven hundred camels to transport his personal garments on a pilgrimage. The price of an elegant costume in the 8th to 9th centuries in Persia could be as high as 30 dinars, over $1,000 in modern terms.[8]

4. Fragment of a wall-painting depicting a textile canopy originally over a Buddha figure, Kinnari Cave, Kumtura, 8th-9th centuries. Museum für Indische Kunst, SMPK, Berlin, inv.no. MIK III 8913a.

Silk textiles in the Islamic world – as in China – were equivalent to 'ready money', used, like real estate, alongside the cash economy. Royalty kept enormous stores of textiles and garments for their own use and for gifts and tribute; a large part of a family's wealth was in cloth; taxes were received in cloth. 'Robes of Honour' were used by Islamic rulers for gifts to subjects. The court had total control over the manufacture of luxury textiles and only those who enjoyed the favour of the ruler had access to them.[9]

No securely dated 7th to 9th century medallion cloth has been identified in Tibet. It seems

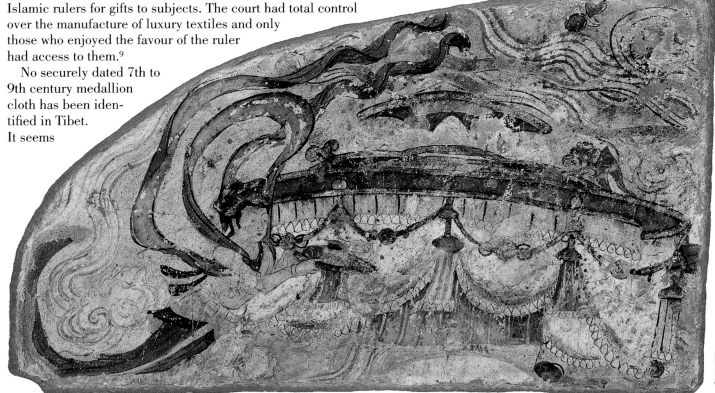

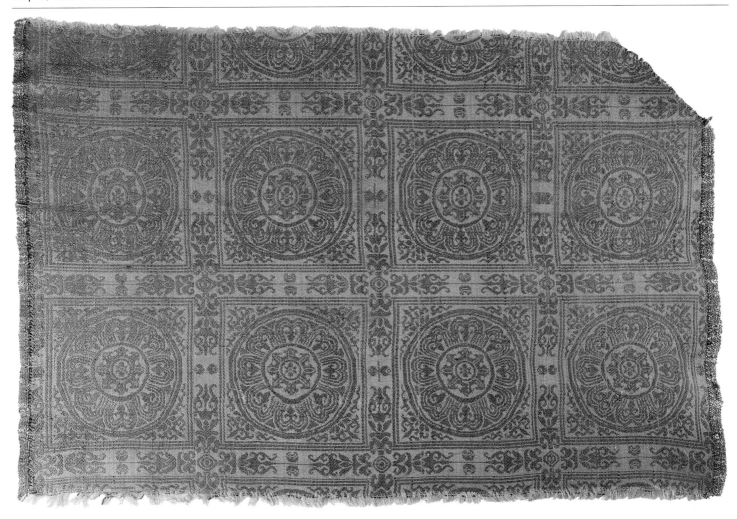

5. Silk brocade panel with repeat pattern of roundels containing lotus-heads and medallions, China, 12th/13th century. 58 x 42cm (1'11" x 1'5"). Courtesy Spink & Son, London.

certain, however, that Tibet, surrounded by civilisations in which the 'Sasanian' medallion had such extraordinary cachet and value, and having access to both ends of the Silk Route, was obtaining these and other luxury textiles in the 7th to 9th centuries. With the disintegration of both the Tibetan and Chinese empires in the mid 9th century, imperial and religious monuments – together with the fragile textiles within them – were destroyed throughout Central Asia and Tibet.

TIBETAN ACCESS TO THE SILK ROUTE

There is a somewhat puzzling survival or revival of the 'Sasanian' medallion textile in Tibet, in the period of the so-called 'Second Diffusion' of Buddhism when Tibetan historical records resume in the mid 10th century. The beautiful textile patterns which cover the ceilings and are also shown on royal garments in the wall portraits in the Sumtsek and Dukhang temples and the Great Stupa at Alchi in Ladakh (cf. 'Dressing the Temple', in this volume) have long been admired by art historians.[10] Another important Tibetan site with 'Sasanian' medallion textile types is the 11th century temple of Yemar or Iwang, near the

6. Wall painting (detail) depicting ducks within a 'pearl' bordered roundel. Cave 60, Kizyl, Central Asia, 6th/7th century. Museum für Indische Kunst, SMPK, Berlin, inv.no. III 8419.

Bhutanese border.[11] In both of these monuments, the textiles painted or carved on images or architecture seem very 'realistic'. One assumes they are based on actual textiles available in Tibet in the 11th century (and later). These monuments are also early evidence of the adaptation of luxury secular garments to the spiritual realm of Buddhism.

The main production site of 'Sasanian' textiles in China in the 7th to 8th centuries had been Shu, particularly Chengdu and environs. The trade routes from Sichuan to Lhasa were certainly well established; were 'Sasanian' roundel textiles made for the Tibetan market in Sichuan after the fall of the Tang empire? Looking to western Asia in.the 11th to 13th centuries, one can find medallion textiles still in production. Fragmentary silks excavated at the medieval city of Rayy in northern Iran compare well to depictions from the same period of medallion cloth at Alchi and Yemar.[12] Silk medallion pattern textiles were also being produced in the Byzantine Empire at this time. Such cloth could have been traded into Tibet via the Central Asian Silk

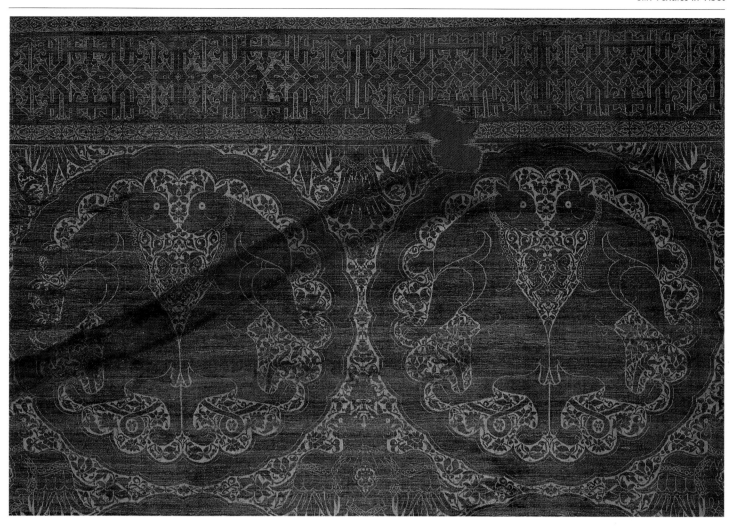

Route, which was rather fragmented in the 11th to early 13th centuries.

The effect of the Song Chinese rejection of foreign influence and the loss by China of control of trade routes across Central Asia in the 10th century left the field open to the Uighur and Tangut states. The treaty of 1044 obliged China to send the Tanguts 50,000 taels of silver, 130,000 bolts of silk and 30,000 catties of tea annually. In addition, 22,000 taels of silver, 23,000 bolts of silk and 10,000 catties of tea were sent by China in exchange for "gifts" from the Tangut state. One horse was worth twenty bolts of silk in the 11th century and four hundred thousand bolts of silk went to the Tanguts in trade annually, aside from imperial tribute.[13]

Because of the fragmented political status of Tibet in the 10th to 13th centuries, there is little written evidence of trade, but monasteries, influential lamas and local principalities were active patrons and were certainly importing luxury goods. Tibet's close relationship with the Tangut state, especially through religious contacts, opened avenues for trade indirectly with China. As we shall see, these contacts resulted in the commissioning of specifically Buddhist textiles.

The Tangut empire established Buddhism as a state religion in 1038, although Buddhism had been known to the Tanguts since the 9th century, perhaps as a result of the movement of Tibetan monks to Minag (Tangut) with the break-up of the Tibetan empire. By the 12th century, Tibetans and Tibetan texts were part of the Tangut Buddhist establishment. Envoys of the Tibetan Karmapa sect visited the Tangut emperor in 1159 and founded a temple.[14] Mongol advances in Central Asia between 1205 and 1227 destroyed the Tangut state, but many aspects of the special religious connections between the Tanguts and the Tibetans were adopted by the new rulers. By the mid 13th century, the Mongols were in control of all the former Tangut territories and indeed of all of Asia. The silk trade was an important financial aspect of this control, as well as a means for the Mongols to assert their imperial authority and cultivate religious leaders (7).[15]

As part of the agreement arranged between the Tibetan Lama Sakya Pandita and the Mongol ruler Güyüg Khan in 1247, Tibetan monastic and noble establishments submitted to the Mongols and paid taxes to them. Presents sent to Tibetan monasteries, lamas, and princes from the Mongol court included gold, silver and "precious robes".[16] Mongol patronage of Tibetan monasteries in the 13th to 14th centuries certainly increased the opportunity

7. Silk lampas weave with felines and eagles (detail), western Central Asia, late 12th or 13th century. 1.71 x 1.09m (5'7" x 3'7"). Cleveland Museum of Art, J.H. Wade Fund, inv.no. 90.2

8. Green Tara (detail), silk *kesi* (slit-tapestry) thanka, Kara Khoto, eastern Central Asia, before 1227. 0.52 x 1.01m (1'8¹/₂" x 3'4"). State Hermitage Museum, St Petersburg.

for luxury goods to come into Tibet from Central Asia, China and Western Asia, and also allowed Tibetan religious and artistic influence to spread throughout the Mongol world. Tibetan monks were in Persia at the Il-Khanid court from 1256 to 1291 and Tibetans had great influence over all aspects of material culture emerging from the Mongol capital at Beijing. The Saskya monastery in southern Tibet, which enjoyed special privileges under the Mongols, served as the terminus for the Mongol mail route in the 14th century and as the residence of exiled Korean princes.[17]

TEXTILE IMAGES FROM CHINA

The political, commercial and religious ties between Tibet, the Tanguts and the Mongols resulted in the creation of new types of Buddhist textiles. Numerous fine 12th to 13th century pictorial silk banners in tapestry weave have been preserved in Tibet. While all are in the style of Tibetan painting of the same period, they were not made in Tibet. The technique is called *kesi* in Chinese and refers to a plainweave structure in which discontinuous weft threads are used to create pictorial patterns in mosaic-like blocks, with slits appearing where areas of different colour meet vertically. The design is created on the loom during the weaving process. The complexity of mimicking, in silk thread, the fine details and vivid colour of a Buddhist painting required great skill. Chinese weavers were producing pictorial tapestries by the 12th century, but the technique and indeed the word *kesi* originated in western Asia, possibly in the Hellenic kingdoms of Sogdiana or Bactria. It was possibly the Uighurs who first commissioned specifically Buddhist *kesi* during their occupation of the great Buddhist pilgrimage centres in Central Asia in the 10th century.[18]

The Tanguts succeeded the Uighurs in Central Asia in the 11th century and, as we have seen, acted as a conduit between China and Tibet. Several of the Buddhist *kesi* banners in the Tibetan style are associated with the Tangut empire. The magnificent finds from the Tangut fortress at Kara Khoto, now in the State Hermitage Museum in St Petersburg, include a large banner of the Buddhist Goddess Green Tara (8).[19] All of the other known early *kesi* banners, however, are in Tibet or have recently left Tibet. The finest of these now in a Western collection is a hanging of Vighnantaka, the Destroyer of Obstacles, owned by the Cleveland Museum of Art (9). The brilliant colour and exuberant floral forms in the Cleveland banner, which even has tiny pearls woven into the attendant Buddha figures, exemplify the mastery of these Buddhist *kesi*.[20] An almost identical, though smaller, *kesi* of Vighnantaka is in the Potala Palace in Lhasa.[21] Other *kesi* of the 12th to 13th century period in the Potala include a banner of Achala, the Immovable, with a woven Tibetan inscription which states that it was commissioned for the Sakya scholar Grappa Gyalshan (1147-1216); and a portrait of Zhang Rin-po-che (1123-1194), founder of the Tsal-pa Kagyupa order.[22]

These tapestry banners are absolutely in the style of Tibetan painting of the 11th to 13th centuries. Variously called 'Kadampa' or 'Pala-dependent', such paintings have been identified among the early wall paintings in the Jokhang Temple in Lhasa (11th to 12th centuries), and in the Shalu monastery, southern Tibet (circa 1045). Numerous portable paintings on cloth *(thanka)* have been brought out of Tibet in the last two decades. The figure types and their postures, the colour schemes, throne arrangements, as well as the garment, crown and jewellery types are all consistent with eastern Indian manuscript illustrations known to have been an important factor in 'Second Diffusion' Tibetan art. Tibetan painters transformed these imported artistic and iconographic conventions in the 11th to early 13th centuries into large scale, richly coloured wall and scroll paintings. Taking this one more step, wealthy and powerful patrons had actual paintings or cartoons copied in luxurious silk at *kesi* weaving centres.

9. Vighnantaka (detail), silk *kesi* (slit-tapestry) thanka with pearls, China, Xi Xia kingdom, ca. 1227. 0.74 x 1.05m (2'5" x 3'5") Cleveland Museum of Art, J.H. Wade Fund, inv.no. 92.72.

Whatever the Tangut connection to these Tibetan-style Buddhist *kesi*, after the Mongol conquest they were clearly made in metropolitan China. Two *kesi* banners which were commissioned in the 14th century can be firmly placed in imperial Chinese workshops. One is the extraordinary Mandala of Vajrabhairava, the Conqueror of Death, now in the Metropolitan Museum of Art, New York (1). This tapestry is in the new Nepalo-Tibetan style of the 14th century, with powerful Buddhist figures displayed against a dense foliate background. Yet it includes, at the bottom, portraits of the Mongol Emperor Tugh Temur (Emperor Wen Zong, r. 1328-32), his brother and their respective wives.[23] The

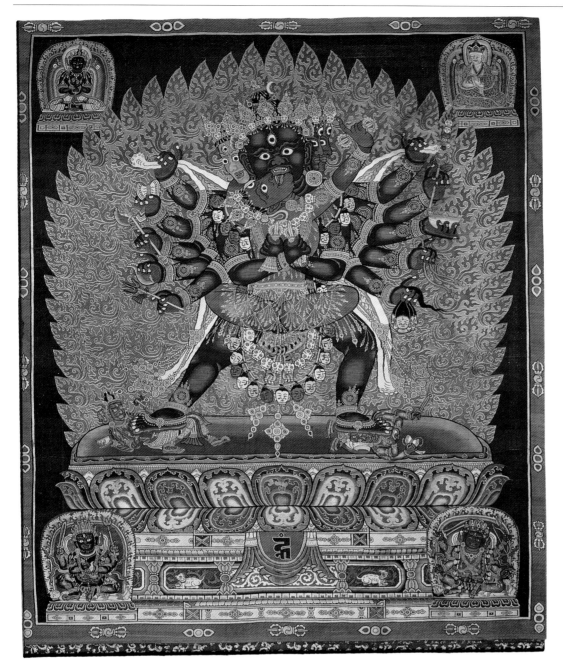

10. *Left:* **Silk *kesi* thanka depicting Chakrasamvara and Vajravarahi in ecstatic embrace *(yabyum),* with Adi Buddha and the Third or Fourth Karmapa above, China, Yuan dynasty, either 1333 or 1360-64. 56 x 68cm (1'10" x 2'3"). Private Collection, USA. Courtesy Hong Kong Museum of Art.**

11. **The Seventh Bodhisattva, silk and gold thread embroidery, China, 14th century. 19 x 43cm (7½" x 1'5"). Cleveland Museum of Art, J.H. Wade Fund, inv.no. 91.2**

clear imperial connection makes it likely that the *kesi* was woven in the state weaving factories in Beijing or Suzhou. A second banner, in the Halpert Collection in New York, which depicts Chakrasamvara and Vajravarahi, the two meditational deities symbolic of the union of wisdom and compassion, in a flaming or scrolling nimbus, includes the portrait of either the Third or Fourth Karmapa, the reincarnated Lamas who headed the Karmapa suborder of the Kagyo order of Tibetan Buddhism (**10**). Both visited the Chinese court in 1333 and 1360-1364 respectively.[24]

The Buddhist arts of Mongol China were dramatically influenced by Tibetan and Nepalese religious themes and artists. The role of the great Nepalese artist Aniko (1243-1306) is only now beginning to be fully understood as a conduit for the style and conventions of Nepalo-Tibetan architecture, painting and sculpture to the many workshops under Mongol imperial control in China. Aniko arrived at Kubilai Khan's court in 1260; in 1274 he was put in charge of "all classes of artisans". There is evidence for his direct role in pictorial textile production in the Yuan history which cites Aniko's design of "innovative woven imperial portraits".[25]

Buddhist embroidered banners from the imperial Chinese workshops also came to Tibet as state gifts. A group of fine Buddhist embroideries have come out of Tibet recently. Although they are small in scale, the workmanship is of high quality and they may have formed a decorative scheme for a particular chapel, as the compositions are similar. Scroll borders of couched gold thread frame enthroned Buddhist figures in cloud or flower arches above, with lotus plants supporting auspicious emblems below (**11**).[26] The floral details and delicate thrones are similar to Nepalese and Tibetan paintings of the 14th and early 15th centuries.

12. Temple hanging depicting a monastery entrance-way, China, carbon-14 dated (95% probability) to 1295-1462 AD. Silk on silk embroidery, 1.73 x 0.79m (5'8" x 2'7"). Asian Art Museum, San Francisco, Avery Brundage Collection, inv.no. 1990.212.

Another fine Chinese embroidery made for use in Tibet is a temple hanging, possibly a section of a *mandala,* now in the Asian Art Museum of San Francisco (**12**).[27] This piece can be compared to a *thanka* depicting Vajrabhairava in the Potala Palace in Lhasa; both have mantras on their borders and many similar decorative details. There is a closely related embroidered *thanka* in the Metropolitan Museum of Art.[28] The elegant *prabhamandalas* ('Circle of Radiance', meaning the halo) around both the two Vajrabhairavas and the small Buddhist figures as well as the lotus scroll motifs of the *mandala* section also appear in 14th to 15th century Nepalese and Tibetan sculpture and painting. A gilt copper *mandorla* from Nepal (**14**) and the gate built for Toghan Temur in 1345 north of Beijing display the same lotus floral chains and scrolling, populated *prabhamandala.*[29]

A spectacular group of embroidered banners have been identified, all with inscriptions of the Yongle emperor (r. 1403-24), who maintained close ties with Tibetan lamas and secular rulers, particularly with the Fifth Karmapa who visited the Chinese court in 1407. All the banners in the group depict protective deities in flaming aureoles. These hangings may be classed among world masterpieces of textile imagery for their extraordinarily fine embroidery work and large size (**15**). One example from the group, now in a Western collection, depicts the wrathful protector Raktayamari embracing his consort. Two others, in the Jokhang Temple in Lhasa, show Vajrabhairava and Chakrasamvara.[30] Although the scale and intricacy of these embroideries are indicative of the finest imperial workmanship, the iconography, colours, and decorative details are all completely Tibetan. One can turn especially to the painted murals of the Great Stupa at Gyantse, southern Tibet, of 1427-39 to see the same vivid compositions, energetic physiognomies and exquisite scrollwork and ornamentation as in the embroideries.

TEXTILE IMAGES MADE IN TIBET

The Gyantse region, with its close ties to the Sakya sect and with its history of Chinese impe-
rial titles and gifts, was the centre of an emerging, purely Tibetan textile tradition in the 14th
and 15th centuries. Palden Zangpo (1318-70), the first Prince of Gyantse, received patents
and titles from the powerful abbots of Sakya monastery, who had ruled much of southern and
central Tibet on behalf of the Mongol emperors since 1268. The prince also sent envoys to
the Mongol court at Beijing in the entourage of the Fourth Karmapa. As a result of these illus-
trious connections, the Prince of Gyantse was appointed Xi Du (military commander), as well
as head of the office concerned with the affairs of the Buddhist monks of the entire Myang
district. This region, south and west of Gyantse, included the ancient Kadampa monastery of
Nasning, which had long had a special relation with artists from Nepal, and where a famous
Chinese scroll was housed. Palden Zangpo continued his close connections with China even
after the fall of the Mongol empire, receiving patents from the first Ming emperor.[31]

The many gifts which came to the Sakya abbots and the princes of Gyantse certainly inclu-
ded luxurious Chinese silks. In the early 15th century, Palden Zangpo's grandson commis-
sioned what is perhaps the earliest recorded Tibetan appliqué banner of a Buddhist figure,
referred to as *gos-sku* ('textile image'). In 1412 and 1413, envoys from the Yongle Emperor
had arrived in Gyantse with "great gifts", and in 1418 the third Gyantse prince, Rabten
Kunzang (1389-1442), ordered a large appliqué of Sakyamuni Buddha and attendants to be
made. For 23 days 37 artisans worked to complete the banner, placing pieces of coloured
silk on a background of 330 bolts of cotton. The next year, on the occasion of a religious
ceremony for the Kalachakra ('Wheel of Time') festival, Rabten Kunzang consecrated
another banner, constructed of 23 bolts of silk, depicting the Buddha of the Future, Maitreya.

95

13. Giant embroidered banner displayed once a year at Labrang, Amdo. Photo ca. 1930, courtesy The Newark Museum, photo archive.

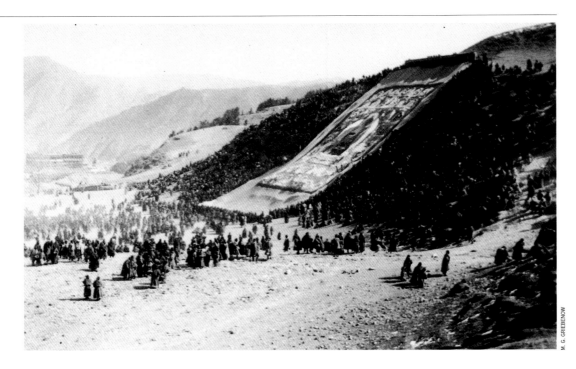

Numerous other appliqué banners were made for this prince who is best known as the patron of the Gyantse Stupa and the adjoining temples of the Palkhor Chöde.[32]

From the mid 15th century onwards, Tibetan princes and lamas relied increasingly on their own artists to design and execute extraordinary textile images. Imported silks of various types and patterns, always in brilliant colours, were of course necessary, but they were now used as the raw materials for a uniquely Tibetan textile: the enormous appliquéd banner.

In 1468, the great lama Gedun Truppa (1391-1474), posthumously recognised as the first Dalai Lama, received offerings of "bales of silk" of many colours and conceived the idea of having a giant *gos-sku* of Sakyamuni Buddha made. The painter Menla Dhondup, the most famous Tibetan artist of the time, was called with his disciples to Tashilhunpo, the monastery near Shigatse in Southern Tibet founded by Gedun Truppa in 1447, to design and execute the work. After three months the *gos-sku* was completed. To consecrate the piece, Gedun Truppa inserted written prayers at the heart level of the image as vows were made to develop the Buddhist doctrine. Auspicious omens, such as rainbows and symbolic signs in clouds, appeared in the sky on the day of this consecration.[33]

The inspiration which led Tibetan artists and lamas to use the appliqué technique for the creation of sacred images, certainly occurred in response to imported Chinese and Central Asian silken banners. One clue to this is the mention of Menla Dhondup as the master artist in the appliqué commissions of the first Dalai Lama. Dhondup, who flourished in southern Tibet from the 1450s to the 1470s, was the founder of the Menri school of painting, the earliest native Tibetan school to be recorded in traditional Tibetan art histories. He is cited in the first Dalai Lama's biography as the king of painters (*pir thogs rgyal po*) when he and his assistants came to Tashilhunpo in 1458 to work on murals. He appears to have trained with artists who had worked in the Gyantse Kumbum in 1427-1439, and seems also to have been greatly influenced by the large Chinese painting or silk scroll (*si thang*) at the monastery of Nasning in Myang, near Gyantse. Menla Dhondup is also known to have executed a mural at Tashilhunpo in 1464 "in the Chinese style".[34]

14. *Prabhamandala,* Nepal, 14th century. Hammered gilt copper, height 0.31m (12"). Newark Museum, inv.no. 59.346.

The commissioning of giant appliquéd banners became popular as an act of particular merit and prestige among Tibet's secular and religious leaders. Size was crucial because these banners were for outdoor display in rituals and festivals. The use of brilliantly coloured, luxurious and costly imported material, and even jewel adornments, was another important aspect of such commissions as recorded in the biographies of the great lamas and princes of Tibet. This practice is exemplified in a second *gos-sku* made in 1469 to the order of the first Dalai Lama. Using silk left over from the large Sakyamuni appliqué, the artists made a smaller banner of the goddess Tara. This was quickly finished and then 2,775 pearls were assembled and threaded onto the appliqué with a rock crystal at the centre. The account of the production of this banner may refer to the renowned 'pearl tanka' still held at Trandruk monastery in Central Tibet.[35]

The giant appliquéd banners would be rolled out for religious ceremonies on steep, bare hillsides or down walls constructed for the purpose in or near the monasteries (**13**). Banners could thus be viewed in reverence by the thousands of monks and lay practitioners who would gather for the teachings and blessings bestowed at such ceremonies. Giant banners

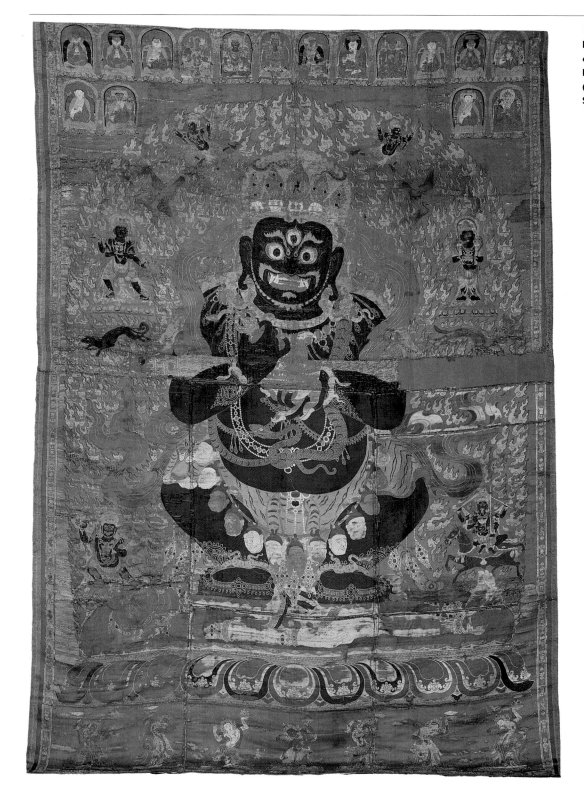

15. Mahakala, silk temple hanging, China, Yongle period, carbon-14 dated (95% probability) to 1280-1480. 2.21 x 3.25m (7'3" x 10'8"). Courtesy Spink & Son, London.

are in the class of great spiritual icons called *Mt' on grol*, 'liberation through sight': images that radiate a spiritual presence to remind onlookers of their own inherent enlightenment.[36]

Appliqué in Tibet is traditionally made of cut pieces of silk (sometimes mixed with wool, cotton or leather) sewn onto a cloth background to produce a pattern or picture much like a painting. Edges are commonly emphasised by cording made of silk thread wrapped around horsehair. Embroidery or painting may be used for details. Appliqué has been used in Central Asia and Tibet from prehistoric times for animal trappings, tent decorations and domestic furnishings. It is also commonly used for altar decorations and religious dance costumes. To produce the great quantity of appliquéd banners and adornments they required, monasteries established workshops, and great lamas travelled with personal appliqué masters. This practice continues today. The present Dalai Lama often commissions appliqué banners for the Kalachakra teachings he gives worldwide. On the occasion of the Seventh Panchen Lama's visit in the mid 1980s a giant appliqué banner was once again unfurled down the wall built long ago for this purpose at Tashilhunpo itself.

Notes see Appendix

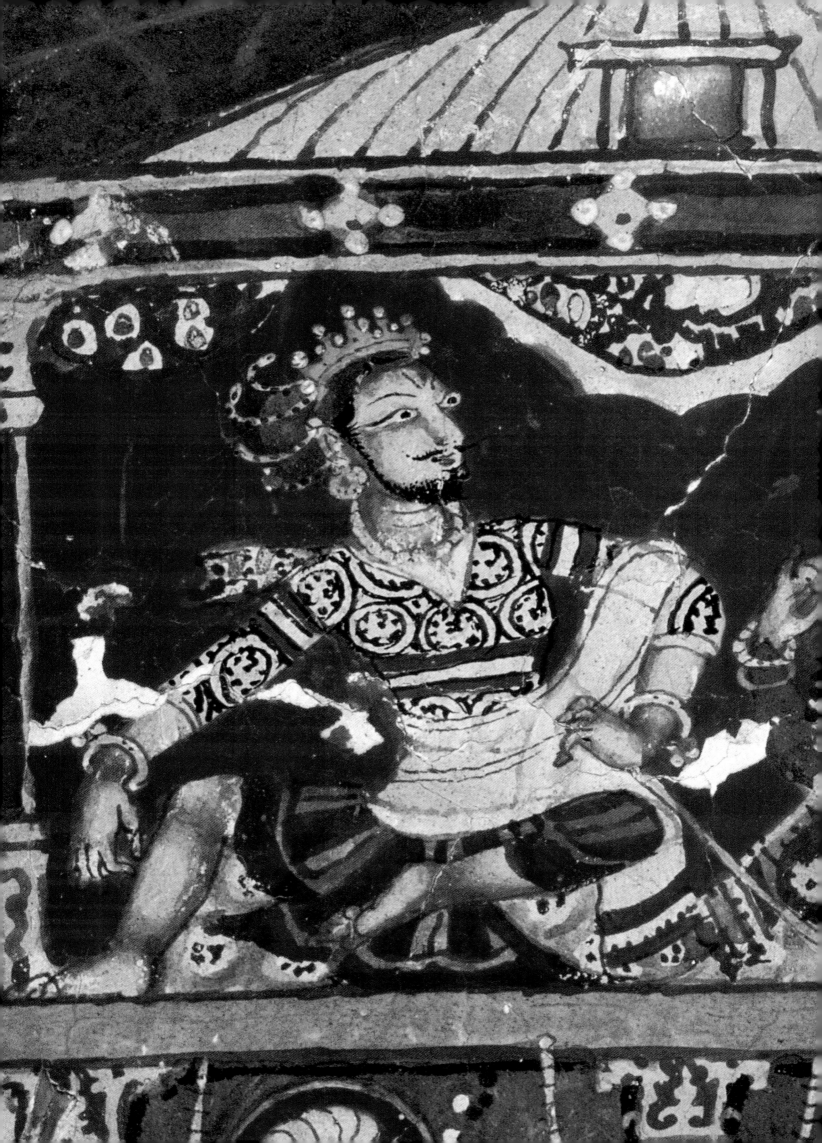

PAINTING

Roger Goepper

The ceiling paintings in the Sumtsek, or Three-Storeyed Temple at Alchi, in Ladakh close to western Tibet, are now thought – partly on the basis of new evidence – to have been painted around 1200 AD. They contain many representations of what are very likely to have been actual textiles of the time. Various resist-dyeing techniques, as well as embroidery and brocades can be identified. Mastery of the complex techniques needed to produce some of these textiles presupposes workshops of highly specialised artisans who must have been active within a rich court setting, under royal or noble patronage. Indian, Near Eastern, Iranian and even Hellenistic influences on the designs are shown to have been modified by local tradition.

Textile Representations in the Frescoes at Alchi

DRESSING THE TEMPLE

1. *Previous pages left:* The Sumtsek at Alchi, seen from the north.

2. *Previous pages right:* The goddess Remati over the entrance to the Sumtsek. The decoration of her garment, with back-to-back lions, is very close to that in (18).

3. *Left:* The temples of Alchi, seen from the right bank of the Indus.

5. *Facing page top left:* Entrance to the Sumtsek with Kashmiri style carved woodwork.

6. *Facing page top right:* Interior of the Sumtsek temple. View from the ground floor into the first upper storey.

Photographs courtesy Serindia Publications, London: figs. 6, 20, 25 by Roger Goepper; all other photographs by Jaroslav Poncar, Cologne

Over the past fifteen years the temples in the village of Alchi, Ladakh (3), with their comparatively well preserved murals, have been discussed in several publications.[1] In the past they have been dated to the 11th or 12th centuries AD, but the construction and decoration of the so-called Three-Storeyed Temple (*gSum-brtsegs*, transcribed here as 'Sumtsek') may now be convincingly placed in the very late 12th or even the early 13th century.[2] In this temple (**1**, **5**) the wall paintings remained in exceptionally good condition until very recently, when the increasing number of tourists entering the small building, as well as maltreatment by the villagers of Alchi and bad weather, have led to severe deterioration.

The main themes of the murals, which cover nearly every square inch of the inner wall surface of the building, are of course Buddhist, and have been analysed elsewhere. These paintings, however, are also an extremely useful source for secular conditions in Kashmir, reflecting the richness of its culture at the turning point from the Indian to the Islamic tradition, and in some respects functioning as illustrations to the text of the *Rajatarangini*, written around 1150 by Kalhana.[3] An interesting, thus far neglected, aspect of the paintings in the Sumtsek will be examined in this article.

Entering the Three-Storeyed Temple and looking upwards towards the richly painted ceilings, one's first impression is of seeing actual textiles fixed into the panels between the beams that bear the weight of the structure (**6**). Some of the panels look like genuine *plangis*, others like *batiks* or cloths dyed in other resist techniques. Only after the eyes have become accustomed to the dim twilight does one realise that the 'textiles' are actually painted onto the wooden boards that rest on the heavy ceiling beams.

The custom of decorating ceiling panels with textile designs can also be documented in other Buddhist buildings in Alchi as well as in the temples of Manggyu and Sumda, where the style of decoration is similar, to mention only a few examples that are especially close to those examined here. That there existed strong local differences in style may be seen in the ceilings of Tabo where the decorations have nothing in common with those of the 'Alchi tradition'. These decorations may stem from the habit of affixing real textiles to the ceilings, partly to embellish the interior, but partly also perhaps to prevent dust or particles of dirt from falling from the upper storey, which can be disturbing to visitors in Ladakhi houses. Possibly, however, we have here the local variant of a decorative scheme common throughout the Indian subcontinent, since the ceilings in Buddhist buildings in Sri Lanka may also be decorated with painted textiles.[4] The custom of covering walls and ceilings with colourful textiles is attested for the Vallabhacharya Sampradaya, a Krishna sect founded in the late 15th century. The hangings are called *pichhavai* when they cover walls, and *chandava* when they decorate ceilings.[5]

It seems evident for a number of reasons that the ceilings in the Sumtsek of Alchi represent real textiles as they existed at the time the ceilings were painted, in the decades

This article is a revised version of an article first published in Volume 56 of the *Transactions* of The Oriental Ceramic Society, London.

4. Panel 7: reproducing the effect of tie-resist dyeing.

7. Panel 19: reproducing the effect of double tie-resist dyeing.

around 1200. The puzzling illusionism of some of the paintings, for instance, appears at times to aim at a realistic rendering of existing dyeing techniques. Then there is a direct correlation between most of the panels with techniques of weaving and dyeing actually used in ancient times on the Indian subcontinent. And many designs on the ceilings can also be identifiedon clothes worn by figures, secular and religious, in the paintings of the Sumtsek and the Dukhang of Alchi.

In addition, hardly a single design on the ceilings can be related directly to patterns on later Indian textiles, while the grammar of their decorative elements and their composition can in some instances be traced back to earlier or contemporary decorative devices in Kashmir, and some examples may even be derived from the 'Iranian' tradition in its widest sense. This stands in striking contrast to the later development of Indian textiles and may furthermore serve as one of the arguments for excluding a later date for the secular scenes in Alchi.[6] Lastly, it is significant that in later temples in western Tibet and even in Alchi itself the decoration of the ceilings evidently follows a different artistic tradition and no longer imitates existing textiles.[7] Until recently it has not been possible to find actual examples of textiles to serve as proof for these suppositions. In the past few years, however, textiles have appeared that are beginning to fill the gap in the historic record, providing evidence for the ideas discussed above.[8]

A detailed and comprehensive study of the textile designs and costumes appearing in the murals of western Tibet, especially the well-preserved examples in the old temples of Alchi, together with the new material that has now become available, would surely extend our field of knowledge about the early history of North Indian and especially Kashmiri textiles. This article is intended as a small stimulus in this direction.

The ceilings in the Sumtsek of Alchi provide a suitable starting point for this research, since they are still comparatively intact[9] and offer a wide variety of designs. The ceilings of the ground floor and the first floor are divided into 48 oblong panels, 24 on each floor. They are arranged in three rows from the entrance to the back wall. The front and the back row contain nine panels each; the middle row is interrupted by a rectangular opening in the floor and has only six panels, three on each side of the opening. The panels have been numbered in a continuous sequence for both floors, beginning, looking upward, in the right corner of the building near the entrance wall, and proceeding to the left, the last number being in the left back corner.

As stated above, the pictures on the panels have been painted directly onto the wooden boards. No actual textiles have been pasted onto the boards as support for the paint layer, as was done for instance in Tabo. The colours and technique of the Tabo paintings correspond exactly with those of the wall paintings of the Sumtsek. Most of the panels appear to be preserved in their original state with hardly any overpainting or correction. Their fresh colours may be explained partly by the fact that the paintings face downwards, so that no

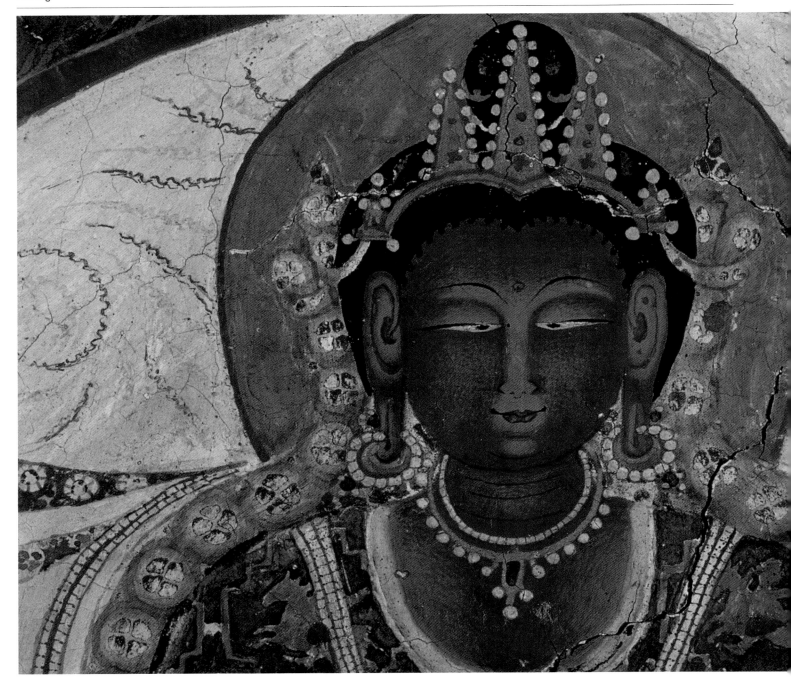

8. *Above: Amitabha in niche 1B, wearing a shawl reproducing resist-dye patterning.*

9. *Facing page below:* deity in the upper storey of the Sumtsek wearing a shawl with patterning similar to that in (11).

dust accumulated on them, and partly by the fact that the temple has been used hardly at all for rites during the past few centuries, so that no deposits of incense have built up. This last may explain the far better state of the murals in the Sumtsek compared to those in the Dukhang in Alchi, which was in use over a much longer period, and is occasionally used even today.

TEXTILE TECHNIQUES

Before analysing some characteristics of the ceiling designs, selected panels will be examined for their representation of certain identifiable techniques of textile decoration. Such identifications seem possible since the rendering of these techniques is often so realistic as to produce a *trompe l'œil* effect.

The comparatively simple resist technique of tie-dyeing must have been known in India at least as early as the 7th century AD, since it is mentioned in the *Harshacarita* and is represented in wall paintings of the period at Ajanta.[10] In Gujarat the term *bandhani* is used for textiles dyed using this technique; in Rajasthan it is called *chundari*. But tie-dyeing must have been known from early times in Tibet as well, and it is still in use there. Cloths dyed using the technique, which in the Western literature is often referred to by the Indonesian word *plangi*, are termed *phrug* in Tibetan.[11]

In the ceilings of the Sumtsek tie-dyeing appears in a few variations. In the simplest version the cloth is folded twice, then bound into little knobs near the folds and dyed in one colour. This results in light-coloured crosses with a 'halo' appearing on the monochrome

10. *Above:* **Hunting scene from the *dhoti* of the Avalokiteshvara sculpture in the Sumtsek, showing figures wearing garments with tie-resist dyeing.**

11. *Right:* **Panel 36: reproducing the effect of wax-resist dyeing.**

background, as for instance in panel 7 (**4**). Textiles dyed using this rather elementary *plangi* technique must have been quite common in Kashmir around 1200. Court ladies or queens can be seen wearing them, as for instance in the paintings of niche IA,[12] where under her white coat, a queen adoring the beautiful Green Tara in the centre wears a red dress completely dyed in this manner.

A more complicated *plangi* appears in panel 19 (**7**). The dyeing is done in two steps: first the material is folded and dyed to produce the blue crosses, then the areas around them are tied and finally the whole cloth is dyed red. The resulting design of blue crosses in whitish discs on a red background is the most common design on textiles worn by persons of widely differing social status in the murals. It seems to have been especially favoured for shawls, such as one worn by the Buddha Amitabha in niche IB (**8**), by an Apsara in the Dukhang, and even on a shawl worn by the Bodhisattva Manjusri in Manggyu.

A king in the Dukhang wears a kaftan-like dress with long sleeves covered with such *plangi* decoration, as do another king and one of his noble ministers riding out to hunt, represented on the *dhoti* of the monumental statue of Avalokiteshvara in the Sumtsek (**10**); a priest of Shiva engaged in making an offering and a musician of the king's entourage from the same circle of paintings are clad in similar costumes. The short jackets of commoners – including those of some of the figures exposed to the eight kinds of danger (*asta-bhaya*), shown at both sides of the Green Tara on the upper floor of the Sumtsek – are decorated in this technique, as are honorific parasols, the caparison of a horse and a cushion on which a priest is seated. The evidence is thus clear that even a dyeing technique as simple as *plangi*

was widely used for all kinds of purposes in various layers of society.

Tie-dyeing could of course be combined with other techniques for colouring or decorating textiles, for instance with stencilled decorations, or with wax-resist dyeing and mordant dyeing (**13**, **17**). In such combinations *plangi* is mainly applied for secondary motifs or for 'space-fillers' as shown by examples in the wall paintings.

The resist dyeing technique, generally known as *batik*, involves applying wax either with a stamp or a brush to the areas of the cloth not to be dyed. It is seen reproduced in painting in panels 36 (**11**) and 42, where even the irregularities in the wax resists are imitated. A female deity flanking the Eleven-Headed Avalokiteshvara on the first floor of the Sumtsek is depicted wearing a scarf in a similar technique (**9**).

Other resist dyeing techniques may be identified, for instance drawn or painted resists, which are difficult to distinguish from painted mordants. Panel 1 has slender dragon-like *vyalas*, fantastic animals prevalent in Indian decorative art, which must have been fairly popular since the design appears on several costumes and other textiles in the Sumtsek and Dukhang murals (**15**).[13]

The mordant dyeing technique can also be identified. During the dyeing process, the colour will 'take' in areas that have been mordanted, leaving the untreated parts of the cloth undyed. This technique is probably illustrated in panel 33 which shows mounted horsemen in two colours and in panels 39 (**13**) and 48 (**28**) with lively dancers. The decoration on a textile such as that depicted on panel 1, with its rows of fantastic *vyalas* (**15**), would probably have been produced by dyeing with two colours in succession, painting on the appropriate mordant in each case. Simple reserve dyeing seems to have been applied mainly for clothes worn by the common people, as in panel 40.[14]

Even the simple technique of stitching is represented on several panels. Since the stitched cross-like decorations on the robe of a Buddha on the second floor of the Sumtsek are presented in slight relief, the identification can hardly be doubted. Panel 12 may even imitate chain-stitching. Certain rich designs resembling brocade might also be interpreted as multicoloured embroidery. As reproduced in these paintings the two techniques can hardly be distinguished from one another.

Some of the more complicated patterns are surely meant to represent silk brocade, as in panels 4 and 18 (**12**, **16**). Several panels with friezes of varying colour depicting running animals (**14**) surely represent brocades with bands of changing colours in the pattern weft, a technique known as far east as China and Japan. It is typical of the technique that the patterned weft should cut through the decorative units regardless of the design, as it does in panel 27 (**19**).

Other complicated designs, especially the pearl roundels, would have been executed in

14. Panel 3: friezes of running animals, reproducing the lampas or brocade technique.

15. Panel 1: fantastic animals of the Indian *vyala* type, reproducing the effect of dyeing with mordants.

the extravagant weaving techniques of lampas or silk brocade that span the Asian continent. A lampas weave is a particular combination of two weaves, a foundation and a supplementary decorative weave, each having its own warps and wefts.[15]

Precise technical identification of the more complicated designs on the Sumtsek ceilings must, however, remain speculative. It is evident from the richly decorated *dhotis* worn by the three colossal clay statues of Bodhisattvas in the niches that the painters in the Alchi temples sometimes had particularly elaborate and luxurious textiles in mind. These designs, however, would be difficult to reproduce on actual textiles, other than by painting them. It is also evident that mastery of the technical complexity of such textiles presupposes workshops of highly specialised skilled workmen who must have been active within a rich court setting under the patronage of kings or nobles of high rank.

A SYNCRETIC CULTURE

Some of the many designs in the ceiling panels of the Sumtsek are typical of the syncretic character of Kashmiri culture in the decades around 1200. On the one hand they document the situation of Kashmir at a crossroads of trade routes, which affected nearly all aspects of local culture. On the other, the designs demonstrate how influences from foreign contexts were integrated and changed by local traditions. To document this only a few typical designs have been selected. An attempt is made to place them in a wider intercultural context, with the caveat that these are only preliminary, not to say sketchy, conclusions.

One of the most striking motifs to appear in several variations among the designs on the Sumtsek ceilings is that of crossed animals regardant: pairs of animals running or jumping past one another in opposite directions, their bodies crossing; in most cases they look back over their shoulders. The most common combination is that of a caparisoned elephant in front, passing a *vyala*. Sometimes they are so entangled that it is difficult to separate them visually. They appear to be fighting. The animals may be rendered fairly realistically as in panel 18 (**16**), which probably represents a piece of silk brocade or lampas on which some of the elephants' heads are turned to face the viewer, or they may be transformed into more ornamental and abstract forms as in panel 9 (**17**); the rendering here is perhaps dictated by dyeing techniques using wax resists or mordant dyes. The rich dress of the crowned Buddha Amitabha on the western wall of the ground floor may represent the wax-resist technique. It is also found on the ceiling of the so-called Great Stupa of Alchi and on that of the temple in Sumda, attesting to its popularity in the region. A variant with two *vyalas*, not represented in the ceilings of the Sumtsek, appears on the long skirt of the saviour Tara (*asta-bhaya-trana-Tara*) high up on the inner walls of the large stupa-like structure in Manggyu, half a day's walk down the River Indus from Alchi.

107

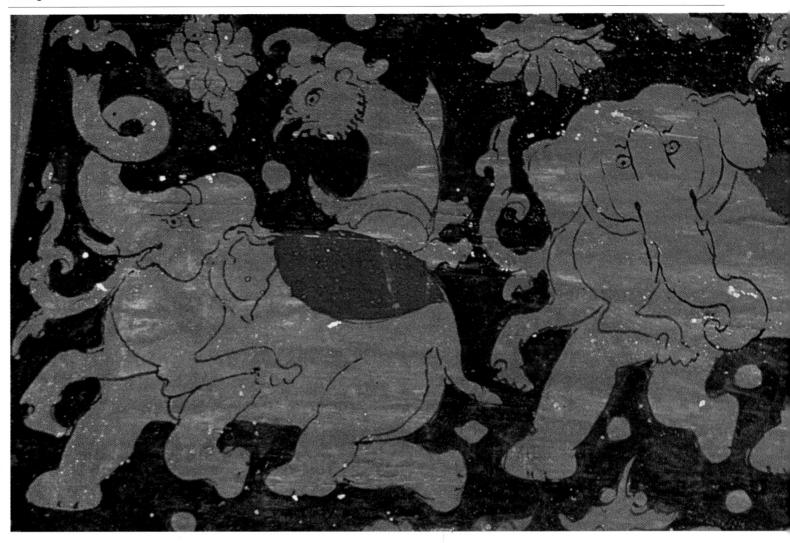

Two lions may also be depicted in this manner. In panel 11 (**18**), which depicts a figured silk, possibly in lampas or brocade rows of simple roundels are filled alternately with mounted archers aiming backwards over the hindquarters of their horses and with lions regardant. This variant may give a clue to the origin of the motif, as will presently be seen. It is used in exactly the same form on the kaftan of a dignitary in niche IA and, over the entrance to the Sumtsek, on the dress of the goddess Remati under her coat of peacock feathers (**2**).

Whereas pairs of animals facing each other or set back to back, often separated by floral or tree-like elements, are quite common in the catalogue of motifs which may be derived from Iranian or Near Eastern ornamental traditions, appearing frequently over wide areas of South and Central Asia, the versions in which part of one animal obscures part of the one behind seem to be comparatively rare. Possibly the motif has been singled out from the originally larger context of frieze-like hunting scenes. An interesting early predecessor may perhaps be seen in the lions on a silver bowl in the Hermitage in St Petersburg, where two antithetic hunting scenes with mounted archers are interlaced by the crossing of the two lions being pursued. The piece is Graeco-Iranian in style and may be dated to the 1st or 2nd centuries AD.[16]

Another silver bowl from the Swat region, now in the British Museum, is about two centuries later. Here two tigers, one attacking and one fleeing from a mounted bowman, figure in one and the same scene. The bowl was probably made during the 4th or early 5th centuries.[17] Two crossed lions appear as an ornamental unit in their own right, without archers, on an often reproduced partly gilt Sasanian silver bottle of the 6th to 7th centuries, once in the collection of P.D. Soltykova, and now in the Bibliothèque Nationale, Paris.[18]

Whether this motif really was distilled or isolated from the larger context of a hunting scene over the span of a few centuries – some of the possible steps in this progress are pointed out above – or whether it is just another variation of paired and more or less stylised animals can hardly be decided with certainty in this context. It is, however, significant that of the four remaining pearl roundels on a fragmentary square pillar, found in the courtyard of the Avantisvamin Temple, south of Srinagar, which was presumably an architectural element in the temple complex, two contain variations of crossed animals.[19] The piece is datable to the 9th century. The second roundel from the top shows two long-necked birds

16. *Above:* Panel 18: *vyalas* and caparisoned elephants crossing and regardant, reproducing lampas or brocade technique.

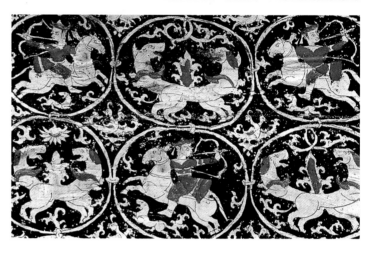

17. *Above:* **Panel 9: crossed animals regardant, possibly reproducing wax-resist or mordant dyeing.**

18. *Right:* **Panel 11: figured silk with crossed lions regardant and mounted Kashmiri horsemen.**

19. **Panel 27: medallions with animals in 'Sasanian' style, reproducing lampas or brocade technique.**

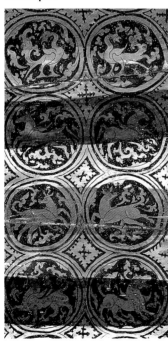

regardant holding a garland in their beaks, reminiscent of similar single birds in earlier Iranian art. The fourth roundel contains two sturdy lion-like creatures with heads turned back and faces touching (**22**).

Although these two examples are the only ones known to the author, they do verify that such pairings of animals set in pearl roundels were in use as compositional units in the decorative arts of Kashmir three centuries before the murals in Alchi were painted, also by Kashmiri artists. The apparent rarity of these earlier examples of the motif invests them with special importance. They also bear evidence that the theme of crossed animals was not confined to the applied art of textile decoration but also had a part in the sculptural tradition from which it probably originated.

Large pearl or beaded roundels are another striking compositional element in the ceilings of the Sumtsek; these roundels have far-reaching implications in the cultural history of Asia from its western edge to China and Japan. They consist of circular central panels with single figures or groups framed by one or two bands of small pearls or beads. There are three varying examples among the ceiling panels in the Sumtsek; three more panels are covered with roundels with simpler borders without pearls. Panel 43 (**20**) – probably imitating lampas or brocade – has five roundels, each with a running deer-like animal and a border of relatively large white pearls between two white lines. The space around the deer is filled with cloud-like elements, similar to those in the sculptured decorative bands of classical Kashmiri architecture. These same elements form the tips of the tails of the deer. Similar animals, but set in squares instead of roundels, decorate the *dhoti* of a Green Tara in niche IA. This panel, with its deer, is particularly close to earlier Sasanian silver work.

In contrast, the five roundels on panel 23 (**21**) present an interesting mixture of Near Eastern/Kashmiri themes on one hand, and purely Indian motifs on the other. Three roundels with neatly drawn bowmen aiming back at lions alternate with two roundels containing half-naked female dancers, clad only in Indian *dhotis*, performing an agitated dance with swords and square shields. These themes and their implications are discussed below.

The third panel of this type, panel 6 (**25**), has only four roundels and these have more elaborate borders: two concentric rows of white pearls frame a broad circular frieze with dark green running beasts and stylised clouds on a black background. Two of the bowmen

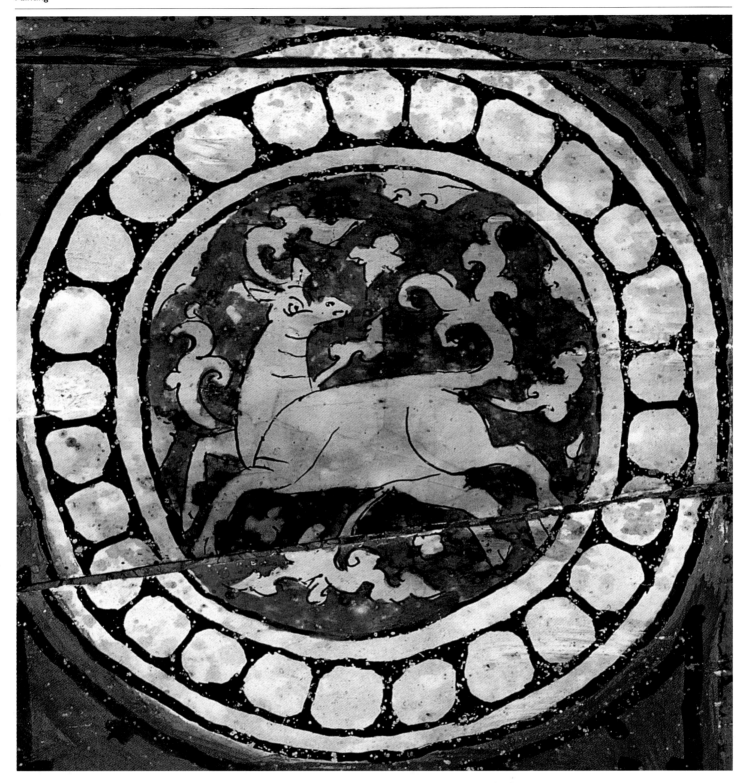

20. Panel 43: pearl roundel with 'Sasanian' deer, probably reproducing lampas or brocade technique.

in the roundels are mounted on galloping horses and are shown with lions or gazelles; the other two ride running male elephants – the prey is missing in these roundels, probably for lack of space. The elephants add an obvious Indian touch to a theme that is basically more associated with West Asian iconography.

Roundels with or without pearl borders are among the commonest textile designs throughout Asia, from the Mediterranean to China and Japan, from the 4th century AD well into the second millennium. In her fundamental study of early Iranian textiles, Phyllis Ackermann derives pearl roundels from bracteates, gilded or silvered medal-like ornaments for clothing, and she sees the Achaemenid bracteates of Persia[20] as the immediate prototypes for pearl roundels on textiles. On the other hand, Otto von Falke, in his monumental history of silk weaving, traces the origin of connected roundels without pearl borders back to mosaic works of late antiquity within the cultural sphere of Syria and Alexandria. The influence of these mosaics extended to Rome and the motif was transmitted to Sasanian textile decoration.[21]

A similar design with a wreath of small leaves as a border instead of the pearls, used as a

110

21. Panel 23: pearl roundel with female dancers, demonstrating the transformation of a Near Eastern into an Indian motif.

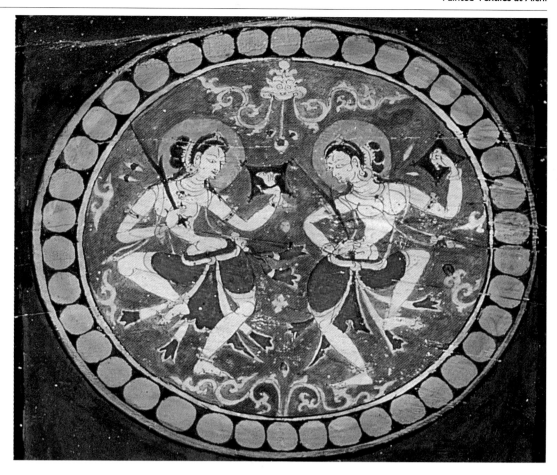

22. Detail of a square pillar in the 9th century Avantisvamin Temple, near Srinagar, showing a pearl roundel with crossed lions regardant.

basic structural element of a pattern on cloth, appears as early as the 1st century AD in Parthian art as a direct antecedent to the later Sasanian textile decoration. This, among other designs, adorns the garments of figures in the large rock reliefs of Taq-i-Bustan (ca. 600 AD),[22] and in the Sasanian period it was also transferred to stucco work, serving as architectural decoration.[23]

The roundel is found in several variations on most of the well known archaeological sites along the Silk Route in Central Asia. Far to the west, in Varakhsha, in wall paintings of the 6th century, the borders of caparisons on elephants display segments of large pearl roundels which have been cut and used without any regard to their central motif.[24] It is interesting to find actual cases of such disregard for the design: silks with fine pearl roundels were cut for use as borders for book covers in Dunhuang during the 7th and 8th centuries.[25] The widespread motif of stylised boar's heads in pearl roundels is documented in Afrasiyab.[26] Very simple roundels containing star-like flowers instead of figures serve as decorations on the garment of a kneeling devotee beside an altar in the murals of Varakhsha; a similar design decorates a stucco band in the eastern multi-columned *aiwan*.[27]

In the wall paintings of Pjandzikent (7th to 8th centuries) trimmed segments of pearl roundels appear in the borders of the caparison on what appears to be a camel and on a carpet-like textile on which a member of the nobility is seated.[28] Fragments of wooden panels, on which a mounted bowman aims back over the hindquarters of his horse, and a group of five standing figures is framed by a border with rosettes in place of simple pearls, have also been found in Pjandzikent. These pieces may have served as architectural decorations.[29]

A simple version of a heraldic flower with a pearl border, as well as the familiar versions with a stylised boar's head and with the head of a bearded man, are found in the murals of the late 5th to the early 8th centuries at Balalyk Tepe.[30] A fragment of a clay medallion which displays a fantastic phoenix-like bird within a beaded border,[31] presumably from an architectural context, has been unearthed in the Toqquz Sarai of Tumshuq.

The pearl roundel with a duck holding a string of pearls in its beak from the Great Cave in Kizyl (6th century) has several times been quoted as an example of how far Sasanian motifs migrated to the east. Intermediate links have been found in Bamiyan and Varakhsha, and nearly identical versions in Kuca.[32] A very well known wooden reliquary with a conical lid,[33] decorated all over with colourful paintings is also from Kuca. The lid displays pearl roundels with winged putti playing musical instruments. The figures are reminiscent of

23. Panel 23: pearl roundel with a mounted horseman wearing a typical Kashmiri hat.

putti found in the wall paintings of Miran and attest to the wide variety of motifs which were used in the central panels of the roundels.

The area dominated by Chinese culture has yielded a large number of actual examples of patterned silks decorated with pearl roundels.[34] Some of these were used as face-covers (*fu mian*) for the dead; for the most part they are preserved in the arid climate of the frontier zones of western China, in the tombs of Astana and Kara Khojo,[35] for example. In the last few decades fifty pieces of silk decorated with pearl roundels have come to light in the area of Turfan alone, many of them from tombs dated between 551 and 706. Both borders and main motifs can be grouped according to traditions with varied provenance.[36]

Only a close technical analysis of the actual silks will provide clues as to whether or not they were produced in China proper, borrowing Sasanian decorative devices. One possible production source is Sogdia, which was an active silk-weaving centre during the 7th and 8th centuries AD. In an article on the excavated examples from Astana the Chinese scholar Wu Min comes to the conclusion that many of them must have been woven in Shu, an old name for Sichuan.[37] The earlier examples, from the second half of the 6th century, are still very Chinese in style whereas the examples from the Tang period in the 7th and 8th centuries look comparatively 'international' in their adaptation of western, primarily Sasanian motifs. They are yet another striking example of the cosmopolitan character of Tang culture. The trimmed roundels on the silk borders of book-roll covers, dating from the 8th century and discovered in the caves of Dunhuang, have already been mentioned.

Apart from such examples of actual textiles, pearl roundels also appear in painted form on the *dhotis* of clay sculptures of Bodhisattvas in the Dunhuang caves dating from the Sui Dynasty (581-618). According to the description given by N. Diakonova in her study of Sasanian textiles they contain winged horses, which she calls 'pegasuses'.[38] The comparatively large size of the roundels places them in the mainstream of the pattern, which extends from Iran over the Asian continent. The most easterly representatives of the motif are found in the renowned patterned silks preserved in the Hōryūji and the Shōsō-in repositories of Nara, Japan, which in fact are much closer to the Near Eastern prototypes than are the examples from Alchi.

This sketchy survey of the distribution and variety of pearl roundels

24. Detail of a square pillar in Avantisvamin Temple; pearl roundel with a rider on a fantastic animal.

25. Panel 6: pearl roundel with a mounted bowman on an elephant, demonstrating the combining of Iranian and Indian elements.

demonstrates the many versions which must be taken into account in order to pinpoint the special characteristics of the examples in the Alchi ceilings. Although they are similar in terms of composition, the design of pearled medallions at Alchi differs considerably from that of the earlier models. Whereas the roundels found on the murals of Bamiyan in Afghanistan, which is nearer to Ladakh than it is to Central Asia, closely follow the so-called 'Sasanian' pattern, the roundels in the Sumtsek of Alchi look unmistakably 'Indian'.

Even the mounted archers whose horses move at a flying gallop and who aim their arrows back over the hindquarters of their horses, not to speak of the half-naked female dancers, differ in many respects from the Iranian prototypes. The garments of the archers look like a Kashmiri version of the dress of Central Asian horsemen. In the Sumtsek the archers wear two slightly different versions of this costume: one consists of a coat-like jacket held together at the waist by a broad belt, with wide trousers and pointed, half-length boots. The long hair of the rider is tied around his head with a band with two large knots at the temples, the ends of which float freely in the air. This version appears in panels 6 and 23 (**25, 23**). In spite of the floating bands at the sides of the head, which are slightly reminiscent of Sasanian headbands, the figures as a whole look entirely Kashmiri. The second version, represented in panels 4 and 11, is similar, but the headband is replaced by a hat with an upturned brim and a pointed crown (**12, 18**).

The attire of these archers is much simpler than that of the noblemen engaged in falconry on Avalokiteshvara's *dhoti* in the Sumtsek, but it corresponds exactly to that of the mounted bowmen in the lowest frieze on the wall to the left of the entrance within the Dukhang of

113

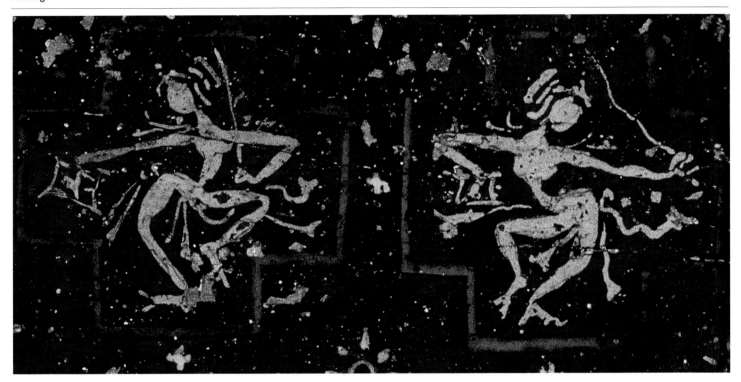

Alchi and also to the attire in similar friezes in Manggyu. The ceilings of Sumda in Zangskar have the same motif, but the bowmen wear helmet-like caps.

It is surely more than a striking coincidence that the topmost roundel of the rectangular pillar fragment in the Avantsvamin Temple, mentioned earlier, which is dated to the 9th century, shows a rider mounted on a fantastic animal, perhaps a sturdy lion, and clad in the same style as his later brothers in Alchi, wearing a jacket and pointed half-length boots (**24**). Whether his head is covered by a hat or his hair is tied with a ribbon cannot be ascertained because of the mutilated state of the stone. Nonetheless, the set of garments described above seems to have been used by horsemen in Kashmir between the 9th and the early 13th centuries. And it differs in some respects from the dress of Iranian horsemen. This leads to the inevitable conclusion that the textiles copied on the ceilings of Alchi were not imports from more westerly lands but were local Kashmiri products in the decoration of which foreign influences had been integrated and changed to conform with local taste.

Similar conclusions must be drawn when looking at the motif of dancers, which is used as the central decoration in pearl roundels, and also appears in other compositions. The same overlapping of cultural traditions, one purely Indian, the other deriving from a more northwesterly context, may be observed. The two pairs of female dancers adorning roundels in panel 23 (**21**) are unmistakably Indian; the design represents a complicated lampas or brocade. The upper parts of their heavy-breasted bodies are bare apart from jewellery. Their hips and thighs are covered with *dhotis* of a dark greenish-blue. The ends of their belts float freely at their sides. The black hair of the neatly drawn girls is tied into decorative knots at the backs of their heads. They are engaged in a martial dance, swinging double-pointed swords and holding small squarish shields. Apparently this is not a real fight. Their movements are agitated, even acrobatic. Stylistically comparable, similarly dressed, single four-armed dancers decorate the *dhoti* of a Green Tara in niche IA of the Sumtsek, and a comparable motif may be seen on the ceilings inside the so-called Great Stupa of Alchi.

Whereas in panel 23 (**21**) the dancers are represented quite realistically, in panel 32 (**26**) they are simplified as white silhouettes on a dark purple background; 33 dancers are set in cruciform fields outlined in blue. This surely suggests resist dyeing. On panel 39 (**13**) there are 24 dancers in two rows, this time as blue silhouettes on a mottled background. Here the intention may be to depict male dancers, as they are depicted in extremely agitated acrobatic poses. Some have daggers in addition to swords, and their shields are either round or square. One balances a sword on its tip in the palm of his hand. The hair of each dancer is tied with a ribbon into two large knots at the side of his head, the ends of the ribbon floating free. The figure in the lower right corner is

26. Panel 32: female dancers with sword and shield, possibly reproducing the effect of resist dyeing.

27. Panel 44: male dancers in kaftan-like dress within a design of connected swastikas.

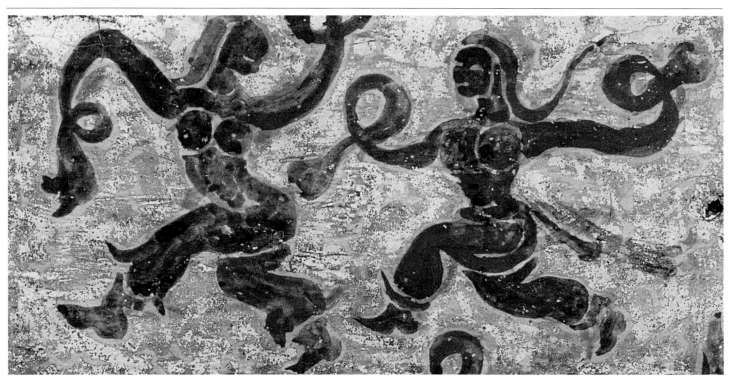

28. Panel 48: female dancers with elongated sleeves, reminiscent of Tang Chinese traditions.

definitely male, wearing a jacket like that of the mounted hunters. The technique represented here is most probably stencil resist dyeing and it is to a certain extent reminiscent of a 15th century Indian fragment found in Fustat, Egypt.[39]

Two other panels with dancers indicate a probable Central Asian connection. Panel 44 (**27**) depicts 24 small figures of male dancers placed between a swastika meander in blue and white lines. The dyeing techniques indicated here probably included resists or painted mordants. The dancers wear long kaftans, white on one side, brown or blue on the other. One of the tight sleeves is of normal length and exposes the hand, the other is very long and falls over the hand like a shawl, forming loops and curves in the air when the arm is moved. In addition the men are clad in long trousers and pointed boots. The usual ribbons with two knots and flowing ends are tied around their heads.

A similar effect is seen on panel 48 (**28**) where nine pairs of female dancers with large breasts and flowing hair are shown as green silhouettes on a purplish background. In this case both sleeves are notably elongated and accentuate the fluent movements of the female body. Both panels, but especially the last one, are reminiscent of the stories told in Tang China about foreign dancing girls whose graceful movements, enhanced by the elongated sleeves of their garments, inspired Chinese calligraphers and painters to achieve a more fluent style in their art.[40] This is one more clue to the cosmopolitan and syncretic character of the late phase of Kashmiri culture. In this case as well there are counterparts to the dancing girls, also represented half naked, in earlier silverware from Iran and the Near East, but they are formally and stylistically so different that it is hardly possible to ascribe a pattern of development or relationship.

The most frequently occurring decorative device on the Sumtsek ceilings are panels with horizontal stripes in different colours with friezes of running animals (**14**). Strangely, textiles with this design are worn by neither people nor deities on the wall paintings of the Sumtsek, but the same decoration appears on the ceilings of the Great Stupa of Alchi and with some slight variations on the ceilings of the Jampal Lhakhang of Alchi and the temple of Sumda. The direction in which the animals are running alternates in each frieze. All the animals – humped bulls, *vyalas*, horses and lions – are winged apart from the bulls; their tails terminate in floral or cloud-like scrolls as they appear over and over again as space fillers in Alchi and in earlier architectural decorations in Kashmir. They are probably ultimately derived from similar forms in the art of the Gupta period.

Of course it might be tempting to connect this design with the friezes of running animals on the so-called 'moonstones' (*chandrakhanda-pasana*), stepping-stones to the stairs leading to stupas and temples at Anuradhapura and Polonnaruwa in Sri Lanka,[41] but here the different animals are mostly grouped together in one single frieze and they are imbued with a clear symbolic meaning. Probably it is more than coincidental that the groups of quadrupeds on the moonstones are composed of the same animals apart from one. In Sri Lanka an elephant takes the place of the *vyala*, and both animals may express the same symbolic meaning. However, since textiles decorated in this way are in no single instance worn by people in

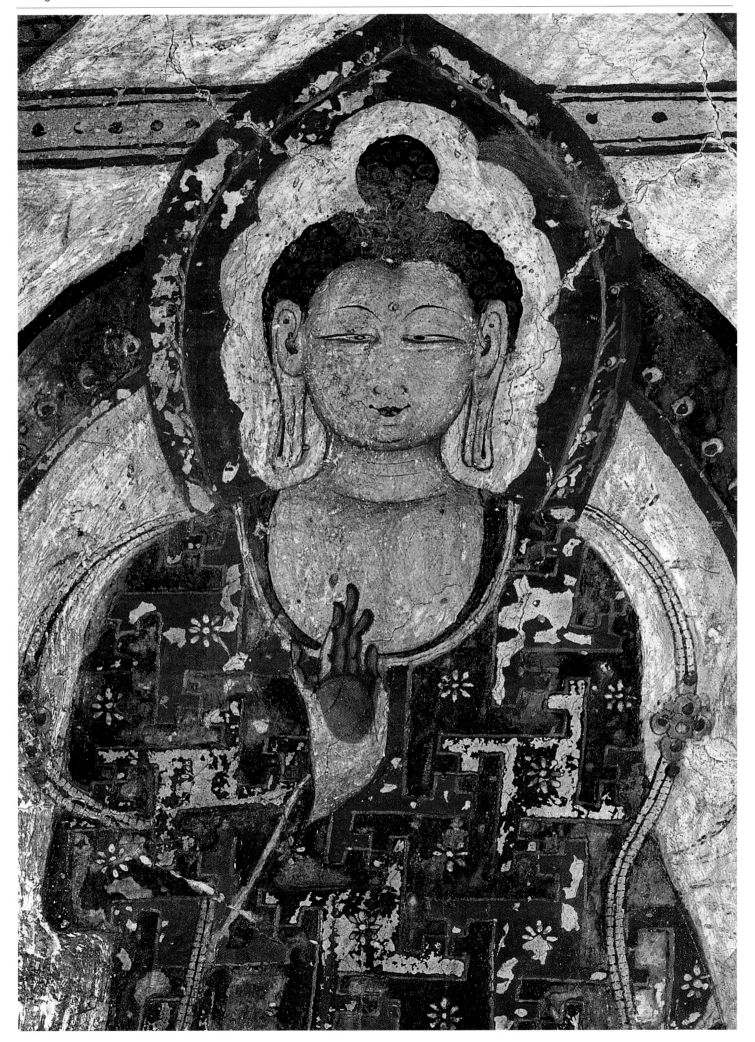

29. *Facing page:* **Standing Buddha wearing a garment with ornament of connected swastikas, similar to (30), niche IA.**

30. *Right:* **Panel 16: connected swastikas, a design originally of Hellenistic derivation.**

31. Panel 38: connected swastikas and rosettes.

the Alchi paintings, one may conclude that they served exclusively ritualistic purposes.

Another design with latent and concealed relations to cultural areas outside Kashmir is that of connected swastikas. In Alchi the swastikas do not appear as the central motif of the design, since they are formed by lines of two different colours running diagonally to the sides of the panel and at right angles to one another across the whole panel and crossing in the centre of the swastikas. The complicated geometric planes between these lines seem to have more importance than the swastikas themselves, since they may either be filled in with two different colours or decorated with ornamental motifs such as star-like rosettes (**31**) or stylised *vyalas* or both alternating with one another (**30**). One panel even has the small figures of dancers with long sleeves. This design seems to have been fairly popular: it not only appears on the ceilings of the Great Stupas of Alchi and of Sumda, it also adorns the robes of a standing Buddha in niche IA of the Sumtsek (**29**), of the colossal clay figure of a Buddha in the temple of Wanla and also of a high ranking person, possibly a king, in the wall paintings of the Dukhang. Variants are seen in the rich robes of Amitabha and Aksobhya on the walls of the Sumtsek.

It can hardly be doubted that the design was introduced from the northwest, either directly or via India. An Indian predecessor may be seen in a relief frieze on the Dhamekh Stupa in Sarnath, datable to the 7th century.[42] An extremely fascinating parallel can be found on a soffit ornament in stucco relief in the Sasanian Palace I, location A, at Kish in Mesopotamia, where the empty spaces between connected swastikas or a so-called gamma cross meander are filled with rosettes.[43] A similar design decorates the stucco section of a revetment, supposedly found in the Sasanian or slightly post-Sasanian ruins of Ctesiphon and now in the Metropolitan Museum of Art, New York,[44] with the only difference that here a rudimentary palmette alternates with the rosettes. J. Baltrusaitis traces the origin of this design back to arrangements of swastikas on Susa pottery and later Cretan art and quotes examples from the Hellenic and Roman area. He also offers two ways of reading this device, either by explaining it as a combination of two diagonally meandering lines that form swastikas at the points where they cross, as with the versions in the Sumtsek ceilings where the two lines are drawn in different colours, or as a space-filling pattern of connected swastikas.[45]

It seems evident, then, that these paintings represent real textiles. Their designs are clearly neither Tibetan nor purely Indian, but are perfectly in accordance with trends in contemporary Kashmiri art, as far as it is known. They appear as an amalgam of heterogeneous artistic traditions from several cultural areas – India, Iran, the Near East – and even reveal the after-effects of distant Hellenistic roots. In some cases, such as the pearl roundels, the design constitutes the last representative of an age-old tradition. But all these different strands have been woven into a distinctive vernacular which must have also existed in the other decorative arts of Kashmir, as the isolated architectural fragment from the Avantisvamin Temple has shown.

The Sumtsek ceilings also allow a rare glimpse into Kashmiri society. On the one hand we see the richness and technical refinement of courtly robes, on the other the simpler, but still beautiful clothing of commoners. This leads to the conviction that a detailed analysis of all the murals at Alchi could eventually lead to a wider knowledge of Kashmiri culture during the period of its still glorious twilight, before it was overrun by Islam.

Notes see Appendix

VISIONS OF BUDDHA LANDS
The Dunhuang Caves

Roderick Whitfield

Over a period of a thousand years caves were cut into the remote cliffs near Dunhuang, at the point where the Silk Road divides, one branch going westwards to the north of the Taklamakan Desert, the other to the south. The caves were decorated with wall and ceiling paintings depicting the Buddhist paradises, visions of immeasurable splendour, and with stucco images. Everyday life is illustrated in the narrative episodes of the *sūtras*, and the imperial power of China is reflected in the hierarchical arrangements of the Buddha and the Bodhisattvas. Nearly five hundred of the caves survive in the dry climate that also preserved hoards of manuscripts, paintings on silk, textiles and embroideries.

118

3. *Stūpa* memorials to Buddhist monks, standing to the east of the caves. The nine-storeyed roofs over the colossal Buddha image in Cave 96 can be seen in the centre, beyond the fringe of trees on the banks of the Daquan riverbed.
All images in this article are courtesy NHK Publishing (Japan Broadcast Publishing Co. Ltd.), Tokyo, and Textile & Art Publications Ltd., London. Photography Seigo Otsuka.

4. *Yaksa* demon in a corner of the ceiling pattern, from a cave of the Northern Zhou dynasty (557-580). In many early caves, the red pigment originally used for broad outlines of figures, and for some of the ornament, has gone black, heightening their dramatic impact. Only when the surface has been protected from light, as in the upper body of the Bodhisattva in (10), can the original intention be seen.

In 366 AD, a Buddhist monk called Yuezun cut a small cave high up an imposing cliff at the edge of the desert dunes known as Mingsha shan, or Dunes of the Singing Sands, on the western border of China. The site was less than a day's journey from the town of Dunhuang, an ancient commandery established in 111 BC by Emperor Wudi of the Han dynasty to control the route from China to the West. Remote and almost inaccessible, Yuezun's cave was probably intended for solitary meditation in a wilderness area: the murals along the top of the walls of Cave 285 show a series of solitary hermits, each in his own mountain cell (14). Though the first cave has long perished in the collapse of a short section of the gravel conglomerate cliff, it was soon followed by others (8) in an uninterrupted series, many of them far larger and grander, and splendidly ornamented to reflect the glory of Buddhist paradises, especially the Pure Land of Amitābha, Buddha of Boundless Light (18). Depictions of textiles, or of patterns similar to those found on Chinese and Western silks, are found in every cave, in textile valances and canopies (11) as well as in the splendid garments worn by heavenly beings (9).

Actively cut and maintained over a millennium, the Dunhuang caves were the physical embodiment of visions of jewelled Buddha lands. Moreover, Dunhuang was simply too remote to feel the effect of anti-religious persecutions that took place in central China. The area was in fact under Tibetan and not Chinese control during the Huichang persecution of 842-45, when 4,600 Chinese temples and monasteries, 40,000 smaller shrines and 260,000 monks and nuns were laicised. So work continued at Dunhuang without serious interruption until the Yuan dynasty when Cave 3, the last cave, sited near the northern end of the long cliff, was cut and painted in 1357, almost a thousand years later than Yuezun's cave of 366.

Throughout this long period, portraits of donors are found in a great many of the caves. They range from ordinary monks (17), to important officials or their wives from prefectures near Dunhuang; the figures gradually become larger after modest beginnings, in response to political changes. From the 9th to the 14th centuries, it was common for some of the older caves to be partly or wholly refurbished, skimming the old decoration with a new coat of plaster and repainting (10), or, in many cases, simply renewing the entrance corridor, with prominent portrayals of the new donors. In a few caves, the rulers of Khotan, Tibet or China are seen with their attendants and accompanying rulers of other states, as the audience at a religious debate (15), or as mourners at the scene of Buddha's *nirvāṇa* or extinction (16). Buddhism could thus be seen to enjoy the favour of the highest in the land. The hierarchical arrangement of Buddha and Bodhisattvas (6), or of Buddha, disciples, Bodhisattvas and magnificently armoured Heavenly Kings also reflected the imperial power of China (12). The concerns of ordinary people, on the other hand, both spiritual and practical, are shown in the depiction of the perils of travel and commerce, or of everyday life, as illustrations to narrative episodes in the *sūtras*.

The most spectacular murals are those where a later layer has been removed to reveal the original colouring at its most brilliant, as in Cave 220, dated 642 (18, 19). The date coincides with the reign of the great warrior Emperor Taizong, and with the inspiring 16-year journey to India (629-645) of the monk Xuanzang in search of Buddhist *sūtras* and images. At this time the greatest influences on the art of the Buddhist caves at Dunhuang came not from India, nor from the Buddhist centres of Central Asia, but from Chang'an, the capital of the Tang dynasty, where great artists of the day imagined new ways of portraying the paradisiacal scenes described in the *sūtras*, so elegantly translated into Chinese through the labours of teams of translators and scribes. The dancers and the musicians shown in the foreground of the Pure Lands (18, 19) are like those who performed in the metropolis: the music and dances, the instruments, and in many instances the performers themselves, were from Kucha or further west, but it was Chinese artists, painting on the walls of the great monasteries and temples of Chang'an and Luoyang, as well as on the finest silk, who created the compositions that were then transmitted and reproduced to the farthest corners of the empire, nowhere more successfully than at Dunhuang.

Dunhuang's position near the point where the two main branches of the Silk Road divided to take the northern or the southern route by oases on the edges of the impassable

Taklamakan desert, ensured that almost all travellers broke their journey here, and made offerings to ensure their safe passage, or to give thanks. The residents of Dunhuang included monks from India and Buddhist centres in Central Asia, merchants from Sogdiana and other western Asian countries, Chinese and Tibetan administrators and officials. All of them contributed to the prosperity of the monasteries in the town of Dunhuang, and hundreds were portrayed as donors on the walls of the cliff-cut caves, of which some 492 survive today.

No further caves were cut after the Yuan dynasty and though many were repaired in the Qing dynasty (1644-1912), the stucco images generally suffered more than the murals. Graffiti testify to Chinese visits over the centuries, but in 1878 a Hungarian explorer, Ferdinand de Loczy, with two companions, was the first Western visitor in modern times to encounter this amazing site. In 1900, a Daoist priest who had established himself there discovered a hidden cache of documents and paintings, sealed behind an 11th century mural. Another Hungarian, Aurel Stein, was quick to investigate and to secure a great quantity of manuscripts and silk paintings from the cache for the British Museum and the Government of India on his second expedition of archaeological exploration from 1906 to 1909. A year later than Stein, Paul Pelliot made a more informed selection of the most important remaining documents and paintings, now in the Bibliothèque Nationale and the Musée Guimet. His painstaking notes of all the legible inscriptions in Chinese and other scripts are still of use today, and have proved to be remarkably accurate.

The dry climate and the remoteness of the site, as well as the sheer numbers of the caves themselves, all helped to preserve the hidden store of votive paintings, *sūtra* manuscripts, secular documents, woodblock prints, and silk textiles and embroideries, as well as the murals and stucco images of the caves. Since then, the existence of this international archive has fostered a whole new field of scholarship worldwide, while at the site the Dunhuang Academy under the direction of Mr Duan Wen-jie has its own specialised staff and series of international publications, both monographs and journals, investigating every aspect of the caves and their contents, as well as carrying out scientific work in co-operation with international organisations such as the Getty Conservation Institute to assure the conservation of the mural paintings, stucco images and the structure of the cliff.

1. *Previous pages, inset left:* **Detail of the landscape from the meditation hall, Cave 285 (14). The overlapping pointed peaks, originally crowned by tall trees, of which only the foliage now remains, are rendered in broad bands of colours in two tones, to give the effect of distance.**

2. *Previous pages:* **General view of the Dunhuang caves looking south along the cliff face. The caves were cut into the gravel conglomerate at the edge of the Mingsha dunes, which rise beyond. The tallest construction, nine storeys high, protects Cave 96, where one of two colossal images of Buddha at the site is to be found.**

5. **Dancers from a depiction of the Pure Land of Amitābha, the Buddha of Boundless Light, dated 642. They dance in Central Asian fashion with whirling scarves, on tiny oval or circular fringed carpets. The dance floor is a precious pavement between two orchestral bands of musicians. The crinkled hems of their skirts display a fashion brought to Tang China in the 8th century by the Central Asian painter Yüchi Yiseng.**

All material in this article is drawn from *Dunhuang, Caves of the Singing Sands: Buddhist Art from the Silk Road,* by Roderick Whitfield, to be published in English by Textile & Art Publications Ltd., London, and simultaneously in German by Hirmer Verlag, Munich, in October 1995. The book is a new 2-volume revised edition, with 400 colour plates, of the original Japanese publication *The Art of Dunhuang (1992).*

122

6. *Above:* Three Buddha triads, over twice life size, dominate the main hall of the late 6th century Cave 427, whose walls and ceiling are completely covered with the Thousand Buddha motif. The triad expresses the Mahāyāna (Greater Vehicle) doctrine of universal salvation, through the agency of Bodhisattvas, enlightened figures who stand on either side of the Buddha.

7. *Right:* Figures mutilating themselves, detail from a group of rulers of different countries at the feet of the Buddha in *nirvāṇa*, Cave 158. Exotic ways of expressing extreme grief are displayed in this scene, along with costumes and headgear equally distinctive of various countries and tribes. Note the pearled lotus medallion.

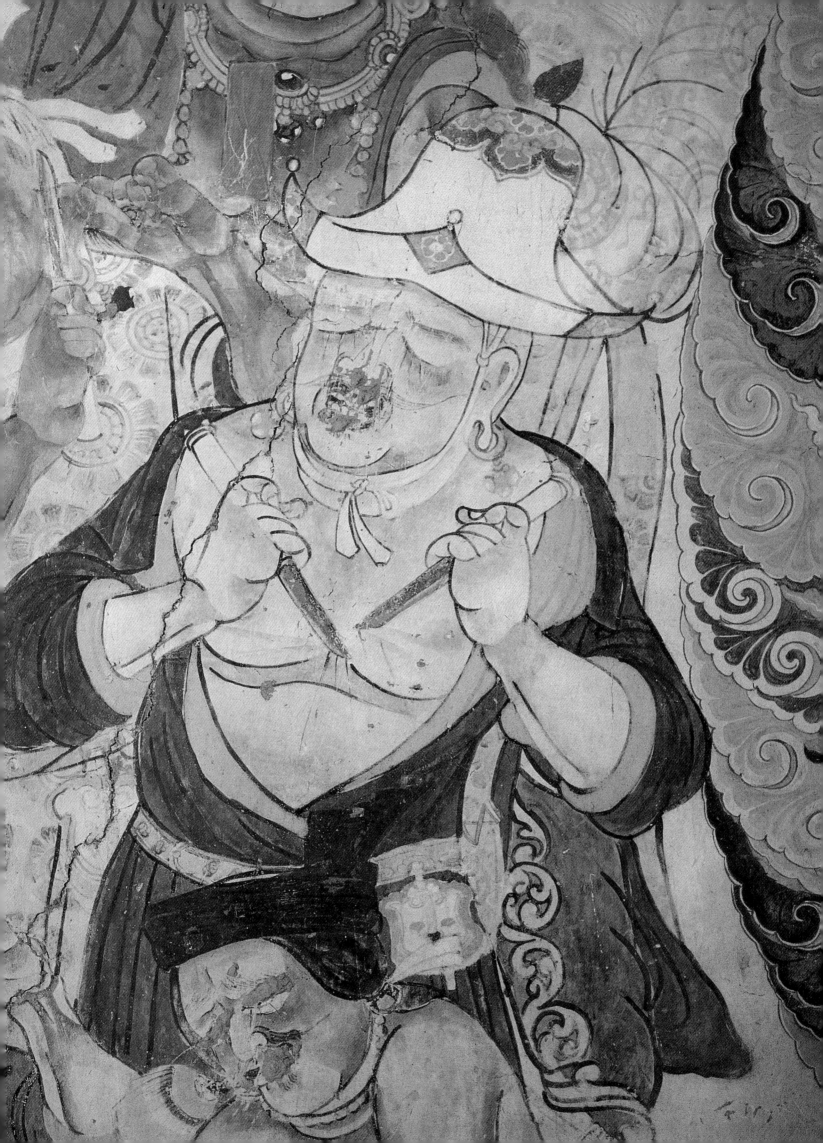

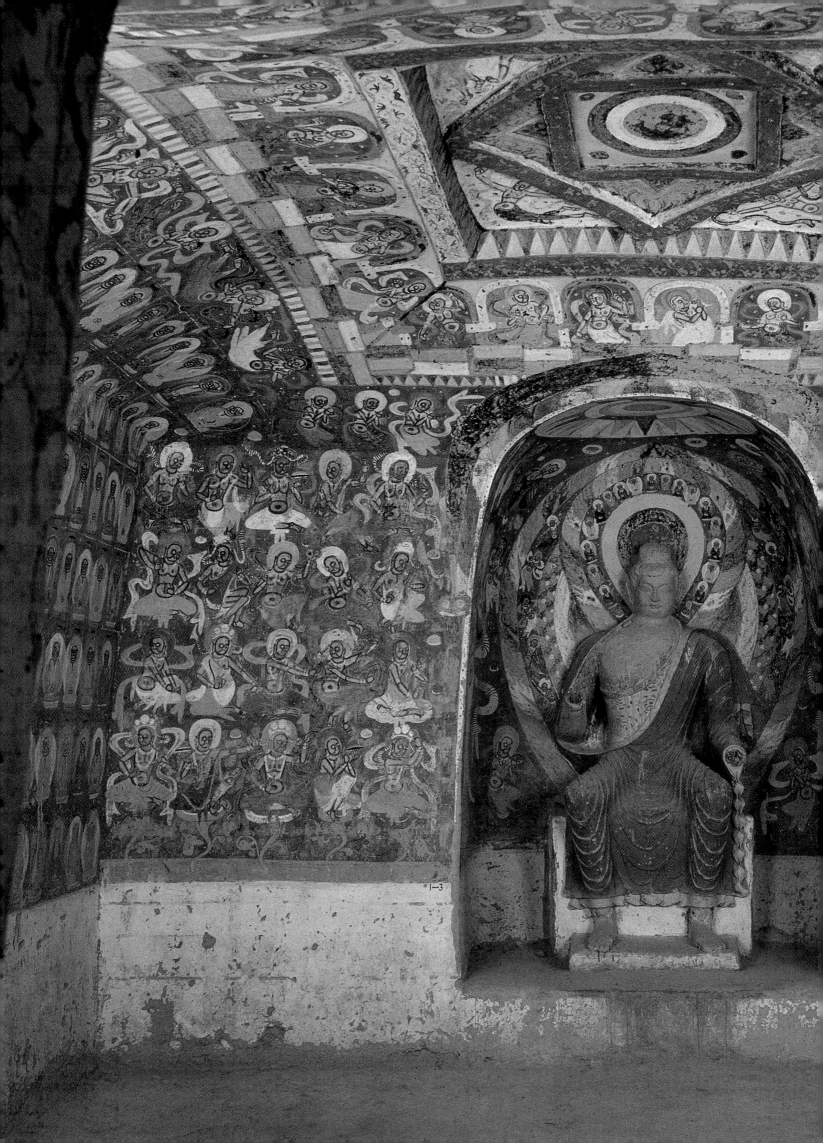

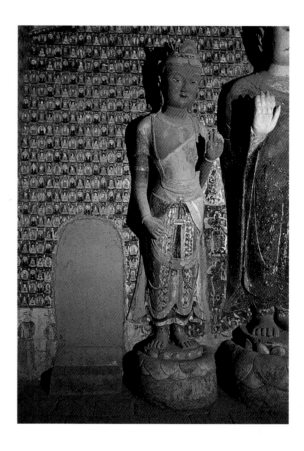

9. *Above:* **Detail of (6). Bodhisattvas wear jewellery and richly-ornamented garments, representing embroidered and woven designs, in contrast to the plain monk's robe of the Buddha. The floral scrolls of the blue and green shawls worn over the shoulder reflect embroidered designs, while the lozenge-based designs of the undershirt and** *dhoti* **or skirt, fastened at the waist, are based on woven silk brocades.**

8. *Left:* **There is room for only a few persons inside the earliest surviving cave, dating from the Northern Liang dynasty (early 5th century, before 439). The seated image represents Maitreya, Buddha of the Future, surrounded by musicians in his heavenly abode.**

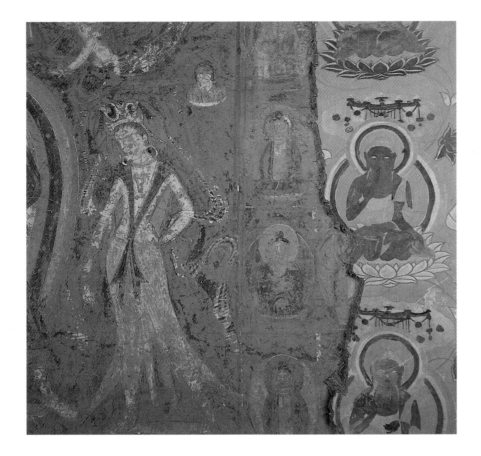

10. *Above:* Nearly six centuries separate the different layers of wall painting seen here. The graceful standing Bodhisattva with blue *dhoti* and barred shawl was painted in the middle or later 5th century, originally on a red ground; the seated Buddhas on a green ground, larger than their 5th century counterparts, were painted when the cave was updated in the 11th century.

11. *Right:* View looking directly upwards at the truncated pyramidal ceiling of Cave 390, early 7th century. A stunning effect is produced by the ranks of the Thousand Buddhas surrounding the central motif of a square tented canopy, with a valance of green and blue triangles and narrow white tassels in alternation, and a rippling border of medallion design.

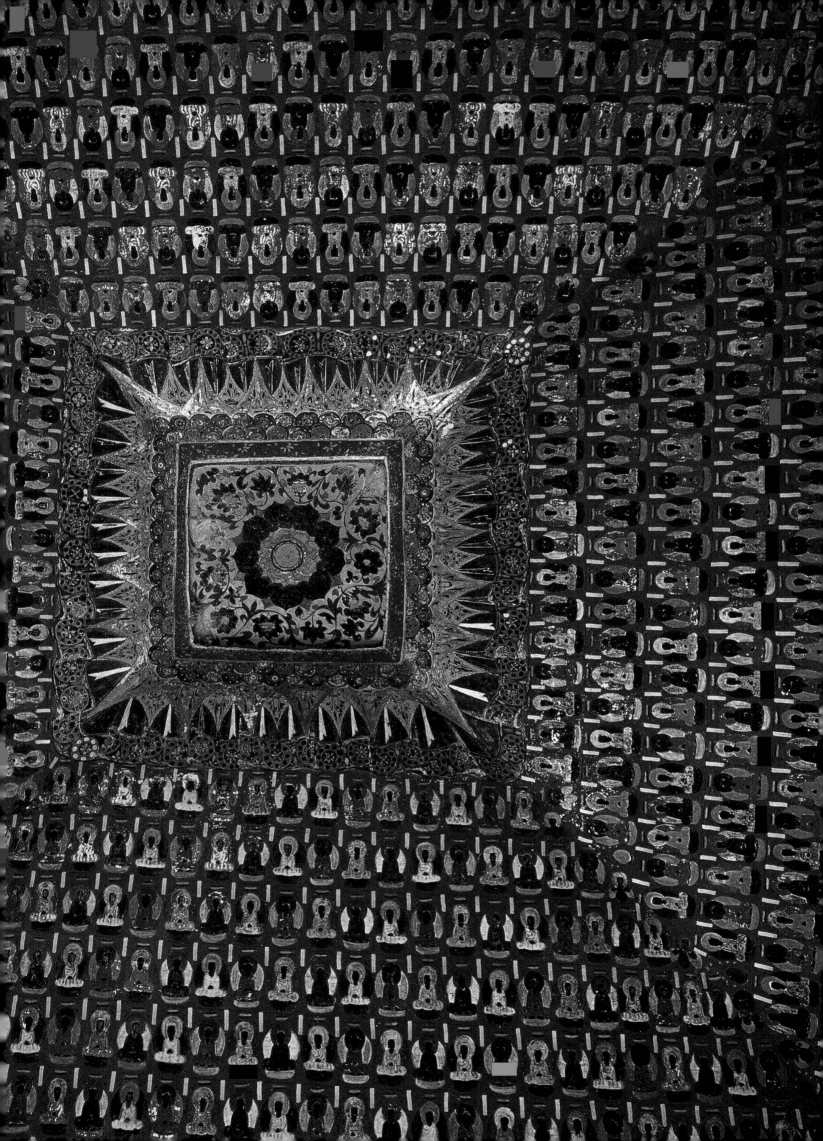

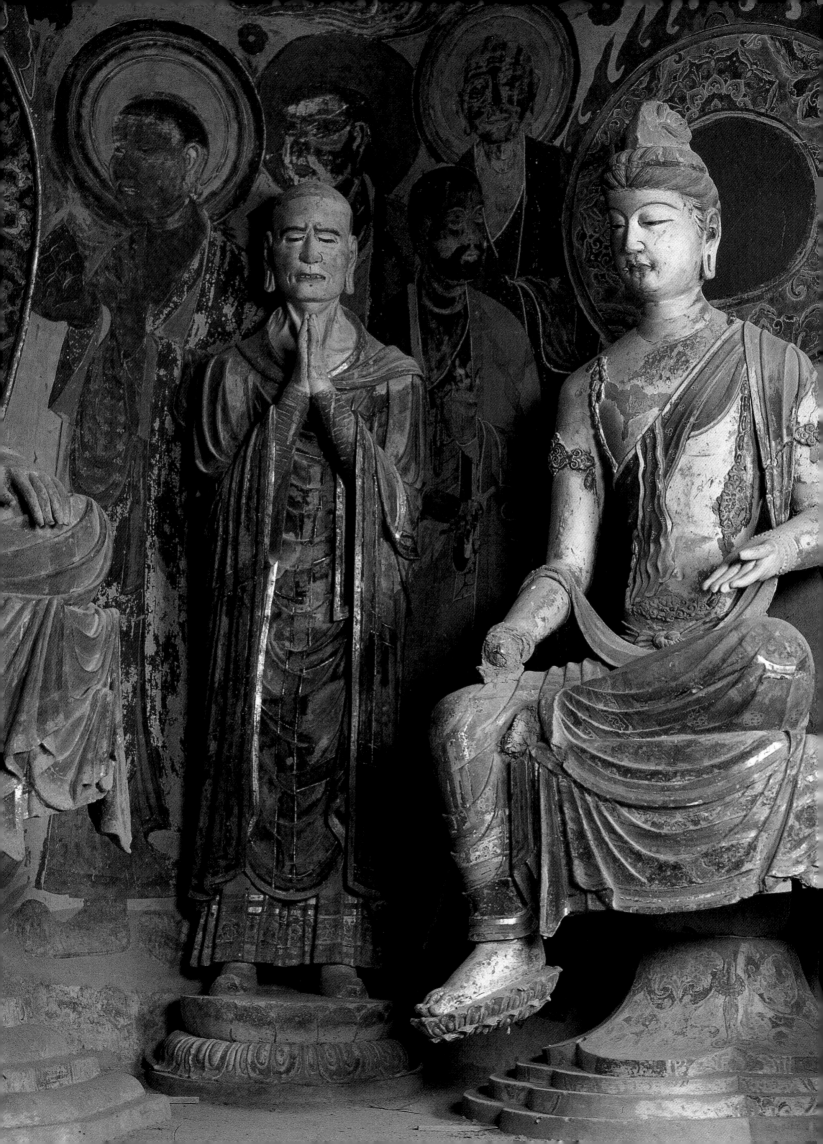

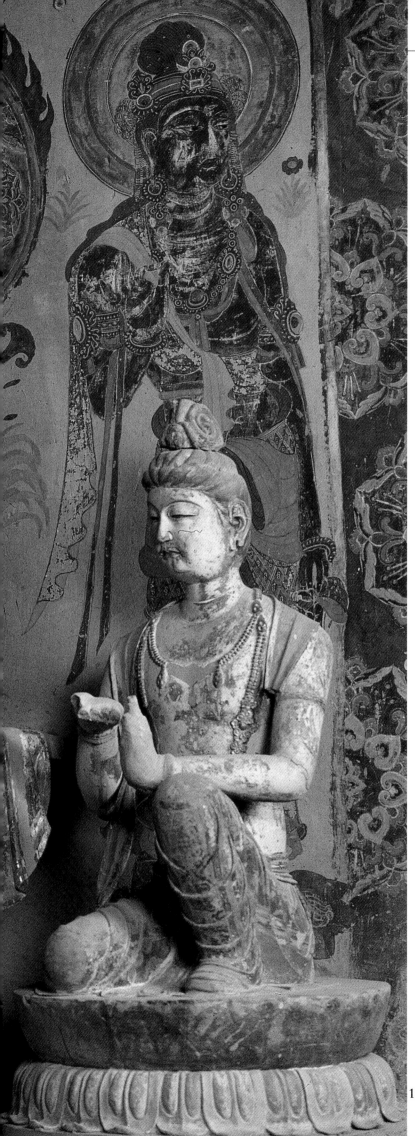

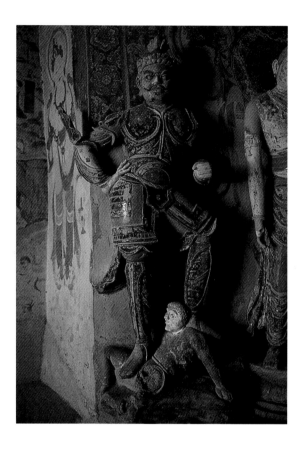

13. *Above:* The full panoply of Tang imperial military might is invoked in this Lokapāla or Heavenly King of the 8th century, standing guard for a group of the Buddha and attendants at the entrance to the main niche of Cave 328. The model for the armour that he wears was probably made of lacquered and painted leather. He stands on a *yaksa* demon representing the vanquished forces of evil.

12. *Left:* The caves of the 8th century display a consummate artistry in the combination of stucco sculptures and paintings on the wall behind. The aged disciple Kāśyapa, intoning a chant, is here in Cave 328 perfectly characterised to complement the serene Bodhisattva, the epitome of beauty at this time. In both figures, the folds and falls of the drapery show a full mastery of modelling in the round.

129

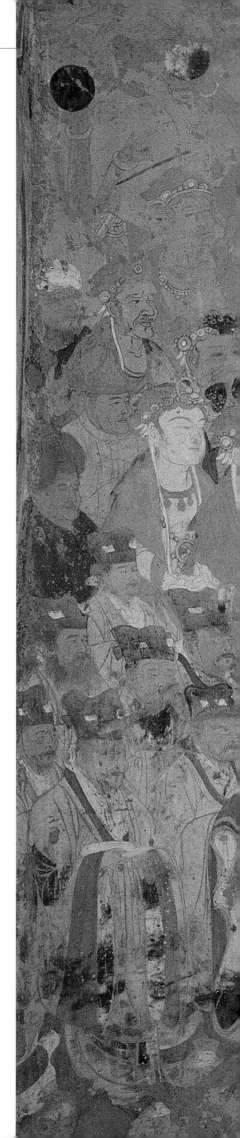

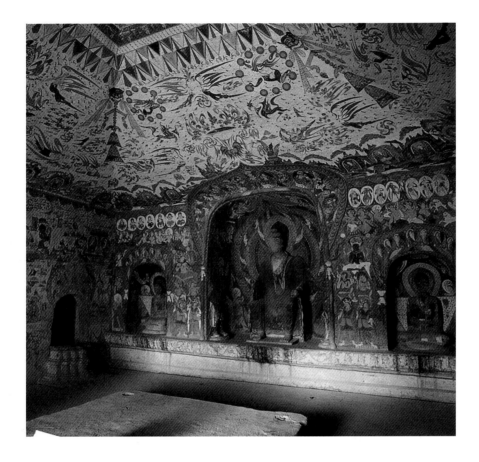

14. *Above:* This cave, dated by two inscriptions to 538 and 539, and its ceiling representing the sky full of heavenly beings, was intended as a meditation hall. Two monks seated in meditation are modelled in niches to either side of the central Buddha, and the niches in the side walls served for meditation practice. A frieze of solitary hermits in their mountain cells runs all the way round the top of the walls.

15. *Right:* The Chinese Emperor and his officials, listening to a religious debate, from the entrance wall of Cave 220, dated 642. Preceded by ceremonial fan bearers, the Emperor wears a 'mortar board' crown with multiple pendants front and back. His enormous robe has embroidered motifs of clouds with the sun and moon motifs and a lean white dragon.

130

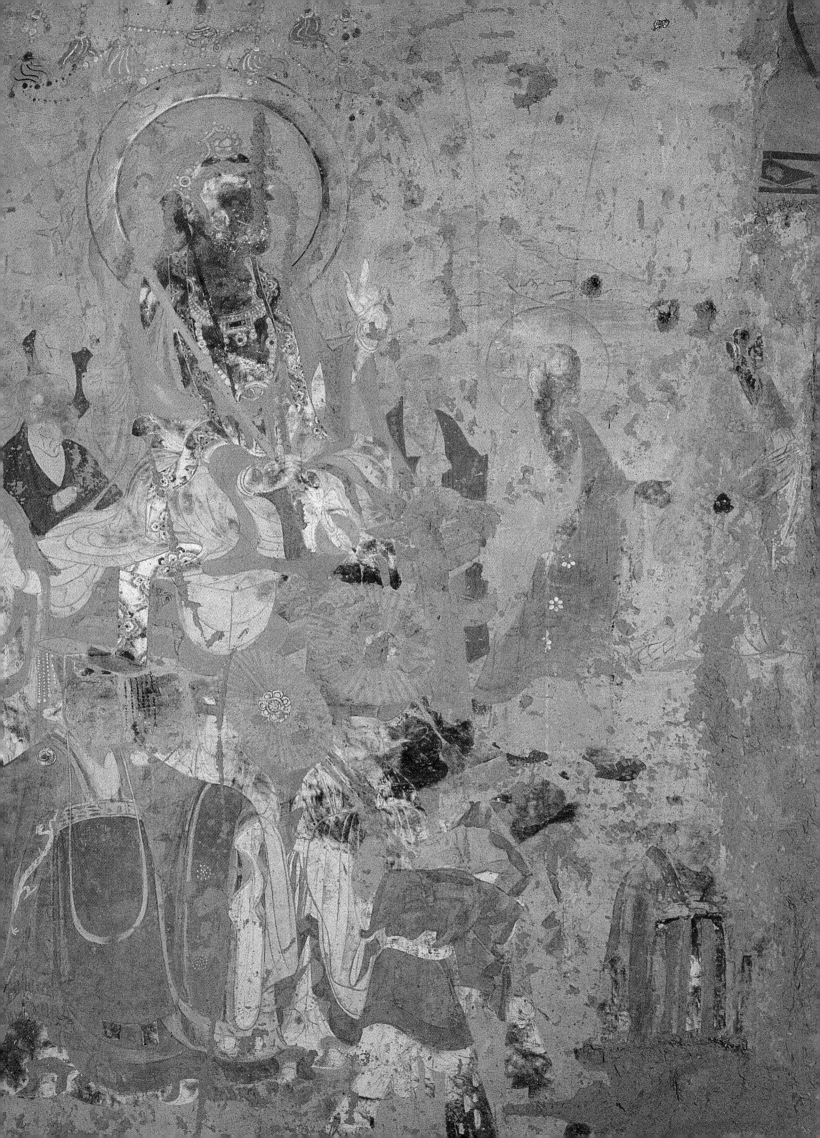

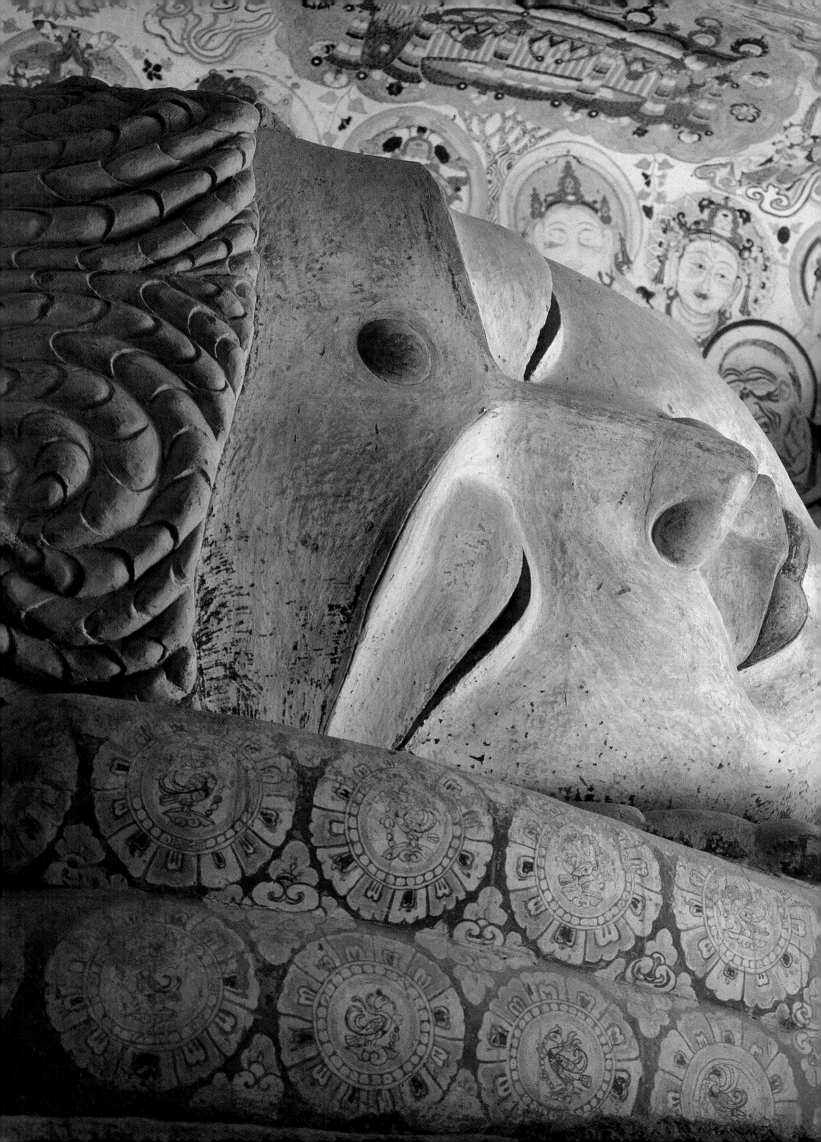

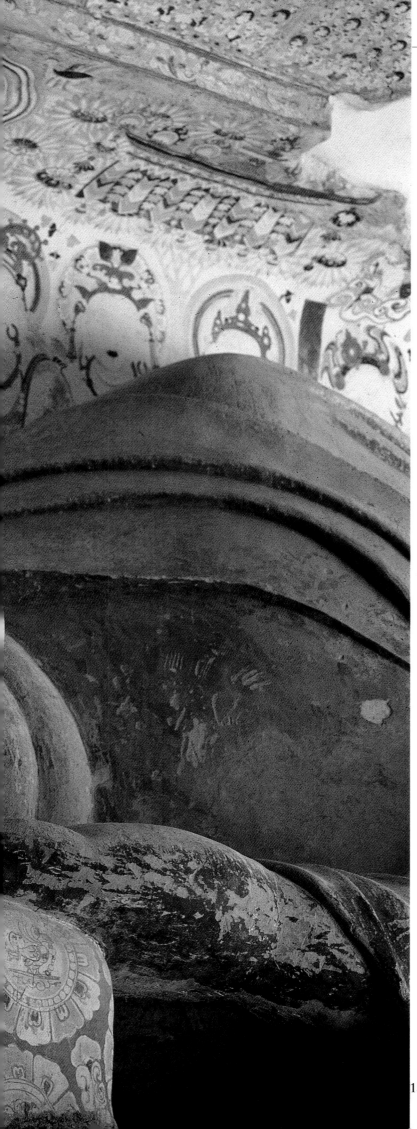

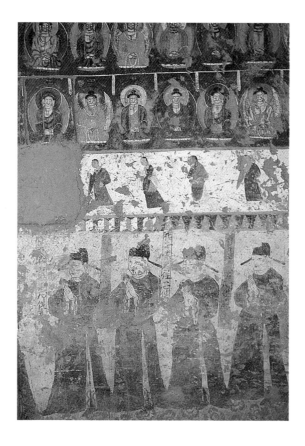

17. *Above:* **The Thousand Buddha motif is found in almost every one of the 492 caves at Dunhuang. In this 5th century example, from the same cave as (10), the white strip at dado level represents monks. The robe colours and modes in which they are worn are shown in regular alternation to produce a varied effect.**

16. *Left:* **Reclining figure of the Buddha in** *nirvāṇa* **15.6m in length, from Cave 158 of the early 9th century. The apparent extinction of the Buddha is revealed in the Lotus** *sūtra* **to be merely an expedient device having no ultimate truth, since he is in fact limitless in time and space, and only assumes different forms to ensure the salvation of living beings. Consequently, he is seen here surrounded by depictions of Pure Lands and serene Bodhisattvas, as well as by grieving disciples and self-mutilating potentates, who have yet to realise enlightenment.**

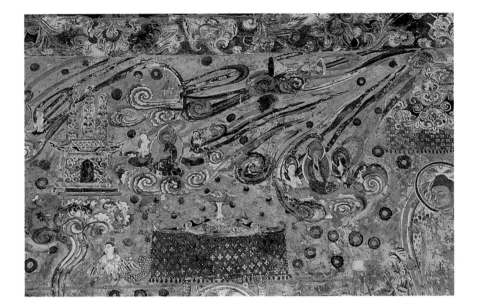

18. *Above:* Detail from a depiction of the Pure Land of Amitābha, the Buddha of Boundless Light, dated 642. The sky is filled with flowers, Buddha groups, musical instruments, and a pagoda with three masts, all flying through the air on five-coloured clouds. Canopy valances above the larger Buddha figures, centre and right, are based on woven designs with small florets in lozenge or chequerboard formation.

19. *Right:* Part of the orchestra of heavenly musicians in the Paradise of Bhaiṣajyaguru, the Medicine Buddha, from the north wall of Cave 220, dated 642. Several of the instruments, and some of the musicians, clearly come from India or the regions west of China, such as Kucha on the Silk Route. They are seated on fringed carpets with borders of half-florets.

CERAMICS

A KIND OF ALCHEMY

Persian Ceramics of the Twelfth & Thirteenth Centuries

Alan Caiger-Smith

The fine minai and lustre wares of the golden age of Persian ceramics are unsurpassed for their technical virtuosity and delicacy of form, while their decoration is imbued with symbolism and allegory taken from Sufic teaching. Although the forms of the vessels and the techniques of their manufacture are Persian in origin, the technique of lustre glazes may have come to Kashan with masters who migrated from Fustat in Egypt as the Fatimid dynasty collapsed in the latter part of the 13th century. As well as vessels, the Kashan masters made large architectural tiles and mihrabs, sometimes travelling great distances to make these at the sites of the mosques they embellish.

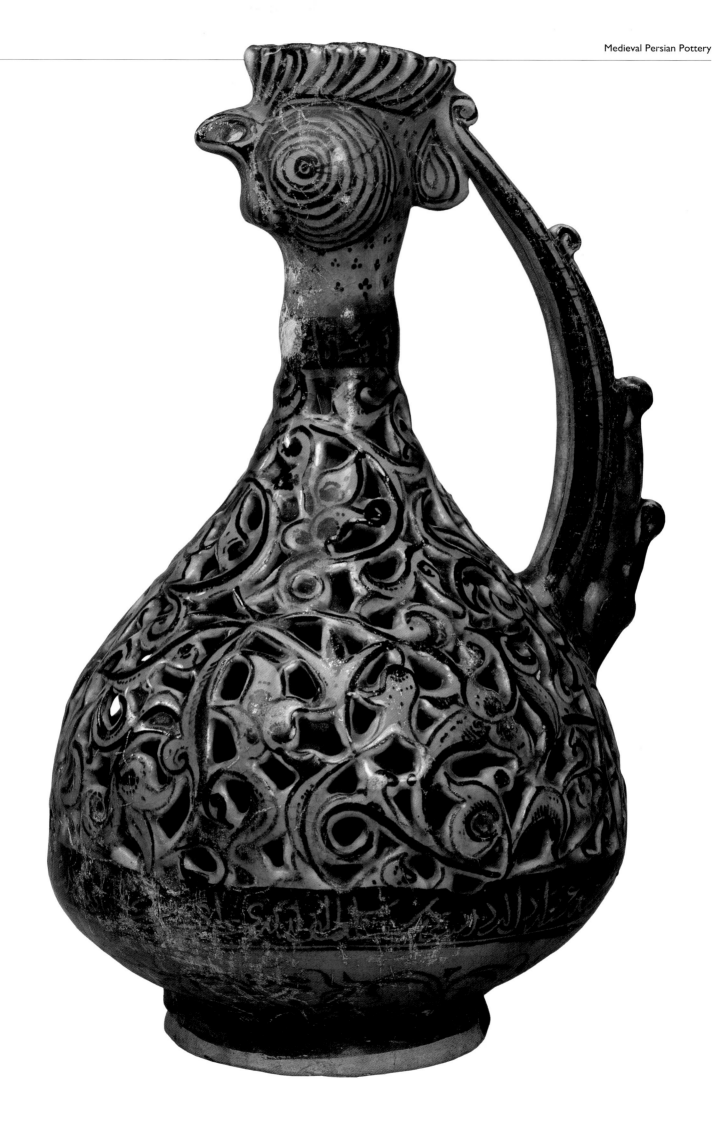

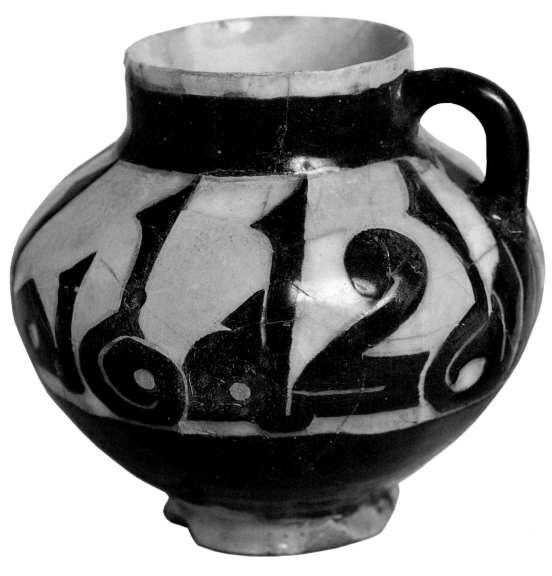

The golden age of Persian ceramics extended roughly from the consolidation of the empire of the Seljuq Turks in the early 12th century to its overthrow during the Mongol invasions in the second decade of the 13th century. Though the techniques established during this amazingly creative period survived the terrible invasions and continued under the succeeding rule of the Il-Khanids, they seldom touched the finesse and imaginative subtlety of what had gone before. Some fine pieces were made, but it is fair to say that the golden age was over. The mode of life that had called such imaginative craftsmanship into being, and that of the artists who enriched it, seems to have perished in the waves of massacre and pillage inflicted by the Mongol hordes as they swept westwards towards the Mediterranean.

Nonetheless, an extraordinary variety of fine ceramics is still in existence after these and subsequent periods of violence and destruction. Those that survive are of course only a small proportion of what was originally made (**2**, **3**). The glazed and decorated bowls, beakers, pitchers and vases of the golden age were, as they still are, things to be treasured by their owners, whether courtiers, landowners, merchants, traders or others. They were so highly esteemed that there appears to have been a commerce even in damaged or imperfect ceramic articles. Many of the examples that have survived into our own times come from carefully concealed hoards, such as the lustre vessels found packed in large jars on the site of the ancient city of Jurjan in the 1940s and in the years following. All these wares stood quite apart from other kinds of pottery.

The vast majority of pots made at this time were of unglazed earthenware, as has always been the case in the Middle East. Vessels were also made from wood or leather, or, for the wealthy, of glass or metals – copper, brass, silver and occasionally gold – but for most practical purposes people used plain earthenware pottery, once-fired in simple updraught kilns. Glazed wares required kilns of a different design, in which the vessels could be positioned without touching and were protected from flying ash and particles of grit. The knowledge of glazing goes back to ancient Egypt, but the widespread use of glazed vessels for food and drink at entertainments was virtually a new social phenomenon (**1**), indicating a

new attitude to ceramics amongst the more affluent members of society. The question which naturally arises is: why did this come about?

The forms of the pots themselves show that the change was partly inspired by the arrival of Sung celadon and white porcelain from China, as gifts or merchandise or plunder. Many of the early Persian Seljuq wares imitate Chinese forms, their decoration and their translucency. In addition, the demand for luxury pottery appears to have been accentuated by the acute shortage of silver throughout the 12th century; the silver vessels that had hitherto been used by people of wealth became almost unobtainable during that period. But for the shortage of silver the advances that were made in the manufacture of glazed pottery might never have occurred. It appears, however, that once glazed ceramics came to be accepted as alternatives to silverware they were soon esteemed in their own right. By no stretch of the imagination could they have been regarded as copies of silverware, and they could be embellished in many ways that silver could not.

The type of clay used for Chinese porcelain has never been found anywhere else in the world. In the Middle East an equivalent for it was made by developing a material which had been known in ancient Egypt but which had never before been used on any scale for serviceable pottery. Ceramic historians know it by the cumbersome name of siliceous frit paste. This synthesised substance became the normal body material for glazed pottery in and around the centres of Rayy and Kashan early in the 12th century (4). Varieties of it have been used for almost all glazed ware of any importance in Persia, Syria and Iraq into modern times, and in some places it is still in use today. It is unfamiliar to craftsmen elsewhere. In Western manufacture the same clays have customarily been used for both glazed and unglazed pottery. People have therefore sometimes failed to recognise that in the Middle East glazed and unglazed wares were used by people of very different social status and were made of different materials by people with different knowledge. Since the properties of frit paste were important and far reaching, it deserves some further notice.

It is described in the earliest technical record of Islamic pottery, the famous treatise on ceramics written by Abu'l Qasim of Kashan, completed in the year 1301 AD.[1] It dates from over a hundred and fifty years after the material came into regular use, but chemical analyses of pottery sherds show that the composition had hardly changed. He reports: "If they want to compound a body out of which to make pottery objects and vessels such as dishes,

4. Frit-paste bowl, carved and pierced white ware. Rayy or Nishapur (?), Seljuq period, 12th century. Diameter: 18.5cm (7"). The inspiration of Chinese porcelain is clear. Freer Gallery of Art, Smithsonian Institution, Washington DC, inv.no. 56.2 (2).

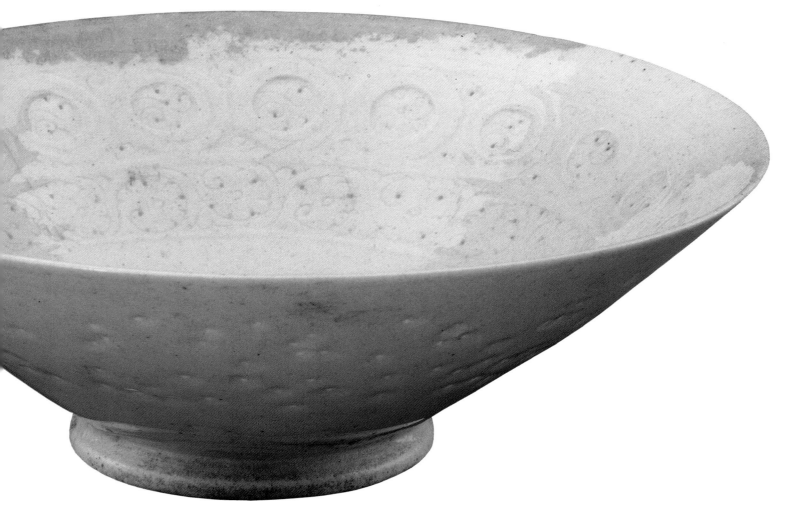

basins, jugs and house-tiles they take ten parts of the aforementioned shukar-i-sang [quartz], ground and sieved through coarse silk, and one part of ground glass frit, mixed together, and one part of white Luri clay suspended in water. This is kneaded well like dough and left to mature for one night. In the morning it is well beaten by hand and the master craftsman makes it into fine vessels on the potter's wheel; these are left standing till they are half dry. Then they are pared down on the wheel and the feet are added, and when they are dry they are washed with a damp linen cloth to smooth over the lines on them so that they disappear. When they are dry again they are rubbed with a wool cloth until they are clean and smooth. This sounds simple enough, but in fact the collection and refinement of the white clay, the grinding of the quartz, and the processing of the glass frit involved a great deal of hard work. In terms of man-hours, the frit paste must have required something like twenty times the labour needed for the preparation of natural clay.

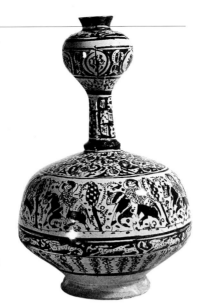

Abu'l Qasim also gives a dramatic description of the preparation of the glass frit, from 105 parts of quartz and 100 parts of soda ash: "This mixture is cooked over a slow fire for six hours and is stirred from morning to night with an iron ladle...until it is well mixed and is become one, like molten glaze, and this is the material for glass vessels. After eight hours they take out the brew by the ladleful. Below, in front of the oven, is a pit full of water, into which they put the [molten] glass frit. When water and fire meet there is a great noise and roaring like thunder, which for all the world could be real thunder and lightning, such that everyone who has not seen it and hears the noise falls on his knees shuddering and

trembling. The craftsmen call this mixture *jawhar* and store it, until the time comes to compound it, in a broken up, powdered and sifted form."

An important characteristic of the frit pastes was their whiteness, whiter than any natural clay. (When potters today include quartz in white engobes they are following in the footsteps of their predecessors eight centuries ago). The pastes also hardened at remarkably low temperatures, far below the temperatures required for porcelain. By about 1,000°C they became almost impervious to water. They could also turn translucent if the pots were thinly made. These pastes were not nearly as hard as Chinese porcelain, but they were an ingenious equivalent, a technical achievement of high standing. (I possess a small lidded bowl made in Persia in the 19th century; it was fired at less than 1,000°C and is distinctly translucent). When European ceramists developed soft paste porcelain five hundred years later, they worked on the same principles.

The whiteness and the fusibility of the paste material opened the way for a specially Islamic development for which there were no Chinese models – the application of strong colour by means of engobes, coloured glazes, and underglaze painting, employed in a manner that would not have been possible in the high-temperature porcelain of the Far East. Any potter who has attempted to treat porcelain with copper, the most popular of all Persian colouring agents, will understand this. At high temperatures, the copper penetrates the body of the vessel and works right through the clay to the other side. At lower temperatures, however, copper compounds provide superb colours and are fairly controllable.

The frit pastes also enabled the craftsmen to use fusible, alkaline glazes based on silica blended with compounds of copper, which were essential for the specially favoured turquoise colours (**7**). When fluxed with soda, potash and lithium, copper produces turquoise blue. With other fluxes it gives a range of green colours. On natural earthenware clays, glazes rich in soda and silica and low in alumina are notoriously unsatisfactory. They craze uncontrollably, so much so that they sometimes shale off the clay altogether, since in cooling the glaze shrinks much more than the clay beneath it. Ideally, a glaze should be under compression: it should shrink less than the clay. By employing a synthesised paste which was itself rich in silica and alkalis, the Kashan potters were able to make wonderful use of turquoise glazes which would not have been serviceable on common clays.

The glazes of Islamic pottery developed in a way strikingly different from those of the Far East and of the West. The technology of the Far East relied principally on high temperature firing of glaze mixtures based on felspar, limestone and kaolin, while most European glazes up to the 18th century were based predominantly on lead. They evolved from the medieval custom of coating the pots with galena (lead sulphide) mixed with clay. Islamic glazes, by contrast, evolved from glass making, in which the ashes of soda-bearing plants (notably *barylla* or glasswort) were fused with quartz to make a clear glass. Glass technology goes back at least as far as 1,000 BC.

Thus the potters who began, under the Seljuqs, to develop the potential of alkaline-glazed frit paste wares and the colours this technique made possible, were in many ways very different from the makers of traditional, unglazed vessels and had at least as much in common with metal workers and glass makers. Through them they appear to have gained some connection with the military aristocracy and merchant classes for whom the majority of luxury vessels in metal and glass were made.

Some of the pots closely resembled the forms of vessels originally made in silver or glass, although the colours and

5. *Facing page, above:* **Lustre painted bottle, Kashan, late 12th century. Height: 30cm (12"). Keir Collection, Ham, Surrey.**

6. *Facing page, below:* **Minai bowl, Kashan, Seljuq period, 12th-13th century. Diameter: 20.5cm (8"). Freer Gallery of Art, Smithsonian Institution, Washington DC, inv.no. 45.8 (1).**

7. *Below:* **Ewer with moulded decoration under opaque turquoise glaze. Rayy or Nishapur (?), late 12th century. Height: 28cm (11"). Ashmolean Museum, Oxford, Barlow Collection, inv.no. 1956-180.**

surface effects were very different. The resemblance is not only visual; the making of the form followed a similar sequence. Metal wares were usually assembled from separately fashioned units; the body, foot and collar were cast or beaten out individually and then brazed, soldered or riveted together. The abrupt transitions of profile from foot to body and body to collar came about as a result of this practice.

Frit-paste pottery was often made in a similar manner. The paste was not very plastic, since there was very little clay in the composition. It could not be easily thrown on the wheel like common clays. All but the simplest forms had to be made in separate stages and were completed either by assembling the various parts or by fashioning an additional part on to a leather-hard form which had already been made. This is why many Persian pots have distinct changes in the curves and angles of the profile, more emphatic than could have been made by completing a form from a single lump of clay (5). The lack of plasticity in the paste was an unavoidable shortcoming, but it was also a challenging discipline and it forced the makers to be especially sensitive to inflexions of profile and the proportions of the various parts of a vessel. The subtle flare of the bases and footrings of Persian pottery vessels, almost always with a graceful feeling of upward lift, are one of their most satisfying features and they came about because they were directly fashioned by the craftsman's hand, not trimmed with a tool. Thus the peculiarities of the frit paste had a positive effect on the forms as well as the colours. Beside Persian wares much European pottery looks clumsy and bottom-heavy.

Various types of frit-paste vessels, carved, pierced, embellished with coloured glazes or with underglaze decoration, as well as occasional moulded figurines of bulls, lions and hawks, continued in production until the Mongol invasions in the 1220s. They were made at Kashan and Rayy and almost certainly at several other centres as well, but the scarcity of archaeological evidence makes it impossible to distinguish between different provenances. Such evidence as there is has been confused by dealers and pirate treasure hunters, some of whom invented the source of the pieces they sold, while others deliberately concealed it.

8. *Above:* **Persian manuscript illustrating the story of Narqah and Gulshak, ca. 1200. Topkapı Library, Istanbul.**

9. *Facing page, above:* **Minai bowl decorated in enamels and gold, inscribed "The work of Ali ibn Yusuf". Kashan, Seljuq period, early 13th century. Diameter: 20.5cm (8"). Freer Gallery of Art, Smithsonian Institution, Washington DC, inv.no. 37.5 (1).**

10. *Facing page, below:* **Small bowl decorated in enamels and gold, Kashan late 12th or early 13th century. Diameter: 23cm (9"). Freer Gallery of Art, Smithsonian Institution, Washington DC, inv.no. 38.12.**

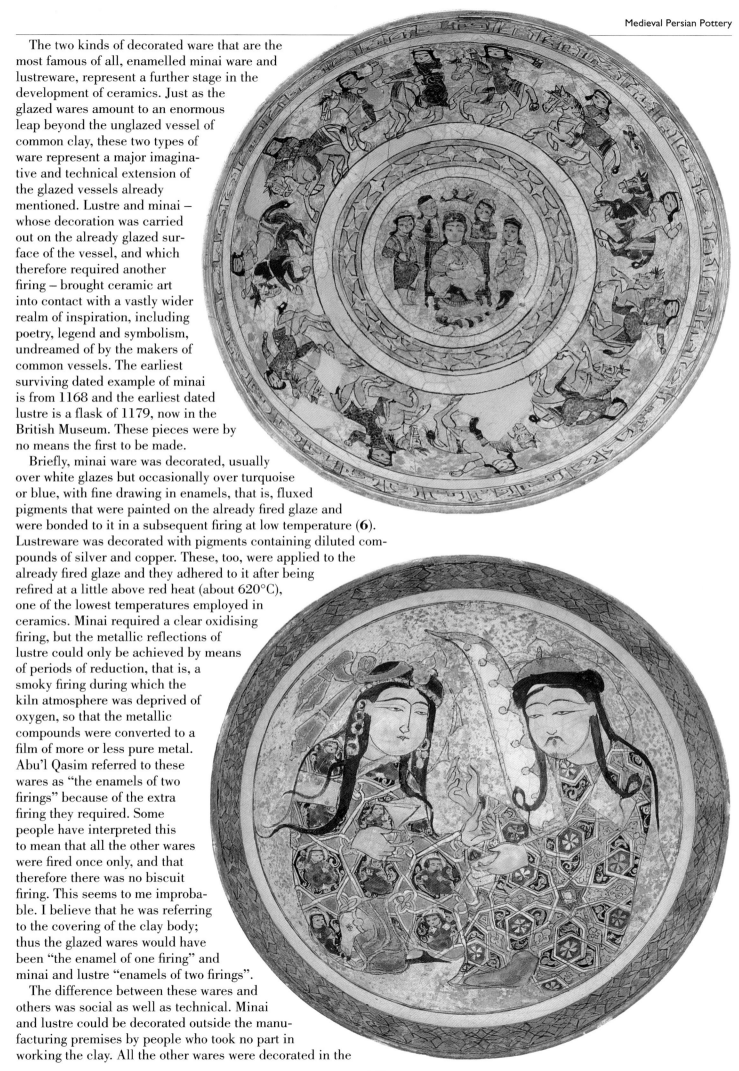

The two kinds of decorated ware that are the most famous of all, enamelled minai ware and lustreware, represent a further stage in the development of ceramics. Just as the glazed wares amount to an enormous leap beyond the unglazed vessel of common clay, these two types of ware represent a major imaginative and technical extension of the glazed vessels already mentioned. Lustre and minai – whose decoration was carried out on the already glazed surface of the vessel, and which therefore required another firing – brought ceramic art into contact with a vastly wider realm of inspiration, including poetry, legend and symbolism, undreamed of by the makers of common vessels. The earliest surviving dated example of minai is from 1168 and the earliest dated lustre is a flask of 1179, now in the British Museum. These pieces were by no means the first to be made.

Briefly, minai ware was decorated, usually over white glazes but occasionally over turquoise or blue, with fine drawing in enamels, that is, fluxed pigments that were painted on the already fired glaze and were bonded to it in a subsequent firing at low temperature (6). Lustreware was decorated with pigments containing diluted compounds of silver and copper. These, too, were applied to the already fired glaze and they adhered to it after being refired at a little above red heat (about 620°C), one of the lowest temperatures employed in ceramics. Minai required a clear oxidising firing, but the metallic reflections of lustre could only be achieved by means of periods of reduction, that is, a smoky firing during which the kiln atmosphere was deprived of oxygen, so that the metallic compounds were converted to a film of more or less pure metal. Abu'l Qasim referred to these wares as "the enamels of two firings" because of the extra firing they required. Some people have interpreted this to mean that all the other wares were fired once only, and that therefore there was no biscuit firing. This seems to me improbable. I believe that he was referring to the covering of the clay body; thus the glazed wares would have been "the enamel of one firing" and minai and lustre "enamels of two firings".

The difference between these wares and others was social as well as technical. Minai and lustre could be decorated outside the manufacturing premises by people who took no part in working the clay. All the other wares were decorated in the

leather-hard state, that is, by applying engobes, or by incising, carving, perforating and underglaze painting. Using these techniques, the decorators would have had to work in close association with the throwers, moulders and other artisans. Minai and lustre, by contrast, could have been taken away and decorated elsewhere and refired to the necessary low temperatures in different kilns by different people. These techniques were therefore open to a much wider range of design ideas. This may partially explain how they came to incorporate subject matter from outside the traditional ceramic context, from metalware, textiles and manuscripts (**8**).

The affinity between minai and book illustration is clear from its delicate line drawing infilled with colour and in the detailed figurative scenes, which include subjects that are not found in other decorated wares. These scenes come from epic history and legend, from the *Shahnameh* and from poems. They are not simply decorative: the subjects themselves are important. They brought a literary element into ceramics and extended the social context in which ceramics were valued.

A number of minai and lustre pieces also include the name of the painter in the inscriptions, something that occurred very rarely in other techniques (**9**). It indicates that the maker had an individual reputation. In the history of ceramics signatures are unusual; when they occur frequently, as they do in Greek black figure wares, for instance, and in Italian maiolica, it is an acknowledgment of individual artistry and an indication of the commercial value of the work. By contrast, not a single signature is known in the whole history of Hispano-Moresque lustreware lasting for four centuries.

Minai enamel decoration appears to be another inheritance from the techniques of glass making. Coloured enamels had no precedent in ceramic tradition (and incidentally were only developed in Europe five hundred years later), but glass makers had for centuries been accustomed to staining the body of the glass in the melt: Roman *millefiori* glass mosaics were being made by or before the 4th century AD, and in the late Roman and early Islamic periods vessels of clear glass were decorated by fusing strands of coloured glass to the surface. Minai enamels were an adaptation of this technique; the coloured glass was finely ground, mixed with an adhesive medium, applied with a quill or a brush, and then fused to the surface in a subsequent firing. Gold leaf was sometimes added subsequently, probably with a cold adhesive. An important difference between glass and minai was that on the latter the drawing could be more delicately controlled than on glass, and the colours showed more brilliantly because they lay on an opaque ground, not on a translucent one. On pottery they became more luminous than anything in glasswork or book illustration. The enamel painters must have delighted in this discovery and it shows in their work.

The book illuminator's convention of making spaces within spaces is beautifully employed on a small dish representing a man and a woman in converse. Another world of smaller abstract forms, patterns and rhythms is constructed within the detail of their robes (**10**).

Lustreware, too, invited a wide range of design inspiration. Here again the pigment was applied to complete, glazed vessels. The style of the earlier Persian lustres suggests that the technique came from Fustat, the former capital of Egypt, a few miles south of Cairo. From the late 10th century onwards, Fustat became a centre of arts and manufactures, supplying luxury goods to Cairo, the new capital. A great deal of lustreware was made there under the Fatimid dynasty in the 11th and 12th centuries (though it is now extremely rare). The decorative imagery often reflected the entertainments current at the court and in wealthy society: noblemen hunting or hawking, musicians, dancing-girls, wine-bearers, with subsidiary ornament of palmettes, vines, hares, birds and other emblems of good omen, sometimes with inscriptions and dedications.

In Egypt the forms of the pots were often poor compared with the lustre painting applied to them. Historians have found this puzzling, but it is not strange if one recognises that the painters may have had no part in making the pots, and probably purchased them simply as plain-glazed vessels.

By 1150 the ruling Fatimid dynasty was approaching collapse, after years of extravagance and instability, and the city suffered recurrent famines and disorders. It was at about this very time that lustreware began to be made at Tell Minis in Syria and in the Persian city of Kashan. It is not difficult to conceive that this came about as a result of a network of personal relationships which held good when the fabric of ordinary civilised life was in tatters, much as certain people managed to escape from central Europe in the critical years in the middle of the 20th century.

It appears that some of the lustre painters from Fustat managed to reach Kashan and continued their art as before, though on vessels superior to anything available in Egypt. This would explain why the style of early Persian lustre retained for a while a strongly Egyptian flavour, although the forms and material were undoubtedly Persian (**13**). It may also explain

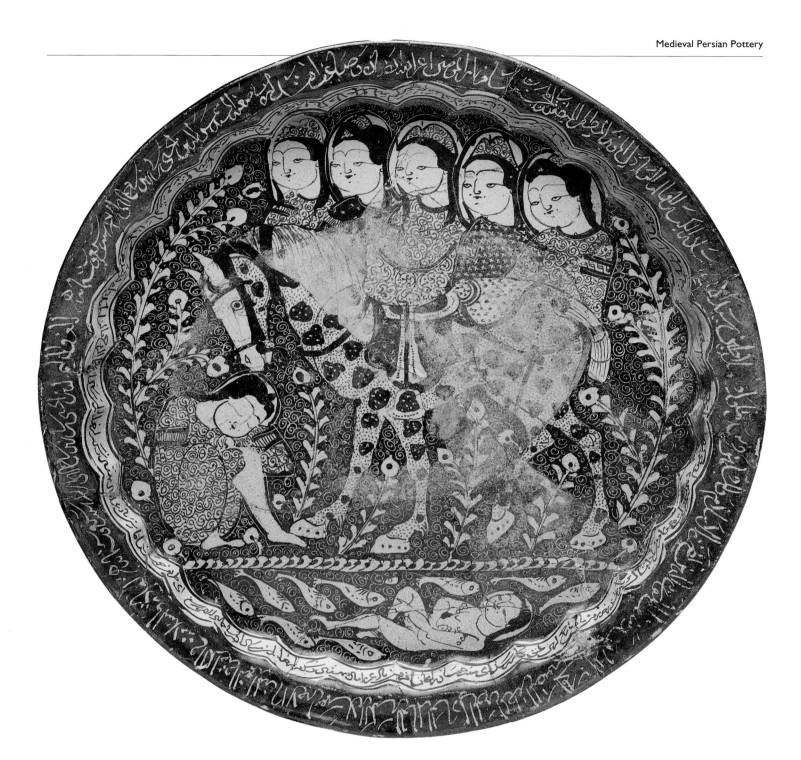

11. Large lustre dish, Seljuq period, dated 1210, signed by Sayyid Shams al-Din al-Hasani. Diameter: 35cm (13"). This unique subject has been interpreted as a Sufi mystical metaphor. Freer Gallery of Art, Smithsonian Institution, Washington DC, inv.no. 41.11.

why no special forms were made for lustreware: the painters simply used the vessels that were already available, as they had done before. However, a change was made in the glaze. The Kashan potters were already accustomed to varying the colours of their glazes, and now, for lustre, they added an especially white glaze incorporating ashes of lead and tin, a practice current in Egypt but seldom if ever followed before in Persia.

The early Persian lustres have been termed the Monumental Style by Dr Oliver Watson[2], because the design was often dominated by a single figure. They were evidently not entirely to Persian taste, for within about one generation the decoration of lustre became increasingly delicate, more like the designs of inlaid metalware and minai enamels. They were not direct copies of metalware, but the shining, patterned surface certainly had affinities with inlaid metalware. However, the connection with minai decoration was much closer: the small figures and details of leafscroll ornament could have been directly imitated from these enamels. It appears that lustre decoration was transformed to agree with established Persian taste.

If this was the case, it involved a conflict familiar throughout the ages, and in our own day too, between craftsmen commanding effective design conventions and patrons who had distinctly different ideas. The changes were not altogether satisfactory. In lustre, the delicate Miniature Style turned out somewhat lightweight and only worked well on small vessels with strong, bright lustre. On larger forms it looked fussy. It was especially disappointing when the lustre was underfired and came out pale banana yellow rather than golden, as quite frequently happened because the firing of lustre was variable and sensitive. Thus, while

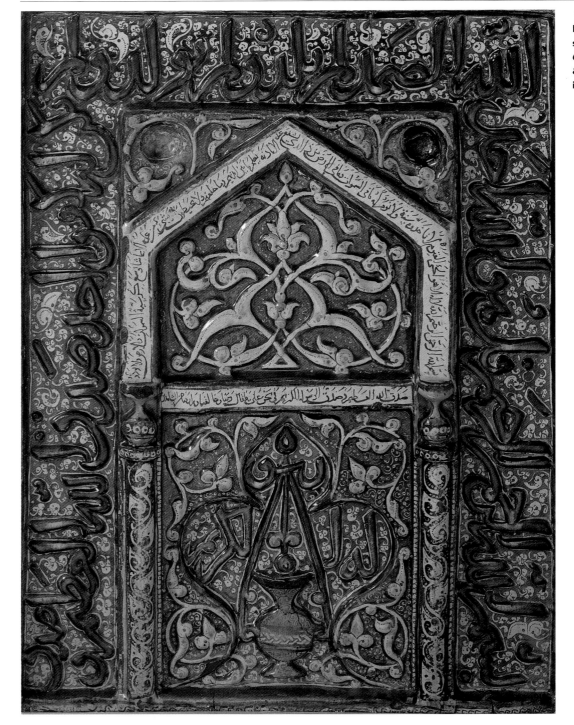

12. The 'Salting' Mihrab,
Il-Khanid period, probably
second half 13th century.
61 x 43cm (24" x 17"). Victoria
& Albert Museum, London,
inv.no. C.1977-1910.

minai enamels continued with little stylistic change right up to the time of the Mongol invasions, the Miniature Style in lustre was superseded around 1200 by a new convention, one which has been termed the Kashan Style. This was a brilliant synthesis between the older Monumental Style and current Persian taste. It was not based on pre-existing models: it appears to have been the painters' own original solution.

The designs were given more weight by the use of decoration in reserve; that is to say, the images were often left white and were defined by painting a solid background around them. The solid areas make the composition powerful even when seen from a distance (11). Coming closer, the detailed drawing, the gestures and expressions of the figures are seen, and the patterns within the larger shapes. Closer still, one sees the incised lines in the solid background, made with a pointed tool through the dry pigment before the firing. Thus the compositions work on three scales, drawing the eye and the mind inward from the dominant image into the smallest detail of the ornament.

One becomes absorbed in a strange world. This is more than what we normally call decoration: it is a kind of design psychology and it has affinities with our personal experience of living – the transition from one scale of perception to the finer scales within it, and then back again to the larger scale. The transitions lead to the realisation that the different scales are not separate but are parts of one another. There is a meditative and metaphysical

13. *Facing page, above:* Large
lustre plate, Kashan, 12th
century. Diameter: 35cm (14").
Keir Collection, Ham, Surrey.

14. *Facing page, below:* Bowl
painted in underglaze black
beneath clear turquoise glaze,
Kashan, Seljuq period, early
3th century. Diameter: 20cm
(8"). Freer Gallery of Art,
Smithsonian Institution,
Washington DC, inv.no. 67.25.

dimension in the best Kashan lustre which was seldom reached in the work of later periods.

Though the lustre painters were probably specialists who were not directly concerned with the making of the clay vessels, they retained a remarkable sensitivity to the forms and proportions of the pots they decorated. This is clearly seen if for a moment one disregards the images and ornaments and looks at the subdivisions of the composition as a whole, especially on flasks and bottles. The horizontal banding, the vertical divisions, medallions and panels are wonderfully disposed in relation to the form and emphasise its character. It is an object lesson in perception. Ill-judged banding can all too easily contradict the character of a form. The banding on Persian pottery intuitively fulfils it. It is usually so right that form and decoration exist as inseparable parts of one single, unified object.

Specialised artistry all too easily becomes a *tour de force* in its own right, separated from the other aspects of the work. Somehow the human organisation of the Kashan workshops must have been close enough to avoid this defect. Far from becoming separated, the makers of vessels and the decorators appear to have worked more closely together as the years went by. They may perhaps all have been members of the same family. Their close working relationship is evident from the emergence in the early 1200s of images painted in underglaze, borrowed from minai and lustre (**14**).

This underglaze painting was done on the fragile, raw clay and must therefore have been carried out within the pottery workshop, with easy access to the kilns. Intimate collaboration between makers and decorators is also indicated by the combination of lustre and blue which developed early in the 13th century and eventually became customary. The earlier lustres had no blue and the change is more than a matter of taste. The blue had to be painted underglaze, on the raw clay, and was carefully planned so that the spaces could later be filled in with lustre. The two elements had to be thought of together.

The techniques of underglaze painting and lustre became fully integrated in the great tiles and mihrabs made at Kashan for religious monuments from about 1200 onwards, up to the collapse of the Il-Khanid principalities around 1350. In

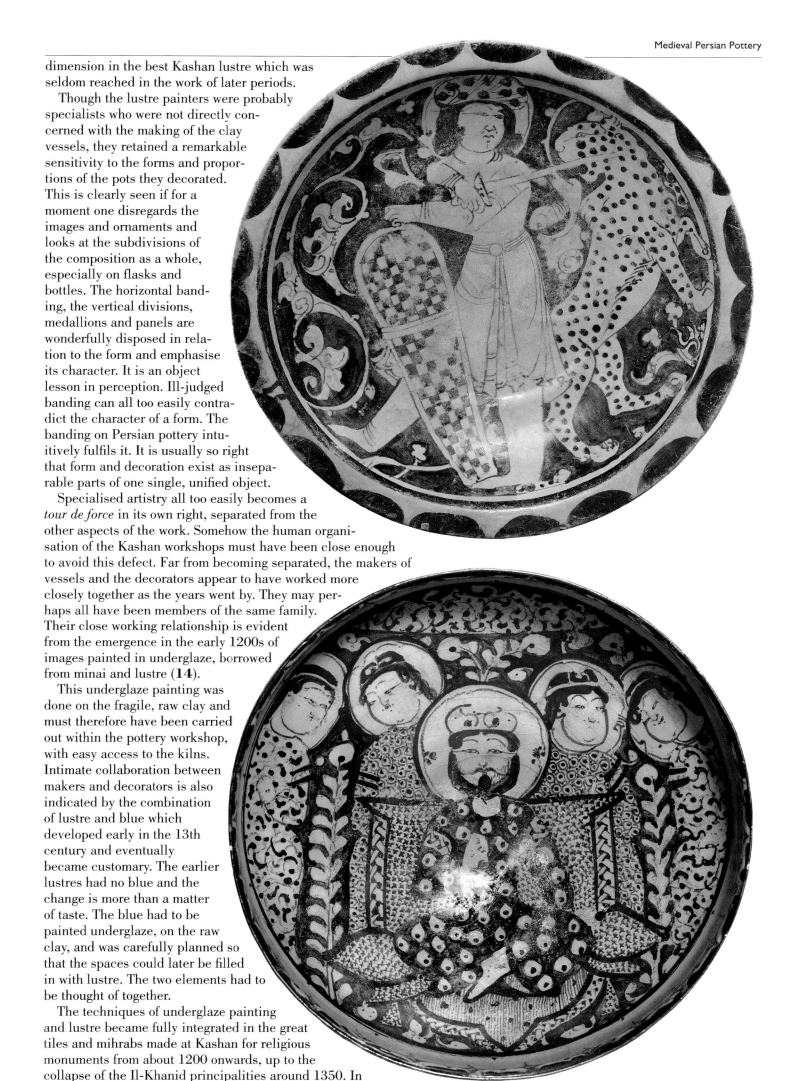

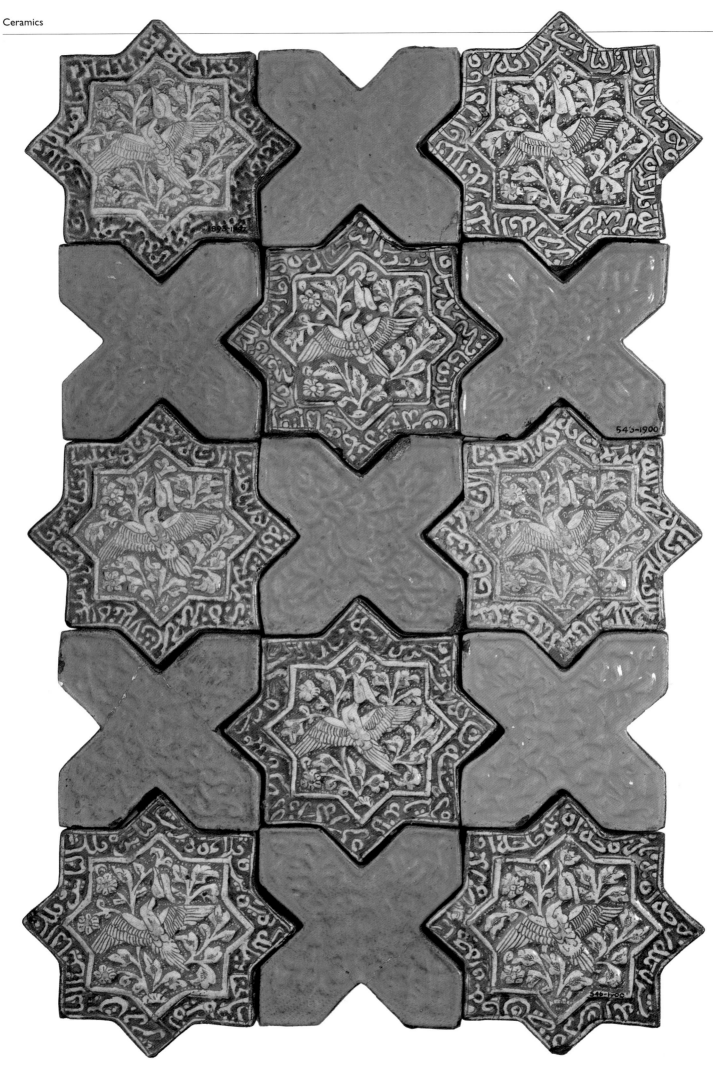

these tiles and mihrabs, all the processes of making came together: the moulded forms, usually incorporating inscriptions in relief from the Qur'an(**12**), the use of underglaze blue and green, and the lustre painting of the linework, spirals and tendrils behind the letter forms, together with areas of solid lustre incised with fine lines. Here the ideas that had earlier been perfected on pottery and moulded figures were applied to architectural units on an inspiring scale.

Historians have often wondered how these great tile slabs were moved, for some of the buildings are far away from Kashan. Were they really carried by pack animals over long and hazardous distances? In at least one case the masters are known to have worked on the site itself. At the palace fortress of Takht-e-Suleyman in northwest Persia, built between 1265 and 1281, moulds for the wall facings have been excavated, together with buckets containing remnants of glaze. Smaller star-and-cross tiles (**15**), used mostly for covering tombs in shrines, may have been made in considerable quantities in Kashan itself and then transported to the site. But the larger slabs, sometimes measuring up to 55 by 40cm and about 4cm thick, are more likely to have been made on the spot, not only to avoid the risks of transport but also so as to fit the dimensions of the masonry.

Tile compositions often included the date of manufacture and the *nisba*, that is, the name and domicile of the maker. From these inscriptions it appears that architectural facings only began to be made on a large scale around 1200 and that they may have been the personal enterprise of two Kashan masters, Muhammad ibn Ali Tahir and Abu Zeyd.

Two important architectural schemes survive from these early years: the tomb chamber of the Shrine at Qum, dated 1206, and the Shrine at Mashad, completed in 1215. At Mashad, the name of Muhammad occurs on the tiles framing the entrance and that of Abu Zeyd is on one *mihrab* and on several star tiles and octagonal tiles. Their names also appear in several other places. The extensive production of large moulded wall slabs in lustre and blue, frieze tiles and smaller star-and-cross and hexagonal tiles which remained current for the following hundred and fifty years apparently stemmed from these two men. Incidentally, the Persian name for tile is *kashi*, after the city that made them famous.

Under the Il-Khanids, from about 1250 onwards, tile making was probably a more important industry in Kashan than pottery. The inference is that some considerable change had occurred in the pattern of daily life: perhaps the society which had treasured the superb lustre dishes – vessels imbued with symbolism and metaphysical overtones – had been destroyed along with much else in the fabric of civilised communication as the Mongol tribesmen tore through the land. When, after several decades, some degree of social coherence was re-established, architectural tiles rather than pottery vessels had the highest importance. They were commissioned by the new rulers of the land for important monuments that were intended to last for ever.

The signatures of Muhammad ibn Ali Tahir and Abu Zeyd also occur frequently on minai and lustreware up to 1215 and 1219 respectively, when they are presumed to have died. The great schemes of architectural tiles can therefore be seen as consequences of the skills of two men following up ideas they had already perfected on relatively small, individual vessels.

The Tahir family dominated Kashan tile manufacture all through the 13th century and the names of Muhammad's son and grandson feature on tile compositions from the 1250s up to 1305. Abu'l Qasim, whose treatise on ceramics was quoted earlier, belonged to this family. He appears to have worked on ceramics for a time, and later became a scholar and court historian at Tabriz. His treatise is part of a larger work dealing with various kinds of manufactures and materials. He called ceramic-making "a kind of alchemy", because each process concerned the refinement and transformation of materials.

It is worth taking Abu'l Qasim's idea further, and considering the theme of alchemy in this broad sense in relation to Persian pottery of the golden age.

The modern world has inherited and developed many techniques for transforming materials into manufactured forms, from postage stamps to aircraft, and we take most of them for granted. We have to make an imaginative effort to appreciate the scarcity of manufactured objects in the past, and the value accorded to whatever had been fabricated by human skill.

16. *Above:* Bull figurine, decorated in lustre over deep blue glaze, Kashan, late 12th/early 13th century. Height: 36cm (14"). Keir Collection, Ham, Surrey.

15. *Facing page:* Star-and-cross tiles, Il-Khanid period, probably second half 13th century. Diameter of each tile: 20cm (8"). Victoria & Albert Museum, London, inv.no. C.1893-1897.

Apart from the scale of production, two major differences stand out: all manufacturing processes depended on personal skill, sometimes acquired over a long time. Secondly, the artistic aspect, the design and detail of the final form, was almost always the work of people with an intimate knowledge of the raw materials, in a sense that has become unusual since the industrial revolution. Thus a special rarity attached to manufactured objects in general. Persian potters deliberately extended this valuation.

Their vessels were undoubtedly intended for use, at least for convivial occasions, if not for everyday purposes. The beakers and small bowls were drinking-vessels; larger bowls and dishes were for serving food and delicacies; ewers and basins and aquamanile figures were for watering the hands during the taking of food. The purpose of other moulded figures has been much debated by scholars, but it seems to me likely that they were used as flower vases and as containers for perfume (**16**). The colour, the decoration and imagery, and the fineness of touch of these wares were more than decorative; they were inspirational. Turquoise blue was more than a pretty colour. Throughout the Islamic world it is believed to protect against evils and to confer physical and spiritual benefit. It is literally and figuratively the colour of the heavens.

Lustre had obvious affinities with light and sun and gold. This may be why in its beginnings, in Mesopotamia and Egypt, it was produced almost exclusively for the court. The association goes deep. Gold is not only a sign of wealth; it is also a symbol of permanence, which is why it is used for wedding-rings. As the sun dominates the heavens and is the source of all bounty, so the ruler's court was meant to dominate human society, dispensing largesse and prosperity. That, I believe, is why lustreware was initially made for the court. The inscriptions on lustreware emphasised the association with providence and well-being in phrases such as "Blessings and power", "Glory, health, long life and success". In the course of time lustreware came to be owned not only by courtiers but by merchants and other citizens, and its golden colour became an invocation of the stability and life-giving power of the sun. This is why lustre vessels of the 13th century were often inscribed with words such as "May the Creator of the World protect the owner of this vessel wherever he may be".

The images on minai usually evoke legend, history and romance and have a timeless mood, like epic poems. The fine drawing, the colours and the gilding, the small vessels with their thin walls, refine the sensibilities and draw one into the scene. These are sensory effects. But the evocation of great events and noble people, daring, beautiful and favoured by fortune, touched people's hearts and motivations. Today we often deplore tales of crime and violence on television and have little doubt that they have a negative influence on their viewers. I believe the owners of minai vessels were equally sure that the effect of the inspiring tales figured in them was benevolent and positive.

Court scenes were a favourite subject for important lustre dishes, and later for underglaze designs. A sun emblem was sometimes painted in the lunette above the principal figures, and a pool of fishes in the lunette below them. Both these suggest protection by a celestial power (**17**). Many courts, especially in Europe, have mirrored themselves in their arts, usually emphasising the dignity of individuals. The Seljuqs reflected their courts in their metalware and ceramics, but because the figures are not individualised they outlived the court and became universal. The figure on the throne is no actual king, but "he who plays the king". The image celebrates and generalises a situation. Everyone at some time enjoys the praise and confidence that comes as if by right to those in favour with their stars, or stands enthralled by the fishes in the pool weaving a magic in their silent movement. These scenes mirror more than the court.

Just who is the king, the ruler? He could be anyone, a wandering dervish, or you or me, anyone who is deeply in tune with the place and the moment, at ease, in command of himself under God. The theme of the *diwan*, the ruler-at-ease, started as a court image but became a spiritual theme of universal validity.

Persian pottery of the golden age, minai and lustre especially, was often inscribed with poetry. Some poems are known only from the inscriptions on ceramics. The verses are usually allegorical and mysterious; they could conceivably refer to situations in daily life, but seem more likely to have an inward, mystical meaning, possibly connected with Sufi traditions, as in these two examples:

> *The good remains, no matter how much time passes,*
> *And evil is the worst provision you can store.*

and, from another vessel,

> *The days will reveal to you that which you do not know:*
> *The one whom you never dealt with will bring you news.*

Such poetic quotations on pottery are quite distinct from conventional clichés invoking health and happiness and their presence may for ever remain mysterious.

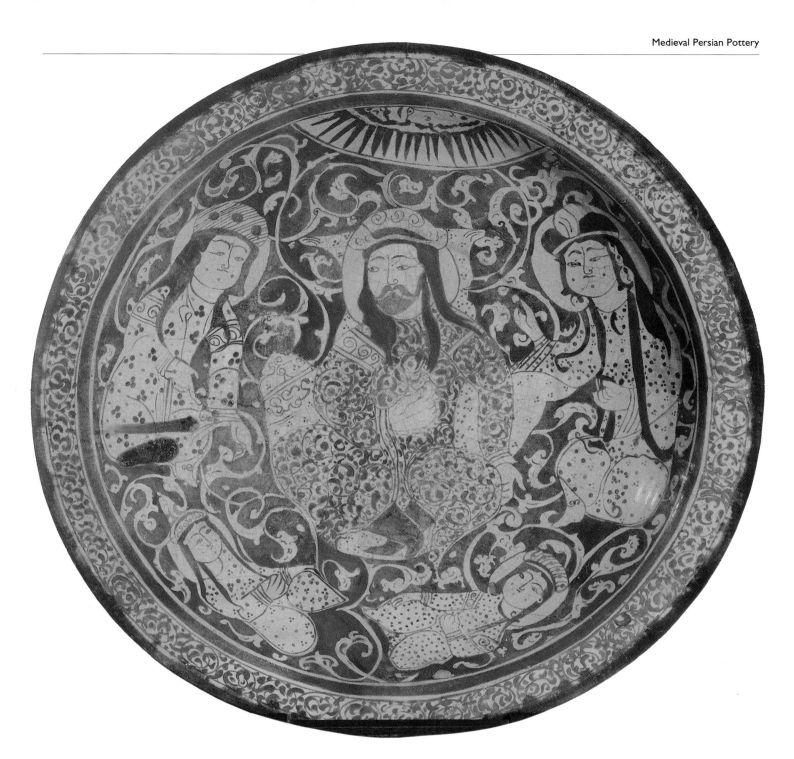

17. Lustre dish, Kashan, early
13th century. Diameter: 47.5cm
(19"). Ashmolean Museum,
Oxford, Barlow Collection,
inv.no. 1956-183.

In this connection it is worth mentioning Dr Watson's discovery that lustre tiles for shrines and mausoleums were not used by orthodox Muslims but only by adherents of the Shia tradition, who were connected with Sufism. Symbolism and allegory are an essential part of Sufi teaching. Poetic or visual symbols capture understanding and are also meant to melt the heart and open the spirit. Lustre and light, in their various shades of meaning, had special significance for anyone connected with this tradition. This is a delicate speculation and I mention it only to indicate that Persian pottery can contain much more than the eye beholds.

Finally, in the context of alchemy and the transformation of materials, there remains one particular feature that is usually concealed from us, because in modern collections pottery is protected in glass cases. This is the sense of touch. Many Persian vessels are thinly and most delicately made and have a beautiful balance in the hand. The potters were converting earthy substances into insubstantial light and resonant colour. Their finest work belongs to a protected, interior setting, far removed from the give and take of everyday life. Its delicacy conveys an exquisite shock, bringing a quiet attentiveness to those who handle it. When they fulfilled commissions, the potters often provided their patrons with more than they were able to ask for. By changing the quality of people's sensory responses and the focus of their minds, their work became an active, civilising force. People can transform clay into vessels, but clay vessels in their turn can transform people. Rightly did Abu'l Qasim call pottery "a kind of alchemy".

Notes see Appendix

WHITE AND BLUE

Chinese Ceramics & the Albers Effect

John Carswell

No one could accuse collectors and scholars of neglecting Chinese blue-and-white porcelain. But while much has been written on its history, design and technique, the question of how the colours interact, creating a seemingly infinite number of subtle visual effects, is rarely considered. The author argues that what we think we see is not what we actually see, and that the aesthetic process determining how the two colours affect the visual field of the onlooker accords with the ideas of the artist and theorist Joseph Albers.

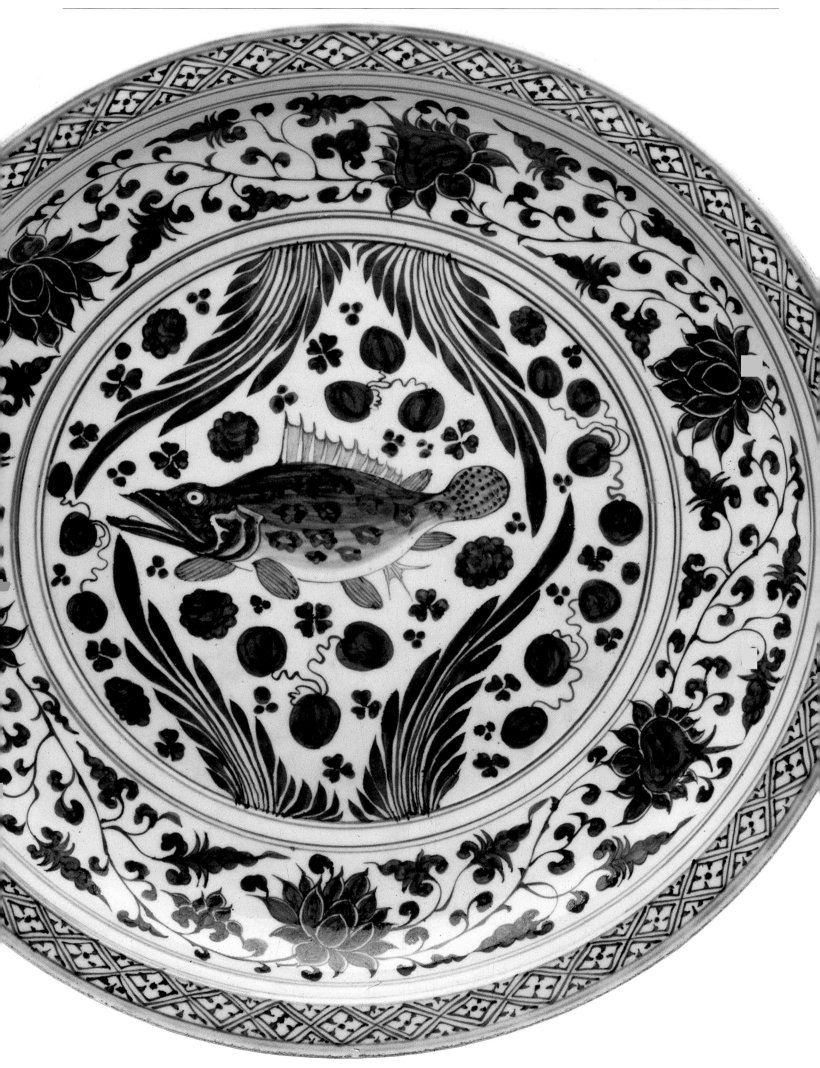

Fig. 1.

Fig. 2.

1. *Previous page:* Dish with a carp amongst waterplants, 14th century. Topkapı Saray, Istanbul, inv.no. 15/1416.

2. Dish with moulded flowers in the cavetto, 14th century. Topkapı Saray, inv.no. 15/1465.

S ome years ago at the University of Chicago I organised an exhibition of Chinese blue-and-white and its imitations. Pieces were borrowed from 27 museums around the world, none of which had ever been exhibited together before. Indeed, in one case – the Metropolitan Museum of Art in New York – we took material from three different departments who seemed to be totally unaware of each other's existence. For instance, when I asked the Curator of the Chinese Department the way to Medieval, she said she really didn't know, perhaps I had better ask at the main desk.

Before the blue-and-white – which included Chinese, Japanese, Islamic, European and even a category which I can only describe as mad Mexican with Sino-Aztec designs – arrived in Chicago we speculated on the different sorts of cobalt blue which we would encounter. In fact, when the exhibition was assembled, it was not the varieties of blue which were so striking, but the different kinds of white. The white in the blue-and-white, whether porcelain or its pottery copies, was seldom white at all. For instance, in the early Yuan pieces it had a distinctly greenish tinge, deriving from *qingbai*, rather than the opaque *shufu* ware. And in the copies it could be anything, from yellowish through greyish to a greenish tone.

But what I want to examine here is the impact the blue has on the white, with reference to blue-and-white in general. My basic argument is that our aesthetic reactions to much blue-and-white are actually conditioned by a specific visual response. The Chinese artists arrived empirically at an understanding of this phenomenon, as indeed have all artists through time. I shall call it the 'Albers Effect', for it was Josef Albers of Bauhaus fame who first codified and analysed the principle, in a post-war course he gave at Yale. This was published in 1975 in his magisterial *The Interaction of Colour*, using his students' work as an illustration. This fundamental work should be required reading for all art historians; but I have seldom met anyone in the field of oriental art who has ever heard of it.

Alber's fundamental thesis is simply that what you think you see isn't what you see at all. All colours are affected by their neighbours, and mutate accordingly. In its extreme form, he demonstrates that you can make a colour take on a different character by the way you encapsulate it, particularly if you surround it with its chromatic opposite. For instance, in fig.1 the turquoise squares in the top and bottom halves of the diagram appear to be different, but they are actually exactly the same. And even more interesting is the proof that you can enhance or diminish the tonal value of what you surround it with. In fig.2 the grey border is an even tone but it is so affected by the background that it appears to diminish from dark to light. This is particularly significant when dealing with monochrome.

To return to China and Chinese porcelain, that the Yuan potters were aware of this is obvious, and if you analyse a series of 14th century pieces you can see to what degrees of sophistication they used this effect. One rare dish (**5**) ignores it completely: the dominant blue enhances the pristine whiteness of the designs, but in the process the silhouettes are simply overwhelmed, and the final effect is rather like a Victorian *decoupée*. The white is certainly a stunning white but there is nothing else with which to compare it.

On another dish (**2**) the 'whiteness' of the flowers in the cavetto is indisputable, but the moulded patterns under the glaze fail to animate the rather dull blotchiness; much more striking are the white serpentine leaves on the rim given an animated emphasis by the dark blue outlines.

On the other hand, two more dishes show the device used with considerably more sophistication. One (**6**) is predominantly sober in its grave, dark blue intensity; the white outlines are used with electrifying effect. If you half-close your eyes you can see that the whites take on quite different qualities according to the amount of blue surrounding them. Compare the ring surrounding the Buddhist emblems with the outlines of the lotus-panels, which are modified by the interior white line of the

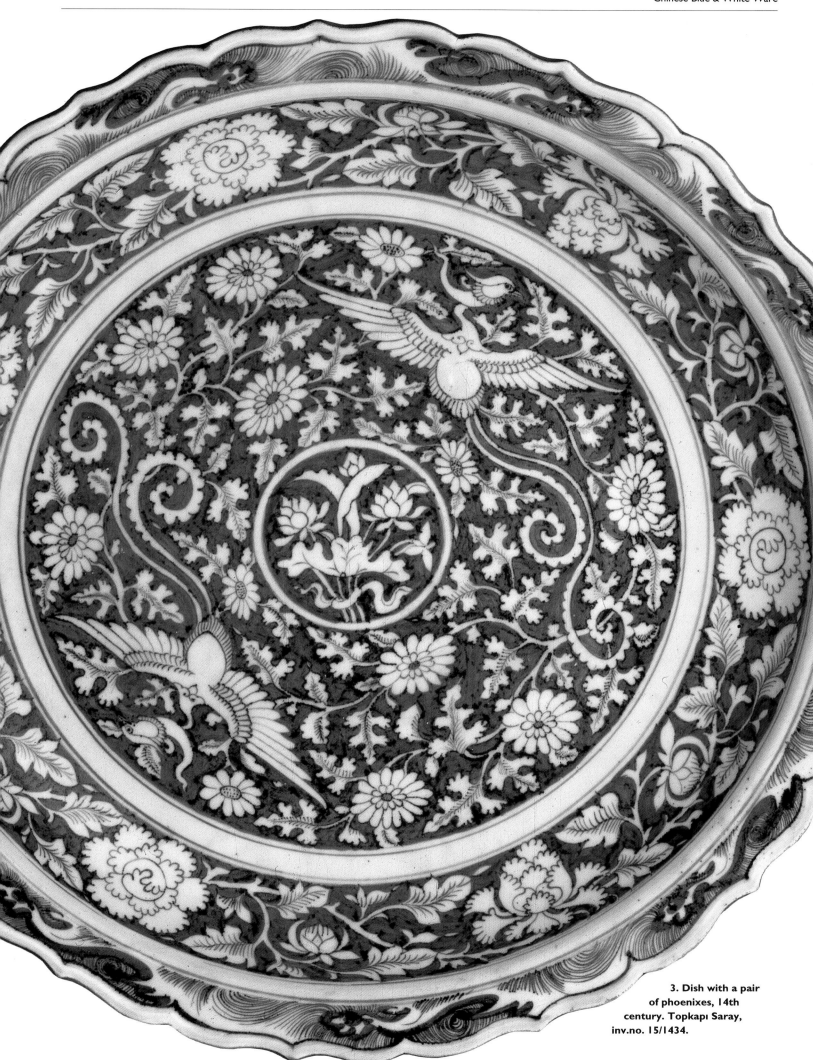

3. Dish with a pair of phoenixes, 14th century. Topkapı Saray, inv.no. 15/1434.

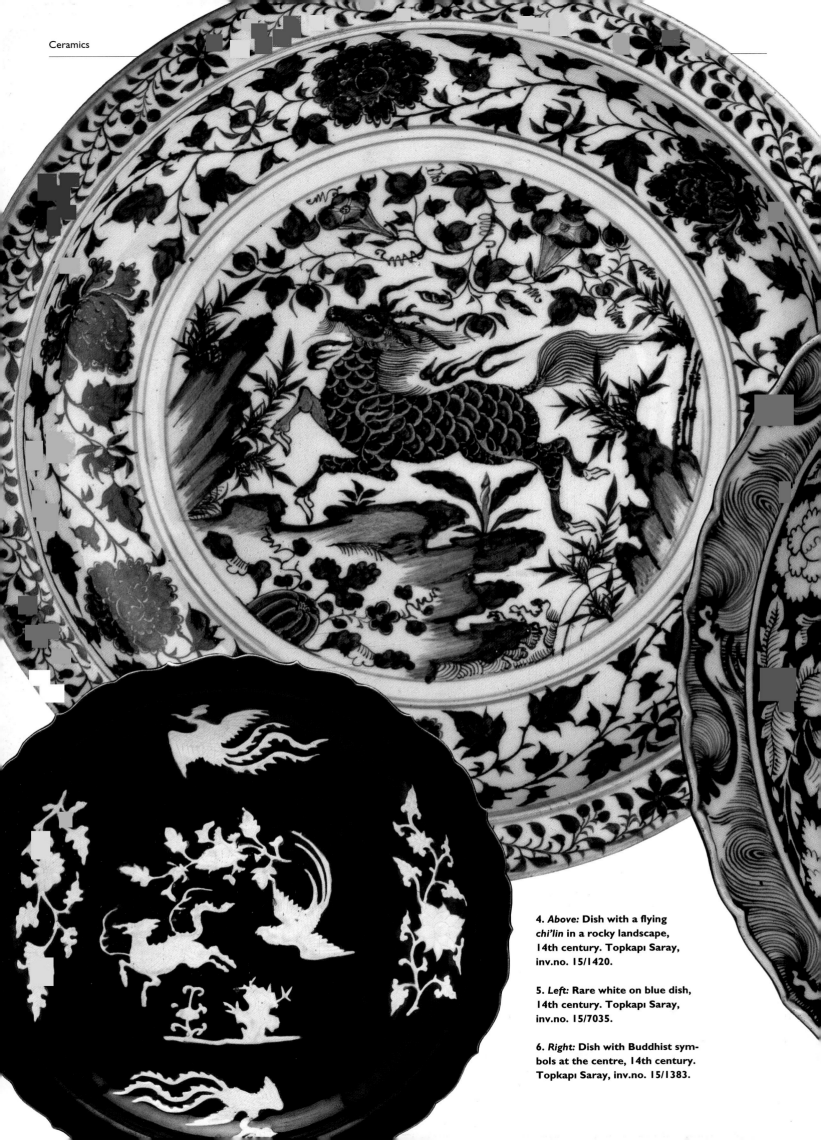

4. *Above:* Dish with a flying *chi'lin* in a rocky landscape, 14th century. Topkapı Saray, inv.no. 15/1420.

5. *Left:* Rare white on blue dish, 14th century. Topkapı Saray, inv.no. 15/7035.

6. *Right:* Dish with Buddhist symbols at the centre, 14th century. Topkapı Saray, inv.no. 15/1383.

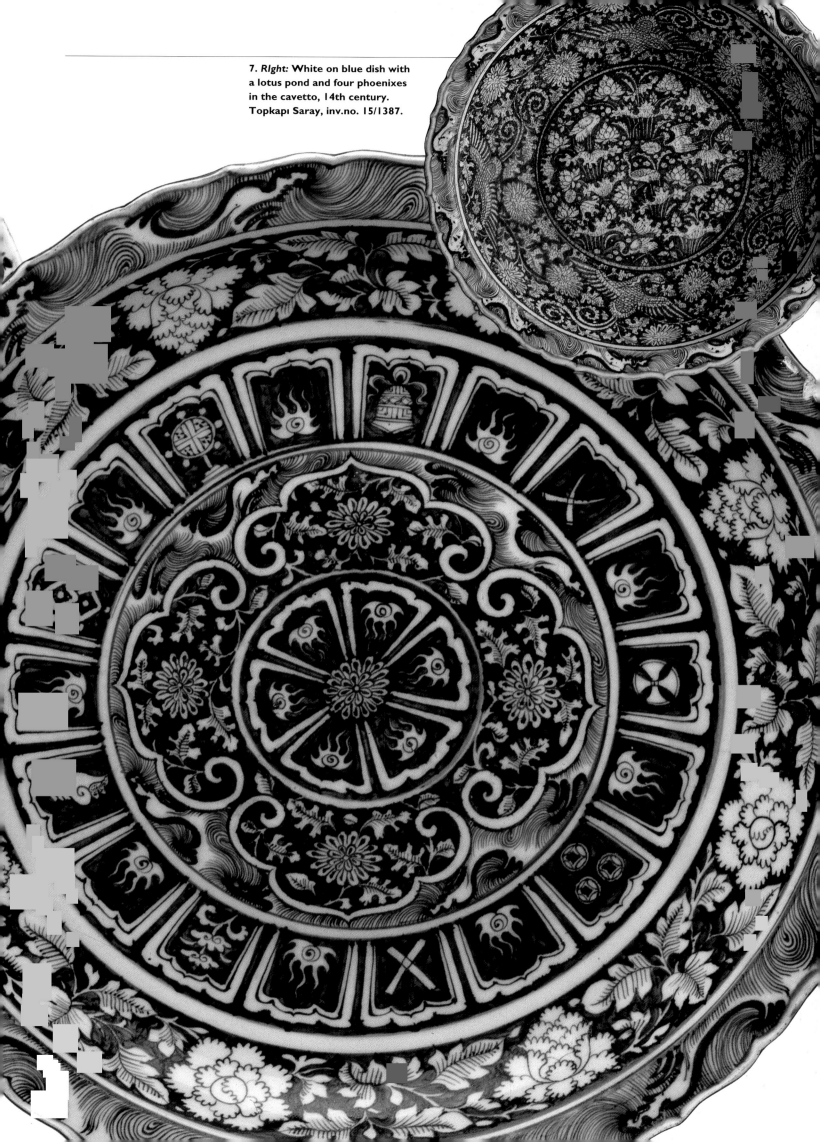

7. *Right:* White on blue dish with a lotus pond and four phoenixes in the cavetto, 14th century. Topkapı Saray, inv.no. 15/1387.

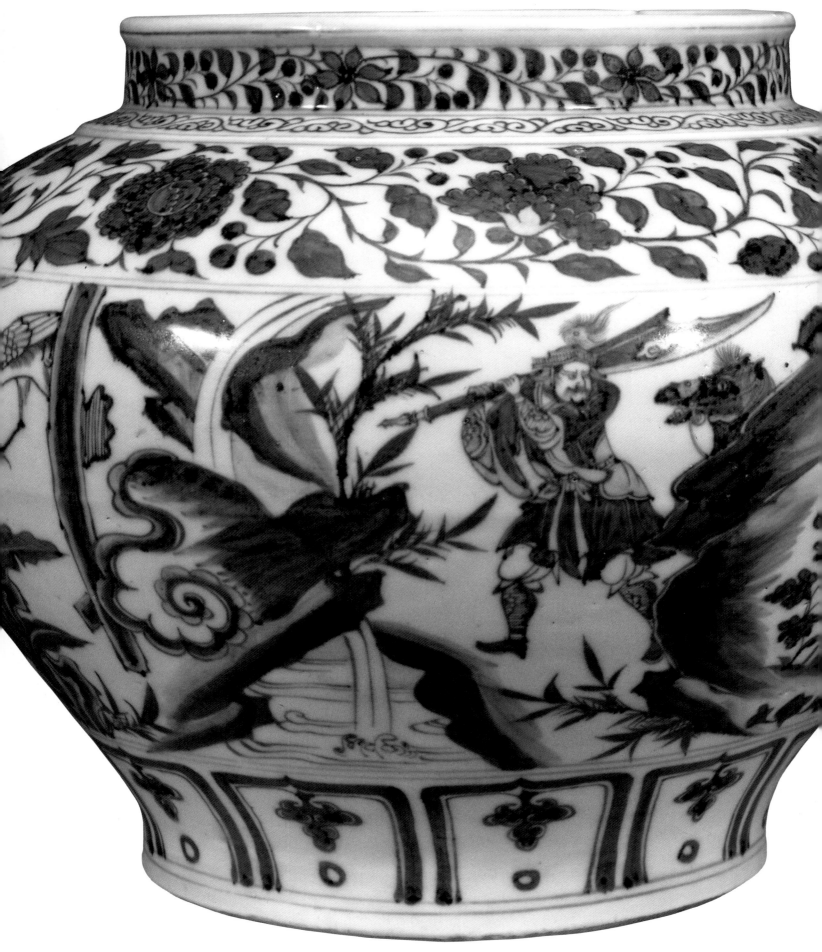

160

frames, which then shade into the dark-blue ground on which the symbols repose. The flowers and leaves in the cavetto have an added sting thanks to the sharp details. On the second dish (**3**), there is less tension and much more equilibrium, but again the white ring in the cavetto has a whiteness which makes it the strongest element in the whole design, to which all the other white motifs are subordinate.

Two further examples are interesting, for here the artists are not at all concerned with the Albers effect. The overall impact is simply of blue on white, and the 'whiteness' of the inner ring of one (**4**) is simply the result of a void in the tangle of animated blue patterns. But the white ground at the centre is essential to dramatise the silhouette of the *chi'lin* leaping across the rocky ravine, through a screen of morning-glory and sprouting bamboo. The same is true of another dish (**1**); the vulnerable fat white underbelly of the fish has a whiteness which depends on isolating the curve of flesh between the dark skin above and the fins below, producing a result quite different to the white ground. Two more dishes make an instructive comparison. One (**7**), even allowing for overfiring and an accidentally speckled surface, is designed in such a way as to completely diminish the white areas; whilst the other (**9**) makes dramatic use of the lotus-panels at the centre, which focus the whole design, with a rippling border of white unadorned waves and a raised white foliate rim. It is extraordinary how many subtle tones are achieved by the different ways in which the cloud-collar panels are hatched and shaded.

When it comes to narrative painting rather than decorative motifs, a recently discovered *guan* is surely a masterpiece (**8**). The dramatic incident depicts the episode known as 'The Three Visits to the Thatched Hut' from the *Romance of the Three Kingdoms*, a 14th century epic recounting historical events that took place in the 3rd century AD. Here again, the use of different kinds of white is extraordinary. Look at the right side of the vase, where the white ground round the leg of the figure carrying a halberd is of quite different intensity to the foaming waterfall and the billowing white cloud on the left. How is this achieved? In the first instance, by planting the dark blue leg on an otherwise blank white ground; in the second, by modifying the whiteness of the water with horizontal and vertical swirls; and in the third instance by surrounding the cloud with a thick, scalloped outline, which makes the cloud almost leap off the surface of the vase. It makes the floral bands seem tame by comparison.

If the Chinese potters had such a sophisticated appreciation of the interaction of blue and white in the 14th century, it comes as something of a surprise to find that in the 15th century they seem to have lost their touch. This statement may cause a sharp intake of breath among some connoisseurs, but I hasten to say that this is not an aesthetic judgement. What I really mean is that there is no sense of monochromatic interplay. It is blue on white, rather than blue and white (**10**). Interaction is no longer part of the game, and whilst this may have led to other, perhaps more painterly, preoccupations, it is quite a different idiom. Such painting is marvellous, but it has none of the crisp, dramatic quality of the Yuan ware.

By the 15th century a whole new category of mass-produced pottery dominates the scene, manufactured for export (**11**). Crudely painted, the patterns have an all-over character, which rather than enhancing the form often negates it. We know almost exactly when this genre began for Giovanni Bellini's *The Feast of the Gods*, dated 1514 (**12**), contains three pieces of it (**13**). It is reminiscent of earlier 14th century wares in design, but imitated at long range with a far clumsier hand. At its best it has a lively, decorative quality with a certain peasant charm. In a

9. *Above:* Dish with six Timurid cloud-collar panels and six Buddhist good luck symbols at the centre, 14th century. Topkapı Saray, inv.no. 15/1480.

8. *Left: Guan* painted with 'The Three Visits to the Thatched Hut' from the *Romance of the Three Kingdoms*, 14th century. Private collection. Photo courtesy Sotheby's, London.

10. *Below:* Large dish painted with landscape and floral sprays in the cavetto, early 15th century. Topkapı Saray, inv.no. 15/407.

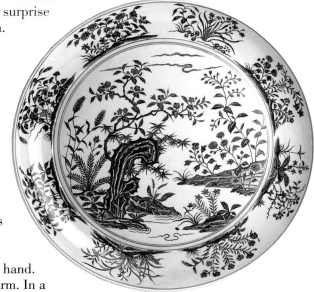

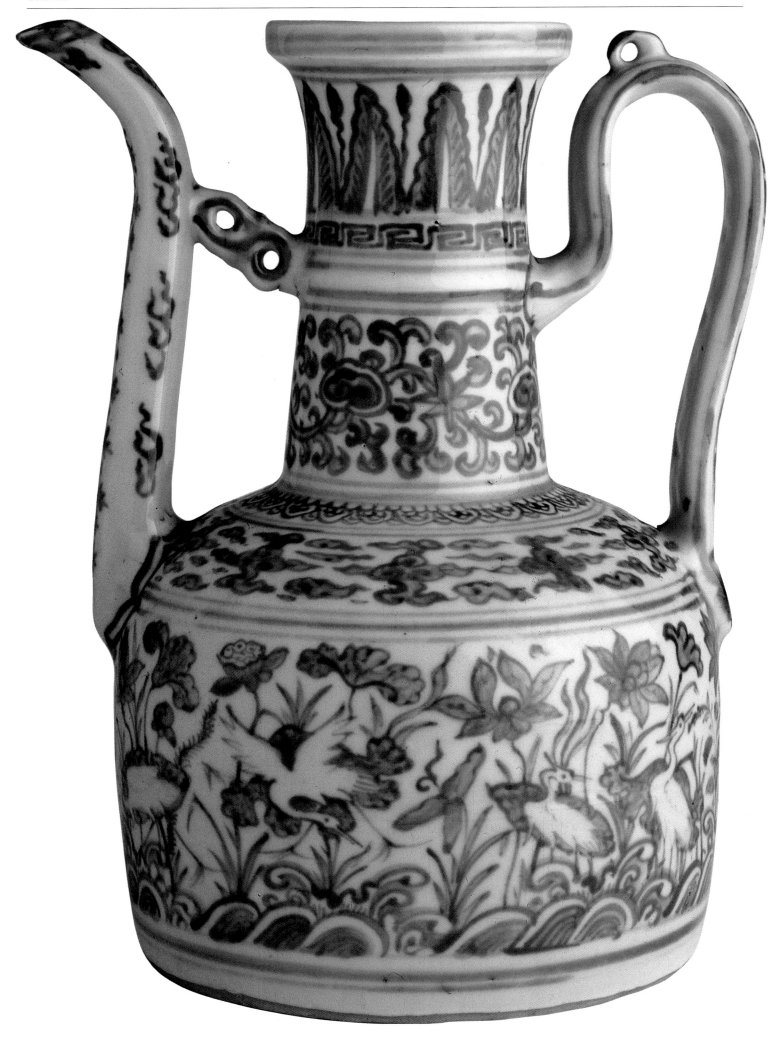

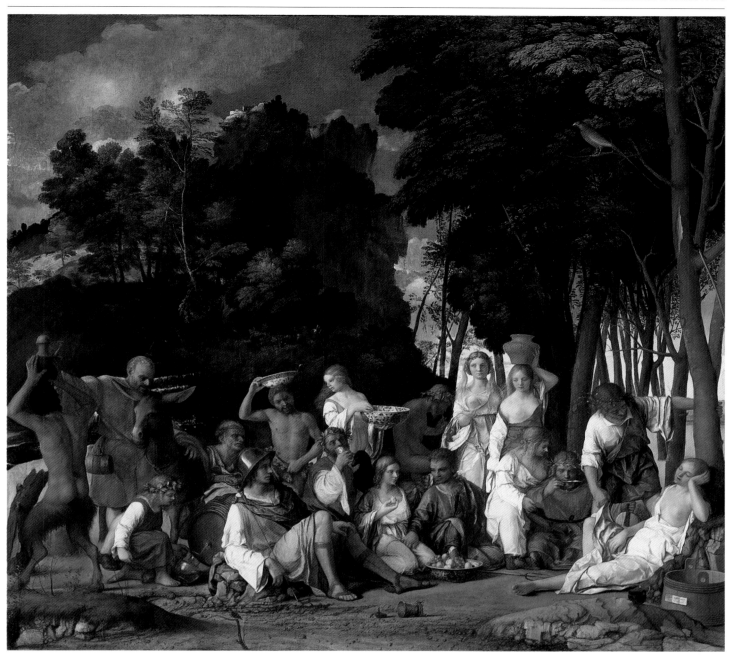

11. *Left:* Ewer with cranes in a watery landscape, late 15th/early 16th century. Topkapı Saray, inv.no. 15/1950.

12. *Top:* Giovanni Bellini, *The Feast of the Gods,* dated 1514. National Gallery of Art, Washington DC.

13. *Right:* Bowl with everted rim similar to that in the foreground of (12), late 15th/early 16th century. Private collection, London.

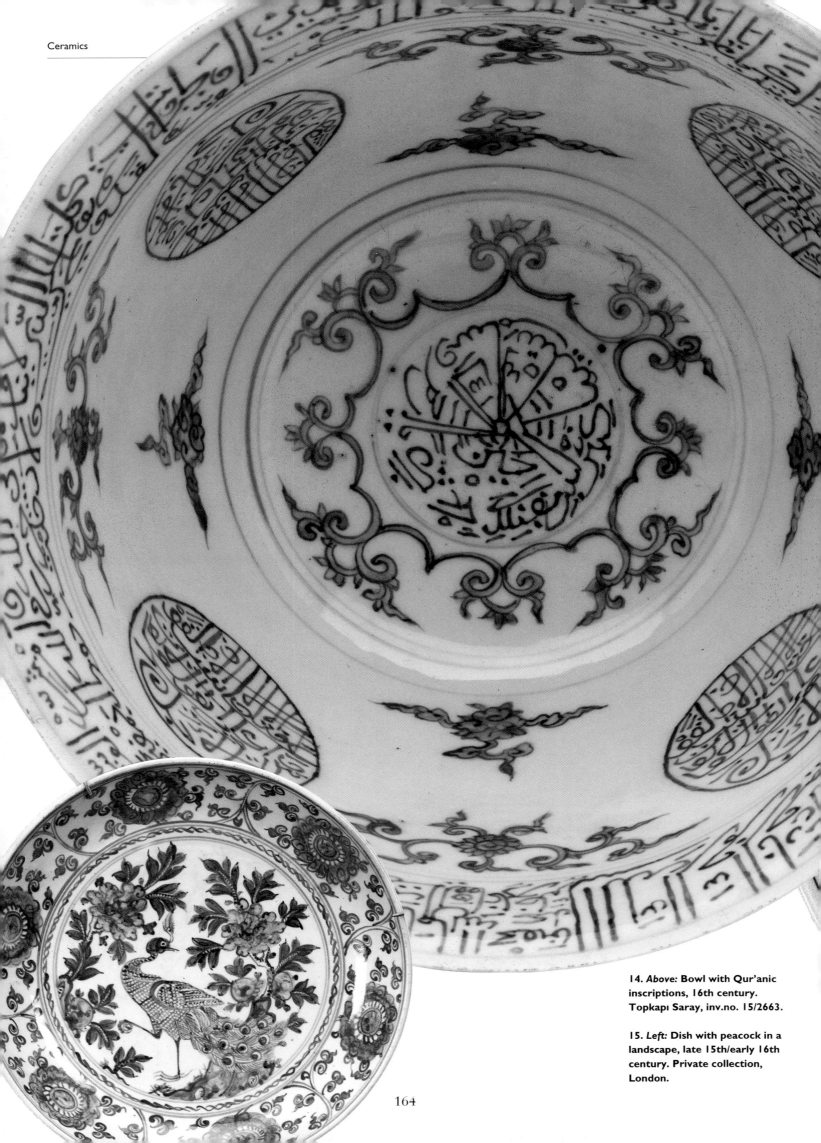

14. *Above:* Bowl with Qur'anic inscriptions, 16th century. Topkapı Saray, inv.no. 15/2663.

15. *Left:* Dish with peacock in a landscape, late 15th/early 16th century. Private collection, London.

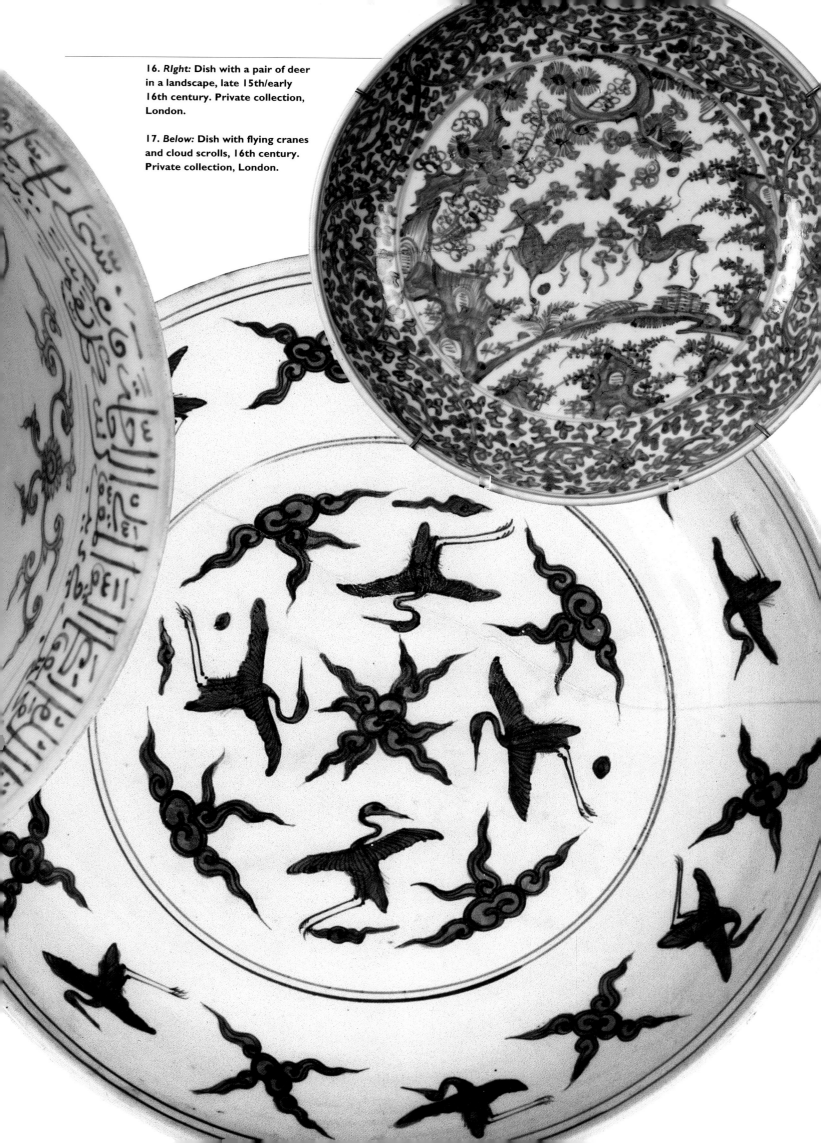

16. *Right:* Dish with a pair of deer in a landscape, late 15th/early 16th century. Private collection, London.

17. *Below:* Dish with flying cranes and cloud scrolls, 16th century. Private collection, London.

typical dish of this period (**15**) the tonalities of the peacock's tail have become hopelessly muddled with the blossoms above – in the 14th century, either one, or the other, would have predominated. This mindlessness is further demonstrated in another dish (**16**) – the dancing deer have truly lost their way and really do want to go home – they are battered by prunus and prickly bushes, and suffocated by the turgid floral border. There is a claustrophobia in much of the mass produced ware of this period.

However, lest one be accused of being beastly to Bellini (for after all, he liked the blue-and-white enough to include it in his masterpiece) the 16th century approach does have some redeeming features. One can, for instance, see it in a series of bowls which were destined for foreign patrons. One (**14**) is pedestrian enough on the exterior, but the interior is sensitively designed to incorporate a mass of Qur'anic inscriptions. Here the white ground again plays a significant role, as a foil for the complex Arabic script. And in some elegant bowls made for the Portuguese market, with the arms and armillary sphere of Manuel II, the broad white circles create other kinds of whiteness, to emphasise the distinctly un-Chinese motifs that they frame.

It is as if the old laws had been revived. On a 16th century dish (**17**), the flying cranes and cloud scrolls at the centre are more tightly bunched than those in the cavetto, and produce – again – two sorts of white ground. More subtly, perhaps, there is a sense of the expanding universe, and a cosmic quality as if one were looking upwards through the flocks of cranes to infinity. Another dish of the same period (**19**) is more restrained in its treatment but beats the same drum. Here the cranes – white cranes this time – drift over water, as if caught in multiple air currents; but round about they have grounded, although white waves still crash on the rocks below. And they are still *white* cranes.

Another dish (**20**) not only exploits the Albers effect but also what one might call a Matisse-like system of interlocking shapes. In this magnificently painted landscape, framed in a pure white cavetto, heavily silhouetted forms – rocks, clouds, sky – interact with each other, the contours locked in perfectly balanced compositions. At the same time the white sky and the white moon, the drifting white clouds and the white waterfall, all have different nuances. For sheer mastery of blue and white this dish reigns supreme, and is as fine as any of the 14th century wares.

This technical manipulation of blue and white can be seen to even more dramatic effect in another well known series of dishes, where figures ride and boats prowl in a darkened landscape. On the rim, cranes peck and pose, and because they are placed against dark blue waterplants they are of an immaculate whiteness (**18**). But let us look carefully at the central scene. Surely this can only be moon-light? The light in the pagoda to the left and the little lights on the junk above blaze out of the hatched background. No 14th century artist could have rendered this better. What does this all mean? Simply, that the tricks of the trade which were so brilliantly exploited in Yuan blue and white, after a break of a century or more, were suddenly revived and became an integral part of the 16th century style. Whereas in the 15th century interlude the painting was blue *on* white, once again it is blue *and* white.

Perhaps it is right that Josef Albers should have the last word: "If one is not able to distinguish the difference between a higher tone and a lower tone, one should probably not make music."

First given as a lecture at the British Museum, part of a Seminar on 16th century Chinese porcelain organised by the Oriental Ceramic Society, October 1994.

18. *Above:* Dish with a romantic landscape with islands, pagodas, a fishing boat and a man on a donkey, 16th century. Private collection, London.

All photographs of ceramics from the Topkapı Saray Collection courtesy Philip Wilson Publishers. See Regina Krahl, *Chinese Ceramics in the Topkapı Saray Museum Istanbul* (1986).

20. *Right:* Dish with deer in a rocky landscape with a tortoise and a waterfall, China, 16th century. Private collection, London.

19. *Below:* Dish with white cranes and plants in a watery landscape, China, 16th century. Private collection, London.

METALWORK

FROM DIVERSITY TO SYNTHESIS

Changing Roles of Metalwork and Decorative Style in China

Colin Mackenzie

The Warring States (481-221 BC) and Han (206 BC-AD 220) periods, together with the short-lived Qin dynasty (221-206 BC) that separated them, were of pivotal importance in the development of Chinese civilisation. A profound change in the role of bronze took place in this period, with the introduction of new types of vessel as well as a range of new techniques including intricate ornamentation in gold, silver and semi-precious stones.

170

1. *Previous pages left:*
Pushou handle, Han period (206
B.C.- AD 220). Height: 46.3cm
(18"). Private collection. Photo
courtesy J.J. Lally, New York.

2. *Previous pages right:*
**Bronze wine vessel (*hu*), inlaid
with gold and silver, 5th-4th
century BC. Height: 38.5cm
(15"). Private collection.**

3. Set of gilt bronze mounts for
a lacquered wine vessel (*zun*),
2nd-1st century BC . Private
collection.

By the start of the Warring States period, the formerly dominant Zhou kingdom (ca.1050-256 BC) had already been reduced to an impotent onlooker, as powerful regional states jostled for power in a cataclysmic struggle that culminated in the emergence of the state of Qin as victor and in the annihilation of the rest.[1] Despite, or perhaps because of the political fragmentation and turmoil, it was a time of unprecedented creativity and invention in philosophy, science and literature. With the unification of the empire under the Han dynasty, Confucianism absorbed important elements from the competing philosophical schools of the previous era and, in its modified form, became the official ideology, a process which is sometimes referred to as the Han synthesis.

A parallel trend can be seen in the art of the era, especially in metalwork. As Jessica Rawson has observed, a fundamental shift in the role of bronze occurred during this period.[2] As the feudal aristocracy was eliminated in the unending wars, the importance of the ancestral sacrifices, on which their moral claim to authority had rested, declined. The sets of bronze ritual vessels and bells, which had formerly been the focus of bronze casting, were

4. Bronze twin-handled oval bowl (*he*), inlaid with gold and turquoise, one of a pair, 5th century BC. Height: 9.5cm (4"). Private Collection.

We would like to thank Eskenazi Limited, London, for generously providing all photographs in this article, unless stated otherwise.

Fig.1. Drawing of a turquoise-headed gold bird from a crown found at Aluchaideng in Hangjin Banner, Inner Mongolia, 4th-3rd century BC. After Tian Guangjin and Guo Suxin, *E'erduosi shi qingtongqi (Ordos-style Bronzes)*, Beijing 1986, p.163, fig.111:3.

Fig.2. *Below:* Bronze *hu*, inlaid with copper dragons from Liulige in Hui Xian, 6th century BC. Height: 52.8cm (21"). After *Zhongguo meishu quanji: gongyi meishu bian (5); qingtongqi (2)*, pl.69, Beijing 1994.

5. *Below:* Bronze twin-handled oval bowl (*he*), late 6th or early 5th century BC. Height: 7.1cm (2½"). Yale University Art Gallery. Stephen Carlton Clark Fund, inv.no. 1994.45.1.

challenged in importance by a new range of articles that reflected the new aspirations and preoccupations of their owners. Indeed, the prestige of bronze itself began to decline, as other materials rose to prominence. Whereas previously the value of a bronze was largely a reflection of the intricacy and precision of its cast decoration, now bronze was often a vehicle for ornament in other materials – gold, silver, semi-precious stones, glass, and even lacquer. In certain cases it was dispensed with altogether, to be replaced by solid gold, silver or iron.

The new range of bronze articles and decorative styles was not, however, to be the product of a unilinear or uniform evolution. Both the regional cultures which had arisen within China proper and the peoples inhabiting the border regions and beyond made important contributions, as increasingly intense contact – military, diplomatic and mercantile – between far-flung regions ensured a rapid interchange of ideas and influences.

THE NEW REPERTOIRE OF BRONZE FORMS

The new range of bronze vessels does not seem to have evolved directly from the ritual repertoire, but instead drew inspiration from pre-existing forms in other materials. Of the handful of vessel forms which continued to be lavishly decorated into the Han period, the *hu* (wine container) was the most important. A new version of the type, much simpler in form than the highly articulated *hu* descended from Western Zhou (ca.1050-771 BC) prototypes, was introduced. The new version, which was initially confined to the Yellow River region and further north, possessed a smooth profile from which the large appendages characteristic of the older type were generally eliminated. Some of the earliest examples of the new version lack a foot-ring and thus seem to be imitating not ceramic vessels, which generally possess foot-rings, but vessels fashioned in softer materials such as leather, which normally lack this feature. The pear-shaped profile and oval section of a *hu* from Liulige in Hui Xian, Henan province (fig.2), are similar to a leather flask from barrow 1 at Pazyryk in the Altai Mountains of southern Siberia.[3]

The non-ritual derivation of the new form is confirmed by one such *hu* in the Museum für Völkerkunde, Berlin, which bears an inscription stating that it was acquired from the Xian Yu, a barbarian tribe that controlled areas of northern Shanxi and Hebei provinces.[4] As the vessel type became established in mainstream Chinese casting, it was modified; the foot gradually became taller and the profile gained a more pronounced shoulder, developments exemplified by the *hu* in plate **2**. It is possible that this particular vessel may be a product of the bronze ateliers of the Zhou state, since its pair was said to have been

6. *Left:* **Gilt bronze table leg from a set of four, 2nd century BC. Height: 18.5cm (7").** **Private collection.**

7. *Right:* **Pair of gilt bronze mat weights, 2nd-1st century BC. Diameter: 6.5cm (2½").** **Private collection.**

8. Bronze zither knob inlaid with gold and silver, 2nd-1st century BC. Diameter: 5.8cm (2"). **Private collection.**

found in the royal Zhou tombs at Jincun near Luoyang.[5]

A second important addition to the vessel repertoire was an oval bowl, here represented by a late 6th/early 5th century BC example in the Yale University Art Gallery (**5**). Since no convincing predecessor of this type, variously known as *he*, *zhou*, or *xing*,[6] is known in bronze from Western Zhou sites, this raises the possibility that this too was based on a pre-existing form in perishable materials. This view is confirmed by the discovery in an 8th century BC tomb in Shandong province of an early bronze example. This piece is described by the excavators as decorated with ridges that seem to imitate stitching, as if the whole vessel was copying a leather prototype.[7] Since leather vessels seem to have been more common in steppe culture than in China, it is possible that the ultimate inspiration for the form lay beyond the northern borders.

Whatever the precise geographical origins of the type, it rapidly acquired widespread popularity throughout the feudal states of Zhou China. While the earliest versions possessed only a single ring handle, by the 6th century BC it had been furnished with another, thereby lending it the symmetry that was *de rigueur* for a ritual vessel. The growing prestige of the type is reflected in the attention paid to its decoration. Finely cast decoration of dissolved dragons covers the sides of the Yale University Art Gallery piece, while gold inlay embellishes another in the British Museum.[8] Even more remarkable is another fashioned in solid gold and furnished with jade handles from tomb 306 at Shaoxing in Zhejiang.[9]

The *he* in plate **4** and its pair are particularly impressive examples. Not only does their decoration employ gold and turquoise inlay, but they are supported on four avian caryatids. The addition of legs or a tall foot was a well tried way of lending a new vessel form greater prominence when it entered the ritual repertoire. The rendering of these avian caryatids and of similar supports on a pair of *he* from the 1923 find of bronzes at Lijialou in Xinzheng, Henan Province,[10] is distinct both from the profile view of the bird found on earlier mainstream Chinese bronzes and from the tall crane-like birds popular in the Yangzi (Yangtze) River region. Instead, their

ROGER ASSELBERGHS, BRUSSELS

frontal pose and outspread wings relate them to a solid gold bird finial from the tomb of
Duke Jing of Qin (r. 576-537 BC).[11] The stance may not, however, have been a Qin invention,
for it is similar to the conventional steppe treatment of the bird. At Pazyryk small wooden
figures of predatory birds with outstretched wings decorate head-dresses,[12] and a solid gold
version with turquoise beak surmounts a crown from a tomb at Aluchaideng in Hangjin
Banner, Inner Mongolia (fig.1). Although the comparative material cited is slightly later
than the caryatids on the *he*, it is reasonable to postulate that earlier steppe examples existed
in perishable materials which could have inspired the adaptation of the motif for use on
Chinese bronze vessels.

While the popularity of the *he* was relatively brief – the majority of known
examples are datable to the 6th or 5th centuries BC and the type virtually
disappears a century or so later – a bucket-like vessel known as *zun* was to
have a longer life span. Unlike the previous forms, this seems to have origi-
nated in a wooden prototype first seen along the middle reaches of the Yangzi River, a region
dominated by the powerful state of Chu. Neither the undistinguished decoration of the
earliest known example, a piece from the tomb of the Marquis Yi of Zeng at Leigudun in Sui
Xian, Hubei province (fig.3), nor its location in one of the lesser chambers of the tomb give
any hint of its future importance. By the 4th century BC, however, it had become standard

**9. Bronze wine pourer (he),
inlaid with copper, 4th century
BC. Height: 30cm (12"). Photo
courtesy Gisèle Croës, Brussels.**

**Fig.3. Drawing of a lacquered
wooden *zun* from the tomb of
the Marquis Yi of Zeng, ca. 433
BC. After *Zeng Hou Yi mu*,
Beijing 1989, p.373, fig.231.**

practice in the Chu region to embellish the lacquered wood body with bronze mounts and, as Rawson has observed, it was one of the vessel types adopted from Chu into the Han repertoire. Although the *zun* was often cast in bronze, the frequent remains of gilt bronze fittings in tombs demonstrate its continued popularity in lacquered wood. The gilt bronze mounts on the modern reconstruction in plate **3** must have come from a truly impressive vessel, since the diameter of the bands comfortably exceed those found in the tombs of Prince Liu Sheng of Zhongshan and his consort Dou Wan at Mancheng in Hebei (fig.4).

Whereas the *zun* was a wooden vessel to which bronze mounts came to be attached, some vessels originally cast in bronze came in time to be fashioned partly in wood. A type of pouring vessel termed *he* (a different character in the Chinese script from the one used for the oval bowl discussed above), illustrated here by a bronze example (**9**), may also have been produced in wooden versions with bronze legs. Sets of three bronze legs with concave inner faces matching the surface of this *he* are known, and their survival detached from their original vessel suggests that it was probably executed in wood rather than in bronze.

The use of bronze fittings, however, went far beyond the embellishment of vessels. Attention became increasingly focused on the beautification of a wide range of wooden objects with decorative bronze fittings, a fashion that recalls the embellishment of furniture with ormolu mounts in Europe. *Pushou* monster mask handles (**1**) may have been applied to the doors of palaces since the Shang period, but it is only from the Warring States period that they begin to survive in quantity, probably because they began to be adapted for wooden articles which followed their owners to the grave.[13] Often, indeed, bronze fittings imitated forms invented in wood. The legs of a low table (**6**) preserve the chiselled contours of wooden prototypes such as a set found at Noin-Ula,[14] while bronze bud-shaped zither knobs inlaid with gold and silver (**8**) imitate closely the more numerous wooden versions found in Chu tombs.[15]

Furniture during the Han period still seems to have been fairly limited in scope; pictorial stone reliefs show people seated, not on chairs, but on mats laid out on the floor. Heavy weights, *zhen*, often filled with lead, were introduced in the Yangzi region during the Warring States period to prevent mats from sliding.[16] By the Han period such weights were often cast as recumbent felines or mythical beasts, with bodies curled to match the circular form of the weights (**7**).

Another focus of attention was the chariot and equestrian harness. Bronze had always been used for chariot and harness fittings, but it was probably the gradual conversion of the chariot from a military vehicle to a ceremonial one during the Warring States period that allowed the use of expensive inlays on its fittings. On a late 4th century lacquer box from Baoshan tomb 2 near Jingmen in Hubei Province, personages wearing civil robes rather than armour are shown arriving in a carriage on what is probably a diplomatic mission.[17]

One of the increasingly important additions to the equipment of the chariot as it assumed

a ceremonial role was the parasol (**10**). The impression of a wooden parasol has been pre-served in the soil in an early Western Zhou chariot pit at Liulihe near Beijing,[18] but it was only in the Eastern Zhou period (770-256 BC) that parts of the parasol began to be commonly cast in bronze. These included the hub from which the wooden spokes radiated, the hooked caps that fitted over them and which held the fabric of the parasol taut, and most importantly, the tubes that sleeved the wooden handle. The almost unbelievable quality and detail of the inlay of some of these tubes suggests that they were designed to be appreciated close-up, and that the parasol may also have been detachable from the chariot for hand-held use.

The conversion of the chariot to a ceremonial vehicle is well illustrated by a pair of large bronze models of four-horse enclosed carriages excavated from the grounds of the mauso-leum of the First Emperor of Qin near Xi'an.[19] On the evidence of the better preserved of the two, it is possible to identify the position and function of some hitherto enigmatic objects. The smaller fitting in plate **11** (one of a pair) may have capped the yoke where it joined the cross-bar, while the ribbed example is similar to one on the corner of the carriage, where it may have served as a hand-hold or as a post for securing the reins. Other parts of the chariot which were frequently highly ornamented include axle caps and pole ends.[20]

Two other categories which exemplify the new range of symbols of authority and social status are weapons and costume hooks. Around the middle of the 6th century BC weapons began to be inscribed with the names of the rulers of states. The highly decorative inscrip-tion inlaid with gold into the *ge* halberd in plate **12** names its owner as the Marquis Shen of Cai (r. 518-491 BC), a small state lying just north of the Yangzi river. Even more than hal-berds, swords came to embody political authority. Short swords with a separate hilt made of perishable material appeared in the north-west in early Western Zhou.

Around the same time, but probably independently, the southeastern states of Wu and Yue developed their own types, characterised by an integral hilt decorated with two ribs and a pommel.[21] The high proportion of Wu and Yue swords (and, indeed, other weapons) bearing inscriptions, compared with vessels, suggests that the former were the more valued in that region. Indeed, the prestige of the swordsmith in the southeast was such that the names of master swordsmiths have been preserved – a tribute that was never accorded to the anony-mous casters of bronze vessels – and talismanic names bestowed on famous examples of

10. *Facing page, left, and details above:* Parasol fitting inlaid with gold and silver, late 2nd-early 1st century BC. Height: 26.5cm (10½"). Private collection.

11. *Facing page, right:* Bronze chariot fittings inlaid with silver, 2nd-1st century BC. Height of taller 7.1cm (2½"). Private collection.

Fig.4. Drawing of a *zun* from the tomb of Dou Wan at Mancheng, late 2nd century BC. After *Mancheng Han mu fajue baogao (Excavation of the Han Tombs at Man-ch'eng)*, Beijing, 1980, vol.1, p.301, fig.203.

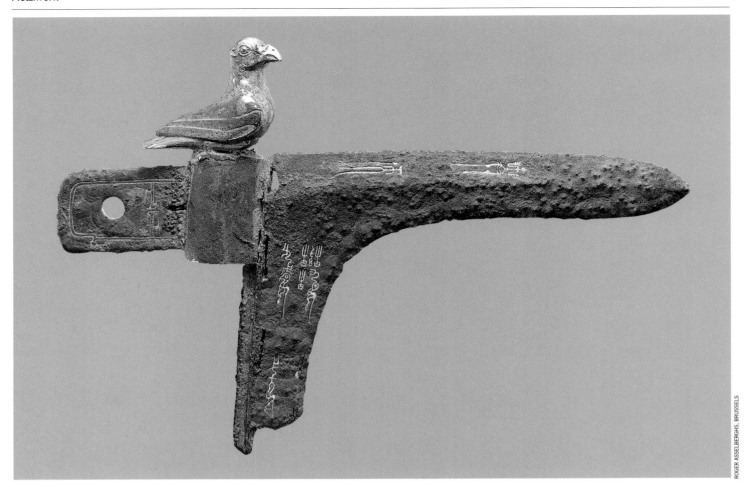

<div style="text-align: right; font-size: smaller;">ROGER ASSELBERGHS, BRUSSELS</div>

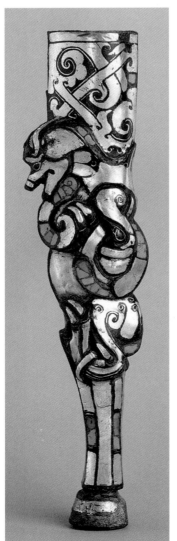

12. *Above:* **Bronze halberd (ge), inlaid in gold, inscribed 'The halberd made for the Marquis Shen of Cai'** (r. 518-491 BC). Halberd late 6th century BC.; the bird finial, probably 4th-2nd century BC, length: 21.5cm (8¹/₂"). Private collection. Photo courtesy Gisèle Croës, Brussels.

13. *Left:* **Bronze ferrule (zun), inlaid with silver and turquoise, 3rd-2nd century BC. Height: 18.5cm (7").** Private collection.

14. *Facing page:* **Bronze sword, inlaid with gold, 4th-3rd century BC. Length: 49.8cm (19¹/₂").** Private collection.

their art.[22] Such swords have frequently been found outside the Wu-Yue sphere, suggesting that they served as diplomatic gifts as well as being, of course, prized spoils of war. The sword in plate **14** is a typical Wu-Yue form, but bears instead of an inscription on its blade, a highly unusual geometric design inlaid in gold.

Whereas the sword seems initially to have acquired greatest prestige in the southeast, the bronze ferrule known as *zun* (a different character in the Chinese script from the vessel type discussed above) may have first become popular in the north, where examples are known from 6th century BC tombs at Fenshuiling near Changzhi and Shangmacun near Houma, both in Shanxi Province.[23] Examples within the Chu sphere are initially rare until the 4th century BC when they were enthusiastically adopted. Ferrules were usually fitted to the base of the shaft of *ge* or *ji* halberds, but such highly decorated ones as those illustrated in plates **13** and **20-21** could hardly have improved the effectiveness of the halberds and reflect instead the new role of weapons – at least those owned by rulers – as ceremonial and luxury items. Likewise, cross-bows acquired fittings inlaid in precious metals (**15**) and were, no doubt, wielded by rulers and nobility as frequently in ceremonial hunts and archery contests as in war.

Perhaps more than any other category of artefact, garment hooks epitomise the luxurious taste of the age. Although their precise origin remains uncertain, recent research by Wang Renxiang and Esther Jacobson points to an indigenous invention and evolution rather than an introduction from the steppes, as had previously been believed by many scholars.[24] Small gold hooks, lacking the stud of the later type, may represent one source. These have been found mainly in tombs of the Qin state, including one in the tomb of Duke Jing of Qin, and it seems possible that this type of hook was a Qin invention.[25] The example in plate **18**, although unusually furnished with a hook on each side, is stylistically similar to a hook from the tomb of Duke Jing and may possibly be a Qin product.

Most of the early hooks are small in size and may have been used to suspend various articles such as swords, mirrors, or even jade ornaments from a belt. By the 5th century BC, however, larger hooks, clearly intended to fasten together the ends of a belt, were introduced, but it was in the 4th century BC that a dramatic increase in their size and in the sumptuousness of their decoration turned them into conspicuous fashion accessories (**16, 18, 25, 27, 28**). Although the evidence of wear on some of the hooks as well as their representation on the belts of the warriors of the 'Terracotta Army', prove that they still possessed a practical function, the care taken to decorate the reverse of the finest examples (**16**) implies that they were intended to be handled and appreciated as works of art in their own right. Garment hooks are also significant in that they were sometimes cast in iron (**18**), and profusely inlaid, an indication that this metal was considered appropriate for luxury objects well before it became the norm for weaponry.[26]

INLAY STYLES

Inlaying materials with coloured stones was practised in China at least as early as the late Neolithic. Sites along the eastern seaboard have yielded objects of clay, lacquered wood and bone inlaid with jade and turquoise. With the advent of the Bronze Age, it was the latter that became the primary inlay material, being set into both the traditional materials and into bronze. Among the earliest examples of turquoise-inlaid bronze are oblong plaques decorated with a simple mask. Two such plaques, one very close to the piece in plate **19**, have been found placed on the chests of skeletons in tombs at the site of Erlitou (ca. first half of second millennium BC) in Yanshi County, Henan.[27]

The plaques are significant, not only for their extensive and totally assured use of turquoise inlay, but also because they provide an immediate source for the so-called *taotie* mask that came to dominate the decoration of bronze vessels of the succeeding Shang dynasty (ca. 1500-1050 BC). Surprisingly, in view of this iconographic link, the technique of inlay was hardly ever exploited on vessels and remained confined to weaponry until its gradual disappearance from all types of bronzes during Western Zhou.[28]

Turquoise and mother-of-pearl did, however, continue to be applied to vessels fashioned in other media such as bone and lacquered wood throughout the Shang and Western Zhou periods. This continuity has given support to scholars who argue that the new use of inlay to decorate bronze vessels from the late 7th century BC represents merely the adaptation of a style and technique long-established in other materials. Other scholars, however, have sought its origin in the steppes and have pointed out that in the new cycle, its treatment differed in many respects from that obtaining in the earlier era. Not only was inlay now commonly applied to vessels, but metallic inlays, initially copper and later gold and silver, were introduced.[29]

Moreover, in terms of the formal relationship between the inlaid areas and the bronze surface there is marked contrast between the two traditions. Whereas on the early plaques and Shang weapons the inlay acts essentially as a background against which the features of the images are defined by the reserved areas of bronze, in the earliest Eastern Zhou examples it is the motifs themselves that are inlaid. The *hu* shown in figure 2 illustrates the new style and also the fact that it was copper, not turquoise, which was most extensively employed on the earliest inlaid vessels.

Although copper continued to be used well into the 4th century BC, it was soon overtaken in popularity by gold and silver inlays. Paralleling this shift was a gradual replacement of the earlier figurative motifs and pictorial scenes by more abstract schemes. And while some of these, such as those on the vessels in plates **2** and **4**, still echoed cast decoration in their division of the surface into horizontal zones and in the organisation of the decoration along perpendicular axes, new, all-over schemes gained popularity. Some of these were highly curvilinear, but others were more rectilinear and organised along strong diagonal axes.

TEXTILE INFLUENCE

That lacquer painting provided the impulse for the curvilinear style is well recognised; the role of textiles in promoting a widespread interest in diagonally-aligned angular designs, on the other hand, has gone unremarked until recently. Both the impressions of textiles preserved in the corrosion products of Shang bronzes and the rich find of silks from the tomb number 1 at Mashan (second half of the 4th century BC) near Jiangling in Hubei confirm that designs in woven silks were commonly based on the diagonal.[30] One of the earliest examples of a diagonally-based scheme inlaid in bronze occurs on a *hu* from tomb 251 at Jinshengcun, near Taiyuan in Shanxi (fig.5). Although textile patterns were sometimes faithfully transferred to bronze, more often they were only a point of departure for freer designs still organised on the diagonal, but combining curves and straight lines. A feature of many of these designs, exemplified by the square wine vessel in plate **22,** is that the

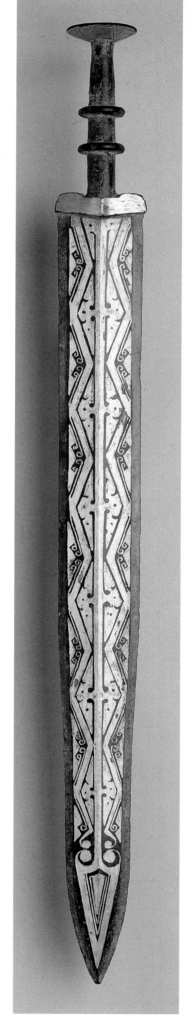

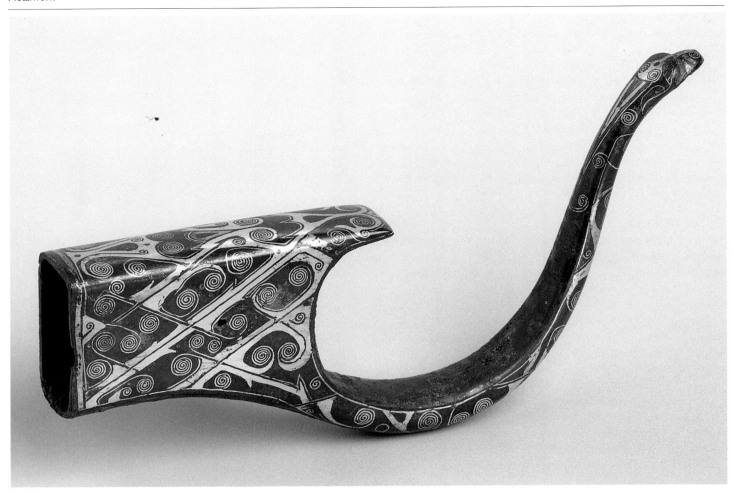

15. Bronze crossbow fitting, inlaid with gold and silver, 4th-3rd century BC. Length: 19.5cm (8"). Private collection.

Fig.5. Drawing of a wine vessel on a tall stem (hu) from Jinshengcun near Taiyuan, first half of the 5th century BC. After Wenwu 1989.9, p.70, fig.17.

linear elements crisscross, producing an illusion of three dimensions.

The realignment of inlay decoration was not confined to vessels; on smaller items such as the crossbow fitting in plate **15**, the tightly-wound spirals are a motif taken over from contemporary cast decoration, but their diagonal arrangement and barbed outline seem also, if indirectly, to draw on textile patterns. Embroidery also appears to have been an influence on inlay designs. Although there is no technical reason why embroidery patterns should imitate woven designs, straightish diagonal axes incorporated into the generally curvilinear schemes of the Mashan embroideries do seem to represent a borrowing from woven designs. Tall crane-like birds are typically shown with wings and tails extended along the diagonal (fig.6) in a manner echoed by the inlaid bird on the ferrule in plate **21**. The treatment of a bird on another ferrule (**20**) also seems to borrow from embroidered versions; the diagonally striated areas and the exaggerated lobing of some of the outlines closely match the rendering of other birds on the Mashan embroideries.[31]

Embroidery may also have stimulated an interest in representing texture in inlay. The use of stippled areas on costume hooks has precedents in both lacquer and cast decoration, but its use as a filler in the interlaced bands on the hook in plate **27** is so reminiscent of the stitching of embroidery that an input from this source seems assured, particularly when the close functional association of hooks and textiles is considered.

Textiles seem also to have been a source of motifs and mannerisms for lacquer painters. The wings of the stylised birds which decorate a lacquered dish from Mashan tomb 1 (fig.7) exhibit a less exaggerated form of the lobing that is conspicuous on the underside of the bodies of the birds on the Mashan embroideries. This stylised bird figure also appears on a vessel handle inlaid in gold and silver (**23**). On both the dish and the handle, remnants of the birds are barely identifiable through the presence of eyes and lobed wings. The fascination of such designs lies in the provision of just enough clues to tempt the beholder to try to decipher coherent creatures among the profusion of purely formal flourishes.

The lobed figure that initially described a part of the bird's anatomy gradually took on a life of its own and was used as a device to represent first swirling clouds and, later, mountain ranges. The most famous examples of the former are the cloud scrolls that decorate the outer coffin from Mawangdui tomb 1.[32] By the beginning of the 2nd century BC, if not earlier, some versions of the scroll began to incorporate references to a stylised landscape. In the light of other, more explicit renderings, the tapering spurs sprouting at intervals from the scrolls on the fittings in plate **11** can confidently be interpreted as highly stylised mountain forms.

17. *Above:* **Gold double-headed garment hook, 6th-5th century BC. Length: 2.2cm (17").** Private collection.

16. *Left:* **Bronze garment hook in the form of a tiger in combat with a bird, inlaid with turquoise, gold and silver, 3rd-2nd century BC. Length: 15.3cm (6").** Private collection.

On the parasol fitting discussed above (**10**) the use of the scroll to describe the contours of a landscape peopled with real and imaginary animals is much more sophisticated. Tufts of striations sprouting from the peaks already anticipate the similar device used for depicting distant vegetation in later landscape representation. Moreover, a real spatial relationship between the figures and their setting is introduced through the overlapping of parts of the animals by the mountain contours. If the late 2nd or early 1st century BC date proposed for this piece on the analogy of a similar one from a tomb at Sanpanshan in Ding Xian, Hebei, is correct,[33] then it is evidence of a dramatic advance in landscape representation during the first half of Western Han.

The creatures in the landscape, as Wu Hung has pointed out in a discussion of the Sanpanshan piece, are probably not arbitrary decorative motifs, but represent *xiangrui*, auspicious omens, much in fashion during the Han period.[34] The imaginary and exotic creatures were inspired by descriptions of supernatural beings in texts such as the *Classic of Mountains and Seas*, which were lent credence by recorded sightings of exotic creatures in the far corners of the vast territory of the Han empire. The four large animals which dominate the landscape also reflect the broader perspective of Han art following its geographical expansion: the elephant had long since disappeared from the metropolitan region of China, and like the peacock in the lower register, may represent tribute from the far south, while the Bactrian camel in the third register must still have been a rarity at the Han capital, Chang'an.

Whether or not the mounted archer in regardant pose – the so-called Parthian shot – about to despatch the tiger in the second register was based on versions of the motif imported from the steppe, there can be little doubt that interest in the theme was fuelled by the Xiongnu mounted nomads, whose military tactics are so vividly described in the *Annals of History* by Sima Qian (died ca. 85 BC). According to Wu Hung, however, in the context of the other motifs on the fitting, the theme here alludes not to the steppe hunter duelling with his prey in the wilderness, but to the ceremonial hunts which took place in the imperial parks stocked with captive animals. The scene in the second register, like those in the others, was thus conceived as a celebration of imperial authority and as confirmation of the dynasty's heavenly mandate to rule.

No less than the content and composition of the design itself, the remarkable fineness of detail testifies to the advances in inlay work that occurred in the first century of Han. The zither peg (**8**) is another example of this new, finely-detailed style. The design of

18. **Iron garment hook, inlaid with gold and silver, 4th-3rd century BC. Length: 25.2cm (10"). Private collection.**

19. *Facing page:* Bronze plaque, inlaid with turquoise, Erlitou period, ca 1600 BC. Height: 15.5cm (6"). Private collection.

20. *Left:* Bronze ferrule, inlaid with silver, 4th-3rd century BC. Height: 11.5cm (4½"). Private collection.

Fig.6. *Right:* Detail of an embroidered silk from Mashan tomb 1 near Jiangling, late 4th or early 3rd century BC. After *Jiangling Mashan yi hao Chu Mu,* Beijing 1985, pl.XXIV:2

Fig.7. *Near right:* Drawing of a lacquered bowl from Mashan tomb 1, late 4th to early 3rd century BC. *After Jiangling Mashan yi hao Chu mu,* Bejing 1985, p.78, fig.64:5.

21. *Far right:* Bronze ferrule, inlaid with gold and silver, 4th-3rd century BC. Height: 21.0cm (8½"). Private collection.

miniature birds reserved against the gold inlay gives less the impression of having been pre-cast into the bronze than of having been executed by scoring the already inlaid gold sheet through to the underlying bronze. If this is the case, then it would seem to be a development of a well known Warring States period technique of incising pictorial designs into thin copper vessels.[35]

FURTHER USE OF PRECIOUS METALS

The extravagant use of precious metals exemplified by these pieces marks a turning point in the history of Chinese metalwork. During the Warring States and Han periods, alongside their use as inlay materials, gold and silver began to be used to create whole objects and, in the form of gilding and silvering, as a means of obtaining similar effects less expensively. This contrasts with the Neolithic and earlier Bronze Ages during which, as Jessica Rawson has observed, jade and bronze, rather than gold, held the attention of the Chinese.[36] While gold is not unknown in Shang period sites, its relative unimportance is demonstrated by its absence from the unplundered tomb of Fu Hao, consort of the Shang ruler Wu Ding, at Anyang. Indeed, it may at that time have represented an exotic taste, since it is most frequently encountered on the periphery of the Shang sphere. Gold sheets were found at a middle Shang site at Taixi in Gaocheng County, Hebei, and a tomb of similar date at Liujiahe in Pinggu County near Beijing yielded a solid gold hairpin, a bangle, an earring and fragments of gold foil.[37] In Sichuan Province, the sacrificial pits recently discovered at Sanxingdui in Guanghan County yielded impressive gold articles, including a staff sheathed in gold, a mask, a tiger ornament and gold foil applied to some of the bronze heads.[38]

Most examples of gold foil seem, however, to have been applied not to bronzes but to wooden objects coated in lacquer, an effective adhesive. The gold sheets found at Gaocheng and Pinggu were associated with lacquer fragments, and a lacquered wood *gu* beaker inlaid with a gold band was discovered in an early Western Zhou tomb at Liulihe near Beijing.[39] This tradition continued into Eastern Zhou, as evidenced by a lacquered wood ladle inlaid with gold and cowry shells found in a late 7th century BC tomb at Liujiadianzi in Yishui, Shandong.[40] Gold sheets from mid-6th BC tombs at Xiasi in Xichuan County, Henan, appear to have been attached mainly to lacquered wood and leather armour.[41]

Since gold sheets did not adhere well to bronze and since the cost of solid gold vessels was prohibitive even for the rulers of states,[42] it was natural to seek a reliable and yet relatively inexpensive method of achieving the effect of solid gold. The Taoist alchemical interest in mercury may have fostered experiments in mercury gilding, which seems, on present

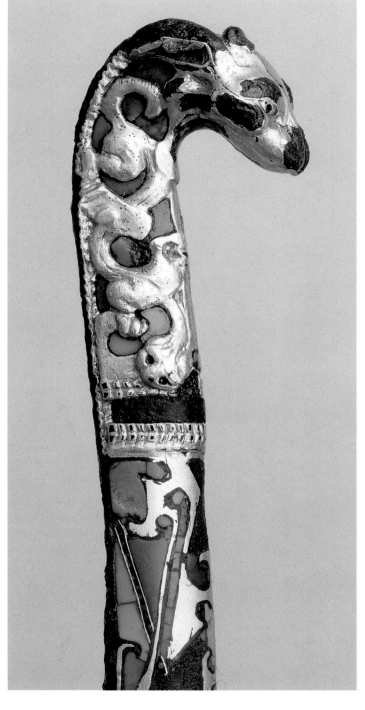

23. Bronze handle and lid fitting for a vessel, inlaid with silver and gold, 4th-3rd century BC. Diameter of vessel mount 18.8cm (7¹/₂"). Private collection.

24. *Left:* **Bronze harness fitting covered in gold foil, 5th-4th century BC. Width: 6.0cm (2¹/₂"). Private collection.**

25. *Above:* **Bronze garment-hook, with appliquéd and inlaid gold and inlaid turquoise (detail), 3rd-2nd century BC. Length: 20.2cm (8"). Private collection.**

22. *Facing page:* **One of a pair of square wine vessels *(fang hu),* 4th-3rd century BC. Height: 41cm (16"). Private collection. Photo courtesy Gisèle Croës, Brussels.**

evidence, to have been introduced first somewhere along the Yangzi Valley. The hilt of a knife from the tomb of the Marquis Yi of Zeng (d. ca.433 BC) exhibits bright gold-coloured patches suggestive of gilding, but irrefutable examples of gilding remain rare until the end of the Warring States period.[43]

A parallel taste for gold also flourished in the northern states. There the use of gold interacted with the tradition of precious metals in the steppes, where they had always been valued for their portability. In the steppes gold and silver were used primarily for personal adornment, and frequent finds of gold and silver earrings in Western and Eastern Zhou tombs on the northern marches represent the eastern extension of this fashion. It was natural, then, that semi-barbarian states such as Qin and Zhongshan, whose origins lay beyond the pale of Zhou civilisation, may have been influenced in their use of gold by contact with the peoples of the steppes. Although the studies cited above have shown that the evidence for deriving the costume hook from the steppes is slight, the use of gold for such hooks is in keeping with the steppe tradition of gold jewellery. Equally, the use of gold or gold-appliquéd-on-bronze for the harness fittings seen in plate **24**, although not unprecedented in Western Zhou, echoes the use of gold and silver foil for covering a wide variety of equestrian and other fittings at Pazyryk.

The gilt bronze plaque from the Ordos region illustrated in plate **26** illustrates the region's role as intermediary between the steppes and China. The ripple pattern that embellishes

185

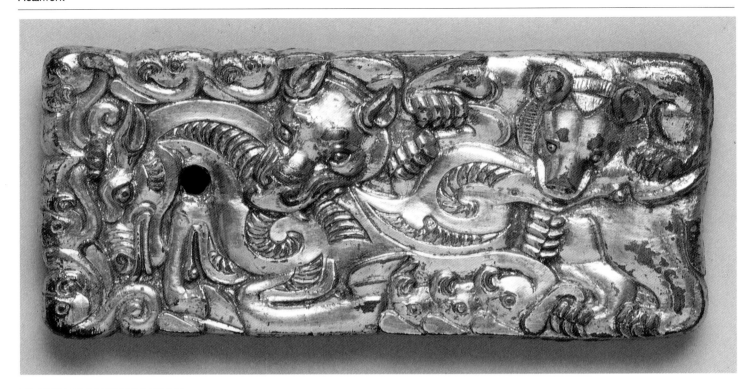

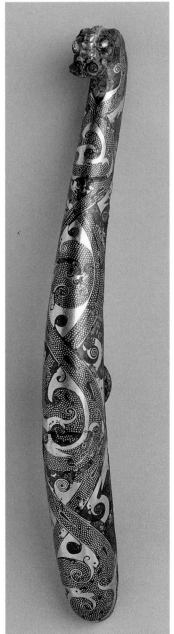

26. *Above:* Gilt bronze Ordos-style belt-plaque, 2nd-1st century BC. Length: 13.2cm (5"). Private collection.

Fig.8. *Right:* Drawing of gold appliqués from a tomb at Alagou near Urumqi, Xinjiang province, 3rd-2nd century BC. After *Wenwu* 1981.1, p.20, fig.5.

27. *Left:* Bronze garment-hook, inlaid with gold and silver. 3rd-2nd century BC. Length: 19.6cm (8"). Private collection.

the bodies and limbs of the interlocked wolf, bear and deer echoes the texturing encountered on gold plaques from Alagou near Wulumuqi in Xinjiang province (fig.8). This style in turn seems to be ultimately derived from further north and west, since it occurs at sites in the Altai mountains, both at Pazyryk and at the earlier site of Bashadar.[44] This ripple pattern appears on a number of small gold leaf-shaped plaques found both in north and south China,[45] while a more linear, less plastic version is seen on the *pushou* mask in plate **1**.

Another instance of an exotic theme that became entirely assimilated to Chinese taste is the twisting feline seen on the head of the garment hook in plate **25**. This pose, originating in Western Asia, is found in the animal combat themes common at Pazyryk and was probably popularised in China by semi-barbarian intermediaries such as the state of Zhongshan.[46] Felines twisting through a half circle became popular themes for bronze vessel supports and were pervasive in carved jade of the Han period, the convoluted configurations of beasts often seeming to defy the intractable nature of the material.

It is tempting, too, to attribute some of the bolder, more plastic inlay styles to the influence of nomad taste. Sixth century BC plaques inlaid with turquoise studs from Chiliktin in Kazakhstan establish a steppe tradition of turquoise inlay which culminates in the Siberian plaques from the treasure of Peter the Great.[47] This predilection for chunks of turquoise inlay is exemplified on the borders of China by the turquoise-beaked bird of the headdress from Aluchaideng (fig.2) The use of studs of turquoise standing proud of the surface on the the pair of *he* in plate **4** and the garment-hook in plate **16** is more reminiscent of this approach to inlay than it is of the use of inlay as a graphic element flush with the surface of the bronze that was the norm in Chinese inlay. Certainly, the use of pear-and comma-shaped inlays on the garment hook in plate **28** seems to consciously mimic the widespread use of these figures in the art of the steppes.[48]

But even if this plastic inlay style was originally inspired by contact with the steppes, in China it was soon developed in ways unknown there. Jade, which had never before been inlaid into bronze, now became a frequent inlay material on garment hooks, a combination which, no doubt, was fostered by the concurrent use of jade for pendants and even for the

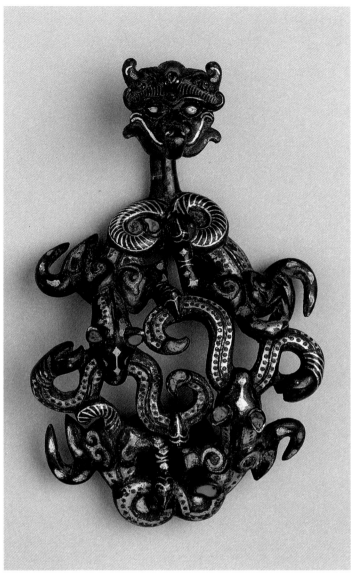

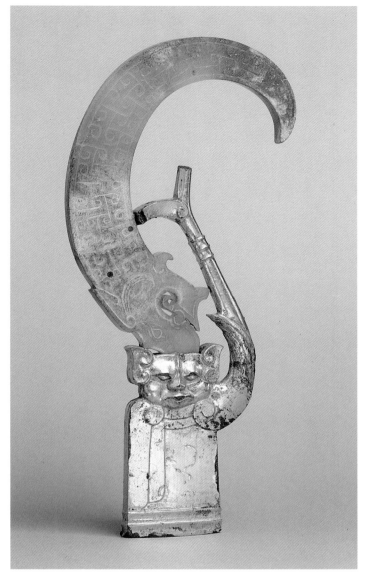

28. *Above:* Bronze garment hook in the form of felines grappling with snakes, inlaid with gold, silver and turquoise, 4th-3rd century BC. Length: 11.6cm (4½"). Private collection.

29. *Above right:* Gilt bronze finial in the form of a half-human monster, to which has been attached a jade pendant in the form of a dragon. Pendant: 3rd-2nd century BC, finial: 2nd-1st century BC. Malachite from the bronze has stained the jade, indicating that the two pieces were conjoined in antiquity. Height: 16.2cm (4½"). Private collection.

hooks themselves. Sometimes the various inlays – jade, glass, and crystal – are exploited no longer merely as coloured elements in a flat pattern, but for their contrasting textures. The contrast between the coolness of jade and the sensuous warmth of gold and gilded bronze seems particularly to have appealed to Warring States and Han taste. This interest even led to the combination of originally separate objects of differing date into a single article, such as the intriguing finial in plate **29**.

Whereas theories of a distinct barbarian taste in inlay remain speculative, the introduction of the technique of granulated gold from Western Asia via the steppes is assured.

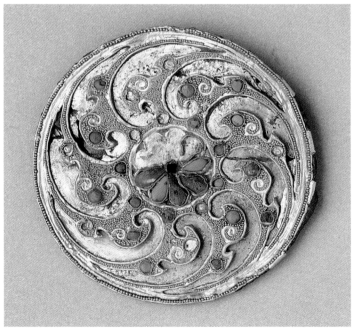

30. Bronze and gold ornament, Eastern Han to Jin period (2nd-4th century AD). Diameter: 4.9 cm (2"). Private collection.

In Western Asia, it had been known since at least the beginning of the first millennium BC, while its first appearance on the Eastern Steppes is no earlier than the 4th century BC, and in China proper the Western Han period.[49] It is significant that its arrival coincides with the adoption of gold for jewellery within China proper. The circular plaque in plate **30** thus embodies a new, even more intricate and delicate style of goldwork than what had gone before, and one which was to survive in jewellery down to the end of dynastic China.

Notes see Appendix

APPENDIX

Acknowledgments, notes, bibliographies, glossaries

SPLENDOUR & AUSTERITY
Pages 8-27

GLOSSARY

haft rangi – 'seven-colour' underglaze tilework
hammam – public baths
han – lodging place for travellers or merchants
iwan – vaulted or flat-roofed hall, open at one end
jami' – Friday Mosque
lajvardina – pottery with a cobalt blue glaze and enamelling
madrasa – structure within which the traditional Islamic sciences were taught
maidan – public square, ceremonial open space
mihrab – arch or arcuated niche, flat or concave, which indicates the direction of Mecca (the *qibla*)
mina'i – pottery in which colours are applied both under and over the glaze
minbar – pulpit, to be found in mosques used for Friday prayer
muqarnas – honeycomb or stalactite vaulting made up of individual cells or small niches; often used as a bridging element.
naskhi – cursive script based on a scribal hand
qibla – direction of prayer, i.e. to the Black Stone in the Ka'ba in Mecca
ribat – fortified religious outpost on the Muslim frontier; caravanserai; royal stopover
riwaq – portico or cloisters around a courtyard; tent-flap
shahada – creed, profession of faith

THE TABRIZ HYPOTHESIS
Pages 30-53

NOTES

1. Pope, Arthur Upham, 'The Myth of the Armenian Dragon Carpets', *Jahrbuch der Asiatischen Kunst II*, Leipzig 1925.
2. Martin, F.R., *A History of Oriental Carpets before 1800*, Vienna 1908, pp.116-120.
3. Jacoby, Heinrich, *Eine Sammlung orientalischer Teppiche*, Berlin 1923.
4. Ellis, Charles Grant, *Early Caucasian Rugs*, Washington DC 1975, p.11.
5. Kirchheim, Heinrich, et al., *Orient Stars: A Carpet Collection*, Stuttgart & London 1993, pp.105-106.
6. Ellis, 1975, op.cit., p.23.
7. Ibid.
8. Ellis, Charles Grant, *Oriental Carpets in the Philadelphia Museum of Art*, Philadelphia 1988, p.133.
9. Ibid., p.145.
10. Ellis, 1975, op.cit., p.11.
11. Yetkin, Şerare, *Early Caucasian Carpets in Turkey*, London 1978, vol.II, p.38.
12. Der Manuelian, Lucy, and Murray L. Eiland Jr., *Weavers, Merchants and Kings: The Inscribed Rugs of Armenia*, Fort Worth 1984, pp.51-60.
13. Thompson, Jon, *Carpet Magic*, London 1983, p.106.
14. Kirchheim, op.cit., p.84; pls.57-59, 63-66, 69-71, 74, 77-78. 15. Eiland, Murray L., *Oriental Rugs: A New Comprehensive Guide*, Boston 1981, pp.10, 251-253.
16. Prakoff, A.V., *Russkoe narodnoe iskusstvo*, Petrograd 1914, pp.32-33.
17. Bier, Carol, 'Weavings from the Caucasus: Tradition and Technology', HALI 48, 1989, pp.17, 24; Christine Klose, 'The Perepedil Enigma', HALI 55, 1991, pp.111-113; Raoul Tschebull, 'Zeikhur', HALI 62, 1992, pp.85-95; Kirchheim, op.cit., pp.103-104.
18. Atkin, Muriel, 'The Strange Death of Ibrahim Khalil Khan of Qarabagh', *Iranian Studies*, vol.XII, nos.1-2, 1979, p.81.
19. Mankowski, Tadeusz, 'Some Documents From Polish Sources Relating to Carpet Making in the Time of Shah Abbas I', in Pope, Arthur Upham, and Ackerman, Phyllis (eds.), *A Survey of Persian Art*, London and New York 1939, vol.III, p.2431.
20. Floor, Willem, *The Persian Textile Industry: Its Development, Products and Their Use (1500-1925)*, forthcoming, ch. I. We are greatly indebted to Dr Floor for making the manuscript of his book available to us.
21. Tavernier, Jean-Baptiste, *Voyages en Perse*, Geneva 1970, p.236.
22. Zubov, Platon, *Shest' picem o gruzii i Kavkaze*, Moscow 1834, pp.87-88; Mirza Bala, 'Karabağ', *Islam Ansiklopedisi*, vol.VI, 1955, p.214.
23. Von Haxthausen, August, *Transcaucasia*, London 1854, pp.438ff.
24. O'Bannon, George, 'A Group of Rugs Attributed to Shusha', *Oriental Rug Review*, April/May 1990, p.12.
25. Zedgenidze, Ya., 'Gorod Shusha', *Sbornik materialov dlya opisaniya mestostei i plemen Kavkaza*, vol.XI, Tiflis 1891, pp.1ff; Piralov, A.S., et al., *Kustarnaya promyshlennost' Rossi*, vol.II, St Petersburg 1913, p.60.
26. Zedgenidze, op.cit., p.23.
27. Ibid., p.37.
28. De Seidlitz, Nicholas, 'The Province of Elizabethpol', *Scottish Geographical Journal*, vol.V, 1889, p.368.
29. Floor, op.cit.
30. Le Brun, Corneille, *Voyage au Levant*, vol.III, Paris 1725, p.495.
31. *Early Voyages & Travels To Russia and Persia*, ed. E. Delmar Morgan & C.H. Coote, Hakluyt Society, First Series, nos.72 and 73, vol.I, London 1886, p.131.
32. Efendiev, O.A., 'Territoriya i granitsy Azerbaidzhanskikh gosurdarstv v XV-XVI VV.', *Istoricheskaya geografiya Azerbaidzhana*, Baku 1987, p.115.
33. Rakhmani, A.A., 'Azerbaidzhan: granitsy i administrativnoe delenie v kontse XVI-XVII VV.', ibid., p.124.
34. Aliev, F.M., 'Azerbaidzhan v XVIII V.', ibid., pp.136-137.
35. Gamba, Jean, Le Chevalier de, *Voyage Dans La Russie Meridionale*, Paris 1826, vol.I, p.326; Keppel, George, *Travels*, London 1827, vol.II, p.214.
36. Zubov, Platon, *Kartina Kavkazskago Kraya*, St Petersburg 1835, Part Four, p.103.
37. Kara Murza, I.M., 'Kovrovyi promysol' v Kubinskom uezd', *Kustarnaya promyshlennost' na Kavkaz*, vol.I, Tiflis 1902, Table III, pp.70-71.
38. Ibid., p.30.
39. Halen, Don Juan, *Narrative*, London 1827, vol.II, p.360; Gamba, op.cit., pp.328-29.
40. *Zapiski Kavkazskago otdela imperatorskago russkago geograficheskago obshchestva*, Book XVII, Tiflis 1896, pp.38-39.
41. Halen, op.cit., p.369 ff; Gamba op.cit., vol.II, pp.317ff.
42. See Yetkin, op.cit., vol.I, pl.84, Kharchang (Harshang) pattern.
43. Ellis, 1975, op.cit., pp.16-17.
44. The sumakhs share one motif with the silk embroideries and Karabagh village rugs: large serrated white leaves. In dragon sumakhs, however, the four leaves radiate outward from a central motif rather than bracketing it as do the bars in the Kasim Ushag design. Four silk embroideries in The Textile Museum, Washington DC (inv.nos. 2.9, 2.11, 2.18, 3.3) also have a version of the central motif, a radiating leaf form. The serrated leaf is widely used in the textiles of Central and Western Asia; it and forms derived from it appear in the dragon and floral carpets, silk embroideries, sumakhs and village rugs.
45. Zubov, op.cit., p.104.
46. Isaev, M.D., *Kovrovoe proizvodstvo Zakavkaz'ya*, Tiflis 1932, p.11. It would be amusing if what was copied from the European tapestries and was still around in 1930 was the 'dragon' sumakh, perhaps as a result of the fact that the Gobelins material had aped a Near Eastern style, as did some 'Savonnerie' items. Isaev's use of the term *kovry* (rug) for the survivors, however, suggests that they were not sumakhs.
47. Golotsin, F.S., *Kustarnoe delo v Rossii*, vol.I, First Part, Tiflis 1904, p.16.
48. Zubov, op.cit., pp.33, 42, 197; Halen, op.cit., vol.II, p.369.
49. Butkova, P.G., *Materialy dlya novoi istorii Kavkaza c 1722 do 1803 goda*, St Petersburg 1869, Part I, pp.243 ff; Dubrovin, Nicholas F., *Zakavkaz ot 1803-1806 goda*, St Petersburg 1866, pp.65-66.
50. Golotsin, op.cit., p.16.
51. One point, moreover, is clear: motifs are not a decisive indicator of provenance. Since all the possible origins of the dragon and floral carpets and their putative successors lie within the same broad cultural sphere, a similarity in "design elements, colour schemes and even small details" is what one would expect to find.
52. Yetkin, op.cit., vol.I, pl.VII, vol.II, pp.111-114.
53. Gantzhorn, Volkmar, *The Christian Oriental Carpet*, Cologne 1991, p.340.
54. Sakisian, Armenag, 'Les tapis à dragons et leur origine arménienne', *Syria*, vol.IX, Troisième Fascicule, Paris 1928.
55. Çelebi, Evliya, *Narrative of Travels...*, London 1846-1850, vol.II, p.113.
56. Inalcik, Halil, 'The Yürüks: Their Origins, Expansion and Economic Role', in *Oriental Carpet & Textile Studies II*, R. Pinner & W.B. Denny (eds.), London 1986, p.55.
57. Davis, Ralph, *Aleppo and Devonshire Square*, London 1967, p.122; Ferriers-Sauveboeuf, *Mémoire de Voyages*, Paris 1790, vol.I, p.254.
58. Tournefort, J.P., *Relation d'un Voyage du Levant*, vol.III, Paris 1717, p.299; Tancoigne, J.M., *Journey into Persia*, London 1820, pp.33, 47; Avril, Phillipe,

Voyage en Divers Etats d'Europe et d'Asie, Paris 1692, pp.50-51; 'Mémoires du Levant', (ca. 1700) *Lettres Edifiantes et Curieuses*, vol.I, p.90; Ferriers-Sauveboeuf, op.cit., pp.253-255.

59. Poujoulat, Baptistin, *Voyage à Constantinople*, Brussels 1841, vol.I, p.155.

60. Tezcan, Hulye, *Topkapı Saray Museum: Carpets*, Boston 1987, p.15.

61. *Le Voyage du Levant de Philippe du Fresne-Canaye* (1573), ed. C.M. Schefer, Paris 1897, p.61; *Journal des Voyages de Monsieur de Monconys*, Lyon 1665, vol.I, p.437; Courmesnin, Baron, *Voyage du Levant*, 2nd edn., Paris 1632, pp.108, 127; Spon, Jacob, and George Wheler, *Voyage*, Amsterdam 1679, p.144; Le Sieur Du Mont, *Nouveau Voyage du Levant*, La Haye 1694, p.199; Montagu, Lady Mary Wortley, *Letters from the Levant...* (1717), J.A. St. John (ed.), London 1838, pp.152, 206.

62. Fernandel et al., *Voyage d'Italie et du Levant*, Rouen 1687, p.28.

63. Mouradgra d'Ohsson, Ignatius, *Tableau Général de l'Empire Ottoman*, Paris 1788, vol.VI, pp.172-3.

64. Hasselquist, Frederick, *Voyages & Travels in 1749-52*, London 1767, p.398.

65. Balpınar, Belkıs and Udo Hirsch, *Vakıflar Museum Istanbul: Carpets*, Wesel 1988, pp.140, 142.

66. Yetkin, op.cit., lists 103 items, some of which may contain fragments from more than one carpet, and a few of which may not be related to the dragon and floral carpets. See C.G. Ellis' review in HALI, 1/4, Winter 1978, pp.377-383, where he notes that Yetkin's publication does not exhaust the list of fragmentary carpets which exist among the mosques of Anatolia.

67. 'Travels of Josafa Barbaro', pp.48-60, and 'The Travels of a Merchant in Persia', p.175, in *A Narrative of Italian Travels in Persia*, The Hakluyt Society, First Series, no.49, London 1873.

68. Barbaro, Josafa, 'Il viaggio della Tana, & nella Persia', in Ramusio, G.B., *Delle Navigationi et Viaggi*, Second Volume, Venice 1559, p.103.

69. Chesneau, Jean, *Le Voyage de Monsieur D'Aragon* (1548), ed. Chas. Schefer, Paris 1887, p.86.

70. Barbaro, in Ramusio, op.cit., p.108. Early English translators could not cope with the terms used and rendered these as "many rugges", not altogether incorrect then, but misleading today.

71. De Nicolay, Nicholas, *Discours et Histoire Verita*, Anvers, 1582, p.149; Tavernier, Jean-Baptiste, *Les Six Voyages*, Paris 1678, vol.I, Book I, p.56.

72. Floor, op.cit.

73. Chardin, Jean, *Voyages*, Nouvelle Edition, Amsterdam 1735, vol.I, pp.255, 257.

74. Inalack, H., 'Harir ii – The Ottoman Empire', *Encyclopedia of Islam*, New Edition, vol.III, pp.211-218.

75. Floor, op.cit.; De Nicolay, op.cit., p.149; Chesneau, op.cit., p.85; Tavernier, op.cit., pp.26, 56.

76. Ferriers-Sauveboeuf, op.cit., vol.II, p.3.

77. Tancoigne, op.cit., p.74.

78. Smith, Eli, *Researches of the Rev. E. Smith and the Rev. H.G.O. Dwight in Armenia*, Boston 1833, vol.II, p.147.

79. Floor, op.cit.

80. *The Travels of Pedro Teixeira*, Appendix B, 'History of Persia', Hakluyt Society, Second Series, no.IX, London 1902, pp.116-117; Floor, op.cit, Ch.I.

81. Ibid., citing Franz Casper Schillinger, *Persianische und Ost-Indianische Reis*, Nuerenberg 1707, p.149.

82. Bell, John, 'Travels from St Petersburg to Various Parts of Asia in 1716, 1717, 1727, etc.', in Pinkerton, John, *Voyages and Travels*, vol. seven, London 1811, p.295.

83. Pococke, Richard, *A Description of the East*, London 1743, vol.I, p.151.

84. Yetkin, op.cit., vol.I, pl.24, vol.II, p.37.

85. Sakisian, op.cit., p.243; Der Manuelian & Eiland, op.cit., pp.72-3.

86. C.G. Ellis in a note to fig.296 of F.R. Martin's *A History of Oriental Carpets Before 1800*, reprinted in *Oriental Rug Review*, vol.VI, no.7, October 1986, pp.21/177.

87. Sakisian, op.cit., p.249; also Yetkin, op.cit., vol.II, pp.37-38.

88. Woods, John E., *The Aqquyunlu: Clan, Confederation, Empire*, Minneapolis & Chicago 1976, p.284.

89. Perry, John R., 'Forced Migration in Iran during the Seventeenth and Eighteenth Centuries', *Iranian Studies*, vol.VIII, no.4, Autumn 1975, pp.206-207; Arhakel of Tabriz (d. 1680), *Livre d'histoires*, St Petersburg 1874-76, p.286.

90. 'Observations of Master John Cartwright', in Samuel Purchas, *Purchas, His Pilgrimes*, Book 9, London 1625, p.1427.

91. Papazian, H., *Encyclopedia Iranica*, vol.II, London & New York 1987, p.472; Arhakel of Tabriz, op.cit., pp.438-440.

92. Ellis, 1975, op.cit., p.13; Beattie, May H., *Carpets of Central Persia*, Westerham 1976, p.56.

93. Ellis, 1975, op.cit., pp.17-19.

94. Eiland, op.cit., p.72.

95. Ellis, 1975, op.cit., p.23.

96. Edwards, A. Cecil, *The Persian Carpet*, London 1953, p.64.

97. Ittig, Annette, 'Carpets XI. Qajar Period', *Encyclopedia Iranica*, vol.IV, London & New York 1990, p.879.

98. Ibid.

99. Discussed by Mohammed Pakzad, *Persische Knüpfkunst von Anbeginn bis zur Gegenwart*, Hannover 1978, p.85. It appeared as lot 188 at Sotheby Parke Bernet, Inc., New York, on 10 January 1976.

100. Meister, Peter W., and Azadi, Siawosch, *Persische Teppiche*, Hamburg & Frankfurt 1971, pp.82-83.

DEMONS & DEITIES
Pages 54-79

The author wishes to thank the San Francisco Asian Art Museum for allowing access to their research library; Don Tuttle for his brilliant photography, and Bob Bengtson and Mort Golub for their unflagging support at all hours, well beyond the call of duty. I am grateful to Alan Marcuson for suggesting this topic and for his continuous enthusiasm throughout the project; and I am particularly grateful to my editor, Dr Jane Casey Singer, for alchemically transforming base metal into gold. My gratitude for the assistance received does not absolve me from responsibility for any errors which may be contained in this article.

SELECT BIBLIOGRAPHY

Alsop, Ian, 'Masks of the Newars', *Orientations*, no.9, September 1993.

Aris, Michael, 'Sacred Dances of Bhutan', *National History Magazine*, March 1980, pp.38–48.

Aryan, K.C., *Rural Art of the Western Himalaya*, New Delhi 1985.

Basilov, Vladimir, *Nomads of Eurasia*, Seattle and London 1989.

Bihalji–Merin, Oto, *Great Masks*, New York 1970.

Bradley, Lisa and Eric Chazot, *Masks of the Himalayas*, New York 1990.

Chazot, Eric and Lawrence Hultberg, *Facing the Gods*, Smithsonian catalogue (unpublished), 1989.

Chazot, Eric, 'Tribal Masks of the Himalayas', *Orientations*, no.10, October 1988.

Dorje, L., 'Llamo: The Folk Opera of Tibet', *The Tibet Journal*, Summer 1984, vol.IX, no.2, pp.13–22.

Elles E.R., *Nepal and the Gurkhas*, London 1883 and reprint 1965.

Elwin, Verrier, *The Tribal Art of Middle India*, Oxford 1951.

Estournal, Jean-Luc, *Les Masques Himalayens*, Paris 1989.

Fitzhugh, William and Aron Crowell, *Crossroads of Continents*, Smithsonian 1988.

Fuchang, Yanm, *The Art of the Mask in Sichuan*, China 1992.

Golub, Mort, 'A Himalayan Mask', HALI 63, June 1992, pp.70-71.

Govinda, Gojami, *Tibet in Pictures, Volume I*, Emeryville, California 1979.

Ivanov, S., *Ancient Masks of Siberian Peoples*, Leningrad 1975.

Jettmar, Karl, *Art of the Steppes*, New York 1967.

Koppar, D.H., *Forgotten Art of India*, Baroda 1989; *Tribal Art of Dangs*, Baroda 1989.

Legg, Stuart, *The Barbarians of Asia*, New York 1990.

Lhalungpa, Lobsang, *Tibet, the Sacred Realm*, Massachusetts 1983.

Lommel, Andreas, *Masks: Their Meaning and Function*, New York 1970.

Lommel, Andreas, *Shamanism, the Beginning of Art*, New York 1967.

Loviconi, Alain, *Masks and Exorcism of Sri Lanka*, Paris 1981.

Martynov, Anatoly, *Ancient Art of North Asia*, Illinois 1991.

Mookerjee, Ajit, *Indian Primitive Art*, Calcutta 1959.

Nishikawa, Kyotaro, *Bugaku Masks*, Tokyo, New York, San Francisco 1978.

Norboo, Samten, 'Migration of the Tamang Tribe from India', *The Tibet Journal*, Spring 1981, vol.VI, no.1, pp.39–42.

Pal, Pratapaditya, *Art of Nepal*, Berkeley 1985; *Art of Tibet*, Berkeley 1983.

Pannier, F. and Mangin, S., 'Masques de L'Himalaya du Primitif au Classique', *Arts Primitifs* Paris n.d.

Riley, Olive, *Masks and Magic*, London 1955.

Roerich, George N., *Trails To Inmost Asia*, Yale 1931.

Rudenko, S.I., *Frozen Tombs of Siberia*, Berkeley 1970.

Sharma, R.R.P., *The Sherdukpens*, Shillong 1961.

Singh, Manjaneet, *Himalayan Art*, New York 1968.

Sioris, George, 'Buddhism in Asia: Tolerance and Syncretism', *The Tibet Journal*, Spring 1988, vol.XIII, no.1, p.20–29.

Slattum, Judy, *Masks of Bali*, San Francisco 1992.

Snellgrove, David and Hugh Richardson, *A Cultural History of Tibet*, New York 1968.

Stein, R.A., *Tibetan Civilization*, Stanford 1972.

Teten, Timothy, *A Collectors Guide to Masks*, New Jersey 1990.

Tsultem, N., *Mongolian Sculpture*, Ulan Bator 1989.

Tung, Rosemary Jones, *A Portrait of Lost Tibet*, New York 1980.

Weihreter, Hans, *Schmuck aus dem Himalaja*, Austria 1988.

Yeshe De Project, *Ancient Tibet*, Berkeley 1989.

Zwalf, W., *Heritage of Tibet*, London 1981.

NOTES

1. See bibliography for further references to masking traditions in the Himalayas.

2. As noted in Alsop 1993, and Chazot 1988.

3. See Alsop, op.cit.

4. See Golub 1992, p.70.

5. Sometimes such individuals are recognised early as candidates for shamanism, and are made apprentices to established shamans. Whether they serve this period of apprenticeship or not, they still undergo this testing period of separateness.

6. Chazot, op.cit., and Bradley and Chazot 1990.

7. Chazot (1988, 1990) suggests that masks of the Middle Hills may have served this function.

8. Snellgrove and Richardson 1968, p.21.

9. Stein 1972, p.34.

10. E.R. Elles 1883 (repr. 1965).

11. For a comparison of the Cham and Lhamo dance forms, see Dorje 1984.

12. Chazot and Hultberg 1989 (unpublished).

13. Singh 1968.

A TIME OF ROSES AND PLEASURE
Pages 80-85

NOTES

1. Published by Mary Krishna, 'Zoroastrian bridal dress', *Embroidery*, vol.15 (iv) 1964, pp.111-4, and briefly described by M. Ellis and B. Rowley in *Treasures from the Embroiderers' Guild*, ed. Elizabeth Benn, Newton Abbot 1991, pp.108-110. My sincere thanks to Marianne Ellis for so generously sharing her information on this outfit, and to Cyrus Mehta for his advice and encouragement.

2. In his article 'The Parsis of Persia', *Journal of the (Royal) Society of Arts*, London 1906, pp.754-62, Sykes states that he first became acquainted with Zoroastrians during his 1893 visit (p.759), and mentions Zoroastrian servants (p.762). M.E. Hume-Griffith, *Behind the Veil in Persia...*, London 1909, p.79, adds that she employed Ella Sykes's Zoroastrian maid. For details of Sykes's life and published works by himself and Ella, see Sir Denis Wright 'Biography: Sir Percy Sykes and Persia', *Central Asian Survey*, vol.12 (ii), 1993, pp.217-33. Evelyn, whom he married in 1902, was with him in Kirman from 1903-5 and then in Mashhad for eight years.

3. For various census figures, see M.M. Murzban, *The Parsees in India*, vol.1, Bombay 1917, pp.108-12, and A.A. Houtum-Schindler, 'Die Parsen in Persien, ihre Sprache', *Zeitschrift der Deutschen Morgenländischen Gesellschaft*, vol.36, 1882, pp.54ff and Table 1, p.55. After pressure from Parsi notables, supported by certain European ambassadors, the Qajar regime in the late 1880s relaxed a number of harsh restrictions concerning Iranian Zoroastrians; see E.G. Browne, *A Year among the Persians*, London 1926, pp.405-6; M.M.J. Fischer, *Zoroastrian Iran between Myth and Praxis*, PhD thesis, Chicago 1973, vol.1, pp.96-105; *Encyclopaedia of Islam*, second edn., Leiden 1986, 'Madjus'.

4. Ella Sykes, *Through Persia on a Side-Saddle*, London 1901, pp.58-9. See also Westergaard, 'Extracts from a letter addressed by Prof. Westergaard to the Rev. Dr Wilson in the year 1843, relative to the Gabrs in Persia', *Journal of the Royal Asiatic Society of Great Britain*, vol.8, 1846, p.351. Browne, op.cit., p.395, notes that elsewhere in Iran Zoroastrian men did not have to dress in this manner.

5. Napier Malcolm, *Five Years in Persia*, London 1905, pp.45-7; Houtum-Schindler, op.cit., p.57; P.M. Sykes, op.cit., p.760.

6. Ella Sykes, op.cit. p.59. Presumably this was because their practice of leaving the face unveiled was distinctive enough; see Ella Sykes, *Persia and its People*, London 1910, p.127.

7. 'Magic chain'-stitch is chain-stitch using two different coloured silks alternately.

8. P.M. Sykes, op.cit., p.761.

9. No jacket is included in the Guild outfit, but an example is in the collection of the National Museum of Scotland, Edinburgh (inv. no. 1977.151B); letter from Jennifer Scarce to Rosemary Ewles of the Embroiderers' Guild, 15 December 1983. Houtum Schindler, op.cit., p.69, calls the jacket *minasuk* "mit engen Aermeln".

10. C. Colliver Rice, *Persian Women & Their Ways*, London 1923, p.73.

11. Hume Griffith, op.cit., p.127. Ella Sykes, 1901, op.cit., p.125-6, describes the first head-covering as a "black silk skull-cap with a gold gimp edging over which a square white handkerchief is knotted", and Houtum-Schindler, op.cit., p.68, adds some terminology. My grateful thanks to Dr Shahin Bekhradnia of Oxford for pointing out some discrepancies; I hope shortly to publish further details on the terminology, order of wearing and fastening of the scarves.

12. This protection is not found on Zoroastrian items in the Victoria & Albert Museum textile collection (e.g. inv.nos. 1026-1903, 1027-1907), so it was probably added after purchase.

13. My grateful thanks to Dr A.H. Morton (School of Oriental & African Studies, London University) for providing the following transcription and translation.

14. For example, in the Victoria & Albert Museum, London, a late 15th century Iranian wine-bucket (inv.no. 438-1876), and an early 19th century torch-stand, possibly Lahore production (inv.no. M.488-1922); A.S. Melikian-Chirvani, *Islamic Metalwork from the Iranian World, 8th-18th century*, London 1982. Also a brass jug dated 1468 of eastern Iranian production, now in the Türk ve Islam Eserleri Museum, Istanbul (inv.no. 2963); T.W. Lentz & G.D. Lowry, *Timur & the Princely Vision*, (exhibition catalogue) Los Angeles 1981, cat.no. 88, p.347. Dr A.H. Morton points out the last phrase on this embroidery could read *zi ja-yi arghawani* ("from a purple place" or perhaps "from the place of a judas-tree").

15. Dr Morton notes that the association of *khuda* with the word *tabah* "violates the literary rules" (personal communication, 15 July 94).

16. Fischer, op.cit., vol.1, pp.200ff, who notes that today's bride follows European fashion. See also J.J. Modi, *The Religious Ceremonies & Customs of the Parsees*, Bombay 1922, pp.17ff.

17. Fischer, op.cit., vol.1, pp.204-5; A.V.W. Jackson, *Persia, Past & Present*, London 1906, p.386, says the bride was "veiled from head to foot in a robe of green silk". For Parsi ritual see Modi, op.cit., pp.24-37.

18. Modi, op.cit., pp.378-400; Khurshed Dabu's *The Message of Zarathushtra*, Bombay 1959, p.137ff, differs in certain details from Modi.

19. Modi, op.cit., pp.397-8; "Jamyad" is a printing error for Zamyad.

20. Ibid., pp.96-7, 267ff.

21. J.J. Modi, *Marriage Customs among the Parsees*, Bombay 1900, p.45.

22. In Sasanian art the *senmurv* was portrayed as a winged griffon, but by the 14th century Persian court painters depicted it as a Chinese phoenix.

23. For the story of creation, see Mary Boyce, *A History of Zoroastrianism*, Leiden 1975, vol.1, pp.132ff, and also pp.90, 302ff. For the significance of the cock, see G. Kreyenbroek, *Sraosa in the Zoroastrian Tradition*, Leiden 1985, pp.118, 172. J. Duchmesne-Guillemin, 'Art et religion sous les Sasanides', *La Persia nel medioevo*, Rome 1971, pp.377-89, feels that such an interpretation of late 19th century Zoroastrian embroidered motifs is obvious.

24. Browne, op.cit., p.428, relates this writing to visual and auditory systems of communicating, stating that in this writing "each letter [is] represented by an upright stroke, with ascending branches on the right for the words and on the left for the letters". This example reads 'nam-i-tu chist?' (what is your name?).

25. Boyce, op.cit., pp.302-3.

26. Ibid., p.89.

SILK IN TIBET
Pages 86-97

NOTES

1. I would like to thank colleagues who have generously given information and access to textile collections related to Tibet: Anne Wardwell, The Cleveland Museum of Art; Dale Gluckman, Los Angeles County Museum of Art; Patricia Berger, Asian Art Museum of San Francisco; Jacqueline Simcox, Spink & Son Ltd; Amy Heller; Ian Alsop; Arthur Leeper and Tony Anninos.

2. Richardson, H. E., *A Corpus of Early Tibetan Inscriptions*, Royal Asiatic Society, London 1985, pp.1-15.

3. Schafer, Edward H., *The Golden Peaches of Samarkand: A study of T'ang Exotics*, Berkeley, Los Angeles and London 1963, pp.8-9.

4. Beckwith, Christopher I., *The Tibetan Empire in Central Asia*, Princeton 1987, pp.69, 101.

5. Schafer, op.cit., p.64.

6. Beckwith, op.cit., p.24.

7. Lubo-Lesnitchenko, E., 'Western Motifs in the Chinese Textiles of the Early Middle Ages', in *National Palace Museum Bulletin*, vol.XXVIII, Taipei Sept.-Oct. 1993, pp.5-10.

8. Folsach, Kjeld von and Keblow Bernsted, Anne-Marie, *Woven Treasures: Textiles from the World of Islam*, The David Collection, Copenhagen 1993, pp.8-10.

9. Ibid, pp.10, 16-17.

10. Roger Goepper has written persuasively on the decorative programme at Alchi, and on a reconsideration of the dating (ca. 1200 rather than 11th or 12th centuries), 'Clues for a Dating of the Three-Storied Temple (Sumtsek) in Alchi, Ladakh', in *Asiatische Studien/Etudes Asiatiques*, xliv/2, 1990, pp.159-69; 'The Great Stupa at Alchi', in *Artibus Asiae*, vol.53 1/2, 1993, pp.113-143, and see 'Dressing the Temple' in this volume.

11. Vitali, Roberto, *Early Temples of Central Tibet*, London 1990, pp.37-61.

12. It is interesting to note that Rayy was destroyed by the Mongols in 1220; problems exist, however, with the authenticity of some fragments attributed to Rayy. Shepherd, Dorothy G., 'The Archeology of the Buyid Textiles', in *Proceedings of the Irene Emery Roundtable on Museum Textiles*, Washington DC 1974; Blair, Sheila S., Bloom, Jonathan M. and Wardwell, Anne E., 'Reevaluating the Date of the "Buyid" Silks by Epigraphic and Radio Carbon Analysis', in *Ars Orientalis*, vol.xxii, 1992.

13. Yoshinobu, Shiba, 'Sung Foreign Trade: Its Scope and Organization', in Rossabi, Morris, ed., *China Among Equals: The Middle Kingdom and Its Neighbors, 10th-14th Centuries*, Berkeley 1983, pp.100-101.

14. Piotrovsky, Mikhail et al., *Lost Empire of the Silk Road, Buddhist Art from Khara Khoto (X-XIIIth Century)*, Milan 1993, pp.62-64.

15. Wardwell, Anne E., 'Two Silk and Gold Textiles of the Early Mongol Period', in *The Bulletin of the Cleveland Museum of Art*, vol.74/10, December 1992, for an interesting discussion of the forced transfer of weavers across Central Asia after Mongol conquests; Von Folsach and Keblow Bernsted, op.cit., for further discussion of 13th century western Asian textiles which have recently come out of Tibet. These lampas-weave gold and silk brocades are primarily of medallion design and may be a continuation of pre-Mongol luxury textiles exported to Tibet.

16. Petech, Luciano, 'Tibetan Relations with Sung China and with the Mongols', in Rossabi, Morris (ed.), op.cit., pp.181-82.

17. Ibid., pp.183-93.

18. Cammann, Schuyler van R., 'Notes on the Origin of Chinese K'ossu Tapestry', in *Artibus Asiae*, vol.xi, 1948, pp.90-110.

19. Piotrovsky, op.cit., pp.140-41.

20. Wardwell, Anne E., 'The *Kesi* Thangka of Vignantaka', in *The Bulletin of the Cleveland Museum of Art*, vol.80/4, April 1993, pp.136-39.

21. Lo Bue, Erberto, *Tesori del Tibet: Oggetti d'Arte dai Monasteri di Lhasa*, Milan 1994, pp.134-35.

22. *Xizang Tangjia*, English edition: *Tibetan Thangkas*, Beijing 1987, pls.62 and 102. The Tsal-pa sect does have an early connection to the Tangut empire; a disciple of Zhang Rin-po-che, Tsang-pa Dung-Khur-ba and his six pupils were in the Tangut state when Genghis Khan invaded in 1215. Tshal-pa tradition holds that Tsang-pa explained the main tenets of Buddhism to the Mongol conqueror; Petech, op.cit., pp.179-80.

23. The Metropolitan Museum of Art, *Bulletin*, Fall 1992, pp.84-85.

24. Huntington, Susan L. and John C., *Leaves from the Bodhi Tree, The Art of Pala India (8th-12th Century) and its International Legacy*, Dayton Art Institute, 1990, no.125, pp.356-57.

25. Bills, Sheila C., 'Bronze Sculpture of the Early Ming (1403-1450)', in *Arts*

of Asia, vol.24/5, Sept-Oct. 1994, p.73, citing the *Yuan Shi*, reprint, Beijing 1976, ch. 203, pp.4545-46.

26. Published examples include a 'Seventh Bodhisattva' in The Cleveland Museum of Art, *Oriental Art*, Winter 1992-3, p.251 and a 'Manjusri' in the Indianapolis Museum of Art, *Hali Annual*, 1994, p.43; there is also a 'Jambala' in the Los Angeles County Museum of Art (accession number M88.121).

27. Catalogued as an altar valance, accession number 1990.212 in a forthcoming publication of the Asian Art Museum of San Francisco. Another section of the mandala is in Spink & Son, Ltd., *Chinese Textiles*, London 1994, no.15, pp.20-21.

28. *Xizang Tangjia*, op.cit., pl.88 and The Metropolitan Museum of Art, *Bulletin*, Fall, 1993, pp.86-87.

29. Compare a Nepalese painting of 'Chandamaharosana' and a gilt copper 'Prabhamandala', both of 14th-early 15th century date in the Newark Museum *Arts of Asia*, Sept-Oct. 1989, cover and pl.91, p.134, respectively and decorative details on the Buddhas' nimbuses on the Juyong Guan gate facade and interior, Bills, S., op.cit., pls.14 and 15.

30. Christie's, New York. catalogue, 2nd June, 1994, no.225, for the Ratayamari with an informative discussion of related pieces. The two Jokhang hangings are published in *Wenwu*, no.11, 1985, pp.66-71 (the author is indebted to Theow-Huang Tow of Christie, Manson and Woods International, Inc., for bringing these to her attention). A woven banner of Mahakala of similar large size and also with a Yongle inscription was at Spink & Son Ltd, London, in 1989, *Art of Textiles*, no.23.

31. Ricca, Franco and Lo Bue, Erberto, *The Great Stupa of Gyantse*, London 1993, pp.13-20.

32. Ibid., p.20. Note that the surviving sections of the Sakyamuni banner were recently hung for a ceremony on the Gyantse wall. These remnants are completely in the style of the wall paintings inside the stupa, as one would expect, since the same artists worked on both appliqué and paintings.

33. *Biography of the First Dalai Lama*, 'Khrungs-rabs Series, vol.I, Dharamsala 1984, pp.262-78. I am indebted to Amy Heller for this reference.

34. Smith, E. Gene, *Introduction to Kongtrul's Encyclopaedia of Indo-Tibetan Culture*, New Delhi 1970, pp.42-43; and unpublished commentary by David Jackson, 1994.

35. *Biography of the First Dalai Lama*, op.cit.

36. Tucci, Giuseppe, *Tibetan Painted Scrolls*, Rome 1949, pp.317-18.

DRESSING THE TEMPLE

Pages 100-117

Since 1981 the author, together with Professor J. Poncar, of the Cologne Fachhochschule, and others, including the late J. van Lohuizen-de Leeuw, has been to Alchi several times in order to document the wall paintings in the early temples. Several thousand photographs, taken by J. Poncar, cover every detail of the murals. The journeys have been made possible mainly by funds provided by the Orientstiftung zur Förderung der Ostasiatischen Kunst in Cologne, which was founded by Professor Hans Siegel, but we also owe thanks to several other contributors. Since the author is not a textile specialist he has had to rely heavily on help from Mrs B. Khan Majlis, M.A., of the Rautenstrauch-Joest Museum in Cologne. She helped to solve many problems and provided specialised literature.

NOTES

1. Snellgrove, D.L. and Skorupski, T., *The Cultural Heritage of Ladakh*, Warminster 1977, vol.1, pp.23-80; Genoud, C., and Inoue, T., *Peinture bouddhique du Ladakh*, Geneva 1978, pp.49-55; Keilhauer, A. and P., *Ladakh und Zanskar: Lamaistische Klosterkultur im Land zwischen Indien und Tibet*, Cologne 1980, pp.225-42; Goepper, R. and Poncar, J., *Alchi: Buddhas, Göttinnen, Mandalas. Wandmalereien in einem Himalaya-Kloster*, Cologne 1982, (revised English edition, Cologne 1984); Pal, P. and Fournier, L., *A Buddhist Paradise: The Murals of Alchi, Western Himalayas*, Hong Kong 1982.

2. Goepper, R., 'Clues for a Dating of the Three-Storeyed Temple (Sumtsek) in Alchi, Ladakh', in *Asiatische Studien (Etudes Asiatiques)* 2, 1990, pp.159-69.

3. Stein, M.A., *Kalhana's Rajatarangini. A Chronicle of the Kings of Kashmir*, London 1900, repr. Delhi 1979.

4. Gunasinghe, Siri, *An Album of Buddhist Paintings from Sri Lanka (Ceylon) (Kandy Period)*, Colombo 1978, pls.XXII-XXVII.

5. Talwar, K. and Krishna, K., 'Indian Pigment on Cloth', in Calico Museum of Textiles, Ahmadabad, *Treasures of Indian Textiles*, Bombay 1980, pp.117-18.

6. Later dates, even going as far as the 16th century, have been proposed by Snellgrove and Genoud.

7. Cf. Basgo in Genoud and Inoue, 1978, op.cit., pl.XXI.

8. I would like to thank Dr Steven Cohen, London, for drawing my attention to this new development and for providing convincing evidence.

9. The ceilings in the Manjusri Temple ('Jam-dpal lha-khang) and in the so-called Great Stupa of Alchi (cf. Goepper, R.,'The Great Stupa at Alchi', in *Artibus Asiae*, vol.53 1/2, 1993, pp.111-143) are not in such a good state of preservation although they are contemporary with the Sumtsek.

10. Bühler, A. 'Indian Resist-Dye Fabrics', in Calico Museum of Textiles, Ahmadabad, ed., *Treasures of Indian Textiles*, Bombay 1980, pp.97-110.

11. Bühler, A., *Ikat, Batik, Plangi*, Basel 1972, vol.1, pp.252-5; Das, S. Ch.,

A Tibetan-English Dictionary, Calcutta 1902, p.844.

12. The numbering of the murals in the Sumtsek is that introduced by Snellgrove and Skorupski, 1977.

13. The kaftan of a royal personage and the jacket of a trumpeter (*dhoti* of Avalokitesvara, Sumtsek); the blanket of queen Maya's bed (conception scene, Dukhang); the caparison of an elephant (throne of Aksobhya, left northern wall, Sumtsek); the garment of a devotee (same scene).

14. Worn by two men in the scenes of the 'Eight Dangers' (*astabhaya*) with the central Tara (Sumtsek, second floor).

15. Definition from Sonday, M., 'Pattern and Weaves: Safavid Lampas and Velvet', in Bier, C., ed., *Woven from the Soul, Spun from the Heart. Textile Arts of Safavid and Qajar Iran, 16th-19th Centuries*, The Textile Museum, Washington DC 1987, p.72.

16. Often reproduced, for instance in Ghirshman, R., *Iran, Parther und Sasaniden*, *Universum der Kunst*, vol.3, Munich 1962, fig.343.

17. Dalton, O.M., *The Treasure of the Oxus, with other Examples of Early Oriental Metalwork*, London 1926, pp.553-5, pls.XXIX-XXXI.

18. Smirnov, J.I., *Vostochnoye Serebro (Argenterie orientale: Recueil d'ancienne vaisselle orientale en argent et en or, trouvée principalement en Russie)*, St Petersburg 1909, pl.LI, no.85; Sarre, F., *Die Kunst des alten Persien, Die Kunst des Ostens*, vol.5, Berlin 1922, pl.CXXVIII; Ghirshman, 1962, op.cit., fig.404.

19. Published by Sahni, D.R., 'Excavations at Avantipura', in *Archaeological Survey of India, Annual Report 1913-14*, Calcutta 1917, pl.XXVII B.

20. Ackerman, P., 'Textiles through the Sasanian Period', in Pope, A. U., ed., *A Survey of Persian Art*, vol.1, London and New York 1938, p.709.

21. Falke, Otto von, *Kunstgeschichte der Seidenweberei*, vol.1, Berlin 1913, pp.60-61.

22. Ackermann, 1938, op.cit., p.689; p.692.

23. Medallion in the Museum für Islamische Kunst, Berlin. Cf. Erdmann, K., *Sasanidische Kunst, Bilderhefte der Islamischen Abteilung*, vol.4, Berlin 1937, p.15 and fig.3.

24. Shishkin, W. A., *Varakhsha* Moscow 1963, pls. VII and XVI.

25. Riboud K. and Vial, G., *Tissus de Touen-houang conservés au Musée Guimet et à la Bibliothèque Nationale, Mission Pelliot 13*, Paris 1970, no.EO 1199, p.201 ff and pl.XXXIX; no.EO 1207, p.221ff and pl.XLIII.

26. Rowland, B., *Zentralasien, Kunst der Welt*, Baden-Baden 1979, p.190, fig.73.

27. Shishkin, 1963, op.cit., pl.XIV; p.77, figs.32 and 177, fig.93.

28. Jakubovski, A.J. and Diakonova, M.M., *Zhivopis' drevnego Pjandzikenta* Moscow 1954, pls.XXVI-XXVII.

29. Tokyo and Kyoto National Museums, eds, *Sukitai to Shirukurôdo bijutsu-ten (Scythian, Persion and Central Asian Art from the Hermitage Collection, Leningrad)*, Exhibition catalogue, 1969, nos.123-4.

30. Albaum, L.I., *Balalyk Tepe*, Tashkent 1960, figs.106-107, 108-109, 115-116, 135, 148.

31. Hambis, L. (ed.), *Toumchouq, Mission Paul Pelliot 1*, Paris 1964, pl.XCVIII, no.260.

32. Rowland, 1979, op.cit., p.166 (Kyzyl); p.93, fig.42 (Bamiyan) and see Rowland, B., *Art in Afghanistan, Objects from the Kabul Museum* London 1971, pl.CXLI; Rowland, 1979, op.cit., fig.43 (Varakhsha).

33. Härtel, H. and Auboyer, J., *Indien und Südostasien. Propyläen Kunstgeschichte 16*, Berlin 1971, p.267, pl.CCXLIII; Fujieda, A. (ed.), *Kyoto to Shirukurodo (Kyoto and the Silk Road)*, exhibition catalogue, Kyoto 1983, no.1,1; Rowland 1979, op.cit. pp.158-9.

34. Meister, M.W., 'The Pearl Roundel in Chinese Textile Design', in *Ars Orientalis* 8, 1970, pp.255-67.

35. Riboud, K., 'Some Remarks on the Face-Covers (Fu-mien) Discovered in the tombs of Astana', *Oriental Art*, new series 1977, pp.438-53.

36. The textiles have been analysed and set into their historical context by Bo Xiaoying: 'Tulufan diqu faxian de lianzhuwen zhiwu' (Textiles with pearl border ornament discovered in the Turfan area), in *Jinian Beijing daxue kaogu zhuanye sanshi zhounian luenwenji 1952-1982*, Beijing 1990, pp.311-40.

37. Wu Min, 'Tulufan chutu Shu-jin de yanjiu' (Study on patterned silks from Shu, excavated in Turfan), in *Wenwu*, 1984.6, pp.70-80.

38. Attendant figure in cave no.424. Diakonova, N., 'Sasanidskiye tkani' (Sasanian Textiles), in *Trudy Gosudarstvennogo Ermitazh 10, Kul'tura i iskusstvo norodov vostoka 7*, Leningrad 1969, p.92, fig.6. A similar bodhisattva is in cave no.420. Cf. Akiyama, T. et al., *Chugoku Bijutsu* (Chinese Art), vol.2, Tokyo 1960, pl.VIII. This piece dates from the Tang Period, 7th to 8th centuries AD.

39. Gittinger, M., *Master Dyers to the World: Technique and Trade in Early Indian Dyed Cotton Textiles*, The Textile Museum, Washington DC 1982, fig.38.

40. Goepper, R., 'Notiz über expressive Techniken in der chinesischen Schriftkunst des 8. Jahrhunderts', in *Oriens Extremus*, vol.19, 1972, pp.31-40.

41. Cf. Paranavitana, S., 'The Significance of Sinhalese "Moonstones"', in *Artibus Asiae*, vol.17, 1954, pp.197-231; Wijesekera, N., *Early Sinhalese Sculpture*, Colombo 1962, pp.62-69; Bandaranayake, S., 'Sinhalese Monastic Architecture. The Viharas of Anuradhapura', in *Studies in South Asian Culture IV*, Leiden 1974, pp.323-8 (formal development of the moonstones).

42. Strzygowski, J., *Asiens bildende Kunst*, Augsburg 1930, fig.385.

43. Baltrusaitis, J., 'Sasanian Stucco. A. Ornamental', in Pope, A.U. and Ackerman (eds.), *A Survey of Persian Art*, vol.1, London and New York 1938, p.606, fig.181.

44. Ibid., vol.4, pl.172 E.

45. Ibid., vol.1, p.619; vol.1, p.606, fig.180.

A KIND OF ALCHEMY
Pages 138-153

SELECT BIBLIOGRAPHY

Atil, Esin, *Ceramics from the World of Islam*, Washington D.C. 1973.

Bagherzadeh, Firouz, *Oriental Ceramics*, vol.4, Iran Bastan Museum, Tehran, Tokyo and New York, 1981.

Caiger-Smith, Alan, *Lustre Pottery*, London, 1985. A general history, including chapters on glazes, pigments and firing techniques used for lustre ceramics.

Fehervari, Geza, *Islamic Pottery: A Comprehensive Study Based on the Barlow Collection*, London 1973.

Grube, Ernst J., *Islamic Pottery of the Eighth to the Fifteenth Century in the Keir Collection*, London 1976.

Watson, Oliver, *Persian Lustre Ware*, London 1985.

NOTES

1. Allan, J.W., 'Abu'l Qasim's Treatise', *Iran*, ii, 1973 (translation and notes); Kingery, W. David and Vandiver, Pamela, *Ceramic Masterpieces: Art, Structure, Technology*, New York and London 1986, ch.5, for a detailed technical account of a dish made in this paste.

2. The evidence presented in Watson 1985 indicates that Kashan was the main centre, and possibly the sole centre, for lustreware in the 12th to 13th centuries. I have followed Dr Watson's distinctions between the principal styles of decoration.

FROM DIVERSITY TO SYNTHESIS
Pages 170-187

NOTES

1. This is a revised version of the introductory article to the catalogue of an exhibition, *Inlaid Bronze and Related Material from pre-Tang China*, organized by Eskenazi Ltd, London, in 1991. I am grateful to Giuseppe Eskenazi for permission to reproduce plates from that catalogue; to Gisèle Croës for plates 9, 12, and 22, and to James Lally for plate 1. I would also like to thank Dr Jenny F. So for her advice during the preparation of this article.

2. Jessica Rawson, 'Chu Influences on the Development of Han Bronze Ritual Vessels', in *Arts Asiatiques*, vol.XLIV (1989), pp.84-99; and Jessica Rawson and Emma Bunker, *Ancient Chinese and Ordos Bronzes*, Hong Kong 1990, pp.47-55, for a full account of this transition.

3. Sergei I. Rudenko, *Frozen Tombs of Siberia: the Pazyryk Burials of Iron Age Horsemen*, London 1970, pls.59, 150A. Although the barrows at Pazyryk date to no earlier than the 4th century BC, there is good reason to suppose that many of the artefactual traditions – in particular the use of leather for vessels – preserved there had earlier roots.

4. This *hu* is discussed by Jenny F. So in Wen Fong (ed.), *The Great Bronze Age of China*, New York 1980, p.268, under the entry for no.70, and is illustrated in Charles D. Weber, *Chinese Pictorial Bronze Vessels of the Late Chou Period*, Ascona 1968, fig.65a.

5. William C. White, *Tombs of Old Lo-yang*, Shanghai 1934, no.262. The attribution of the Jincun tombs to the Zhou royal house is discussed in Li Xueqin, *Eastern Zhou and Qin Civilizations*, New Haven and London 1985, pp.29-36.

6. These vessels have traditionally been classed as *zhou*. Hayashi identifies them as *xing* (Hayashi Minao, *Shunjū Sengoku jidai no kenkyū*, Tokyo 1989, pp.125-27). The inscriptions on the only inscribed examples, two vessels discovered at Luoyang and Wuhan, both name them as *he* (*Wenwu*,1981.7, pp.65-67, figs.3, 7-8, and *Jianghan kaogu*, 1983.2, pl.8:3).

7. *Wenwu*,1983.12, pl.2:4 and p.2. I am grateful to Jenny F. So for bringing this piece to my attention, and for pointing out seams apparently imitating stitching.

8. Hayashi, op.cit., p.288, fig.3:254. This is similar to an excavated piece from Fenshuiling, near Changzhi, in Shanxi (*Wenwu*, 1972.4, pl.5:4).

9. *Wenwu*,1984.1, pl.5:1.

10. Sun Haibo, *Xinzheng yiqi*, Beijing 1937, pp.124-25.

11. *China Pictorial*, 1987.5, p.15.

12. Rudenko, op.cit., pl.137A-B.

13. For examples of *pushou* attached to the doors of Han tombs, see *Mancheng Han mu fajue baogao* (Excavation of the Han Tombs at Man-ch'eng), Beijing 1980, vol.1, p.18, fig.9, and vol.2, pl.IX.

14. Umehara Sueji, *Studies of the Noin-Ula Finds in North Mongolia*, Tokyo 1960, pl.LXXIV.

15. *Xinyang Chu mu* (Two Tombs of the Chu State at Xinyang), Beijing 1986, pl.LXXXVII:3. The pegs do not seem to have served for accurately tuning the instrument, given their square cross-sections, but up to nine strings could be wound around each peg. See Li Chunyi, 'Han se he Chu se diao xian tansuo' (Explorations into the tuning of Han and Chu zithers), *Kaogu*, 1974.1, pp.56-60.

16. For a discussion of bronze *zhen*, see Sun Ji, 'Han zhen yishu' (The art of Han weights), *Wenwu*, 1983.6, pp.69-72. Both the gilt bronze Han period *zhen* and their Warring States predecessors are often found in sets of four. In addition to the set from the tomb of the Marquis Yi of Zeng (see *Zeng Hou Yi mu* – Tomb of Marquis Yi of Zeng State, Beijing 1989, vol.2, pl.LXXXI:4), other sets have

been found in Jiangsu (*Kaogu xuebao*,1988.2, pl.16:2) and Guangdong (*Kaoguxue jikan 1*, 1981, p.113, fig.5:4).

17. *Baoshan Chu mu* (The Chu Cemetery at Baoshan), Beijing 1991, vol.2, pl.VIII.

18. *Kaogu*, 1984.5, pl.1, and p.410, fig.5.

19. *Qin ling er hao tong che ma* (Bronze chariot and horses no.2 from Qinshihuang's tomb), *passim*.

20. See the famous example in the Freer Gallery of Art, Washington DC, published in Thomas Lawton, *Chinese Art of the Warring States Period: Change and Continuity, 480-222 BC*, Washington DC 1982, pp.64-65, no.25.

21. The earliest southeastern dagger, from Changxing Xian in northern Zhejiang Province, is illustrated in *Wenwu*, 1979.11, pp.93-94.

22. *Wu Yue chun qiu: He Lü nei zhuan* and *Yue jue shu: ji bao jian*.

23. See *Kaogu xuebao*, 1974.2, pl.4:2, and *Kaogu*, 1963.5, p.241, fig.14:1.

24. Wang Renxiang, 'Daigou gailun' (A general survey of ancient Chinese belt hooks), in *Kaogu xuebao*, 1985.3, pp.267-312, and Esther Jacobson, 'Beyond the Frontier: A Reconsideration of Cultural Interchange between China and the Early Nomads', in *Early China*, vol.13, 1988, pp.208-210.

25. *China Pictorial*, 1987.5, p.15, and *Kaogu yu wenwu*, 1981.1, p.30, fig.19:15.

26. Iron blades with cast bronze handles occur intermittently from the Shang dynasty onwards (see note 28), but there is little evidence that iron was an important material for weaponry until the Western Han period.

27. *Kaogu*, 1984.1, pp.37-38, figs.2 and 5, and pl.4, and *Kaogu*, 1986.4, p.321, fig.6, and pl.7:1.

28. A rare example of late Western Zhou turquoise inlay occurs on two iron-bladed axes which are highly unusual in that they are also inlaid with gold. See *Orientations*, vol.26, no.1, January 1995, back cover.

29. For differing views on the origins of inlay in the Eastern Zhou period, see Rawson, *Chinese Bronzes: Art and Ritual*, London 1987, pp.52-53. The fullest treatment of the question is in Jenny F. So, *Eastern Zhou Ritual Bronzes from the Arthur M. Sackler Collections*, Washington DC 1995. Recently published photographs of two of the bronze heads from Sanxingdui show them partially masked in gold foil, described as adhered to the heads with a mixture of lacquer and lime. Although not technically inlay, this raises the possibility that there could have been a very limited use of gold inlay during Shang. See *Zhongguo qingtongqi quanji: Ba Shu* (Complete Compendium of Chinese Bronzes: Ba and Shu), Beijing 1994, pp.18-21, pls.21-24.

30. *Jiangling Mashan yi hao Chu mu* (Chu Tomb no.1 at Mashan in Jiangling), Beijing 1985, pls.XII-XX.

31. Ibid., p.65, fig.53, p.68, fig.56.

32. *Changsha Mawangdui yi hao Han mu* (Han Tomb no.1 at Mawangdui, Changsha), vol.2, pls.27-31 and pp.32-43.

33. *Hebei Sheng chutu wenwu xuanji* (Selection of cultural relics unearthed in Hebei Province), Beijing 1980, no.242.

34. Wu Hung, 'A Sanpan Shan Chariot Ornament and the Xiangrui Design in Western Han Art', in *Archives of Asian Art XXXVII*, 1984, pp.38-59.

35. Charles Weber, *Chinese Pictorial Bronze Vessels of the Late Chou Period*, pp.49-90.

36. Rawson and Bunker, op.cit., p.19.

37. *Gaocheng Taixi Shang dai yizhi* (The Shang Period Site at Taixi in Gaocheng), Beijing 1985, pl.CII:1, and *Wenwu*, 1977:11, p.6, figs.5-6.

38. *Wenwu*, 1987.10, pls.1:1-2,4 and p.4, figs.5-6. See also note 29.

39. *Kaogu*, 1984.5, pl.2:4.

40. *Wenwu*, 1984.9, p.6, fig.10.

41. *Xichuan Xiasi Chunqiu Chu mu*, Beijing 1980, pp.203-207, pls.LXXIII-VI.

42. A few solid gold vessels are known from the 5th century BC, including the gold and jade *he* from Shaoxing discussed above (note 9) and a bowl and goblet from the tomb of the Marquis Yi of Zeng (*Zeng Hou Yi mu*, vol.2, pls.XVII-XVIII).

43. Ibid., pl.XI:6. A gilded bronze pin, first half 5th century BC, is also reported from tomb 306 at Shaoxing in northern Zhejiang (*Wenwu*, 1984.1, p.23, fig.33:1). Silver- and gold-coloured lacquers from 4th century BC Chu tombs at Xinyang, southern Henan, may also be intended to create the illusion of precious metals.

44. Rawson and Bunker, op.cit., p.297, for a drawing of the Bashadar carvings.

45. See, for instance, the examples from the tomb of Liu Sheng at Mancheng in Hebei (*Mancheng Han mu fajue baogao*, vol.2, pl.LXXV:2).

46. William Watson, *Cultural Frontiers in Ancient East Asia*, Edinburgh 1971, pp.112-14, for a discussion of the animal combat theme, and Rudenko, op.cit., *passim*, for examples of predators twisted through a half turn.

47. For the Chiliktin plaques, see *From the Land of the Scythians: Ancient Treasures from the Museums of the U.S.S.R.*, 3000-100 BC, New York n.d., pl.3, no.29. Bunker discounts the possibility that the nomad use of turquoise inlays could have influenced their re-adoption by the Chinese, but Jacobson adduces the Chiliktin plaques to support her case of a nomad stimulus: see Emma Bunker, 'Sources of Foreign Elements in the Culture of Eastern Zhou', in George Kuwayama (ed.), *The Great Bronze Age of China: A Symposium*, Los Angeles 1983; Jacobson, op.cit., p.206.

48. Pear- and comma-shaped cells, sometimes inlaid with turquoise, are a feature of the gold plaques of Peter the Great's Siberian treasure (see M.P. Zavitukhina et al., *Frozen Tombs: The Culture and Art of the Ancient Tribes of Siberia*, London 1978, cat. no.5) and similar figures in a variety of materials are widespread among the Pazyryk finds (see Rudenko, op.cit., pp.230-36, figs.108-15).

49. An ear-ring with beaded edges is perhaps the earliest example of granulation from the eastern steppes (Rudenko, op.cit., pl.68B). Gold ingots in the form of horse and unicorn hooves decorated with beading from Ding Xian tomb 40, datable to the second half of the 2nd century BC, are among the first examples of granulation in China (*Wenwu*, 1981.8, pl.1:1-2).

ADVERTISEMENTS

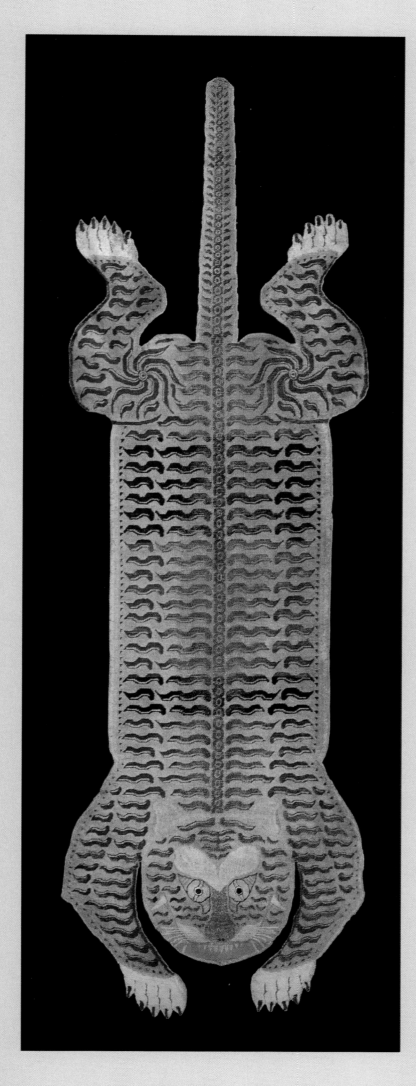

Carpet woven in the shape
of a tiger pelt
Ningxia, North western China
17th/18th century
112 x 356 cm

John Eskenazi

Antique rugs and textiles
Oriental art

John Eskenazi Ltd
15 Old Bond Street
London W1X 4JL
Telephone 0171-409 3001
Fax 0171-629 2146

Eskenazi & C.
Via Borgonuovo 5
20121 Milano
Telephone 02-86464883
Fax 02-86465018

Images of Faith

The Inaugural Exhibition
of the London Gallery

25th May - 23rd June 1995
Monday to Friday 10.00 am to 6.00 pm
Saturday by appointment
Catalogue available by request

A S I A N A R T G A L L E R Y

永
美
堂

A rare *Huanghuali*
square games table
(*qizhuo*) 17th century
Height 85.1 cm,
width 88.3 cm
(removable top not
illustrated)

Dr. Bettina Klein
Japanese and
Chinese fine arts

New address
Bergweg 57
61440 Oberursel
(approx 20 km
from Frankfurt)
Germany
Tel: 0 61 72/93 72 91
Fax: 0 61 72/93 72 92

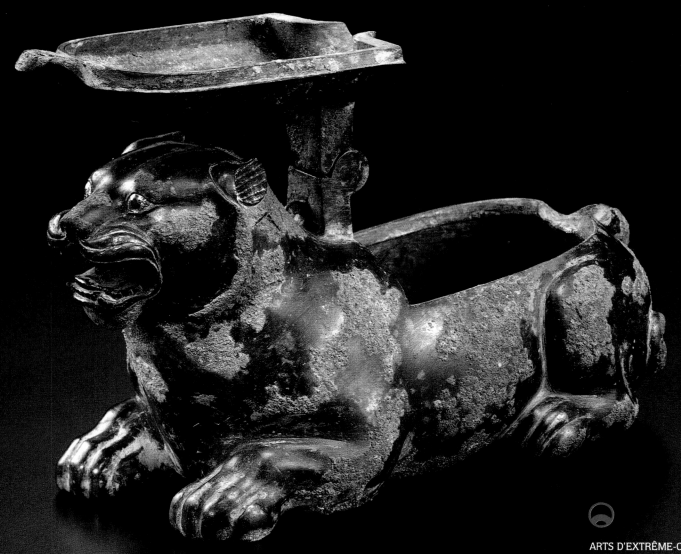

Gisèle Croës

ARTS D'EXTRÊME-ORIENT
54 BOULEVARD DE WATERLOO
1000 BRUSSELS - BELGIUM
TELEPHONE 322/511.82.16
TELEFAX 322/514.04.19

BRONZE OIL LAMP
IN THE SHAPE OF A TIGER
CHINA.
LATE WARRING STATES PERIOD
(475-221 BC)
CIRCA 3RD CENTURY BC
LENGTH 18 CM
MAXIMUM HEIGHT 12 CM

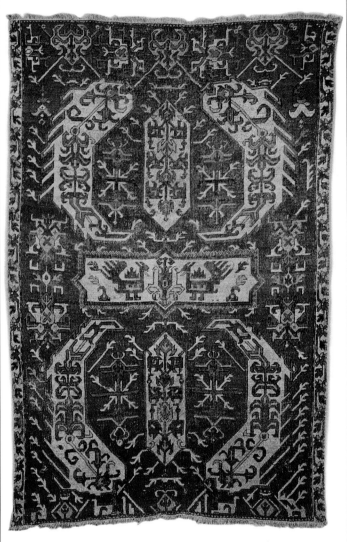
200

Azizian

TAPPETI ED ARAZZI ANTICHI

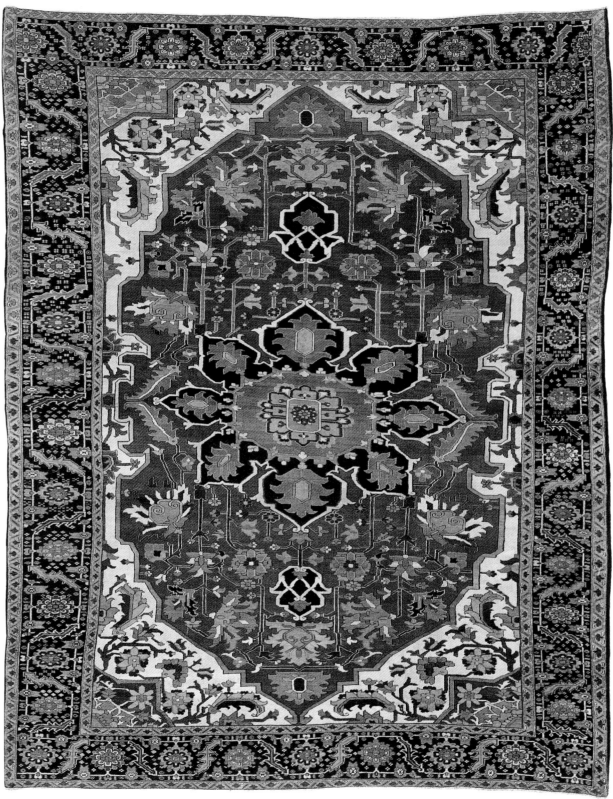

Heriz Serapi, northwest Persia, late 19th century
405 x 295cm

Via Colonnetta, 5
20122 MILANO - ITALY
Tel. (39 2) 5512802
Fax (39 2) 5512803

New Gallery:
Via Sant'Andrea, 11
20121 MILANO - ITALY
Tel. (39 2) 76001888

Silver Treasures of Islam

The art of the silversmith in the Islamic world:
its true æsthetic and historical significance.

Kunuz is the most comprehensive study
in the field and is illustrated
with over 330 previously unpublished colour images.

The book will be published in September 1995
in English and French editions.

LAK

INTERNATIONAL EDITION
100, Bd Abdelmoumen Casablanca, Morocco
Tel: 00212-2-251640 - Fax: 00212-2-231409

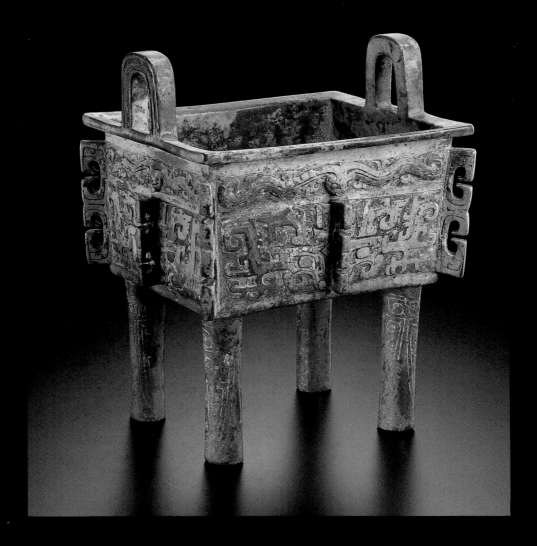

HALI PUBLICATIONS PRESENT
A MAJOR NEW BOOK ON THE WEAVINGS OF CAUCASIA

CAUCASIAN CARPETS AND COVERS

the weaving culture

by Richard E. Wright & John T. Wertime

Who produced the 19th and early 20th century knotted pile carpets and utilitarian flatwoven covers and containers of Caucasia, with their bold use of colour and striking design, and for whom were they made? These questions have never been adequately addressed until now.

CAUCASIAN CARPETS AND COVERS is a new, radical and historically rigorous analysis of carpet and textile weaving in the region. It overturns much of the accepted wisdom that has for too long distorted the Western view of this tradition.

The overthrow of Soviet hegemony in Caucasia and the resulting liberalisation of communications and trade has allowed the authors access to previously little-known traditional 'heirloom' items. Securely based on primary documentary and objective sources and coupled with a systematic analysis of woven structures, their studies shed new light on this absorbing subject.

This book sets the standard for Caucasian carpet and textile scholarship.

Publication Date: September 1995

Large format: 340 x 240mm

184 pages including technical appendices

90 colour images, 7 colour maps

32 black and white illustrations

Clothbound with French-fold dust jacket

£44 $80 DM113
plus postage and packing of £5 $10 DM15

Please use the card provided to order your copy NOW or call our HOTLINE on (44) 171 328 1998 or write to HALI, 'Caucasian Carpets and Covers', Kingsgate House, Kingsgate Place, London NW6 4TA, UK. Fax: (44) 171 372 5924

EMIR

Depuis
1919

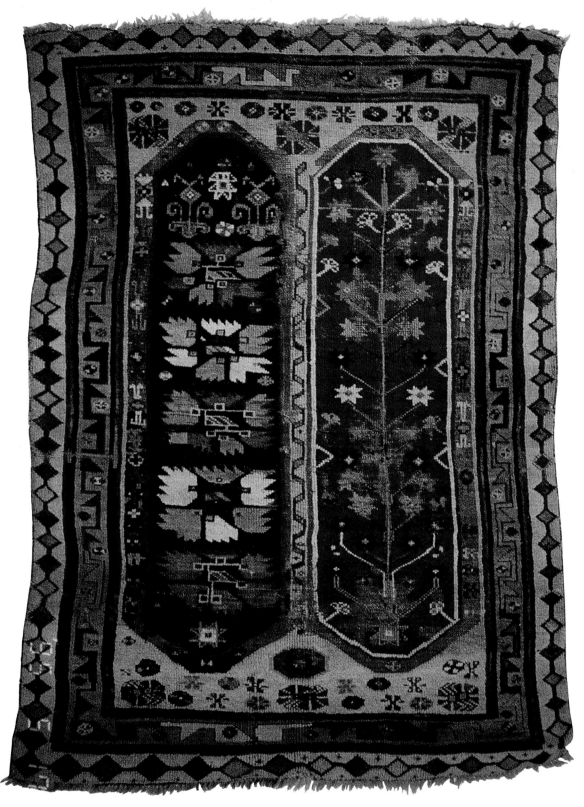

Antique Makri, south west Anatolia, 18th century
1.93 x 1.25m

7, rue de la République 69001 Lyon Tél. 78 28 05 22 Fax. 78 27 22 11
52, rue d'Antibes 06400 Cannes Tél. 93 39 12 50

TAPIS PERSANS TAPIS CHINOIS ANCIENS TAPISSERIES ANCIENNES

FUNERARY MASK
ATONI TRIBE, TIMOR. WOOD, HAIR, 19TH CENTURY OR BEFORE, 17" HIGH (37.5 CM)

THOMAS MURRAY

ASIATICA – ETHNOGRAPHICA

P.O. BOX 1177 . MILL VALLEY, CA 94942 . TEL 415.679.4940 . FAX 415.453.8451

Yves Mikaeloff

Old Master paintings and drawings
carpets, tapestries
furniture
&
porcelain

will be exhibiting at

The Grosvenor House Art & Antiques Fair
15th - 24th June 1995
Grosvenor House, Park Lane, London W1A 3AA
and
Biennale Internationale des Antiquaires de Monte-Carlo
29th July - 15th August 1995
The European Fine Art Fair, Basel
16th - 24th September 1995
The European Fine Art Fair, Maastricht
9th - 17th March 1996

10 et 14 rue Royale, 75008 Paris, France Tel: 33 (1) 42 61 64 42 Fax: 33 (1) 49 27 07 32

Address in Iran
Vakil Mosque Ave. 37
Shiraz
Tel. 071-29560

Old Luri Gabbeh
231 x 135cm

**The Specialist
for Tribal Rugs
and Kilims of
Southern Persia**

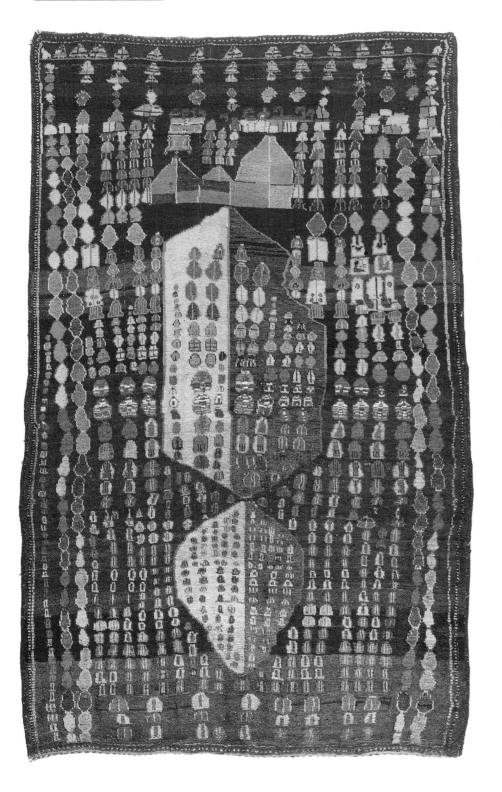

Zollanvari AG
8043 Zurich, Switzerland
Freilagerstrasse 47
Block 4, 5th Floor
Postbox 156
Tel. 01-493 28 29
Fax 01-493 07 73

Hollaendischer Brook 5
1. OG
D-20457 Hamburg, Germany
Tel. 40-32 47 85
Fax 40-32 69 98

ZOLLANVARI

Order extra copies now for yourself or as a beautiful and original gift for a friend.

Price: **£44 $72 DM113**
Plus Postage and Packing
£5 $10 DM15

Extra Copies

For further information call our Hotline on 44 171 328 1998.

To help us respond to the needs of our readers, please answer the questions on the reverse of this Order Card.

Ensure your collection of THE HALI ANNUAL series is complete!

Articles in the 1994 edition included: **Textiles and Society,** The Islamic Tradition. **Love and Understanding,** The Orient Stars Collection. **Tracing the Dragon,** Designs in Early Chinese Textiles. **Identifying with the Gods,** Burmese Court Costume. **Dyeing Under Fire,** The Afghan Ikat and Carpet Projects. **Brussels Style,** Pre-Renaissance Tapestries. **Embroidery in Britain 1200-1750,** The V&A Collections. **The Moment of Greatest Sanctity,** A Pacatnamu Ritual Textile. **From the Infinite Blue,** Mapuche Textiles from Southern Chile. **Seeing and Believing,** Navajo Blankets. **Carpets at Auction,** Auction Review 1993-1994.

Softcover Price: **£34 $55 DM87**
Hardcover Price: **£44 $72 DM113**
Plus Postage and Packing **£5 $10 DM15**

1st Edition

For further information call our Hotline on 44 171 328 1998.

To help us respond to the needs of our readers, please answer the questions on the reverse of this Order Card.

If you have enjoyed THE SECOND HALI ANNUAL, why not subscribe to HALI, *The International Magazine of Antique Carpet and Textile Art.*

	1 Year (6 Issues)	2 Years (12 Issues)
UK	£56	£102
GERMANY	DM178	DM332
REST OF EUROPE	£60	£108
USA & CANADA	$104	$189
*REST OF THE WORLD	£75	£138

*Airmail rates available on request

HALI

The International Magazine of Antique Carpet and Textile Art

Subscription

For further information call our Hotline on 44 171 328 1998.

To help us respond to the needs of our readers, please answer the questions on the reverse of this Order Card.

READER'S PROFILE

Please ✓ the relevant box. Thank you for your co-operation.

How did you obtain this copy of THE SECOND HALI ANNUAL?
- ☐ Bookshop, *please state name and city:*_____
- ☐ Other, *please specify:*_____

Do you subscribe to HALI, *The International Magazine of Antique Carpet and Textile Art?*
- ☐ Yes ☐ No

Which of the following best describe you? (You may ✓ more than one box, if necessary)
- ☐ Collector
- ☐ Academic
- ☐ Fashion Designer
- ☐ Auctioneer/Expert
- ☐ Dealer
- ☐ Student
- ☐ Architect/Specifier
- ☐ Museum Professional
- ☐ Interior Designer
- ☐ Medical/Scientific Professional
- ☐ Other, *please state your interest/profession:*_____

Which subjects are of most interest to you? (You may ✓ more than one box, if necessary)
- ☐ Oriental Carpets
- ☐ Oriental Textiles
- ☐ European Carpets
- ☐ European Textiles
- ☐ Chinese Art
- ☐ Japanese Art
- ☐ Himalayan Art
- ☐ Indian Art
- ☐ Southeast Asian Art
- ☐ Native American Art
- ☐ Pre-Columbian Art
- ☐ Tribal Art
- ☐ Other, *please specify:* _____

READER'S PROFILE

Please ✓ the relevant box. Thank you for your co-operation.

How did you obtain this copy of THE SECOND HALI ANNUAL?
- ☐ Bookshop, *please state name and city:*_____
- ☐ Other, *please specify:*_____

Do you subscribe to HALI, *The International Magazine of Antique Carpet and Textile Art?*
- ☐ Yes ☐ No

Which of the following best describe you? (You may ✓ more than one box, if necessary)
- ☐ Collector
- ☐ Academic
- ☐ Fashion Designer
- ☐ Auctioneer/Expert
- ☐ Dealer
- ☐ Student
- ☐ Architect/Specifier
- ☐ Museum Professional
- ☐ Interior Designer
- ☐ Medical/Scientific Professional
- ☐ Other, *please state your interest/profession:*_____

Which subjects are of most interest to you? (You may ✓ more than one box, if necessary)
- ☐ Oriental Carpets
- ☐ Oriental Textiles
- ☐ European Carpets
- ☐ European Textiles
- ☐ Chinese Art
- ☐ Japanese Art
- ☐ Himalayan Art
- ☐ Indian Art
- ☐ Southeast Asian Art
- ☐ Native American Art
- ☐ Pre-Columbian Art
- ☐ Tribal Art
- ☐ Other, *please specify:* _____

READER'S PROFILE

Please ✓ the relevant box. Thank you for your co-operation.

How did you first become aware of HALI?
- ☐ Bookshop
- ☐ Word of mouth
- ☐ Fair or Exhibition
- ☐ Direct Mail
- ☐ Through a Dealer
- ☐ Other, *please specify:*_____
- ☐ Advertisement in THE ANNUAL
- ☐ Advertisements in other publications

Which of the following best describe you? (You may ✓ more than one box, if necessary)
- ☐ Collector
- ☐ Academic
- ☐ Fashion Designer
- ☐ Auctioneer/Expert
- ☐ Dealer
- ☐ Student
- ☐ Architect/Specifier
- ☐ Museum Professional
- ☐ Interior Designer
- ☐ Medical/Scientific Professional
- ☐ Other, *please state your interest/profession:*_____

Which subjects are of most interest to you? (You may ✓ more than one box, if necessary)
- ☐ Oriental Carpets
- ☐ Oriental Textiles
- ☐ European Carpets
- ☐ European Textiles
- ☐ Chinese Art
- ☐ Japanese Art
- ☐ Himalayan Art
- ☐ Indian Art
- ☐ Southeast Asian Art
- ☐ Native American Art
- ☐ Pre-Columbian Art
- ☐ Tribal Art
- ☐ Other, *please specify:* _____

ISLAMIC ART

A week of sales of Islamic and Indian Art
is held bi-annually in London in April and October

Our Autumn Islamic sales will be held on 18th and 19th October 1995.
For further information, please contact John Carswell or Brendan Lynch on (0171) 408 5154

SOTHEBY'S, 34-35 NEW BOND STREET, LONDON W1A 2AA.

An Artuqid silver and gold-inlaid bronze jug inscribed to
Majd Al-Din 'Isa Al-Zahir Artuqid ruler of Mardin 1376-1404 A.D., Jazira, circa 1375-1400 A.D.
Sold in London on 27th April 1995 for £128,000

SOTHEBY'S
FOUNDED 1744

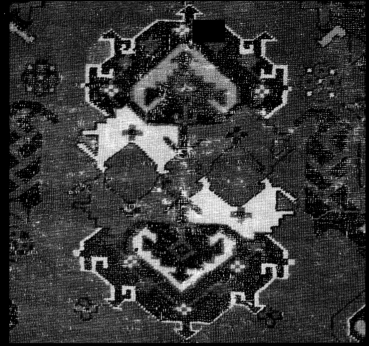
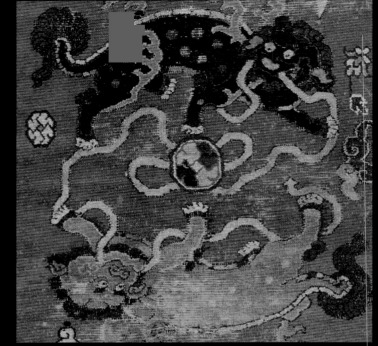

CARPETS AND TEXTILES AT SOTHEBY'S

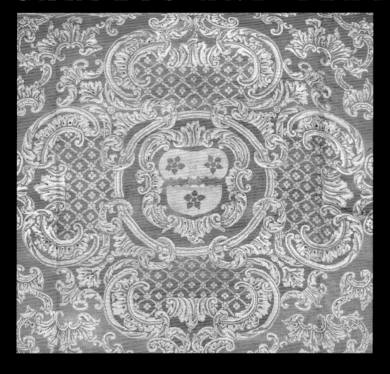
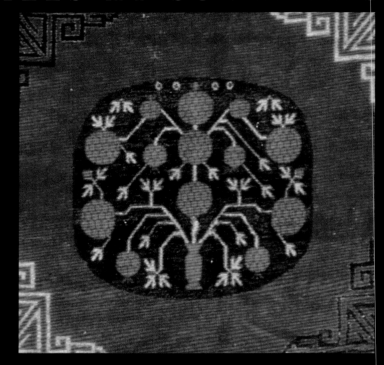
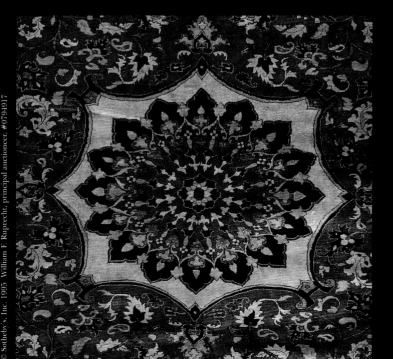
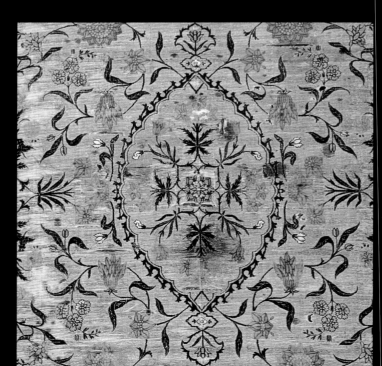

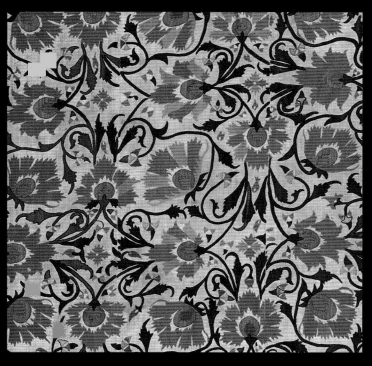

THE WEAVINGS ILLUSTRATED IN DETAIL HERE ARE A SELECTION OF THE WIDE RANGE OF CARPETS AND TEXTILES OFFERED AT SOTHEBY'S DURING THE LAST YEAR.

To find out more about buying or selling rugs and carpets at Sotheby's, please call:

Jacqueline Coulter
in London at (44 171) 408 5152
Sotheby's, 34-35 New Bond Street, London W1A 2AA

Mary Jo Otsea
in New York at (212) 606 7996
Sotheby's, 1334 York Avenue New York, New York 10021

AUCTION SCHEDULE FOR RUGS AND CARPETS

Auctions in New York:
September 13th, 1995
December 14th, 1995

Auction in London:
October 18th, 1995

Rugs and carpets are also included in French Furniture sales in New York and London, *Arcade Furniture & Decorations* sales in New York and *Colonnade Furniture & Decorations* sales in London.

For a complete Sotheby's sale schedule and to order catalogues, please call:
in the U.S. (800) 444 3709;
outside the continental U.S. (203) 847 0465;
in the U.K. (0234) 841043.

SOTHEBY'S
FOUNDED 1744

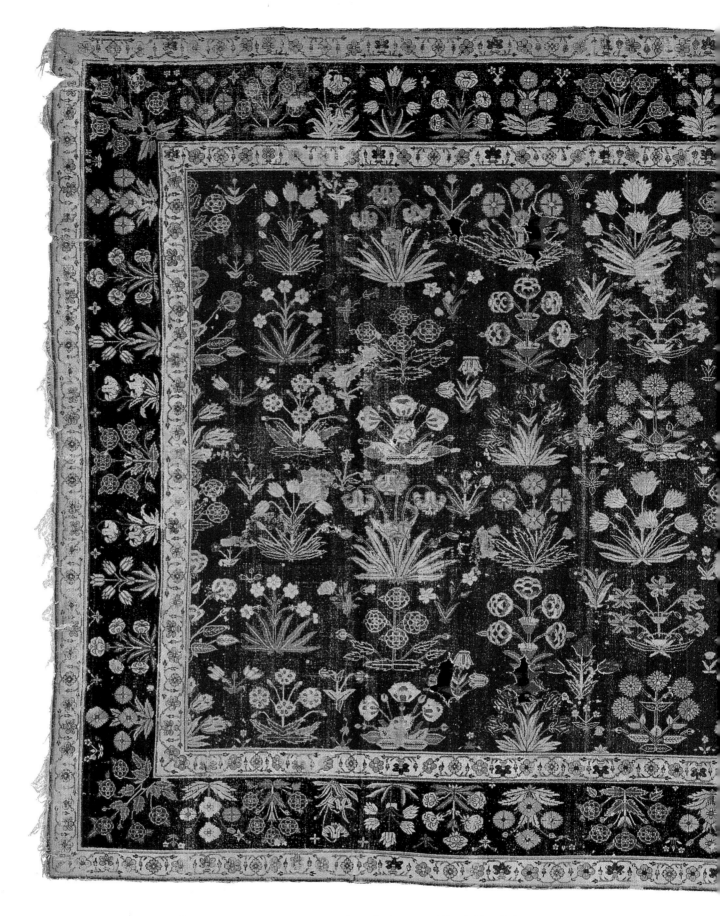

Mughal Floral Carpet, Lahore, Northwest India, mid 17th century, 3.00 x 4.57m

Provenance:
Hagop Kevorkian. Sold Sotheby's, London, December 5, 1969, lot 13
J. Paul Getty Museum, Malibu

Literature:
Dimand, Maurice S., *The Kevorkian Foundation Collection of Rare and Magnificent Oriental Carpets*,
Special Loan Exhibition, New York; The Metropolitan Museum of Art, 1966, ex. no. 25
Eiland, Murray, *Chinese and Exotic Rugs*, Boston, 1979, fig 110
Sassoon, Adrian and Wilson, Gillian, *Decorative Arts: A Handbook of the Collections of the J. Paul Getty Museum*, Malibu, 1986, fig. 310

Exhibited:
The Kevorkian Foundation Collection of Rare and Magnificent Oriental Carpets, 1966; a travelling exhibition

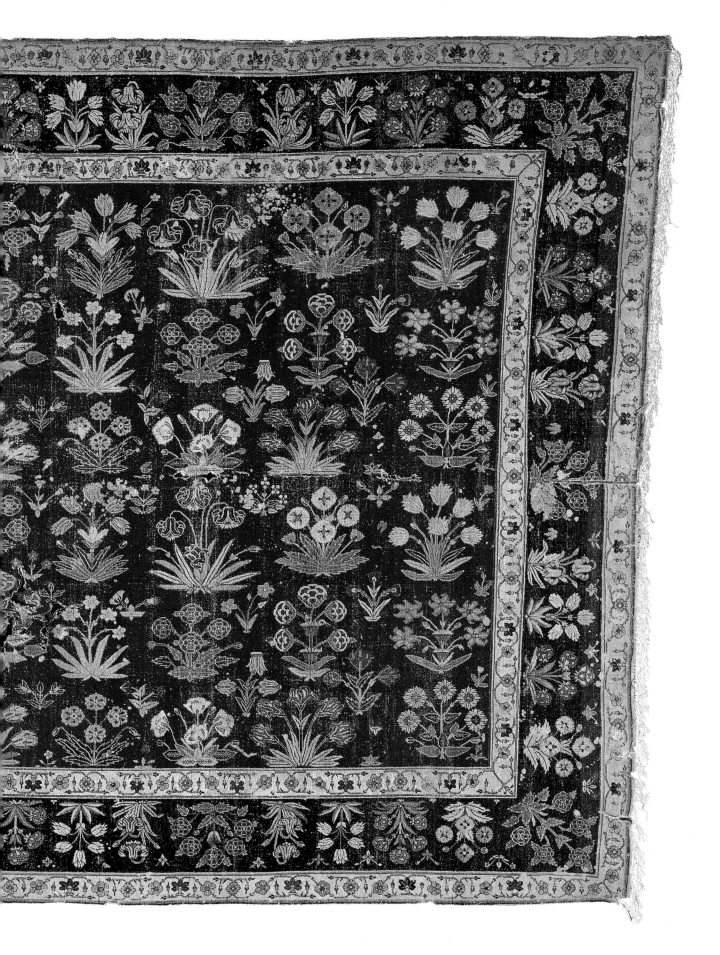

EM

Emil Mirzakhanian

Via Bagutta 24, 20121 Milan, Italy
Tel: (02) 76002609 Fax: (02) 783719

GALERIE ARABESQUE
Antique Oriental Carpets

Ming dynasty
(1368 - 1643)
seat back
China

Dr. Ulrike Montigel
Breitscheidstrasse 98
D-70176 Stuttgart, Germany
Tel: (49 711) 63 47 34

OTTOMAN ART

ANTIQUE CARPETS AND KILIMS

UZBEK IKAT

UZBEK SUZANI

UZBEK IKAT

KASHMIR SHAWL

CAUCASIAN SOFREH

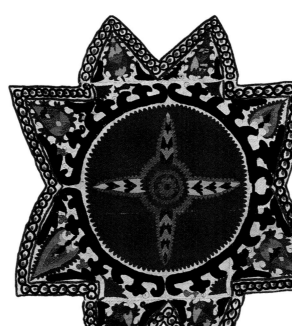

UZBEK SUZANI

JAF KURDISH BAG FACE

AVAR KILIM

CAUCASIAN FRAGMENT

STUDIO VANNINI

KONYA RUG

OTTOMAN KILIM

CAUCASIAN SHADDAH

BERGAMA BAG FACE

GALLERY: VIA DELLA SPOSA, 15/A - 15/B, 06123 PERUGIA, ITALY TEL/FAX: (39 75) 573 6842
RESTORATION WORKSHOP: VIA DELLA SPOSA, 16, 06123 PERUGIA, ITALY

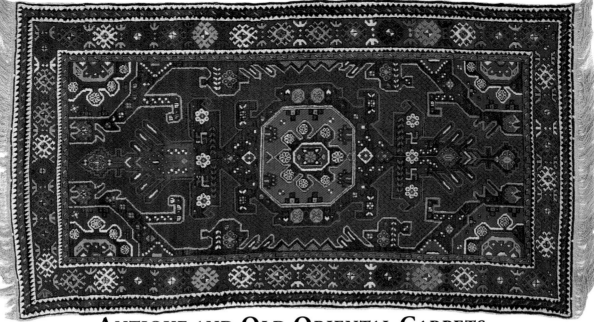

Record Price for any Carpet

A Savonnerie carpet, France, circa 1740-50,
manufactured from a cartoon by Pierre-Josse Perrot
18ft.8in x 19ft.10in (567cm x 603cm)
Sold in London 9th June 1994 for £1,321,500 ($1,994,144)

year after year after year

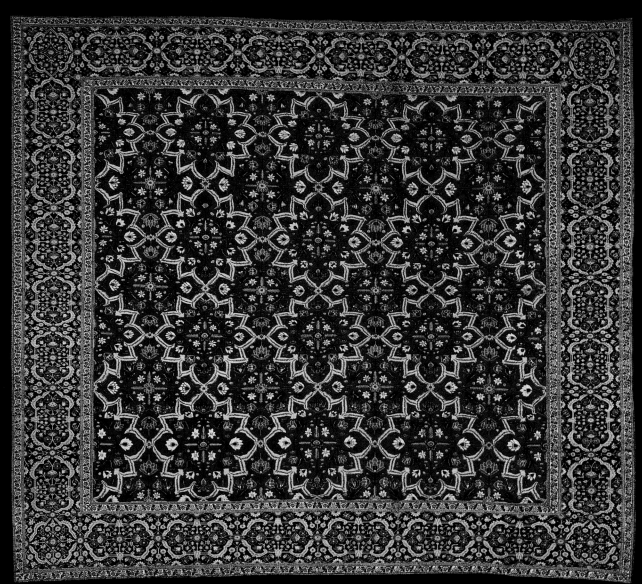

1995

Record Price for any Oriental Carpet

The Vanderbilt Mughal Millefleur 'Star-lattice' carpet
North India, late 17th/early 18th century, 12ft.8in x 13ft.6in (386cm x 411cm)
Sold in New York 10th April 1995 for $992,500 (£620,313)

To find out more about buying or selling Carpets
or Islamic Art at Christie's please contact:

William Robinson in London
on (44171) 389 2370
Christie's London
8 King Street, St. James's,
London SW1Y 6QT
Tel: (0171) 839 9060
Fax: (0171) 389 2215

James A. Ffrench in New York
on (212) 546 1187
Christie's New York
502 Park Avenue, New York,
New York 10022
Tel: (212) 546 1000
Fax: (212) 223 3985

CHRISTIE'S

222

J.P. WILLBORG
Antique rugs, textiles, African art

Meğri rug, south west Anatolia, circa 1840-1870, 123-6 x 178.5cm.

Exhibited and Published: "Textile Treasures from Five Centuries", by Peter Willborg
at the Gallery Heland Wetterling, Stockholm, no. 11, p. 42 - 43, 1995

Provenance: Rolled up in newspaper in a Swedish warehouse since 1936

Member of the Swedish Art and Antique Dealers Society.

Sibyllegatan 41, S-11442 Stockholm Sweden. Tel. + 46 8 783 02 65, 783 03 65 Fax + 46 8 783 59 93

TEFAF
BASEL

16-24 SEPTEMBER 1995
MESSE BASEL, SWITZERLAND

The European Fine Art Fair Basel
(TEFAF Basel)
is a new international art and
antiques fair with a markedly central
and southern European character.

Information:
Tel. (31-73) 890 090